D1211716

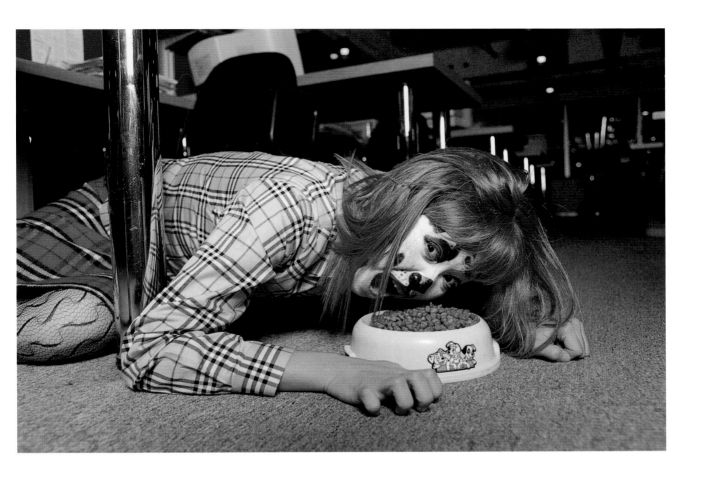

CONTEMPORARY
ASIAN art

WITHDRAWN

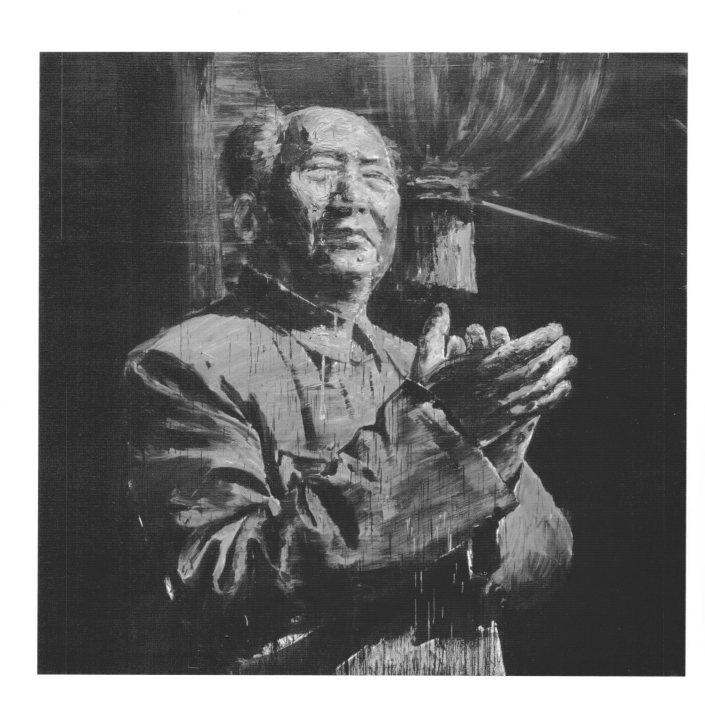

CONTEMPORARY
ASIAN art

Melissa Chiu + Benjamin Genocchio

PROPERTY OF
SENECA COLLEGE
LIBRARIES
NEWNHAM CAMPUS

PROPERTY OF
SENECA COLLEGE
LIBRARIES
MARKHAM CAMPUS

Thames & Hudson

with 235 illustrations, 204 in colour

FEB 07 2011

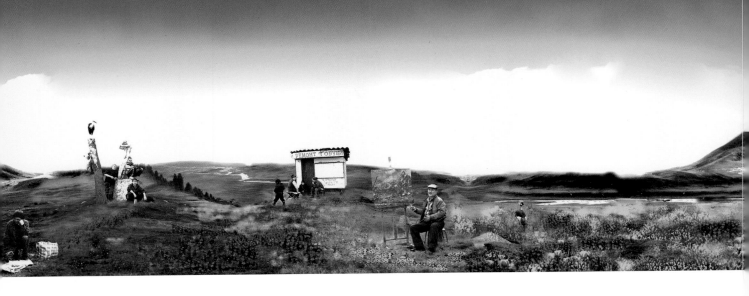

NOTE TO THE READER

In many Asian countries, family names commonly
precede given names. Some individuals, however,
have chosen to adopt Western order – given name,
followed by family name. This book respects the
preferred name order of each individual.

For consistency, and in order to aid the general reader,
the use of diacritical markings in specific regional
languages has also been avoided.

Dimensions supplied in illustration captions cite
height, followed by width, followed by depth, as
appropriate.

First published in the United Kingdom in 2010 by
Thames & Hudson Ltd, 181A High Holborn,
London WC1V 7QX

© 2010 Melissa Chiu and Benjamin Genocchio

All Rights Reserved. No part of this publication may
be reproduced or transmitted in any form or by any
means, electronic or mechanical, including photocopy,
recording or any other information storage and retrieval
system, without prior permission in writing from the
publisher.

British Library Cataloguing-in-Publication Data
A catalogue record for this book is available from
the British Library

ISBN 978-0-500-23874-5

Printed and bound in Singapore by Tien Wah Press
(Pte) Ltd

To find out about all our publications, please visit
www.thamesandhudson.com. There you can subscribe
to our e-newsletter, browse or download our current
catalogue, and buy any titles that are in print.

p. 1 **Cao Fei** *Hungry Dog (Rabid Dogs Series)* 2002
Digital C-print, 60 x 90 cm (23 1/2 x 35 1/2 in.)

p. 2 **Yan Pei-Ming** *Mao Rouge* 2006
Oil on canvas, 350 x 350 cm (137 3/4 x 137 3/4 in.)

pp. 4–5 **Alexander Ugay, in collaboration with Roman
Maskalev** *Paradise Landscape* 2004 (detail)
Digital print on canvas, 80 x 400 cm (31 1/2 x 157 1/2 in.)

contents

Takashi Murakami *The World of Sphere* 2003
Acrylic on canvas mounted on board, 350 x 350 cm (137 7/8 x 137 7/8 in.)

introduction

Much as global political and cultural dominance by the United States prompted frequent reference to the twentieth century as 'the American Century', so the phrase 'the Asian Century' – associated with a historic 1988 meeting between Chinese leader Deng Xiaoping and Indian Prime Minister Rajiv Gandhi – signifies a belief that the twenty-first century will be dominated by Asia. To some extent, the implied promise contained in this phrase has already been fulfilled. In the past decade, the balance of geo-political, economic and even military power has shifted away from America and Europe towards Asia. Japan, Taiwan and Korea are at the cutting edge of technological trends, while China and India have re-emerged as international powers. The Chinese economy has enjoyed decades of record growth; India, too, continues to undergo unprecedented social and economic transformation. Both countries are nuclear powers, and in 2003 China became only the third nation to achieve a manned space flight.

The international art world has mirrored these geopolitical changes. In museums and art galleries around the world, observers of contemporary art today will more than likely confront pieces by Asian artists, some of them working in their home countries, others living in art-world centres such as New York, London and Berlin. It is hardly possible to overstate the growing visibility of Asian artists. The fame of Japanese artist Takashi Murakami (b. 1962) has extended well beyond the art world since his 2002 collaboration with the luxury brand Louis Vuitton on the production of limited-edition handbags; in 2008 he was voted one of *Time* magazine's one hundred most influential people. In that same year, Chinese artist Cai Guo-Qiang (b. 1957) had a retrospective at New York's Guggenheim Museum. Asian artists are now fixtures at world-survey exhibitions such as Documenta and the Venice Biennale. In this sense, then, contemporary Asian art is not restricted to Asia but is a global phenomenon.

Contemporary Asian art is also an emerging scholarly field. Along with magazine and journal articles and books that have documented this new sphere of study, there have been a growing number of major pan-Asian periodic exhibitions devoted to Asian artists, including the Asia-Pacific Triennial of Contemporary Art begun in 1993 at the Queensland Art Gallery in Brisbane, and the Fukuoka Asian Art Triennale begun in 1999 at the Fukuoka Asian Art Museum in Japan.[1] An increasing number of important international shows have also taken place, complete with catalogues. These include

'Contemporary Art in Asia: Traditions/Tensions' in New York, Vancouver, Perth and Taipei (1996), and 'Cities on the Move' in Vienna, Bordeaux, Copenhagen, London, New York and Bangkok (1997–99).[2] Courses have been founded at universities, and to a lesser extent museums have assembled collections of contemporary Asian art, notably the Fukuoka Asian Art Museum, the Singapore Art Museum, the Queensland Art Gallery in Australia and the Asia Society Museum in New York. There are also several major private collections in Europe, Australia and America. Whereas not long ago critics and historians either dismissed Asian artists as feeble imitators of their international peers, or were obsessed with revealing an 'authentic' culture devoid of Western or any other influences, there now exists a growing appreciation for the specific cultural circumstances and references that shape and distinguish contemporary Asian art.[3]

What, then, is it that distinguishes a work of art by a contemporary Asian artist? How is the work understood by viewers in and outside the region? What is its status and relationship to more traditional modes of Asian art? How can we assess its merits in an international or global art-world context? These are some of the questions underlying this book – a broad-ranging study intended to introduce the emerging field of contemporary Asian art from the 1990s onwards.

We will also explore some of the circumstances in which these artworks have been created, and will highlight the artists' ongoing dialogues with memory, imagination and the demands of everyday life, in the belief that artworks are always as much the product of particular social, cultural and historical circumstances as they are highly individual creative acts.

The book is organized thematically, an approach that avoids orthodox historical narratives (chronology, stylistic transition, a charting of movements and schools) and allows for both an in-depth analysis of the principal issues governing contemporary Asian art and an introduction to a wide range of artists, many of whom will be unfamiliar to readers outside the region.

The art discussed ranges from painting (in oil, tempera and ink) to sculpture, photography, performance, installation, video and new media. That said, it seems crucial that certain distinctions we are making here are understood clearly, for perhaps more so than anywhere else contemporary Asian art takes many forms and encompasses a range of purposes and points of view. National cultural expectations, and the continuation of localized artistic traditions, are of primary concern to a large number of Asian artists: this, however, is not the subject of our book. Rather, we focus on those artists who identify with the experimental language, media and styles of the international contemporary art world. This, in turn, presents significant challenges to scholarly efforts to define contemporary Asian art, much less to survey adequately the variety of artists and art practices in an immense, diverse region that includes nearly thirty countries, and whose three billion inhabitants – more than half the population of the world – speak dozens of regional dialects and languages.

Cai Guo-Qiang *Inopportune: Stage One* 2004
Installation view: Guggenheim Museum, Bilbao (exhibition copy)
Nine cars and sequenced multichannel light tubes

Nam June Paik *Li Tai Po* 1987
Installation view: Asia Society Museum, New York
Ten antique wooden cabinets, one antique radio cabinet, antique Korean printing block, antique Korean book, eleven colour TVs, 244 x 158 x 61 cm (96 x 62 x 24 in.)

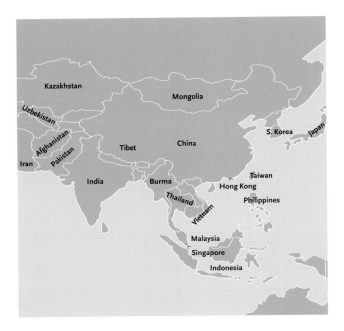

The challenges begin with 'Asia' itself. As a term, it is more of a discursive concept than a homogeneous physical, social or even cultural entity. It is an idea more than a location. The word 'Asia' is often believed to have been first used by fifth-century BC historian Herodotus, originating from the Greek term for Anatolia (Southern Turkey) to distinguish the Persian Empire from Greece and Egypt. By the Middle Ages, 'Asia' was in widespread use across Europe to describe a distinct landmass, though definitions of its parameters varied and have continued to do so over the centuries. Today there are so many definitions of 'Asia' that the term remains elusive, confusing and contradictory.

For the purposes of this book, in geographical terms we will concentrate on contemporary art and artists from four sub-regions: East Asia (Japan, South Korea, Taiwan, Hong Kong, Tibet, Mongolia and mainland China); South Asia (India and Pakistan); Southeast Asia (Malaysia, Singapore, Indonesia, Philippines, Burma, Thailand and Vietnam); and Central Asia (Kazakhstan, Uzbekistan and Afghanistan). Although commonly considered part of the Middle East, Iran is also included here because of its cultural, linguistic, religious and ethnic ties to the Asian region; the Persian Empire

ruled for centuries over much of Central Asia, and people living in Iran today have much in common with their Central Asian neighbours, not to mention Persia's substantial influence on the art and architecture of South Asia during the Mughal period (1526–1858).

Contemporary Asian art, however, is not confined to Asia. As mentioned above, many successful Asian artists live outside Asia, chiefly in Europe, the United States, Canada and Australia. Others commute between homes in different countries. 'Contemporary Asian art' in this sense, then, is understood not merely as a set of art objects from a specific geographical area, but as a discursive framework within which experimental art connected to the region can be understood. This approach allows us to identify shared attitudes, ideas, themes and references. Curiously, such an interpretive framework would seem to have greater currency and use outside of Asia than within it, where the people tend to distinguish readily among the numerous different regional and cultural traditions and to identify themselves along national, ethnic and linguistic lines. Some Asian art historians have even argued that the term 'Asian art' is not a valid concept.[4] At the same time, contemporary art within Asia has a shared regional history, which it is worth pausing to review briefly, if only to dispel a widespread belief that until recently there was no such thing as contemporary Asian art.

ORIGINS AND PRECURSORS

In Europe and America in the decades after World War II, contemporary Asian art was chiefly identified with a few key artists living in the West. Most famous, perhaps, were the Korean Nam June Paik (1932–2006) and the Japanese Yayoi Kusama (b. 1929), Yoko Ono (b. 1933) and On Kawara (b. 1933). Back in the 1960s, all of these artists were living in New York – a crucible of innovation and experimentation in the visual and performing arts that was rapidly emerging as the centre of the international art world.

One of Paik's first video artworks (1965) was a short tape of Pope Paul VI's visit to the city. That same year, Kusama exhibited her first multidimensional mirror environment,

Map of Asia

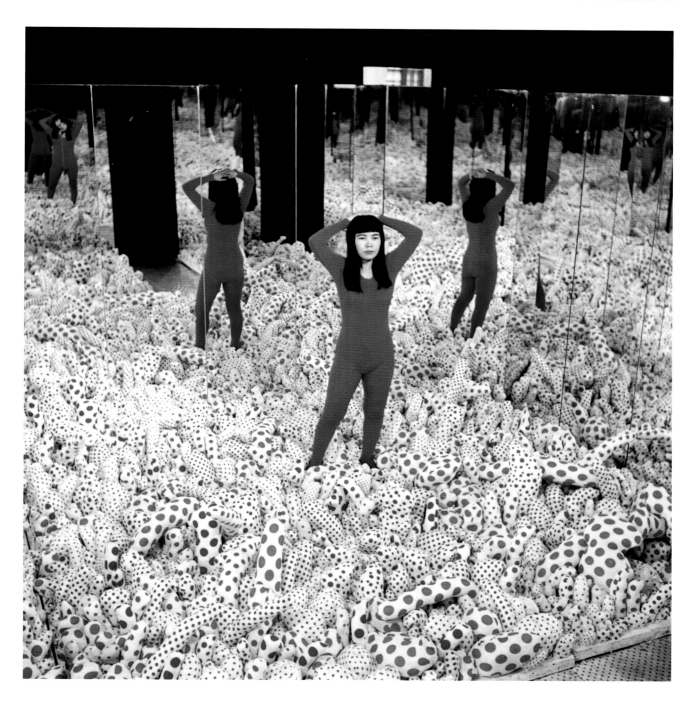

Yayoi Kusama *Infinity Mirror Room – Phalli's Field (or Floor Show)* 1965
Installation view: Castellane Gallery, New York
Sewn stuffed fabric, wooden panel, mirror

Infinity Mirror Room – Phalli's Field at Castellane Gallery in New York. Also in 1965, Ono presented *Cut Piece* at New York's Carnegie Recital Hall, a daring performance work in which she knelt motionless on a stage as members of the audience were invited, one by one, to cut off a portion of her clothing with scissors. In 1966 Kawara began his 'date paintings', recording the day, month and year he made each painting in block numbers and letters on a monochromatic ground; since then he has painted over two thousand, making this one of the world's longest-running conceptual art projects.

Having attained a comfortable acceptance among a broad constituency of international experimental artists, Kawara, Paik, Kusama and Ono were included in Western art-historical accounts of the period. This was acceptable to some of the artists. As Paik noted: 'I have never thought of myself as expressing Korean-ness or Asian-ness. Art is simply an expression of the individual.'[5] But this sentiment, laudable as it is, also underscores some of the problems in available art-historical narratives. Until recently there were few histories of modern art in Asia, and, insofar as histories were written, in catalogues and occasional books, they were largely nation-based and chronological, with an emphasis on art and artists reflecting national themes. Because of this, it has long been assumed that there was little or no experimental art going on in Asia during the period. But Kusama had already gained notoriety for experimental works on paper before moving to New York in 1958, while Ono first performed her *Cut Piece* in Kyoto in 1964. Even earlier, in the mid-1950s, avant-garde artists across Asia had begun to challenge tradition-based art forms.

Pioneering this challenge were the Japanese groups Experimental Workshop, a cross-media art and technology collective that included Katsuhiro Yamaguchi (b. 1928) and Toru Takemitsu (1930–1996), and more importantly Gutai (a word meaning 'concreteness'), led by Yoshihara Jiro (1905–1972). The Gutai group staged actions and performances, as well as interventions in museums and social spaces, beginning in 1955 with an event in a park in the city of Ashiya. The group's actions and events were often short spectacles, neither scripted nor choreographed, with an emphasis on process over end product. Kazuo Shiraga's (1924–2008) *Challenging Mud* (1955) was an early Gutai performance, for

Yoko Ono *Cut Piece* 1964
Performance at Carnegie Recital Hall, New York, 21 March 1965

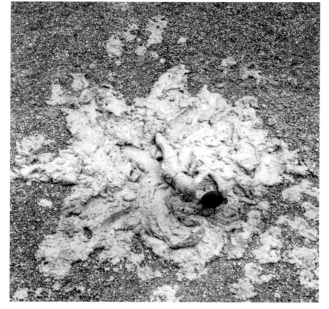

Kazuo Shiraga *Challenging Mud* 1955
Performance at 1st Gutai Art Exhibition, Ashiya

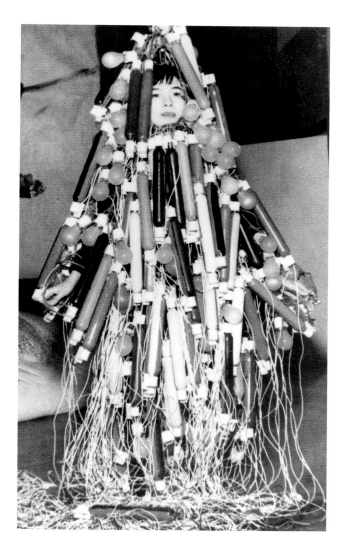

which the artist rolled around in and wrestled with mud. For *Electric Dress* (1956), Tanaka Atsuko (1932–2005) constructed a wearable robe made of red, green, yellow, blue and white lights that lit her up like a Christmas tree.

Gutai artists also made a specialty of process painting. Shiraga famously painted abstract pictures with his feet, while Shozo Shimamoto (b. 1928) made radical spray pictures by smashing containers full of paint onto canvas or by firing small hand-made cannons with paint-filled balls at his canvases. Yoshida Toshio (1928–1997) was even more radical in ambition. His 1955 statement 'What I Want To Do' describes plans for paintings made with novel materials and equipment:

> One [painting method] involves a helicopter and a huge tank. The tank is as big as a gas tank but without a roof. Inside, it is lined with canvas, and a helicopter is placed in the center. Paint cans equipped with nozzles are attached to the tips of the helicopter blades. When the blades rotate, paint automatically splatters onto the canvas. I am very interested in the sensation of speed and in work that is created as a result of mechanical movement.[6]

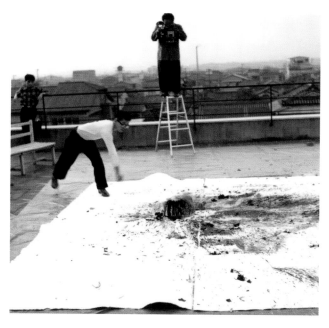

Tanaka Atsuko *Electric Dress* 1956
Performance at 2nd Gutai Art Exhibition, Tokyo

Shozo Shimamoto making a process painting 1956
Performance at 2nd Gutai Art Exhibition, Tokyo

Through exhibitions in Amsterdam, New York and Turin, the Gutai group acquired an international reputation. While their paintings were often misunderstood as a Japanese version of Art Informel or Abstract Expressionism, their performances attracted the attention of many leading art-world figures, including Allan Kaprow, who around the same time began to pioneer the idea of artistic Happenings.

Japan continued to be central to experimental art in Asia throughout the 1960s. Tokyo's Group Ongaku and Hi Red Center were connected to Fluxus, the international interdisciplinary art movement founded in Berlin, though active in New York and elsewhere. Other Asian pioneer dissenters included the Japanese movement Mono-ha (meaning roughly 'school of things'), a loose group of artists residing in Tokyo who were involved in creating installations, ephemeral art and sculpture emphasizing the use of raw, natural substances, sometimes combined with industrial materials. Mono-ha, founded in 1968, the same year as the Land Art movement in the US, began with a sculpture by Sekine Nobuo (b. 1942), *Phase – Mother Earth* (1968), a daring conceptual take on positive and negative space. For the piece, the artist dug a hole outdoors in the ground and then shaped the displaced soil into a cylindrical sculpture. Lee Ufan (b. 1936), a Korean-born painter and sculptor resident in Japan since 1956 (he also widely influenced emerging installation and performance art in Korea in the late 1960s and 1970s), was in many ways the intellectual leader of the Mono-ha group. Writing about *Phase – Mother Earth*, he noted:

Look at those 'idea-obsessed' men who fuss about in parks everywhere, even in natural landscapes, in their

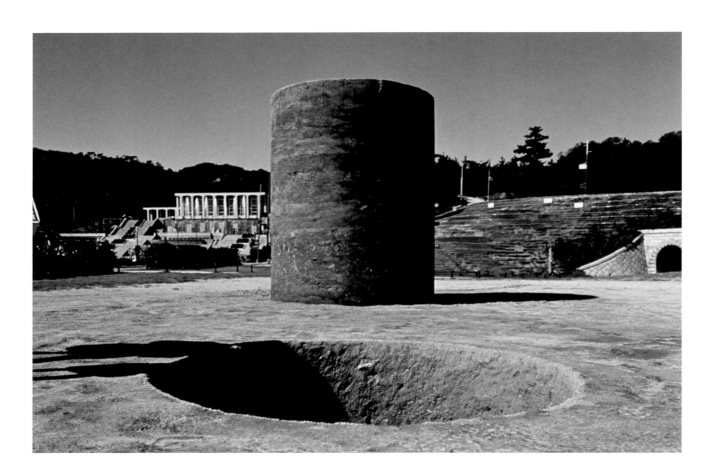

Sekine Nobuo *Phase – Mother Earth* 1968
Installation view: Suma Palace Park, Kobe
Earth, 260 x 220 x 200 cm (102 3/8 x 86 5/8 x 78 3/4 in.): 2 parts

efforts to improve and embellish nature.... They artificially assert their will on things out of a desire to give form, but generally end up all the more objectifying the line between their works and nature. Yet among these goings-on, one lone 'Happener' unveiled a near-miraculous different world. The sight was almost mythological ... as if a giant had 'carved out' and 'deposited' the earth right there, an altogether amusing shape.... And yet it turns [the earth] into a thing of moving expressiveness that vividly conveys the world 'as-it-is'.[7]

Here Lee outlines an innovative approach to making art, involving increased attention to the raw, material presence of *mono* – things. In so doing, as the Japanese art critic Akira Tatehata has observed, Lee conceived a powerful theoretical foundation not just for Sekine's new and innovative sculpture but for the artists associated with Mono-ha.[8]

Across the rest of Asia, post-war political independence, modernity and industrialization had a powerful transformative influence on the cultures in many countries, as on life in general, providing a catalyst for experimentation in the arts.[9] Certain similar experiences can be described throughout much of the twentieth century: first, an encounter with Western and other Asian art; second, a desire to modernize visual culture; third, an attempt to adapt modernism to local aesthetic values and subjects; finally, a self-conscious development of individual artistic voices. These four impulses occurred at different times, with different levels of intensity, in each country in the region. Several prominent artists, for instance, spent parts of their career away, returning with new optimism and ideas about how to reshape local artistic developments (a further complicating factor is that for some artists Western art was mediated through other Asian artists and art centres: for example, many Korean and Thai artists learned of Western art via Japanese art schools). In the best cases, modernism was not imported wholesale or copied, but was adapted to different sets of cultural, political and social circumstances. The Indonesian curator and critic Jim Supangkat has coined the term 'multimodernism' to charac-

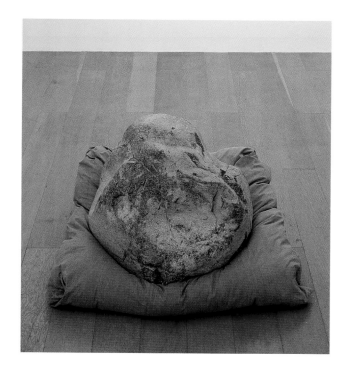

terize the disparate modern artistic directions that were manifested in Asian countries in accordance with local conditions.[10]

Abstraction and Expressionism spread rapidly to Asia, especially Taiwan, India and Korea. Artists involved in the Fifth Moon Group (*Wuyue pai*) in Taipei in the 1950s, including Liu Guosong (b. 1932) and Zhuang Zhe (b. 1934), were fascinated with Abstraction, which they viewed as an alternative to the local dominance of traditional Chinese ink and brush painting and a necessary means to the reinvigoration of Taiwanese art. In India, a variety of European modern art styles (Expressionism, Abstraction and Cubism) had an influence on those artists associated with the Bombay Progressive Artists, an influential group that emerged following independence from Britain in 1947. Among its members were Francis Newton Souza (1924–2002), Syed Haider Raza (b. 1922), Maqbool Fida ('M. F.') Husain (b. 1915) and Tyeb Mehta (b. 1925), several of whom sought to fashion a fresh cultural self-image by combining nationalistic subject matter and sentiments with modernist styles. In the 1960s, Nasreen

Lee Ufan *Perception* 1969
Stone, cushion, light; dimensions variable

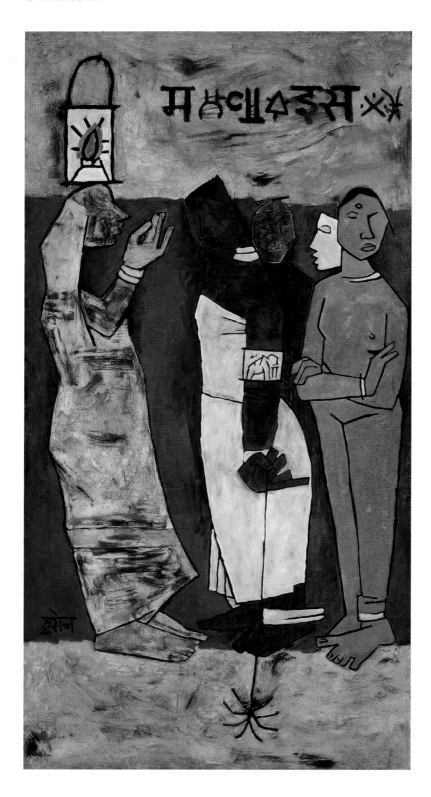

M. F. Husain *Between the Spider and the Lamp* 1956
Oil and acrylic on Masonite board, 243 x 122 cm (95⅝ x 48 in.)

Mohamedi (1937–1990), who had studied in London and lived in Paris and Tokyo before settling in Mumbai, engaged with international geometric abstraction in a conscious rejection of local revivalist nationalism. At around the same time the Informel group – abstract painters based in Seoul – were the first Koreans to be invited to participate in important international exhibitions, such as the São Paulo and Paris biennials. Among the artists associated with the group were Kim Tschang-yeul (b. 1929), Youn Myeung Ro (b. 1936) and Park Seo-bo (b. 1931); Seo-bo was also involved in the Korean monochrome movement.

Elsewhere, the importation and adaptation of a modernist sensibility meant something quite different. In the Philippines, the artists who formed the group known as the Thirteen Moderns opposed the dominant modes and ideals of traditional art taught in national art schools. A pioneer of Filipino modernism was Victorio C. Edades (1895–1985), who had studied at the University of Washington in Seattle in the 1920s. He reinvigorated Philippine art with the introduction of a style of Post-Impressionism inspired by Cézanne and Gauguin but with a Filipino accent. In Thailand, Damrong Wong-Uparaj (1936–2002), who studied at the Slade School of Fine Art in London in the 1960s, painted abstractions and modernist-inspired, narrative-based, rural scenes of daily Thai life. Though often executed in a loose, expressive manner that looks unchallenging today, these are nonetheless important for the development of modernism in Thailand, emerging at a time when art continued to be viewed largely as the expression of public devotion both to religious belief and the king. Modernist painting remained an important option for progressive Thai artists well into the twentieth century.

While some artists looked to outside influences to reinvigorate their local artistic traditions, others sought homegrown sources of inspiration. They began to study and explore the roots of their traditional culture, which continued to exist alongside the encroaching modern world. Paralleling the development of a more Western, modern style of art was thus a widespread revival of traditional artistic practices

and religious influences, and an enthusiasm for folk art and craft traditions. In Indonesia, for example, the aftermath of Dutch colonial rule (which lasted nearly 350 years), the Japanese occupation during World War II and the struggle for independence (finally recognized in 1949) saw traditional arts and subject matter from the past dominate efforts to develop a distinctive national painting style. Indonesian artists sought creative inspiration in Balinese and Javanese dance, the sculptures of the Borobudur temple on Java and the distinctive *wayang kulit* shadow puppets. S. Soedjojono (1914–1986) and Hendra Gunawan (1918–1983) were among the exponents of this style of painting. Even Affandi (1907–1990), Indonesia's foremost Expressionist painter, painted socio-cultural themes. In Malaysia, indigenous craft traditions held sway over artists until the mid-1960s, exemplified in the batik paintings of Chuah Thean Teng (1914–2008). Meanwhile, in Pakistan, Abdur Rahman Chughtai (1894–1975) and Mohammad Haji Sharif (1889–1978) were drawn to Mughal painting traditions, while Sadequain (1930–1987) looked to develop a new style of Islamic calligraphy.

For Korean artists of the mid-1970s, monochrome or 'monotone' painting (*dansaek-hwa*) offered a contemporary form of expression that was nonetheless grounded in Korean artistic traditions.[11] Park Seo-bo, Lee Dong-yeop (b. 1946), Huh Hwang (b. 1946), Suh Seung-Won (b. 1942), Kwon Yong-woo (b. 1926), Ha Chong-hyun (b. 1935) and Kim Ki-rin (b. 1936), among others, created subtle-toned, largely monochromatic paintings. Their emphasis on a rejection of decorative detail in favour of a more austere visual pleasure reflected the aesthetics of traditional Korean ceramic art, such as Silla-period (57 BC–AD 935) earthenware and Joseon (1392–1910) white porcelain – a marked departure from the conscious rejection of illusion and reduction of the picture plane to a flat surface that characterized Western Colour Field painting and Minimalism. Nor were Korean monochromes rigorously minimal or monochromatic; some showed pencil strokes, while others incorporated perforation, cracking and stippling.

Nasreen Mohamedi *Untitled c.*1970s
Graphite and ink on paper, 47.6 x 47.6 cm (18³/₄ x 18³/₄ in.)

Park Seo-bo *Ecriture No. 60 ~ 73* 1973
Oil on canvas, 130 x 162 cm (51 ¹/₈ x 63 ⁷/₈ in.)

A different approach is required to assess those countries with Communist governments, where access to developments in Western contemporary art was often controlled and sometimes banned. Such locations include China, Vietnam, North Korea and much of Central Asia, which until the early 1990s was under the political control of the former Soviet Union. This often led to the development of parallel art scenes – an official and an unofficial art world. The official art world was frequently ruled by the government propaganda department, which granted licences to hold exhibitions and supported a system of art schools, art exhibitions and state-run museums. The unofficial art world consisted of artists who produced work that, by and large, could not be shown in public because of its provocative social nature, or sexual or political content. Any transgression risked censure, and even imprisonment. More often these artists found opportunities to show internationally, or exhibited in local private spaces such as their apartments and working studios.

It is not just Communist countries, however, where censorship has been an issue: it remains a fact of life to varying degrees all across Asia, specifically where political, religious or social conflict has been a fact of life. M. F. Husain, one of

India's best-known artists and a Muslim, has lived in exile in Dubai and London following the publication of an article in 1996 about nude images of Hindu deities he painted in the 1970s. This led to death threats by Hindu nationalists, charges of obscenity and eventually a warrant for his arrest. Husain is not alone: many artists, critics and curators working in Burma, Pakistan, Indonesia, Malaysia, Singapore and Iran have been subjected to intimidation and censorship, ranging from the closure of exhibitions, destruction of work and arrest, to restrictive government policies and limitations on what they are allowed to create, publish and show.[12]

Social and political commentary and criticism remain a popular target for censors. But in some countries – Burma and Vietnam specifically – simply making a work of abstract painting, installation or video art is viewed with suspicion and routinely banned out of hand. Even colours can be suspect: during the period in 2008 following nationwide pro-democracy protests in Burma spearheaded by Buddhist monks against the ruling military junta, government officials sought to prohibit artists from painting pictures of monks or using red and orange paint in their works – colours associated with Buddhist clothing.[13] In short, government censors often

Li Keran *Sunset on the Pass* 1964
Ink and colour on paper, 111.8 x 137.2 cm (44 x 54 in.)

presume a veiled criticism in anything they do not under-stand, or into which they believe they can read a symbolic meaning. Website art, virtual gatherings and collective event-based projects that are difficult for the authorities to monitor are just a few of the new, enterprising ways in which artists have sought to circumvent government restrictions.[14]

Censorship has been prolonged and brutal for artists in China, a country largely closed off from the world following the Communist overthrow of the Nationalists in 1949. During the post-revolutionary period, Chinese art was heavily influ-enced by Soviet-inspired Socialist Realism, which became the official and sanctioned art style of the Chinese Communist Party. Artists were forced to conform to this new genre and revolutionary subject matter. During the Cultural Revolution (1966–76), Western influences in art were banned and artists routinely imprisoned. Even traditional artists making calligra-phy or ink and brush painting, such as Li Keran (1907–1989) and Shi Lu (1919–1982), were subjected to scrutiny and censure. For much of this period, the subject matter and style of art in China were heavily prescribed. Artists were invited to produce propaganda or art that sold a political line – no exceptions.[15]

Things began to change in 1979 with Deng Xiaoping's 'Open Door' policy, along with the first real avant-garde art group in the country, known as The Stars (*xing xing*). Led by Huang Rui (b. 1952) and Ma Desheng (b. 1952), The Stars were experimental artists, mostly painters and a few sculptors, such as Wang Keping (b. 1949), one of the leading avant-garde artists of the late 1970s and 1980s. As a group, The Stars focused on individual self-expression using Abstraction, Surrealism and other Western art styles, in contrast to the Socialist Realist art of the Cultural Revolution. They originally garnered widespread attention for an unsanctioned exhibi-tion of twenty-three artists organized in a park outside the National Art Museum in Beijing in September 1979 – one of the first, defiant public displays of experimental art in China. The police closed the exhibition after three days, a not-unfamiliar response to early contemporary art in Communist countries.

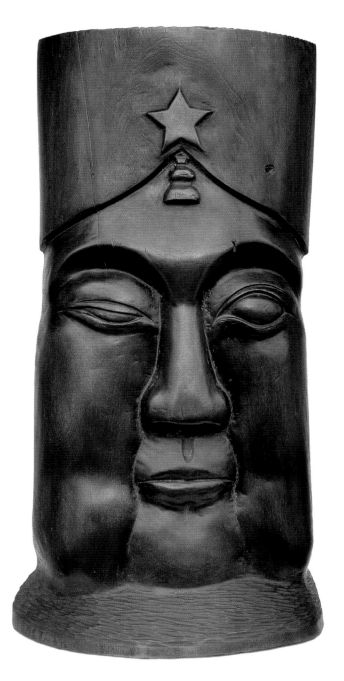

Wang Keping *Idol* 1979
Birch wood, height 67 cm (26 3/8 in.)

In the following years, many members of The Stars left China. Ai Weiwei (b. 1957) was the first to depart, moving to the United States in 1981. In 1983 Li Shuang (b. 1957) – a rare female member of the group – went to France, where she was followed a year later by Wang Keping, and three years later by Chen Zhen (1955–2000). Huang Rui and Ma Desheng settled in Japan and Switzerland respectively. In all, nine Stars artists left China, establishing a pattern of Chinese artist migration over the next decade. Among those who left were Cai Guo-Qiang, Xu Bing (b. 1955), Wenda Gu (b. 1956), Huang Yong Ping (b. 1954) and Yan Pei-Ming (b. 1960). A curious consequence of this migration was the creation of a de facto Chinese contemporary art community living outside of China, which until the late 1990s came to represent Chinese contemporary art to the international art world.[16] As of 2010, many of these artists were once again living and working in China, where they are now relatively free to make whatever art they wish. Young artists also no longer feel bound to leave in search of opportunities. This is not to suggest, however, that the visual arts enjoy complete freedom in China: art fairs and museum shows are still censored, and the internet is heavily policed.[17]

After decades of political and economic isolation, Central Asian artists have also begun to reconnect with the world, joining the free market of ideas and images following political independence from the Soviet Union in the early 1990s. Most contemporary artists in these former Soviet states (among them Uzbekistan, Tajikistan, Kazakhstan, Kyrgyzstan and Turkmenistan) were initially trained in architecture, monumental Socialist Realist painting and sculpture at Soviet art schools. Today, however, the region has emerged as the site of a complex new-media art culture, with appealing local particularities of content and style.

The first **Stars** exhibition, staged on the fence separating the National Art Museum in Beijing from a small park to its east, 27 September 1979

Wang Keping *Waiting* 1987
Wood, height 72 cm (28 3/8 in.)

ART WORLDS EMERGE

It is now commonplace to observe that the borders of the nation states in Asia that we know of today are largely inherited boundaries drawn during the twentieth century. After World War II, many Asian nations gained independence from European colonial powers, and with this came new borders and an emphasis on developing and promoting local cultures as a sign of nationhood. To claim the status of a modern nation it became practically mandatory to possess a national art museum, even though the financial support and government commitment in these newly developing and post-colonial countries – some of which were mired in a constant state of political crisis and economic flux – were not always forthcoming. The timing, mission, quality and scale of the institutions have understandably varied throughout the region, where up until recently there had been little history of public museums.

Among the earliest of these institutions was the National Museum of Modern Art, Tokyo, which opened in 1952, followed two years later by the National Gallery of Modern Art in New Delhi, following independence from Britain. In 1959 the National Art Gallery of Malaysia opened in Kuala Lumpur. Other national art museums took a little longer, including

the National Art Museum of China (1962); the National Art Gallery, Bangkok (1977); and the National Taiwan Museum of Fine Arts (1988). More recently, the Indonesian National Gallery opened in 1999, while in 2007, after a three-decade delay, the National Gallery of the Arts opened in the Pakistani capital of Islamabad, victim of changing priorities during successive power shifts between military and civilian regimes.

For many of these national museums, traditionalism – understood as the preservation of an indigenous cultural heritage – was the goal. This reflected an effort to foster the expression of a localized cultural identity. It was not until the late 1980s and 1990s, and even more recently, that there was any real investment in dedicated contemporary art museums in Asia. Behind this investment was, in part, rapid economic expansion – in Japan first, followed by the 'Asian Tigers' Taiwan, South Korea, Singapore and Hong Kong, nations that pursued highly successful, export-driven models of development. Although inaugurated as early as 1969, the National Museum of Contemporary Art in Seoul was relocated to a purpose-built building in 1986 and began to showcase more international art. In Japan, for a time, art museums became a symbol of new-found wealth and status, among them the Yokohama Museum of Art, which opened in 1989, and the Museum of Contemporary Art (MOT), Tokyo's first contemporary art museum, opened in 1995.[18] Elsewhere, Singapore Art Museum was founded in 1996 and today holds the largest public collection of twentieth-century Southeast Asian art; the Museum of Contemporary Art, Taipei, opened in 2001.

Building and maintaining contemporary art museums have not been the sole prerogative of governments. Private museums have also become increasingly popular in the region as manifestations of the commitment of a certain class of people to contemporary art. In Tokyo, the Hara Museum of Contemporary Art opened in 1979, but today is just one of the many private art museums in Japan; others include Mori Art Museum in Tokyo and Naoshima Contemporary Art Museum on the island of Naoshima. In South Korea, some of the strongest contemporary art museums are privately owned and operated; in fact, many are run by corporations. Examples in

Xu Bing *Art for the People* 1999
Installation view: Victoria and Albert Museum, London
Dye sublimation on Dacron polyester, 11 x 2.75 m (36 x 9 ft)

Seoul include the Leeum – Samsung Museum of Art and the Artsonje Centre, largely financed by the Daewoo Corporation. In the Seoul area alone there are more than twenty active, privately funded contemporary art museums. A private museum building boom is also occurring in China, and to a lesser extent in India. Examples in Beijing include the Today Art Museum, which opened in 2002, and the Ullens Center for Contemporary Art, which opened in 2007. In Delhi, the Devi Art Foundation opened as a private exhibition venue in 2008.

Investment in cultural infrastructure also led to a proliferation of biennial and triennial exhibitions of international contemporary art, frequently promoted by local governments to fetch prestige for their cities and to attract tourism. They were defined, in some cases, by a focus on local and regional perspectives, but for the most part included Asian and international art. Most were based on the model of their European predecessors, like the Venice Biennale initiated in 1895 to expose Europeans to international art. Asian periodic exhibitions began with the Tokyo Biennale, which lasted eighteen editions (starting in 1952 and ending in 1990). The oldest continuous show is the Triennale-India, begun in Delhi in 1968, but most are more recent. Today they are found in, among other cities, Jakarta (since 1982), Taipei (since 1992), Brisbane (since 1993), Gwangju (since 1995), Shanghai (since 1996), Busan (since 1998), Fukuoka (since 1999), Tashkent (since 1999) and Singapore (since 2006). Other periodic exhibitions include the Chiang Mai Social Installations begun in 1992, an event run by artists with art installed across the city focusing on regional social and political concerns.

Biennials and other such recurring exhibitions have done much to foster contemporary Asian art.[19] They have become an alternative periodic forum for artists, whether from Asia or elsewhere, and they have promoted the circulation of artwork, helping to identify regional trends while drawing Asian artists, critics and curators into regional and transnational art discourses; here, too, increasing government support for artist travel and residency programmes has been crucial. Participation in biennials beyond Asia has also been a way for artists to gain broader recognition. Much attention has

Exterior of the Leeum – Samsung Museum of Art, Seoul; interior of the Ullens Center for Contemporary Art, Beijing; Shanghai Art Museum, Shanghai Biennale, 2006

Su-Mei Tse *L'écho* 2003
Video installation: 4 mins, 52 secs; dimensions variable

been focused on the Venice Biennale. In 1956, Japan established a national pavilion there, making it one of only two Asian countries admitted into the club of thirty nations with permanent buildings in the Giardini. In 1995, the second, South Korea, opened its permanent pavilion. That same year, Taiwan established a presence with an offsite pavilion, followed later by Singapore, Hong Kong, India, Central Asia, Indonesia, China and Thailand, all pursuing an offsite strategy. Participation at Venice has launched the careers of several artists: in 2003, Su-Mei Tse (b. 1973) won the Golden Lion for her digital video installations in the Luxembourg pavilion.

Finally, alternative spaces – including the Philippines Baguio Arts Guild founded in 1987; Singapore's 5th Passage Artists Ltd founded in 1991; Para/Site Art Space founded in Hong Kong in 1996; and SSamzie Space and Insa Art Space founded in Seoul in 2000 – have played a valuable role in the development of contemporary Asian art. In fact, these spaces have often emerged as a city's sole site for showing innovative, experimental art in the absence of museum support or a developed commercial gallery system. Alternative spaces possess two common characteristics: they are non-collecting organizations, and they are artist- or project-driven. Many are also short-lived, inhabiting temporary locations in low-rent urban areas, though circumstances vary greatly from place to place and country to country. Japan saw the earliest development of this phenomenon when, in the early 1960s, the Neo-Dada Organizers artist group gathered regularly in the 'White House', the studio of one of its members, for performances and radical impromptu exhibitions. Sagacho Exhibit Space (1983–2000) was another important and long-running alternative space in Japan, but since then countless alternative spaces have sprung up across Asia, some government-sponsored, others privately funded or surviving through donations and artist rental fees. Cemeti Art House, founded in Yogyakarta, Indonesia, and Taiwan's IT Park, both established in 1988, are two of the longest-running alternative art spaces in the region. More informally, artists' collectives, such as VASL, an artist-led initiative in Pakistan, sponsor residencies, workshops, and shows of local and international artists.[20]

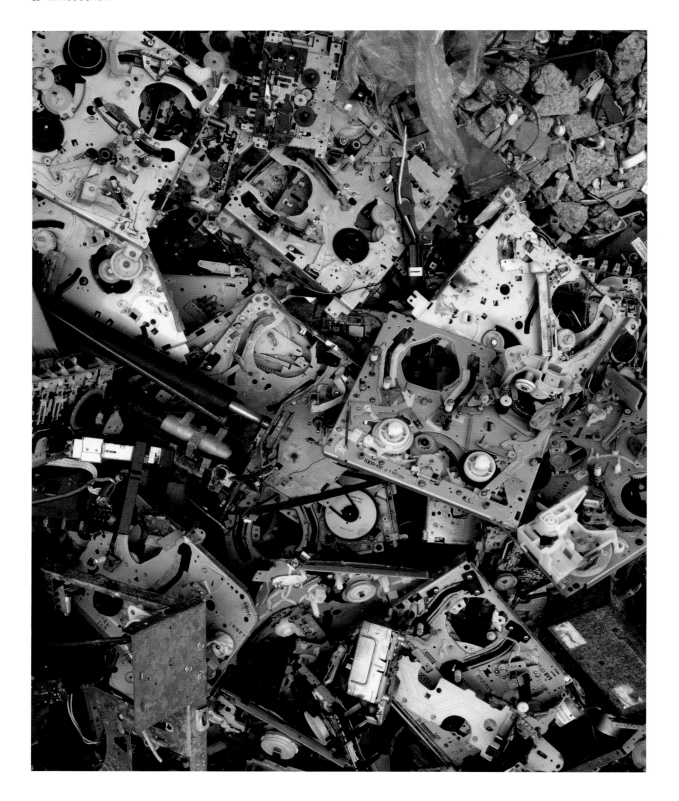

Xing Danwen *disCONNEXION, image b5* 2002
Colour photograph, 148 x 120 cm (58¹/₄ x 47¹/₄ in.)

By the end of the 1990s, most Asian countries had a national art museum as well as a contemporary art scene with galleries, artist-run spaces and, increasingly, international art biennials and triennials. A growing system of art-school education was also beginning to swell the number of artists living and working in the region. The strongest of these art scenes – in Japan, India, Taiwan and South Korea – had a domestic market, with artworks acquired, sold and evaluated by dealers, collectors, curators and art critics. Still, in comparison to Europe, the United States or Australia, the development of regional forums for the display and collection of contemporary art is recent.

THEMES AND ISSUES

Today, contemporary Asian art is both sympathetic to the cultural and historical frameworks within which it is produced but also – clearly – attuned to the global networks and international marketplace in which it is frequently exhibited, bought and sold. To grasp its history we must decode an intense,

multifaceted dialogue between cultures not just within Asia, but also in Europe and America and elsewhere. Moreover, we must recognize ways in which the free-flowing movement of ideas, culture and technology, which has been greatly potentiated by globalization, continues to engender new, exciting acts of artistic imagining. (Globalization is understood to describe a process by which the world's people are increasingly unified as part of an interconnected economy.) For instance, curator and writer Apinan Poshyananda has argued that Thai artists have over the past decade begun to question and redefine 'Thai-ness' in the context of globalization.[21] The 'Malaysian-ness' of Malay art has been similarly debated and questioned.[22]

In China, a country fast becoming the manufacturer for the world, the local impact of global economics finds increasing expression. Consider two works from the early and mid-2000s. In *Yiwu Installation* (2006), Liu Jianhua (b. 1963) assembled a pile of cheap, mass-produced, export products spilling out of a shipping container – buckets, dolls,

Chen Chieh-jen *Factory* 2003
Super 16mm transferred to DVD: 31 mins, 9 secs

clocks, umbrellas and flashlights – all of them made in Yiwu, a manufacturing centre in Zhejiang Province. The work suggests how the world's consumer tastes are powering China's re-emergence. In a similar vein, the photographic series *disCONNEXION* (2002–3), by Xing Danwen (b. 1967), documents scrapyards of discarded electronic circuitry and devices – wires, motherboards, cell phones – collected globally for recycling in China. Xing's series highlights the uneasy relationship between the developed world and China as both a source of manufacturing goods and a dumping ground (by some estimates, as much as forty million metric tons of scrap materials are imported here each year).

In illustrating the relevance of the new global economy to Asian contemporary art and artists, let us introduce two more examples: *Factory* (2003), a video by Chen Chieh-jen (b. 1960), following the return of unemployed Taiwanese workers to their former textile factory, abandoned after the company owners moved their operations to mainland China. The workers survey rooms of discarded furniture and idle industrial equipment, contemplating the ways in which globalization is reshaping their society. Gulnara Kasmalieva (b. 1960) and Muratbek Djumaliev (b. 1965), collaborating artists from Kyrgyzstan, the smallest country of Central Asia, capture the latest stage in their country's journey from post-Soviet economic collapse to new-found global integration in *A New Silk Road* (2006), a five-channel video work documenting the international commodity market along the 'new silk road', the highways connecting China through Central Asia to Europe. Panoramic images show the flow, in one direction, of rusty Soviet trucks hauling scrap metal from Central Asia to furnaces in China, while from the other direction fleets of shiny Chinese 18-wheelers arrive with manufacturing goods destined for the world. Interspersed at intervals are images of Kyrgyz residents, farmers and shop owners, living in the tiny towns along the route who have found ways to profit from the traffic. This work invites us to reflect on the ways in which age-old pathways have re-emerged as global supply chains for twenty-first-century cultural, economic and technological transmissions.

As implied by the descriptions of these four artworks, throughout the period covered by this book no single style, technique or movement could be said to predominate. For this reason, the individual experiences of the artists remain crucial for our understanding of their art, and this book is grounded in the social and cultural contexts within which the art was created. This is carried out through a general discussion of the themes and issues that have significantly affected the art of the period. Works are juxtaposed in ways that suggest visual and conceptual relationships. While thematic generalizations run the risk of oversimplifying, contemporary Asian art does broach issues, anxieties, beliefs and tensions that are socially, politically and geographically specific. These themes should not be understood as mutually exclusive; for example, the authority of 'tradition' and the vast scope of its influence on contemporary Asian artists mean that a discussion of this subject cuts across the book's chapter divisions. Just as artists tend to create work across different media in search of the best means of expression for an idea, so their explorations of subjects, issues and themes are equally varied. For this reason, a discussion of some artists appears in multiple chapters.

Chapter 1 examines a characteristic strength underlying much of contemporary Asian art – its relationship to history and tradition. This is an element generally missing from American art of the same period, and less strongly felt (though sometimes present) in the contemporary art of Europe. But while tradition in Asian art was once entirely about tradition itself – specifically, the transmission of cultural values from one generation to the next – in contemporary Asian art it is more of a starting point, one of many available sources of inspiration. This chapter considers art that conflates Asian historical traditions, aesthetics, and cultural and spiritual values with contemporary, often Western-inspired practices and motifs. Many Asian artists have sought ways to accommodate and update tradition in all its forms, and their art has reflected this.

Chapter 2 focuses on the engagement with issues of politics, society and the state, ranging from histories of particular countries (the legacy of colonialism, religious conflict and warfare) to contemporary social, economic and political challenges

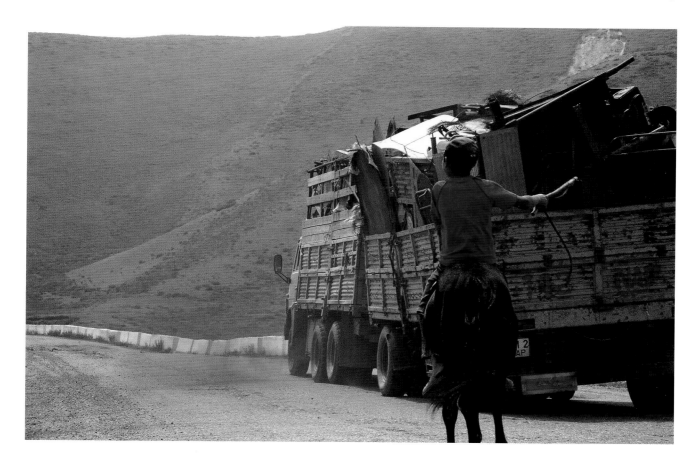

within those countries (AIDS, censorship, migration and gender inequality). Art can play witness and help heal, but cannot prevent the suffering and tragedy.

Chapter 3 explores the engagement with consumerism that also characterizes much Asian art, mirroring the emergence of consumer classes arising from economic prosperity. Experiments with popular culture and instantly recognizable cultural signifiers – political figures such as Mao Zedong and Mahatma Gandhi, film stars, manga (comic) and anime (animation) characters – are also discussed here.

It would be accurate to say that the majority of contemporary artists live in urban metropolises across Asia, many of which have exploded in size in the past twenty years. Chapter 4 addresses some of the deep social and political anxieties that have resulted from these artists' experiences of living in dense,

highly modernized and developed environments. Their artistic attention has increasingly shifted to questions of social transformation, with key concerns relating to urbanism, the environment, and the use and application of new technologies.

It will also become evident that Asian artists have been at the forefront of the current revolution in new media, which has allowed them access to – and, in some cases, successful intervention in the workings of – global art markets and institutions. The future of contemporary Asian art and the forms it may take are among the subjects discussed in the Epilogue.

While the study of contemporary Asian art remains a work in progress, all efforts have been made to make this book as inclusive as possible. Still, it serves primarily as an introduction to the artists who have come to crystallize our present notion of contemporary Asian art.

Gulnara Kasmalieva and Muratbek Djumaliev
Racing, from the series *A New Silk Road: Algorithm of Survival and Hope* 2007
Digital photograph, 25 x 35 cm (9 7/8 x 13 3/4 in.)

chapter 1

RETHINKING TRADITION

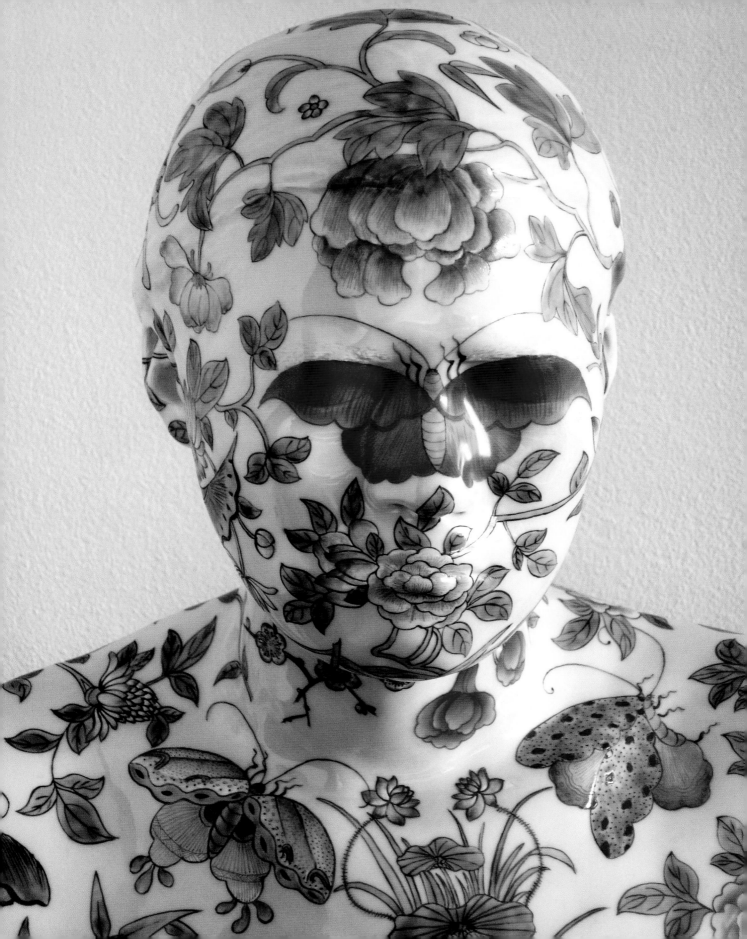

Although modern industrialization in Asia has had a tremendous impact on art, as on everything else, deep-seated cultural traditions remain. Even today, within Southeast Asian nations, the significance of religious art, for instance, cannot be overstated. In South Asia, miniature painting is devoted to the retelling and reinterpretation of national myths and stories. Many artists in China, Korea and Japan continue to specialize in ink and brush painting, with masters such as Chinese ink painter **Wu Guanzhong** (b. 1919), Korean ink painter **Suh Se-ok** (b. 1929) and Japanese *nihonga* painter Ikuo Hirayama (b. 1930) widely revered and popular, even though their art may be little known outside their own countries.

Traditions are often presumed to be singular, timeless and unalterable, and therefore at odds with contemporary life. But in the past couple of decades contemporary artists across Asia have been increasingly willing to experiment with traditional artistic techniques, forms and values, sometimes out of nostalgia for the past, sometimes in a self-reflexive, post-modern critique of identity, at other times to revel in the commodification of difference in the new global art market. Whatever the motive, these artists feel free to approach tradition as a starting point, and as an inspiration to be used and combined with more contemporary practices – altered, negotiated with and even deconstructed in any way they see fit. They sometimes ignore expectations of what traditional art should look like and, equally, its longstanding commemorative, nationalistic, political or ideological uses.

Many new and hybrid modes of expression have emerged, frequently integrating local traditional art forms such as ink painting, calligraphy, ceramics, dance and textiles with

Wu Guanzhong *Rising Sun on Mt. Hua* n.d.
Ink and colour on paper, 179 x 95 cm (70¹/₂ x 37³/₈ in.)

ephemeral, confrontational, contemporary practices such as video, performance, installation and mixed media: for example, Iranian artist **Farhad Moshiri**'s (b. 1963) experimental calligraphy *Eshgh (Love)* (2007), in which Swarovski crystals and glitter are used to write the Persian word for love; or Indonesian artist Arahmaiani's (b. 1961) fusion of classical dance and Balinese costumes with Coca-Cola bottles, condoms and pornography in her provocative installation/performance *Nation for Sale* (1996); or, more broadly, the co-opting of vernacular materials such as bamboo, volcanic ash, rocks and found objects in contemporary Filipino art, notably in installations and assemblages by the late Roberto Villanueva (1947–1995) and Santiago Bose (1949–2002).

If, at times, this juxtaposition of traditional Asian elements and modern techniques and forms seems incongruous, it is worth recalling that cultural interaction is hardly

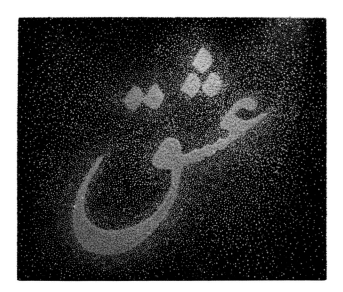

a contemporary phenomenon. Across Asia, an adapting of traditions and Western influences was an integral part of art and life for most of the twentieth century. In those places where there was a longstanding colonial presence, such as the Philippines and Indonesia, the process has arguably been going on even longer. Moreover, as post-colonial theorists such as Edward Said have shown, dynamic cultures constantly borrow from one another: 'Every domain is linked to every other one, and ... nothing that goes on in our world has ever been isolated and pure of any outside influence.'[1]

INK AND BRUSH

In East Asia, experimentation had at least one specific area of focus, an effort to transform practices of ink and brush painting and calligraphy, once associated with a literati tradition of gentleman-scholars. Many of the artists who contributed to this new emerging sensibility were self-trained, or were not a product of the usual apprentice systems in the traditional arts, and consequently their work bears little resemblance to traditional imagery associated with this art. The sum of their activities was also frequently viewed as a challenge or slight to tradition by artists whose primary concern was the continuity of traditional art forms. And there is perhaps some truth in the complaint, for underlying this

Suh Se-ok *Person* 1992
Ink on mulberry paper, 38 x 28 cm (15 x 11 in.)

Farhad Moshiri *Eshgh (Love)* 2007
Crystals and glitter on canvas with acrylic mounted on board, 155 x 176 cm (61 x 69¼ in.)

challenge was a proposition that is second nature to contemporary artists in the West but not necessarily familiar to traditional artists in traditional cultures – that the value of an artwork need not necessarily lie with its craftsmanship or with strict adherence to established forms and techniques, but might rightfully arise out of a concept or idea.

Nowhere is this more apparent than in the work of the Chinese artist **Xu Bing** (b. 1955). Born in Chongqing, Xu grew up in Beijing, where he attended the Central Academy of Fine Arts, China's premier art school, before relocating in 1990 to New York. There he built a successful international career by blending elements of Chinese ink painting and calligraphy

Xu Bing *Book from the Sky (Tianshu)* 1987–91
Installation view: Elvehjem Museum of Art,
University of Wisconsin, Madison
Hand-printed books and scrolls

with Western conceptual, video and installation art. Much, if not all, of Xu's work focuses on the relationship between art and language, as epitomized by a 1994 performance in Beijing called *A Case Study of Transference*, in which a pig whose body had been painted with English nonsense words was mated with a pig covered with Chinese nonsense characters in a symbolic effort to bridge the cultural and linguistic divide. The characters Xu used were drawn from *Book from the Sky* (1987–91), an earlier installation and today, still, one of his most important works with invented language.

Xu's interest in the relationship between language and meaning converged once again in a series of installations, begun in 1994, which simulate a classroom environment with desks, calligraphy copybooks, brushes and ink. Viewers were invited to sit and practise the artist's 'New English Calligraphy', while watching an instructional video demonstrating the writing technique. Of course, this was no ordinary calligraphy. 'New English Calligraphy' consisted of written English-language words rearranged into squares to simulate written Chinese characters, which when decoded could still be read as English (the letters are read from left to right and top to bottom). Xu saw his interactive, experimental calligraphy

as a provocative unsettling of the usual relationship between language and meaning:

> I have created many text-based works. On looking at them people generally feel both a sense of familiarity and estrangement, or estrangement yet familiarity. But what is happening on the surface and internally are different. They function like a computer virus. Their action within people's minds causes a confusion about original concepts, customs and modes of cognition impeding normal thought processes. What they do is create a new free space and reclaim the origin of the thought process and thereby allow re-appraisal of one's own culture.[2]

The prestige enjoyed by Xu's *New English Calligraphy* has to some degree obscured the recognition of other Chinese experimental artists who took a keen interest in traditional calligraphy. Before emigrating to the United States in 1987, **Wenda Gu** (b. 1955) had been making experimental paintings combining invented calligraphy and landscape imagery: he, along with Xu Bing and others, was part of the '85 New Wave movement, a group of young Chinese artists who, emboldened by the economic liberalization in China during the 1980s, began to experiment with art media and subject matter.[3] Gu's *Pseudo Characters* series of paintings (1984–86), an early and controversial work in China, consisted of giant sheets of rice paper splashed with inverted or incorrectly written characters in ink and acrylic, often massively drawn so as to dwarf background landscape imagery in a deliberate inversion of the standard tropes of Chinese ink painting. The series caused immediate offence: 'pornographic, vulgar, obscene and superstitious' is how one Chinese Communist Party official described the paintings.[4]

More recently, younger Chinese artists have sought to subvert as well as to reinterpret China's exalted calligraphic tradition. **Qiu Zhijie** (b. 1969) and **Song Dong** (b. 1966) mimic traditional methods of calligraphy instruction in which students make copies of the work of masters until they are able to develop their own style. Documentation of Qiu's performance *Writing the 'Orchid Pavilion Preface' One*

Xu Bing *Square Words – New English Calligraphy* 1994–96
Installation view: Institute of Contemporary Arts, London
Desks, chairs, copy and tracing books, ink, brushes, video

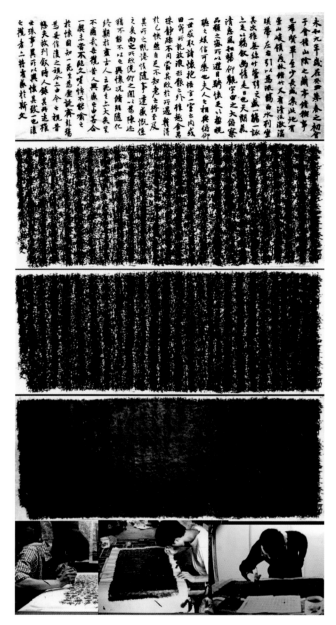

Wenda Gu *The Mythos of Lost Dynasties* 1984
Ink on paper, 335.3 x 150 cm (132 x 59 in.)

Qiu Zhijie *Writing the 'Orchid Pavilion Preface'*
One Thousand Times 1990–95
Ink on paper, each 80 x 150 cm (31½ x 59 in.)

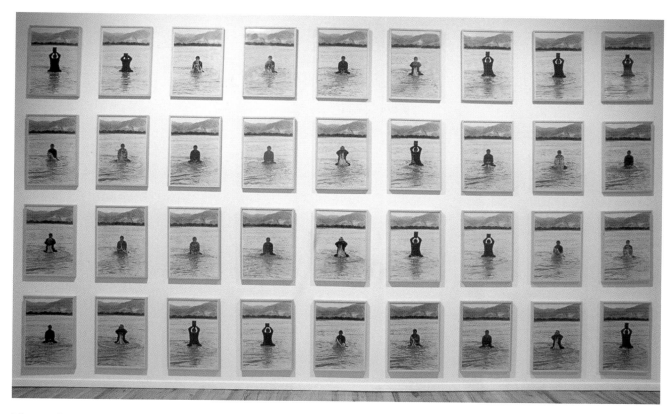

Thousand Times (1986–97) shows the artist copying a fourth-century calligraphy classic by Wang Xizhi. But Qiu's version differs significantly from the original, with the artist confining his writing to one sheet of paper, each character layered on top of the other until the sheet is covered in ink. Writing becomes an act of erasure. Similarly, for *Water Writing Diary*, a performance project begun in 1995, Song used a calligraphy brush on a stone slab to write words in water that evaporate leaving no trace, as he said, to 'emphasize the process and experience of its production'.[5] It is the activity that counts, rather than the end result, in this and other related works. Song's *Printing on Water* series of thirty-six photographs (1996) shows the artist kneeling in the Lhasa River in Tibet, hands clasped around a heavy old wooden seal carved with the Chinese character for water (*shui*). Song repeatedly and vigorously stamps the river in front of him: the action is intended to evoke the imposition of Chinese language and culture on Tibet, formally annexed in 1951.

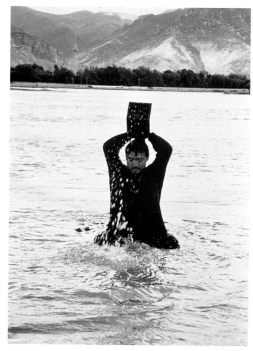

Song Dong *Printing on Water* 1996 (installation and detail)
Photographs, each 62 x 42 cm (24 3/8 x 16 1/2 in.)

There are two other important artists who assimilate Chinese ink-painting traditions into contemporary art, though they stand a little apart from the rest in so far as neither references calligraphy. One is Hong Kong-based **Wilson Shieh** (b. 1970), who paints and draws humorous, stylish, contemporary subjects in the antique *gong bi*, or fine-line style of painting, requiring mastery of a meticulous, highly detailed, brush technique. Typically, his paintings depict solitary figures in playful poses surrounded by animals, musical instruments or decorative objects, as in *Earthenware Ding (Tripod) with Red Paint* (2002), in which a nude male figure balances precariously on an upturned tripod vessel. Other elements of play and curiosity in paintings in the same series include a figure balancing an outsized gourd on his back. The artist sees his work as a personal homage to antiquity: 'Using ancient works of art and their symbolic potential,

I attempt to bring together the past and the present, thus finding a dialogue and new visual language between them.'[6] The task of the viewer, faced with Shieh's concoctions, is not so much to find a narrative as to identify the visual borrowings and cues.

Yun-Fei Ji (b. 1963), brought up by his grandmother on a collective farm outside Hangzhou during the Cultural Revolution, uses ink-painting techniques to make statements about Communist Party experiments in central planning and collective living. *The Empty City: East Wind* (2003) is part of a series of ink paintings devoted to the Three Gorges Dam – a massive decade-and-a-half-long project begun in late 1994 that dammed the Yangtze River to stem flooding and generate hydroelectric power for China's booming economy, but also led to the displacement of millions of people and destruction of archaeological sites. At a glance, *The Empty City: East Wind* looks something like a traditional Chinese landscape scroll showing majestic views of mountains and water (*shanshui*). Closer inspection, however, reveals a hybrid landscape of demolished buildings, stunted or dead trees, and rock crevasses strewn with detritus, boxes, cars, bamboo and packing materials, in which soldiers pursue emaciated scavengers. Here, as the artist explains, he has combined imagination with something close to documentary:

It is all based on research from my trip to see the Three Gorges and the area where cities were being taken apart to make way for the building of the dam. In this work I wanted to use the buildings and the changing seasons as the backdrop for a narrative about the dead and the scavengers ... who live in these torn-down or empty cities and scavenge all the metal and doors. I saw these people when I was there.[7]

Elsewhere in East Asia, artists have sought to revitalize ink painting with modern and contemporary subjects and motifs. Buddhist scroll paintings of the Goryeo period (*c.* 918–*c.* 1392) provide a loose source of formal inspiration for the ink paintings on paper composed by the Korean Kim Ho-Suk (b. 1957), several of which express the national sense of outrage provoked by the atrocities of the Japanese

Wilson Shieh *Earthenware Ding (Tripod) with Red Paint* 2002
Ink and colour on silk, 38 x 27 cm (15 x 10 5/8 in.)

Yun-Fei Ji *The Empty City: East Wind* 2003
Mineral pigments on Xuan paper, 135.9 x 90.2 cm
(53 1/$_2$ x 35 1/$_2$ in.)

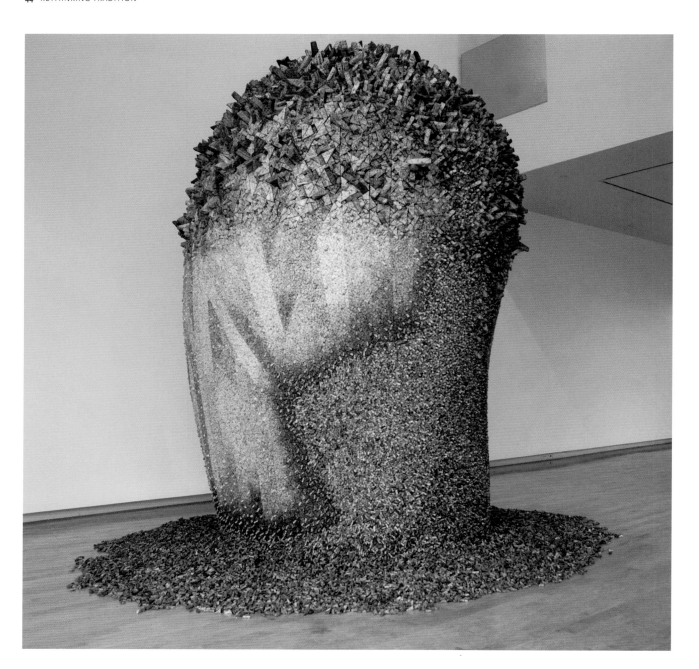

Chun Kwang-Young *Aggregation 08-AU022* 2008
Mixed media with Korean mulberry paper,
325 x 230 x 200 cm (128 x 90 1/2 x 78 3/4 in.)

occupation of Korea in the period preceding and during World War II, including the notorious use of Korean 'comfort women', slave labour camps and the suppression of anti-Japanese uprisings. As Kim has said: 'I feel a deep sense of responsibility to preserve traditional Korean painting in its purist form, but I also have a responsibility to make it relevant to people's lives.'[8] *The History of Korea's Resistance Against Japanese Colonialism: Comfort Women* (1990) honours the estimated eighty thousand women, mostly Koreans, forcibly recruited by the Japanese military to provide sexual services to soldiers.

Another Korean artist discreetly consonant with tradition is **Chun Kwang-Young** (b. 1944). His preferred material is mulberry paper, ideally already used. This is the basis of *Aggregation 08-AU022* (2008), a 3.25-metre-high (over 10 ft), approximately 650-pound object made up of triangular bricks of folded and tied mulberry paper wrapped around Styrofoam triangles. Rough and textured, like bark, mulberry paper was widely used across Korea and China for wrapping, packaging and writing until as late as the 1960s. Today it is expensive and thus little used, forcing the artist to recycle whatever stocks he can get his hands on (he scours second-hand shops for books and periodicals, which he pulls apart for the pages). He prefers paper inscribed with Korean characters, the letters hinting at the ways in which his art is deeply embedded in Korean history and cultural traditions, but also helping to create variation in design and surface texture. The subtle tones of the paper are also sometimes augmented with tea and dyes.

In Southeast Asia, a parallel can be drawn in the work of the Vietnamese artist **Nguyen Minh Thanh** (b. 1971) with the previous examples from East Asia of efforts to transform practices of ink and brush painting and calligraphy. Nguyen's large-scale, experimental paintings of women produced in watercolour and ink on hand-made *do* paper have few precedents in Vietnam's extensive ink-painting tradition. For *Portrait of Mother* (1998), the artist used several sheets of paper arranged in a grid for an outsized depiction of his mother in traditional clothing – a *khan dong* (headband) and

a black *ao dai* (high-necked, tight-fitting, silk tunic worn over trousers) – as an attachment to the past and emblem of ingrained filial piety in a society like Vietnam that is still largely dominated by Confucianism. The picture is not an attempt to assert specific Vietnamese values, but through it Nguyen conducts a dialogue with the viewer about what it means to be Vietnamese.

This subtle blending of contemporary art (the scale, the format) and local influences also reminds us that while Asian artists might participate in the global exchange of cultural images and ideas to enhance their art practice they do not, as a result, inevitably diminish or negate their own traditions.

Nguyen Minh Thanh *Portrait of Mother* 1998
Ink and watercolour on eight sheets of *do* paper,
240 x 160 cm (94 ¹/₂ x 63 in.)

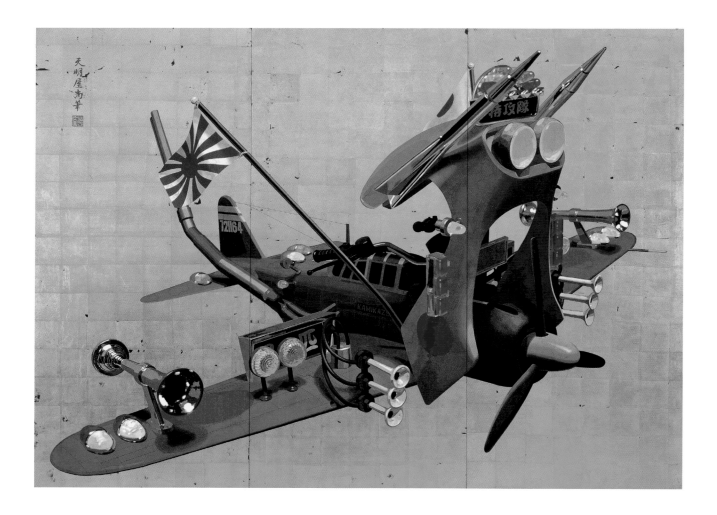

TOP Mami Kosemura *Flowering Plants of the Four Seasons* 2004–6
Animation: 3-screen installation

ABOVE Tenmyouya Hisashi *Kamikaze* 2003
Acrylic and gold leaf on wood, 200 × 272.4 cm (78³/₄ × 107¹/₄ in.)

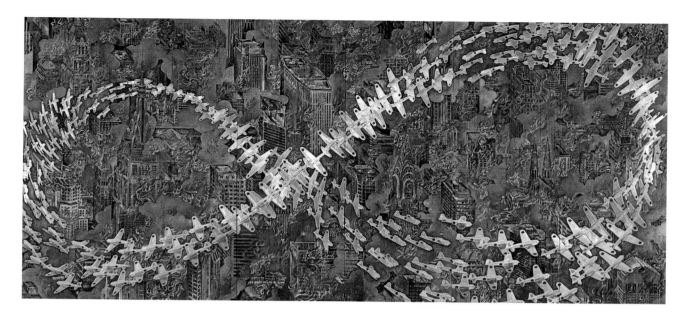

SCREENS, PRINTS AND SCROLLS

Other highly exalted artistic traditions are undergoing re-examination. In Japan, references to *byobu* (traditional folding screens made from joined panels covered in painting and calligraphy) and *ukiyo-e* prints (woodblock printing, popularly adopted across Japan during the Edo period, 1615–1868) have become a popular way for artists to engage with historical issues, cultural inheritance and values, and evolving notions of nationhood. **Mami Kosemura** (b. 1975) marries the traditional subject matter of screen paintings with the language of new media, as in *Flowering Plants of the Four Seasons* (2004–6), a video installation fusing imagery of flowers and plants, videotaped outdoors in Japan over the course of a year, with digital animation. Nature is brought to life in this subtle, ever-evolving scene – a shimmering wall of light installed in a dark room. The artwork's theme is the provisional and fragile nature of existence, and for this and other reasons can be seen as an extension of the tradition of landscape screen painting devoted to seasonal change which has played such an important role in Japanese art.

Self-taught painter **Tenmyouya Hisashi** (b. 1966) conflates the forms and techniques of traditional screen painting with motifs reflecting Japan's more recent history as well as modern consumer culture. *Kamikaze* (2003), painted in acrylic and gold leaf on wood panels, depicts a World War II Zero fighter plane decoratively enhanced with horns, lights, missiles and Japanese flags. It looks like a souped-up automobile, but the artist's use of the Zero plane is contentious, for across Asia it is a symbol of Japanese militarism. Here it is refigured to suggest a resurgent nationalism, not entirely concealed beneath a friendly, colourful veneer. **Aida Makoto**'s (b. 1965) over 3.5-metre-wide (12 ft), multi-panel screen *A Picture of an Air Raid on New York City (War Picture Returns)* (1996) similarly addresses the legacy of World War II, the artist imagining what might have happened had the war turned out differently. His unnerving vision depicts New York engulfed in fire and chaos as squadrons of Japanese fighter planes circle in an infinity pattern above.

There is no shortage of Japanese artists who reference ukiyo-e woodblock prints in forms ranging from quotations of past iconic masterworks to humorous depictions of contemporary life rendered in an ukiyo-e mode. Through the 1970s and '80s, living in the US, **Masami Teraoka** (b. 1936) began updating traditional ukiyo-e portraits, usually for the purposes of social commentary. *Geisha in Bath* (1988), produced during the height of the AIDS epidemic, shows

Aida Makoto *A Picture of an Air Raid on New York City (War Picture Returns)* 1996
Six-panel sliding screens, hinges, *Nihon Keizai Shimbun* newspaper, black-and-white photocopy on hologram paper, charcoal pencil, watercolour, acrylic, magic marker, correction liquid, pencil; CG of Zero fighters created by Mutsuo Matsuhashi, 169 x 378 cm (66 ¹/₂ x 148 ³/₄ in.)

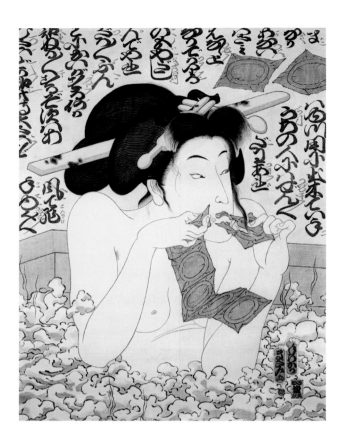

Woodblock printing was used in China for centuries, long before it was popularly adopted in Japan during the Edo period. China is also the origin of a literati tradition of landscape painting which has been immensely influential in East Asia, where, like ukiyo-e, it is referenced today in contemporary artwork in a variety of media, including video. *Seven Intellectuals in a Bamboo Forest* (2003–7), **Yang Fudong**'s (b. 1971) five-part film, takes its inspiration from a popular subject in Chinese literati painting and literature – the apocryphal story of seven intellectuals who gathered together in a bamboo forest to escape social and political turmoil during the third century AD. Yang's film follows the escapades of seven young contemporary urbanites, evoking something of the uncertainty felt by Chinese now caught in a similar process of cultural, political and economic change. In an interview, the artist elaborates on his motive for making the film:

> My impression of the traditional version of the Seven Sages is that they seem to be an anonymous group. It was not their identity that was important but their spirit.... In making the film about contemporary youth, I was more concerned with the idea of a group – a group consisting of seven young people today. This is very interesting: you do not know what the future of these young people will be. The film is about the future.[10]

The narrative is elliptical, without beginning or end, Yang's characters wandering anonymously through rural and urban settings. Each episode is carefully scripted and the imagery highly stylized, leading critics to draw parallels with French New Wave cinema. But a more productive parallel might be drawn with Shanghai cinema of the 1930s and '40s, especially films by Yuan Muzhi, Fei Mu and Shi Dongshan.

China's exalted landscape painting tradition also provides a starting point for **Huang Yan**'s (b. 1966) *Chinese Landscape – Tattoo* (1999), a photographic series depicting the artist with a traditional mountain landscape painted on his torso and arms. In successive photographs, Huang assumes different poses to emphasize the body as a moving background, in contrast to the silk or rice paper used in traditional landscape painting. The composition preserves the appearance of the

a Japanese courtesan in a foamy bath tearing open a condom wrapper with her teeth. More recently, **Tabaimo**'s (b. 1975) animated video installation *Japanese Bathhouse* (2000) immerses the viewer in a dreamy digital version of a traditional communal bathhouse which mimics the colouration and style of ukiyo-e prints, while incorporated into background imagery is one of ukiyo-e artist Hokusai Katsushika's (1760–1849) famous views of Mount Fuji. Inclusion of realistic sound effects, actual wooden floorboards and pyramidal stacks of wash buckets in the installation space adds to the sense of verisimilitude, but also to a feeling of physical confinement. Here the artist uses tradition, but in a visual mash-up that is scarcely traditional in its effect. As she explains: 'I construct spaces in order to create a feeling of discomfort. It's the opposite of seeking to gratify the viewer by creating a pleasant environment in which one might contemplate the work.'[9]

Masami Teraoka *Geisha in Bath*, from the *AIDS Series* 1988
Watercolour on canvas, 274.3 x 205.7 cm (108 x 81 in.)

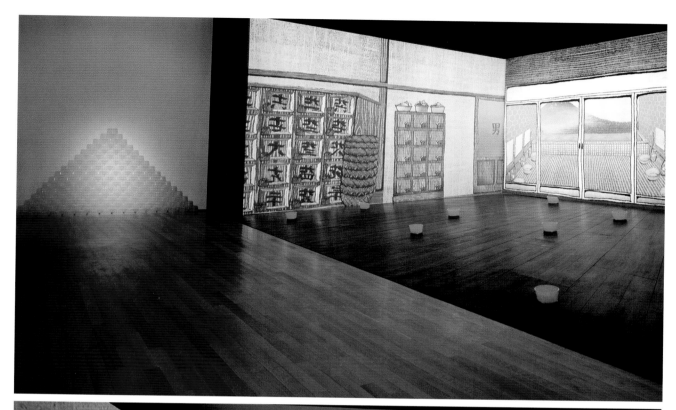

Tabaimo *Japanese Bathhouse* 2000
Three-channel video installation with sound,
450 x 958 x 521 cm (177 x 377 x 205 in.)

original image, but the artist's movement cracks and peels the paint, creating gaps and creases that alter the landscape. The piece has an added symbolic significance, typifying the process through which artists assimilate and transform traditional art practices: by using his body as the painting surface, Huang transforms landscape art into performance.

Korean Yoo Seung-ho (b. 1973) provides a further example of the assimilation of landscape-painting traditions into contemporary art. At first, his works look like conventional Korean landscape paintings, with the usual array of craggy mountains, rocky outcrops and viewing pavilions. On closer inspection, it becomes evident that the imagery is comprised of mind-boggling details – thousands of minute *Hangul*, or Korean characters, or sometimes English letters, drawn with a very fine ink pen in a manner suggestive of the way in which the late nineteenth-century French Pointillist painters used

TOP Yang Fudong *Seven Intellectuals in a Bamboo Forest, Part I of V* 2003
Black-and-white film transferred to DVD

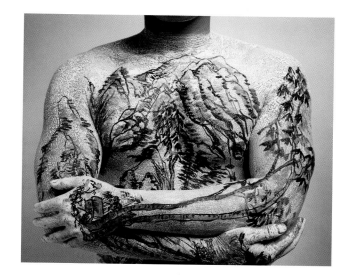

(2000) is a recreation of the tenth-century Chinese painting *The Night Revels of Han Xizai* by Gu Hongzhong (*c.* 937–975) depicting the secret gatherings of the intellectual and court official Han Xizai, who, according to some versions of his life story, was later accused of plotting a rebellion against the emperor. Wang's vision involved recreating the painting as a series of tableaux enacted by denizens of the Beijing art world. Instead of an official, Wang centered his image on Li Xianting, or Lao Li, a dissident critic and curator who was removed from his post as editor of the art magazine *Meishu* in 1983 for supporting Western-style modern art, and was later co-curator (with Gao Minglu) of 'China/Avant-Garde' at the National Art Museum in Beijing in 1989, the first major show of 1980s experimental Chinese art. Designed to be read from right to left, like a traditional scroll, Wang's panoramic photograph shows Li and the same cast of figures repeatedly engaged in leisure activities, such as watching dancers, talking or taking a rest. For Wang, the work is a reflection on the embattled status of intellectuals in Chinese society:

> What has been haunting in my mind is the position and destiny [that] Chinese intellectuals experience in our history. In such an era that lacks ideals, people have cast doubt on the heroes and ideals of the past. I wanted to catch some scenes that describe [the] loss of hope [and its replacement] with [a] desire for money and power.[11]

Wang is one of the pioneers of appropriation photography in China. Many others have followed, among them Hong Hao, who similarly takes scroll paintings as a starting point for

tiny marks to create a picture. *Yodeleheeyoo!*, for instance, is the collective title for a series begun in 2006, in which the painted mountain landscape is made up of an onomatopoeic Korean word relating to mountaineering (it is the sound Korean people shout from a mountaintop in expectation of an echo). These densely written renderings succeed in surpassing our expectations of landscape art, for pronunciation of the words adds an unexpected sound component. The work becomes a sonic landscape.

The activities of Beijing-based photographers **Wang Qingsong** (b. 1966) and **Hong Hao** (b. 1965) go far beyond the conventional boundaries of literati painting: they make new art by taking a specific, pre-existing image and altering or combining it with others in some way. Wang's *Night Revels of Lao Li*

TOP Huang Yan *Chinese Landscape – Tattoo* 1999
Colour photograph, 80 x 100 cm (31¹/₂ x 39³/₈ in.)

ABOVE Wang Qingsong *Night Revels of Lao Li* 2000
Chromogenic print, 120 x 960 cm (47¹/₄ x 378 in.)

his photographs. *Spring Festival on the River No. 7* (2000), a panoramic photographic frieze, reproduces in its entirety a twelfth-century scroll by Zhang Zeduan (*c.* 1085–1145), *Along the River During Qing Ming Festival*, which offers a view of urban life during the Song dynasty. Into this vista the artist has collaged photographic decals of modern people and daily life in Beijing that allow for, in effect, a layering of contradictory passages of history. Onto one section of the scroll, for instance, showing boats moored in a river, the artist has collaged contemporary images of people bathing, some naked, others taking photographs, or driving trucks and cars. Landscape art becomes a metaphorical meeting-point between the old and the new, in which life in the city is portrayed as both different from and yet continuous with the past.

DECORATIVE ARTS AND THE MINIATURE

Another way in which Asian artists assimilate and transform tradition is through the use of indigenous craft, or artisan-based materials, skills, practices and techniques, albeit in radically altered form. This trend is so prevalent that a striking contrast may be observed between, on the one hand, the cultivation of ideas over workmanship common among younger European and American artists, and on the other the emphasis on technical skill and ingenuity shared by many contemporary Asian artists – a quality that is viewed by some critics and curators in the West as evidence of a lack of originality. But an understanding of the cultural context from which these works arise reveals another aesthetic at work, which could – and should – be posed in opposition to that view: Geeta Kapur, the Indian critic and curator, notes that the best work in this genre does not simply appropriate living craft traditions or 'vestigial skills', but 'possess[es] a language that transcends it'.[12] Thus, the approach is rarely one of simple revivalism and more an engagement or negotiation with tradition, while transforming it into contemporary forms.

For **Ah Xian** (b. 1960), China's venerable heritage of imperial porcelain production underpins an ongoing series of cast porcelain busts. Initiated in 1998, these portray his friends and family, and are decorated with traditional Chinese ceramic designs and motifs manufactured and painted at

Hong Hao *Spring Festival on the River No. 7* 2000
Chromogenic print with collage, 38 x 1,200 cm (15 x 472 1/2 in.)

Ah Xian *China, China – Bust 34* 1999
Overglaze iron-red on porcelain,
39 x 40 x 21 cm (15 3/8 x 15 3/4 x 8 1/4 in.)

Lu Shengzhong *Poetry of Harmony* 2000
Paper cut, set of four, each 228.6 x 63.5 cm (90 x 25 in.)

Jingdezhen, a city famous for producing fine court porcelain during the Ming dynasty (1368–1644) and, later, the centre of an export trade to Europe and outer Asia. China, however, never had a tradition of portrait sculpture (this evolved separately in Europe): Ah Xian nonetheless mastered the form, wedding it to China's heritage of ceramic art. *China, China – Bust 34* (1999) incorporates sculptural representations of antique fans, cabinets, lanterns, vases and other culturally specific objects, all set in relief from – and distorting – the head of the figure. The artist here makes reference to a national cultural heritage that can simultaneously inspire pride in contemporary artists and also be a burden to them: 'Those who have grown up steeped in Chinese ways can hardly escape the influence of thousands of years of Chinese history and cultural traditions.'[13]

In China, as elsewhere these days, contemporary artists feel free to use any media or material in any fashion that appeals to them. They ignore distinctions between what used to be called painting and what used to be called sculpture, and, equally, the division between art and craft. **Lu Shengzhong** (b. 1952) does wildly flamboyant paper cuts incorporating thousands of repeated little red figures – all carefully hand-cut with scissors and scalpels from red tissue paper – emulating a distinctive Chinese handicraft originating in the sixth century and today, still, a popular form of vernacular decoration at wedding ceremonies and festivals (red is an auspicious colour in China). Lu uses traditional materials and techniques to make his artworks, though they are utilized to serve a wide variety of formal and expressive purposes, from elaborate experimental installations to murals and wall-hangings incorporating positive and negative cut-out forms.

Exquisite craftsmanship is a quality also associated with much traditional art in South Asia, especially Pakistan and India. Here artists have preserved and reinvented miniature painting traditions that flourished long ago under the Mughal Emperor Akbar (1542–1605), who founded ateliers, brought artists from Persia to work alongside Indian Hindus and Muslims, and established a courtly system of patronage. Over time regional styles of miniature painting evolved in South

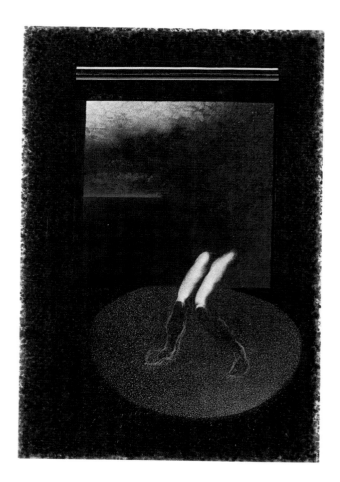

Asia, though their shared characteristics include meticulous attention to detail and an enthusiasm for story-telling. Identification with this tradition is strongest today in Pakistan, where in the 1980s renewed interest in the art form saw a revival centered on the National College of Arts in Lahore, the school once presided over by John Lockwood Kipling, the father of Rudyard Kipling. **Zahoor ul Akhlaq** (1941–1999) was especially influential in reviving miniature traditions. In the late 1960s he studied at the Royal College of Art in London, where he saw and was fascinated by Mughal miniature paintings in the British Museum.

Subsequently, young contemporary Pakistani artists embraced miniature painting, partly as a statement of cultural survival, and partly as a way to address local histories as well as contemporary social and political issues. Salima Hashmi,

Zahoor ul Akhlaq *A Visit to the Inner Sanctum 4* 1996
Acrylic on canvas, 210.8 x 142.2 cm (83 x 56 in.)

Shahzia Sikander *Who's Veiled, Anyway?* 1994–97
Vegetable colour, dry pigment, watercolour, tea and collage
on hand-prepared *wasli* paper, 28.6 x 20.6 cm (11¹/₄ x 8¹/₈ in.)

one of the pre-eminent writers on Pakistani art, describes the challenge for contemporary artists working in this tradition:

> Embraced as a tribute to a grand tradition, contemporary practice in this discipline presents certain dilemmas for the [contemporary] artist. The desire to experiment and subvert the rigidity of ritual goes alongside the deep awe in which the skills of the old masters are held.[14]

Shahzia Sikander (b. 1969) graduated from the National College of Arts in Lahore in the early 1990s and today, living in New York, is widely admired for her paintings which both continue and depart from the miniature tradition. As the artist has explained: 'I am interested in the play, the flirtation with tradition, but it remains primarily conceptual, focusing on issues between scale and labour, precision and gesture, the norm and its transgression.'[15] Formally, Sikander's works share the characteristics of traditional miniatures, including choice of medium (vegetable colour and freshly ground pigments on hand-prepared paper); conventional themes and subject matter, such as religion, mythology, gardens and animals; and small-scale, delicate detail and the use of decorative painted borders around a central image. But her paintings also include imagery that is often contemporary, frequently personal and occasionally political. *Who's Veiled, Anyway?* (1994–97) shows a woman on horseback obscured by painted white lines that suggest she is wearing a burqa, the capacious garment worn by women in some Islamic countries. From the imagery, as well as the title, the painting seems to question the idea that women in Islamic societies are psychologically clad in burqas whether they are physically or not, no matter what they are doing.

Sikander's miniatures set a powerful example of alluring yet ideologically progressive art from Pakistan. Her success has inspired other Pakistanis trained in miniature techniques to explore the contemporary possibilities of the form. Among them are **Saira Wasim** (b. 1975), now living in Chicago, and Nusra Latif Qureshi (b. 1973), now living in Melbourne. Wasim's *New World Order* (2006) took inspiration from the United States-led 'war on terror', depicting President George

W. Bush in the manner of a Mughal emperor with a gold halo, seated on a globe flanked by allied world leaders, all painted in smaller scale. Similarly, Qureshi's *Familiar Desires I* (2005) upholds conventions of miniature painting in its use of a border to frame a central image of a dancing woman dressed in a sari. However, the turquoise tendril pattern surrounding the figure, combined with a fine outline of a couple embracing which fills the central portion of the painting, are a radical departure from traditional miniature pictorial conventions.

Other Pakistani artists use miniature painting to explore contemporary issues. **Imran Qureshi** (b. 1972), Muhammad Zeeshan (b. 1980) and Aisha Khalid (b. 1972) have achieved

Saira Wasim *New World Order* 2006
Gouache and gold on *wasli* paper, 26 x 15.9 cm (10¹/₄ x 6¹/₄ in.)

Imran Qureshi *Moderate Enlightenment* 2007
Gouache on *wasli* paper, 22.9 x 17.8 cm (9 x 7 in.)

growing influence and recognition. Qureshi was trained at the National College of Arts, where he now teaches a new generation of miniaturists. He makes jewel-like miniatures that register today's concerns. His series *Moderate Enlightenment* (2006–7) pokes fun at a public relations effort by the government of General Pervez Musharraf to supplant the negative image of 'fundamental' Islam with a softer, more 'enlightened' image, officially dubbed 'Enlightened Moderation'. The paintings in the series depict devout Muslims engaged in harmless activities: one, for instance, shows a bearded man wearing a traditional hand-crocheted Muslim prayer cap and *salwar kameez* (long tunic over loose trousers) blowing soap bubbles, while another shows a man doing strength exercises with weights. In a deliberately exaggerated manner, the artist portrays Muslims as open, playful and friendly, in contrast to widespread depictions in the foreign media of Islamic men as terrorists in the wake of the September 11, 2001 attacks on New York's World Trade Center.

Most traditional miniatures were never intended to be displayed on walls as art, but were bound together in folios to tell an epic story, much like a book or manuscript. For this reason, Indian **Nilima Sheikh** (b. 1945) falls into the category of artists influenced by miniature painting. Rather than taking inspiration from the distinctive, elegant, detail-oriented style of the genre, she is drawn to its narrative qualities. In *When Champa Grew Up* (1984), story and structure emerge through sequential, intimate imagery filled with private meaning. As Sheikh explains: 'I chose a serial form – pages, folio pictures to be … unfolded and read laterally.'[16] The series of a dozen paintings, tempera on hand-made paper, recounts the true story of a girl married off as a minor and then allegedly murdered barely a year later by her in-laws over an insufficient dowry. The series opens with a picture of the girl carefree on a bicycle and ends with an image of women relatives mourning her death. The paintings tell the story of her short, tragic life, mimicking the way in which miniatures once recounted love stories or the exploits of kings.

PERFORMANCE, RITUAL AND RELIGION

Evolving attitudes towards cultural traditions are widely evident in art that deals with the role and place of religion in society, though this is especially prevalent in those countries that identify an official religion. In Thailand, for instance, Buddhism has been the state religion for hundreds of years, and until the modern era religious iconography dominated the local art history. **Vasan Sitthiket** (b. 1957) and **Michael Shaowanasai** (b. 1964) are at the forefront of an artistic rethinking of religion and society there. Sitthiket's painting *Lord Buddha Visits Thailand* (2009), one of several similar works, shows the Buddha visiting the country, where he is witness to rampant consumerism, street protests, sexual tourism and renegade monks having sex or enriching themselves – a nation in chaos. It is an indictment of Thai society. Similarly, Shaowanasai's performances and photographs confront Buddhist doctrine as a system of power and control demanding blind devotion. *Study in Sculpture* (2000) is a series of photographs depicting the artist in a seated lotus position imitating a Buddhist sculpture, shrouded in a saffron cloth – the colour of monks' robes in Southeast Asia – tightly bound with rope.

Until recently installation, performance and conceptual art in Thailand were dismissed as Western art styles with little local relevance or application. **Montien Boonma** (1953–2000), who trained in Thailand, Italy and France, was a pivotal figure in bringing these contemporary art forms into play in his native country. He was also foremost among contemporary Thai artists in conceiving art projects that both embrace

Nilima Sheikh *Champa, before her marriage, and with her mother,* from the series *When Champa Grew Up* 1984
Tempera on hand-made paper, 12 parts: each 30.5 x 40.6 cm (12 x 16 in.)

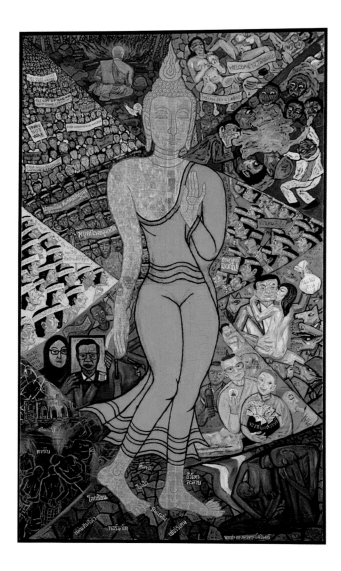

istic space for reflection and meditation – hence the title, a play on a phrase attributed to His Holiness the Dalai Lama: 'Our own heart, our own mind, is the temple.'[17]

Boonma frequently used medicinal herbs in his work to symbolize both hopes for healing and his religious faith, especially from the early 1990s onwards when his wife was diagnosed with breast cancer and, soon after, the artist himself developed a brain tumour as well as the cancer that would eventually claim his life. As he said: 'I believe in having faith in something. And that faith becomes our anchor, whether it's the Buddha or whatever.'[18] He constructed his sculpture *Nature's Breath: Arokhayasala* (1995) out of perforated metal blocks filled with herbs, while for *House of Hope* (1996–97), an installation, he created strings of medicinal herbal beads suspended from the gallery ceiling: the strands, falling from above, evoked prayer beads along with Buddhist practices of cleansing with aromatic herbs. Entering the artwork suggested a symbolic act of healing.

Writing in the exhibition catalogue for Boonma's retrospective at the Asia Society Museum in New York in 2003, Apinan Poshyananda observed that, along with Cai Guo-Qiang, Chen Zhen, Wolfgang Laib and Ernesto Neto, Boonma

experimental art forms and evoke the pervasive influence of Buddhism in Thailand. Many of his sculptures and installations incorporate Buddhist iconography, including prayer beads, begging bowls, bells, stupas and other symbols of religious devotion and practice. Based on traditional Thai temple architecture, Boonma's *Temple of the Mind: Sala for the Mind* (1995) consisted of roughly hewn wooden boxes smeared with pungent medicinal herbs stacked on top of one another to create a spiral tower, inside of which were hanging bells. Oddly statuesque, like a stupa, the structure provided a ritual-

Vasan Sitthiket *Lord Buddha Visits Thailand* 2009
Oil and gold leaf on canvas, 260 x 150 cm (102³/₈ x 59¹/₈ in.)

Michael Shaowanasai *Study in Sculpture* 2000
C-print, 101.6 x 101.6 cm (40 x 40 in.)

had helped to foster growing experimentation among artists with herbs and aromas, often as symbols for healing.[19] Most obviously, the use of healing and herbs are everywhere present in the work of **Chen Zhen** (1955–2000), for whom the practice of traditional Chinese medicine had a lot in common with art-making. He said: 'The method of devising and composing a Chinese prescription is a process of conceptual and plastic creation.'[20] Although not associated with a formal religion or sect, the artist became increasingly interested in the mystical healing properties of traditional medicine after he developed leukaemia, and he incorporated aspects of his study and research into sculptures and installations. *Obsession of Longevity* (1995) is an occultist-like healing apparatus with two chambers, back to back, in each of which Chen installed herbal remedies, medicinal ingredients, imagery of viruses and talismans for healing. In part, this was a play on the Chinese preoccupation

Montien Boonma *House of Hope* 1996–97
Steel, medicine balls, strings, clay, wooden stools,
400 x 300 x 600 cm (157 1/2 x 118 1/8 x 236 1/4 in.)

Chen Zhen *Obsession of Longevity* 1995
Metal gypsum, Chinese medicine, paraffin, foam rubber,
220 x 335 x 200 cm (86 ⅝ x 131 ⅛ x 78 ¾ in.)

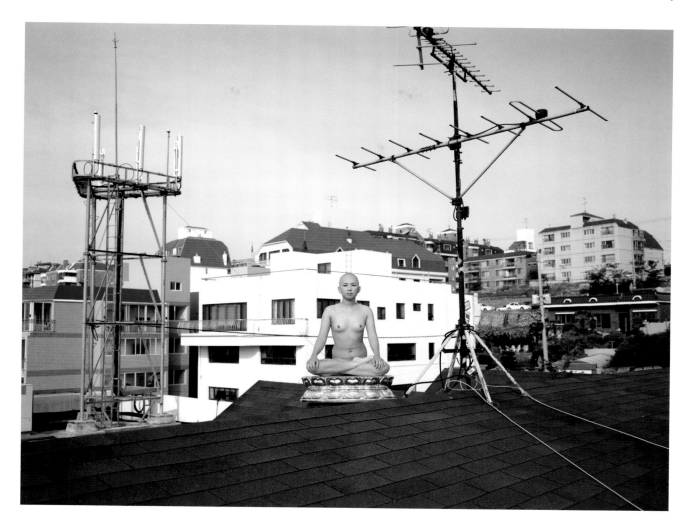

with longevity, but it was also a metaphor for hope, faith and the possibility of healing in the face of an incurable disease.

The history of Asian art reveals a long and devoted tradition of religious iconography. This comes as no surprise, for Asia is the birthplace of many of the world's spiritual and belief systems, including Hinduism, Buddhism, Sikhism, Confucianism and Taoism, and today remains a centre of religious practice and instruction. Much contemporary art in Asia is expressly concerned with religion, especially Buddhist practices and beliefs. The Korean photographer **Atta Kim** (b. 1956) rehearses some of the challenges of reconciling a devout religious practice with the lifestyles of modern urbanites. *The*

Museum Project #141 (2001), from the *Nirvana* series, shows a naked woman seated cross-legged in lotus position on a pedestal atop a roof in Seoul. Radiating serenity, the meditating figure seems out of place in the metropolis, surrounded by antennas serving as a token for the distractions of the mass media. It is a metaphor for the contemplative power of religion and the yearning for a state of peace and serenity that this promises. It is also an inadvertent – or backhanded – testament to the enduring power of religion in Asia's rapidly modernizing and increasingly urbanized cultures, especially Korea where some 42 per cent of the country's population live in and around the capital – one of the highest rates in the world.[21]

Atta Kim *The Museum Project #141*, from the *Nirvana* series 2001
Chromogenic print, 122 x 162 cm (48 x 63³/₄ in.)

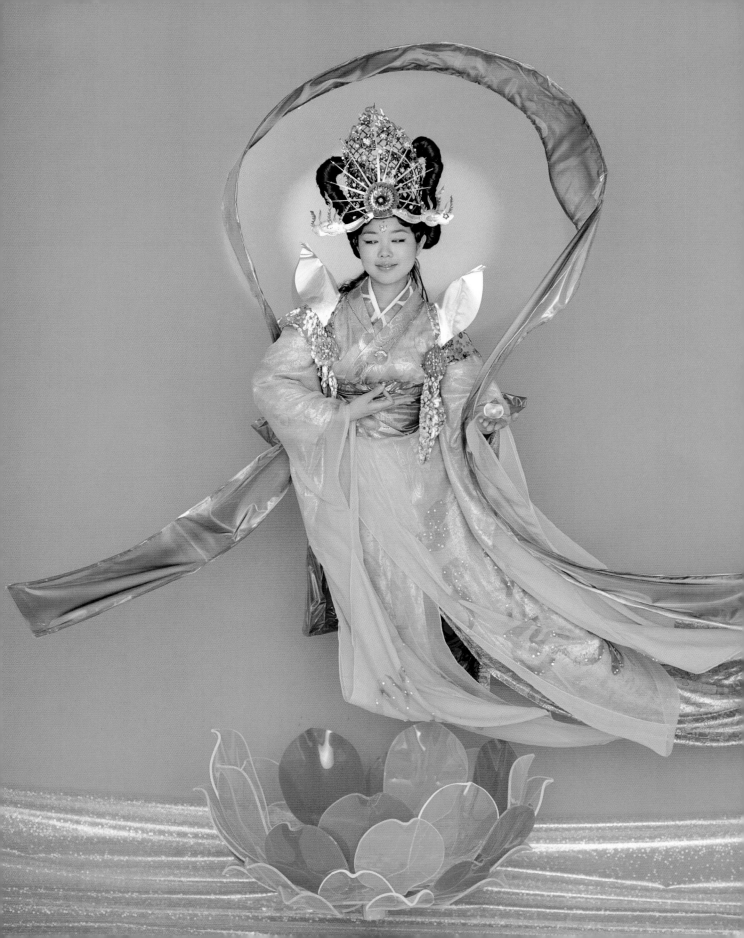

Similarly, Japanese artists Tatsuo Miyajima (b. 1957) and **Mariko Mori** (b. 1967) marry technology with Buddhist ideas and imagery. Miyajima's post-Minimalist sculptures using digital LED counters are intensely meditative, the constant flutter of small blinking numbers serving as a visual representation of the Buddhist emphasis on the impermanence of things. For Buddhists, attaining and perfecting dispassion for impermanent worldly things can ultimately result in a state of Nirvana, or total freedom from worries, troubles and desires. Mori's 3-D video installation *Nirvana* (1996–98) emulates this blissful state, showing the artist as an *apsara* (a Hindu and Buddhist flying angel) in flowing robes, floating through

a landscape trailed by fantastic creatures playing musical instruments. Using 3-D glasses, viewers have the illusion of interacting with the artist and her surreal surroundings. To experience this inspired and uplifting installation is seemingly to inhabit a weightless world in which everything we cling to in our lives melts into nothingness. Other, related works, such as *Kumano* (1997–98), are a fusion of religious symbolism, new technology, fantasy and popular culture.

The reverence of icons has an extensive history in Asia. Continuing this tradition is Japanese photographer **Hiroshi Sugimoto** (b. 1948), who produced a series of black-and-white photographs of Sanjusangendo (Hall of Thirty-Three Bays),

Mariko Mori *Nirvana* 1997 (video still)
Projector, DVD player, screen, 3-D glasses; dimensions variable

Hiroshi Sugimoto *Sea of Buddha* 1995
Gelatin silver print, 42 x 53.3 cm (16^1/$_2$ x 21 in.)

located in a twelfth-century temple complex in the old Japanese capital of Kyoto. Sugimoto trained his lens on clusters of the life-sized Buddhist sculptures filling the full length of the structure, each sculpture – of Kannon, a *bodhisattva* of compassion – hand-made and unique. Sugimoto photographed his *Sea of Buddha* series (1995) at dawn, when the building is lit by natural sunlight. The sculptures are suffused with an otherworldly aura, evoking unseen forces at work. Striving to capture a spiritual essence as well as a tangible reality, the artist has said:

> Spirituality is a particular characteristic of the human being that no other animals have. I'm just trying to investigate where this comes from. In that process I sometimes stir up ancient memories and spirits, and maybe people who see my art respond to that.[22]

The Indian sculptor **Ravinder Reddy** (b. 1956) brings a pop sensibility to Hindu religious sculpture. Specifically, he articulates 'a dual sensibility', according to art critic Kamala Kapoor, meaning that his work combines both 'an affinity for the extraordinary and the transcendent – qualities inherent in Indian classical sculpture – and for the prodigious world of the everyday'.[23] Reddy makes gigantic, elaborately ornamented, visually seductive busts and figures of temple gods and goddesses, using polyester resin gilded or painted in garish colours, then adorned with hairstyles of sculptured fruit and flowers. The most successful of these are iconic in their style,

Ravinder Reddy *Radha* 2007
Gold leaf on polyester resin fibreglass,
200 x 163 x 200 cm (78³/₄ x 64¹/₄ x 78³/₄ in.)

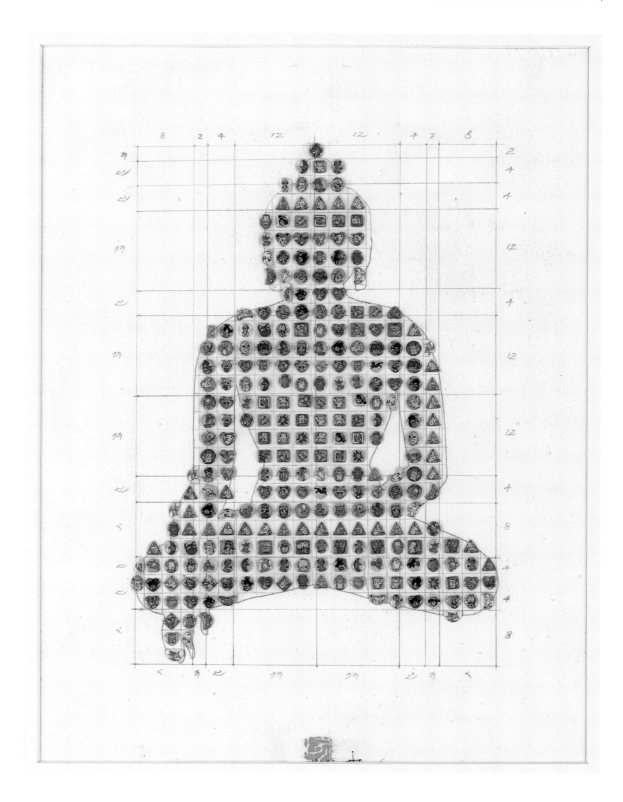

Gonkar Gyatso *Pokémon Buddha* 2004–5
Pencil and Pokémon stickers on paper,
24 x 18 cm (9³/₈ x 7¹/₈ in.)

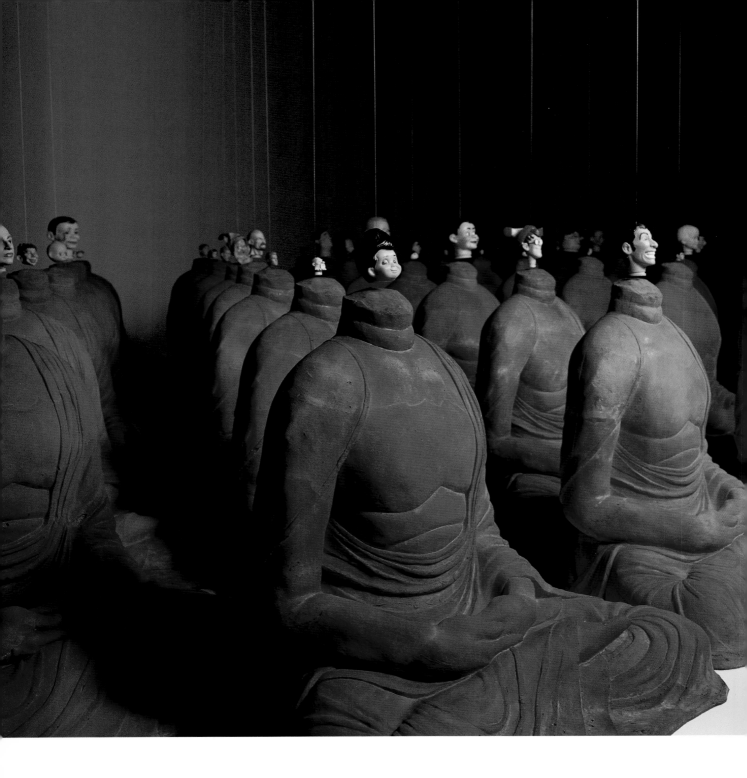

Michael Joo *Headless (Mfg. Portrait)* 2000 (detail and installation)
Urethane foam, pigment, vinyl plastic, styrene plastic,
urethane plastic, stainless-steel wire, neodymium magnets,
167.5 x 853.4 x 548.6 cm (66 x 336 x 216 in.)

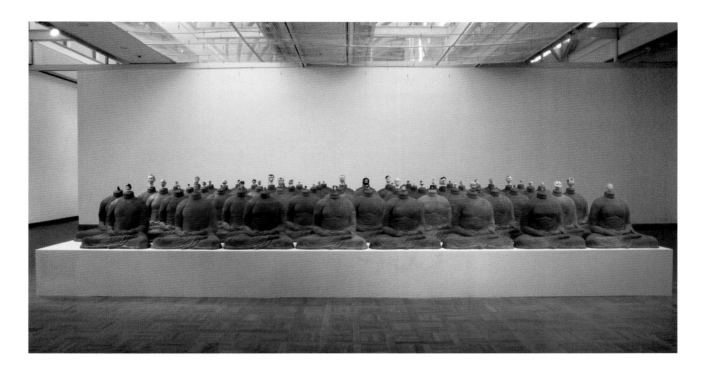

with red lips, painted eyelashes and giant, unblinking eyes: it is little wonder they are often compared by Western art critics to Andy Warhol's celebrity portraiture. For the artist, these busts are a meeting-point between the reverence for the transcendental forms of Indian religious icons and modern and secular ideas of visual pleasure and beauty: after all, appreciation of beauty belongs squarely to the realm of human awareness.

The Tibetan **Gonkar Gyatso** (b. 1961) and Korean-American **Michael Joo** (b. 1966) explore the effects of the widespread absorption of Asia's religious and cultural history into popular culture as another bankable visual symbol. Gyatso's *Pokémon Buddha* (2004–5) is a gridded pencil outline of a Buddha seated in lotus position and filled with stickers of characters from the popular Japanese video game and anime, elevated here to the status of a kind of global religion. Similarly, Joo's installation *Headless (Mfg. Portrait)* (2000) engages in the ironic, symbolic transformation of Buddha statues into cultural kitsch: here the plastic heads of different cartoon characters hover over rows of headless terracotta-

coloured foam sculptures of the Buddha seated in meditation, as if to suggest one kind of symbol morphing into another. Joo presents this as an allegory of the banality of mass culture.

From the mid-1990s onwards, many Central Asian artists turned to Buddhism, Indian meditation, Sufism and, above all, the spirituality and perceptions of the indigenous Steppe peoples. One of the most prominent is **Almagul Menlibayeva** (b. 1969) from Kazakhstan, who draws on her country's nomadic tribal heritage and shamanistic, pre-Islamic religious traditions for inspiration. Through a synthesis of Central Asian and European art traditions, Menlibayeva engages in what she calls 'romantic punk shamanism', a term that reflects the rebellious qualities of her work (specifically use of nudity in art from a Muslim country) and a celebration of nature and the imagination. Her video *Apa (Ancestors)* (2003) shows a group of Kazakh women naked and buried in snow up to their waists. They writhe about chanting, the performance invoking the powerful unseen forces or spirits that affect the living. Another video work, *Steppen Baroque* (2003)

presents a mythological vision of Kazakhstan in which women, nude or draped in traditional fabrics, re-enact Kazakh tales and rituals to evoke the cultural and spiritual legacies that linger throughout the landscape.

The capacity of digital space for deepening the dimension of spiritual experience is explored in the work of several other artists, including Vyacheslav Akhunov (b. 1948), born in Kyrgyzstan but now living in Uzbekistan, where, as in much of Central Asia, artists have had an uphill struggle because of little or no museum infrastructure and the absence of patronage. *Ascent* (2004), made in collaboration with Sergey Tychina (b. 1958), uses video to explore the repetitive nature of religious devotion. The work shows Akhunov's younger collaborator climbing the tight spiral staircase of a medieval tower. He appears to be a follower of Sufism, in which strenuous, repetitive activity is tied to religious devotion. Were

this all, the video might have been a mundane reflection on tradition and religion in Central Asia, but there is more. When the protagonist reaches the top of the minaret, he sits down and opens a laptop before proceeding to watch a replay of the video of himself climbing the tower. Here the repetitiveness of devotion crosses over to the digital realm as a video loop. In a similar fashion, India's **Ranbir Kaleka** (b. 1953) uses video looping to invite meditation on existential issues in *Man with Cockerel 2* (2004), a simple poignant video that silently and relentlessly repeats itself in a six-minute sequence. It shows a man losing, chasing and eventually capturing an escaped cockerel. The meaning is inconclusive, except to suggest that the mind's aim for constancy can never be realized, and life inherently involves uncertainty and loss.

In addition to belief systems indigenous to Asia, introduced religions have taken hold across the region. Over the

Almagul Menlibayeva *SteppenBaroque II* 2003
Production photograph from *SteppenBaroque*;
Lambda print mounted on alu-dibond,
70 x 100 cm (27⁵/₈ x 39³/₈ in.)

Almagul Menlibayeva *Apa I* 2003
Production photograph from *Apa*;
Lambda print mounted on alu-dibond,
150 x 100 cm (59 1/8 x 39 3/8 in.)

Ranbir Kaleka *Man with Cockerel 2* 2004
Video projection on suspended Plexiglas; 5 mins, 42 secs

past thousand years Islam has been widely assimilated, with more Muslims now living in Asia than in the whole of the Middle East (Indonesia, though not an Islamic state like Pakistan, is the world's most populous Muslim-dominated country). Many artists living in these nations incorporate identifiable Muslim elements into their artwork, for example Pakistani artist Aisha Khalid's (b. 1972) miniature painting *Silence with Pattern* (2000), which draws on geometric tile patterning used to decorate mosques. Muslim extremism, terrorism and ongoing sectarian violence are also a defining feature of much contemporary art about Islam, especially since the terrorist bombings in the United States in 2001 and the Bali bombings of 2002. One example: in 2003, Indonesia's national contribution to the 50th Venice Biennale included the work of several artists responding to Islamic terrorism and religious conflict.

When Spain colonized the Philippines in the sixteenth century, the missionaries brought Christianity, and today Christians make up about 90 per cent of the population. Not surprisingly, many Filipino artists employ Christian iconography in their art, among them Manuel Ocampo (b. 1965), who as a youth received some instruction in painting from a Catholic priest. Today he creates complicated, layered, collage-like, socio-political allegories fusing religious iconography with folk art, cartoons, text, European art and found images of people and events. One recurring motif in his art is the Christian cross. *La Liberté* (1990) depicts a black hooded figure with a cross in one hand and a rifle in the other, standing in a field of bones in front of a faceless crowd. In the foreground, a serpent is twisted around a swastika. In this painting, religious and political signs are interpreted as equally pernicious, both for what they conjure and for what they aim to dispel.

We will end this chapter with Mongolian installation and earthwork artist **Chaolun Baatar** (b. 1951). The *toono* or *tono*, a wheel-like central roof ring creating an open skylight at the top of a *yurt* or *ger* (the portable tent used by the nomadic people of Central Asia), is the basis for Baatar's series of site-specific works, beginning with *Burning Toono–I* (2002), for which an

enormous representation of a toono was carved into the sand of a dry river bed in Inner Mongolia, then filled with leaves, grass and gasoline, and set alight. Just as the toono symbolizes the connection between nomadic people and nature by allowing them to keep an eye on the stars and sky while inside the windowless yurt, so Baatar sets the toono on fire in his works as a ritualistic celebration of his Mongolian identity. The design formed by the flame is stamped onto the landscape.

The diverse, enterprising current of Asian contemporary art inspired by traditional forms and techniques gave artists and the Asian art scene of the past few decades a distinctive regional flavour. Ultimately, however, the significance of local traditions for contemporary artists was overshadowed by an embrace of social and political themes, which increasingly captured the attention of the global art world in the 1990s and are the subject of the following chapter.

Chaolun Baatar *Burning Toono–I, The Skylight* 2002
Installation view: North Inner Mongolia, 16 September 2002,
3:00 am. Dry grass, cashmere, horse wine and gasoline,
50 x 50 x 0.5 m (164 x 164 x 1½ ft)

chapter 2

POLITICS, SOCIETY AND
THE STATE

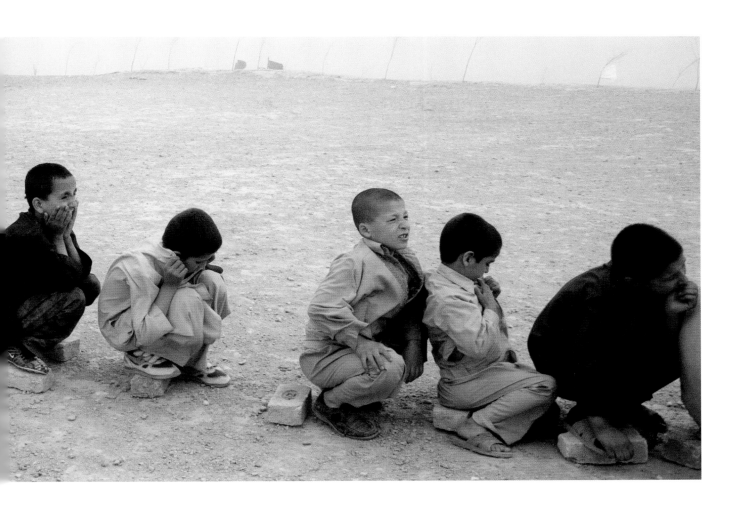

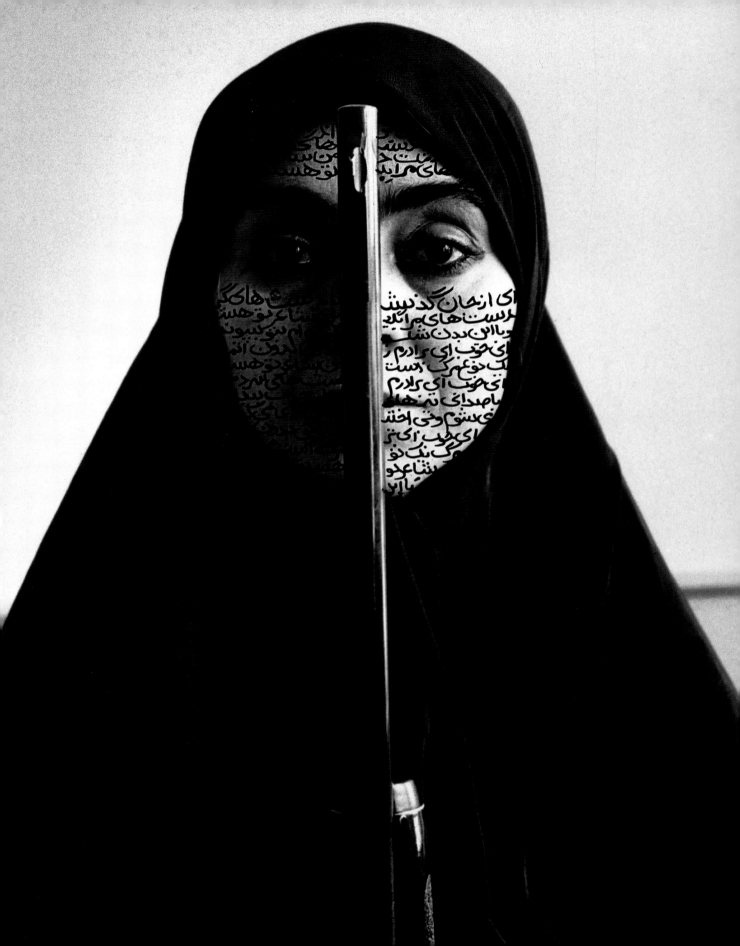

Social, economic and political inequity are realities of existence in Asia, where millions of people continue to live in poverty. Asia is also the site of ongoing, devastating wars and sectarian conflicts. From this context has emerged a widespread belief among contemporary artists that art practice in Asia carries with it a moral responsibility for social criticism, at times political dissent. As a result, artists across the region have grappled with daily life issues and concerns, ranging from religious conflict, war, human rights, AIDS, social injustice, migration and censorship to corruption, colonialism and neo-colonialism, along with intractable problems of violence, sexism and racism. Sometimes this agenda has entailed a rejection of fine art as a privileged category, with artists turning to murals, public art, activism, community participation, street performance and various other methods in an effort to reach an audience beyond the art world's insulated apparatus of presentation and display.

In countries where art is assumed to be divorced from social or political issues, these strategies have brought artists into direct conflict with government, testing the limits of tolerance and free speech. In Indonesia during the Soeharto presidency (1967–98), for example, historian Caroline Turner has observed that many artists, including **Dadang Christanto** (b. 1957), **FX Harsono** (b. 1948), **Heri Dono** (b. 1960), Arahmaiani (b. 1961) and Nindityo Adipurnomo (b. 1961), showed great bravery and commitment to making art opposing poverty, graft, and political and military abuses.[1] Even artists who did not make political work found themselves under scrutiny. As artist and art historian Jim Supangkat noted in 1996: 'The current political situation in Indonesia has caused the security forces to view almost every expression of artistic creativity as they would a demonstration designed to disrupt society and bring chaos.'[2]

In this context, to avoid the wrath of the censors, Indonesian artists used codes, symbols and signs to convey veiled and indirect political messages in their work. Harsono's *The Voices are Controlled by the Powers* (1994), a sculptural installation, employs traditional masks from *wayang topeng* mask drama, with severed mouths, to comment on the lack of free

Dadang Christanto *Kekerasan I (Violence I)* 1995 (detail)
Terracotta, brick

speech in Indonesian society, while *Voice Without a Voice/Sign* (1993–94), nine big prints of a hand, each forming a letter in sign language to spell out the word 'demokrasi', with the final hand bound with rope, stands for repression and the silencing of democratic hopes among the Indonesian people. Meanwhile Dono's *Flying Angels* (1996), an installation created at a time of increasing political repression and social turmoil, used hand-made, mechanized puppets of angels with flapping wings – modelled on the traditional Javanese *wayang kulit* shadow puppets – to symbolize the desire among the Indonesian people for greater freedom of movement and expression. As the artist explained: 'Angels have wings and can fly wherever they want.'[3]

Art's capacity for effecting social change is not easily quantifiable, but that does not mean it lacks instrumentality in the wider world, or that artists are not politically active. Take, for instance, the work of artist collectives Sahmat in India, or

FX Harsono *The Voices are Controlled by the Powers* 1994
Wooden masks, cloth, 30 x 350 x 350 cm (11^7/$_8$ x 137^3/$_4$ x 137^3/$_4$ in.)

Heri Dono *Flying Angels* 1996
Polyester resin, clock parts, electronic components, paint, wood, cotton gauze, each 60 x 135 cm (23^5/$_8$ x 53^1/$_8$ in.)

Artis Pro Activ (APA) in Malaysia, which promote social and political change. Art has the ability to show us things shorn of habitual trappings – to present alternatives and challenge the way in which we understand and see the world. It is like a multifaceted mirror in which we can see issues reflected and re-presented. It can also provide relief to individuals, or speak to an audience who may or may not share similar views but who are troubled by an inability to make their voices heard, whether through a lack of representation in the political process or the belligerence of government censorship.

PARTICIPATORY PRACTICES

Some of the most compelling art in Asia has involved artists working collaboratively with the public, or coordinating non-artists to participate in projects that confront the injustices of politics, economics, gender, race and class, or offer poetic insights into processes of everyday living. In these works the collaborative spirit supersedes the artist's individual interests or ego to evoke the ideal of a community, albeit a temporary and imaginary one. Thai artist **Rirkrit Tiravanija** (b. 1961) goes further than many other artists in this area, building communal structures for living and socializing, or facilitating interactive open-ended social events in which museum audiences are invited to perform actions.

Much of Tiravanija's art is process-oriented, participatory and relational. For a 1992 exhibition called *Untitled (Free)*, he transformed a New York gallery into a makeshift restaurant where, using cooking skills learned from his grandmother, a former chef who had a television cooking show in Thailand, he prepared and served free Thai meals to any and all visitors

Rirkrit Tiravanija *Mai Mee Chue (pad thai)* 1990/2004
Installation view: Chiang Mai University Art Museum, Thailand
Five woks, pad thai ingredients, cooking equipment and utensils,
a glass case, a lot of people

to eat at communal tables. Blurring the relationship between audience, artist, art and environment, the performance was very much in the tradition – initiated in the 1960s by German conceptual artist Joseph Beuys – of 'social sculpture', in which society as a whole was deemed to be one large, living work of art and everybody an artist. But the work also owed its inspiration in part to the Southeast Asian Buddhist practice of social giving, which includes making offerings of alms at temples and the daily ritual of cooking and giving free food to monks at monasteries.

Tiravanija's projects have extended beyond the gallery. In 1998 with the Thai artist Kamin Lertchaiprasert (b. 1964) he co-founded *The Land*, an ongoing collaborative social experiment in artist-run rural communal living and self-sustainable development on farmland near Chiang Mai, Thailand. Here, amid rice paddies, vegetable fields and water buffalo, artists from around the world have come to live, work on the land, and undertake utilitarian-based art projects ranging from the construction of ecologically sound and sustainable architecture to experiments in alternative-energy sources used to run the community.

Like Tiravanija's other relational art projects, the basic concept behind *The Land* is the cultivation of a place for social engagement, though in this case with intentions towards the creation of an alternative, holistic community and the bringing together of art with other fields of thought. As Tiravanija explains:

> Rather than have an exhibition, we give artists, especially young artists, a space to think about art; to grow rice but to do so in ways that create ideas about art making. *The Land* is a place to re-think our daily structures.[4]

Tiravanija's artwork in a participatory vein has provided themes for other Thai artists. Among them is **Surasi Kusolwong** (b. 1965), whose elaborate performance/installation pieces present ad hoc recreations of temporary Thai street-market stalls and offer Thai massages free of charge to gallery-goers. For the 1998 Biennale of Sydney and subsequent works, Kusolwong assembled a mound of bright, cheap, mass-produced, everyday goods imported from a Bangkok street market, which for the duration of the exhibition were free to be taken away. This induced frenzied consumption. But,

Surasi Kusolwong *Night Market* 2001
Thai objects, twelve luminaires, six table bases

in contrast to Tiravanija's works described above, Kusolwong's exploration of acquisitive instincts involves a pivot away from the spiritual (or at least the creation of a sense of community) towards consumerism. Both artists' work may be process-oriented, participatory and relational, but Kusolwong seems to be more interested in exploring consumer desire.

Because of economic and political isolation, it was only in the mid-1990s that consumer goods became widely available in China: as a result, people there experienced consumerism much later than in other parts of Asia. In Zhengzhou, **Wang Jin** (b. 1962) staged an interactive performance outside a newly opened shopping centre. Titled *Ice: Central China* (1996), the piece presented a wall built from blocks of ice with desirable consumer objects frozen inside, such as cell phones, televisions, cosmetics and jewelry – items that at the time were beyond the reach of many Chinese citizens – as an allegory for China's new consumer economy. In the end, viewers began to smash the ice to get hold of the items. Similarly, **Lin Yilin**'s (b. 1964) performance *100 Pieces and 1,000 Pieces* (1993)

tempted viewers with the promise of free money that was wedged between bricks in a makeshift wall that he built at night along a Guangzhou street. Lin and others tried to pry out the money, often ripping and rendering it worthless. In cases where it did not rip, it went back into circulation bearing markings of the performance.

Taiwanese social conceptualist **Lee Mingwei** (b. 1964) also emphasizes the setting up of social experiences – places for people to engage with each other and participate in the creation of the work of art, although Lee's subject matter is essentially intimacy and trust between strangers. *The Letter-Writing Project*, at the Whitney Museum of American Art in 1998, invited museum visitors to sit, kneel or stand inside a booth made of pale wood and translucent glass and write a letter that they had always wanted to write but never had, communicating unexpressed gratitude, forgiveness or regret. Participants were then asked to either seal and address their letters (for posting by the museum) or leave them unsealed in slots on the walls of the booth for other participants and visitors to read. Here the artist creates a space for people to insert their own personal history, giving them authorship over the work.

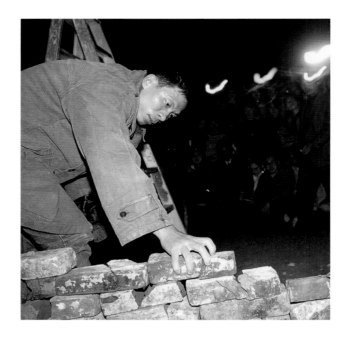

Wang Jin *Ice: Central China* 1996
Black-and-white photograph, 165 x 109 cm (65 x 43 in.)

Lin Yilin *100 Pieces and 1,000 Pieces* 1993
Performance: 50 mins

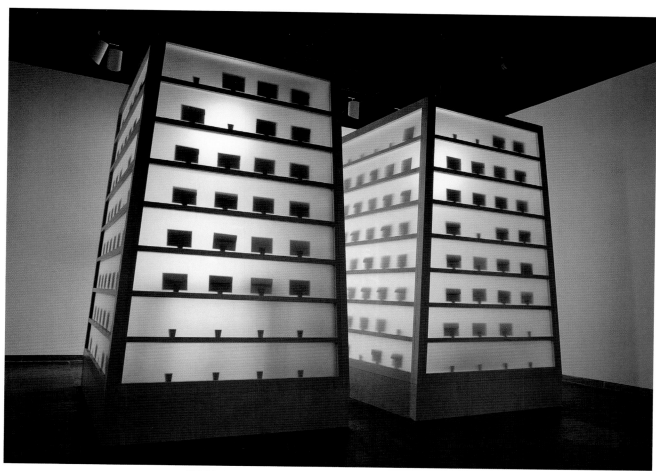

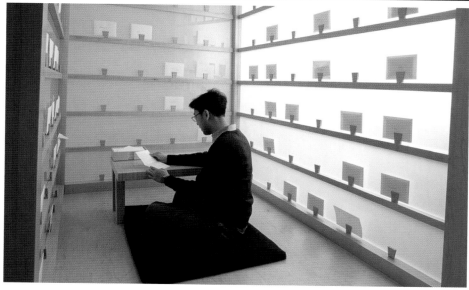

Lee Mingwei *The Letter-Writing Project* 1998–2008
Installation views: The Whitney Museum of American Art, New York
Wood, glass and paper

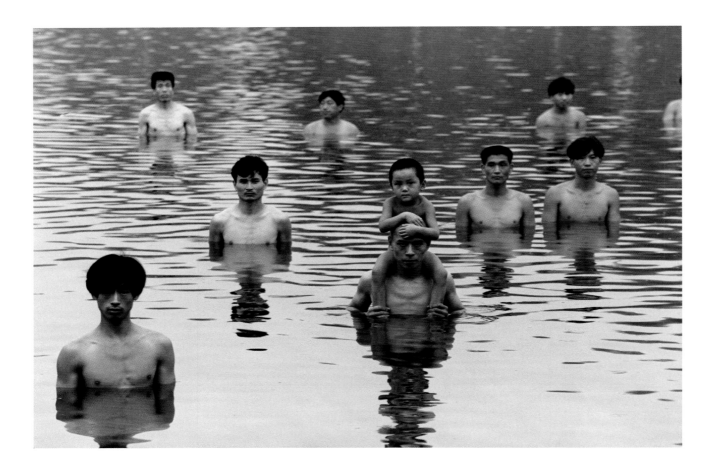

Reflective of an interest among artists in individual and community rights is **Zhang Huan**'s (b. 1965) conceptual performance *To Raise the Water Level in a Fishpond* (1997), staged in Beijing's East Village artist community. Here the artist collaborated with itinerant workers, many of whom had illegally migrated to the city from poor rural areas to work in factories and on building sites. The concept behind the piece was simple: wading en masse into a fishpond, the workers raised the level of the water by one metre (3 ft 3 in.) with their collective body mass. Captured in photographs, the performance gave weight and voice to this otherwise silent and invisible community, who, because they existed outside the government's official work unit structure, were often referred to as a 'floating population' – a phrase that makes Zhang's concept and performance particularly resonant.

SOCIAL CONSCIOUSNESS

Much energy also coalesces in work that is socially engaged, reflective of a desire to bring contemporary art more into alignment with economic, social and political realities in the region. During the 1990s in Asia, as elsewhere, AIDS/HIV awareness became a popular subject for artists. In Thailand, the artist and social activist Chumpon Apisuk (b. 1948) emerged as an influential art world figure after founding Concrete House, an alternative space for exhibitions, performances and art-related social activism near Bangkok. His own art focuses on local social health issues, especially the uncontrolled spread of AIDS among sex workers in Thailand. For *Alive* (1995), an interactive multimedia installation that has taken different forms in different venues, the artist recorded conversations with HIV-infected individuals and

Zhang Huan *To Raise the Water Level in a Fishpond* 1997
Colour photograph of performance, Beijing, China,
105 x 155 cm (41¹/₄ x 61 in.)

their relatives. Some of the speakers recounted their life stories, while others made a plea for understanding. In addition to recordings, the installation included photographs of interviewees and a diary in which viewers were invited to express responses to the installation. In a corner of the exhibition, a fax machine received updates from around the world on the AIDS crisis.

In Vietnam, understandably, caution in dealing with social and political issues was a necessary survival strategy among artists into the 1990s, when the country's Communist Party leaders began to reform the economy and open up – slowly – to outside influences, a process referred to as *doi moi*. **Truong Tan** (b. 1963) was the exception. Widely regarded as Vietnam's most adventurous and controversial artist after

several of his paintings were confiscated from a 1995 exhibition in Hanoi, Tan's themes and subject matter transgressed state-sanctioned Confucian morality governing sexuality, and were at odds with typical academic Vietnamese painting (showing women in *ao dai* and bucolic landscapes of rice paddies) promoted in art schools. His paintings about homosexuality and the threat of AIDS in Vietnam, such as *Untitled #23* (1994–95), present silhouettes of men aroused or having sex with other men in a style akin to that of American graffiti artist Keith Haring. Another painting, *Come in Please* (1996), depicts the transition of a healthy man into an emaciated figure after having sex with another man. Seizing upon the spectre of AIDS, Tan dramatizes his own conflicts, fears and desires.

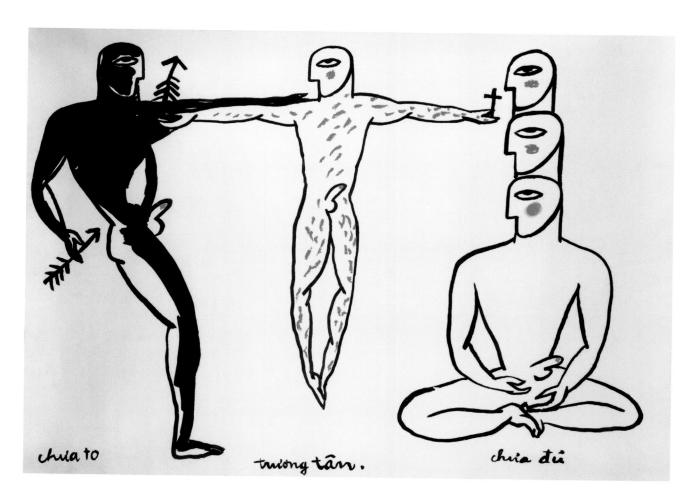

Truong Tan *Untitled #23* 1994–95
Ink and gouache on rice paper, 61 x 85 cm (24 x 33¹/₂ in.)

There came a point in this photographic session when I could have made a serious pass at Stephen and it would probably have turned into sex. He was the sort of person who'd agree to most things. He had already told me about this guy he'd just met who'd asked him to be his slave at the Mardi Gras parade and he'd said "Yes." He'd also told me he was HIV positive.
I remember those heady days before, when life seemed freer and taking photos could be a prelude to seduction. But times had changed and I had changed too.

Even artists who are not overtly political are sometimes swayed by social and political imperatives. In 1969, the Chinese-Australian photographer **William Yang** (b. 1943) left Brisbane to live in Sydney, where for the next three decades he documented the city's burgeoning gay and lesbian sub-culture. He photographed his lovers, friends, gay parties, clubs and orgies, the annual Gay and Lesbian Mardi Gras and, eventually, the devastating impact of AIDS on the gay community. His images are a witness to the times. Black-and-white portraits of men predominate, on some of which the artist scribbled brief notes about the subject and photo shoot. Fear of AIDS underlies *Stephen #1* (1992), a portrait of a naked man face down on a bed with a handwritten text across the top part of the picture, describing a moment when the photo shoot could have turned into sex. Moments before, the text says, Stephen had told the artist he was HIV positive.

In addition to art that was a response to the AIDS crisis, some of the most conspicuous socially minded art being produced within the Asian art world of the 1990s was identity-based. Lee Wen (b. 1957) is a Singaporean who, at the age of thirty, left behind a career in banking for art. He is widely known for a series of satirical performances, first presented in the early 1990s and collectively titled *Journey of a Yellow Man*, in which he covers his body with yellow paint to exaggerate

William Yang *Stephen #1* 1992
Digital print, 37.5 x 28 cm (14³/₄ x 11 in.)

his 'Asian' identity as a Singaporean of Chinese descent. He then wanders through cities all over the world, using various strategies to record and display his performances, including photography, video art, mixed-media installation, drawing and painting. By taking on the 'Yellow Man' persona in shifting contexts, the artist tests cultural perceptions of race and ethnicity, and probes assumptions about Asians. As the Singaporean critic Lee Weng Choy has written:

> Lee Wen's 'yellow man' is an ambiguous, ironic figure – his 'yellowness' can be read as an exaggeration of his ethnic identity – but rather than simply affirm it, his performance plays with questions of identity. And more than just addressing ethnic identity, his performance evokes other questions as well. The performance of 'yellow man' is a performance of posing and destabilizing categories.[5]

'Yellow Man' is related to 'Pink Man', and not only because of the colours. Since 1997, Thai artist **Manit Sriwanichpoom** (b. 1961) has developed the alter ego 'Pink Man' – in this case,

as a satirical symbol of crass consumption in Thai society. His character is a plump Asian man (the artist's friend, Sompong Thawee) dressed in a loud pink satin suit, pushing a matching shopping trolley. Several photographic series show him touring a Bangkok business district, visiting popular tourist sites in the countryside, and even attending the Venice Biennale. 'Pink Man' wanders the world quietly and aimlessly, like a robot, pushing his supermarket cart. He lives only to consume, a symbol of excess and materialism in Thailand, where the artist believes consumerism is becoming entwined with nationalism: 'What I am satirizing is the conspiracy to mythologize the nation state.... My intent is good: I don't want to see Thailand become a fat man in a pink suit.'[6]

There is a distinction to be made between artists who adopt a single persona or character and enact it in a variety of settings versus artists who use the conventions of self-portraiture in different contexts. Japanese artist **Morimura Yasumasa** (b. 1951) was among the first contemporary Asian artists to use self-portraiture to pose questions of identity amid broader

Manit Sriwanichpoom *Pink Man Begins* 1997 (detail)
C-print, each 50.8 x 61 cm (20 x 24 in.)

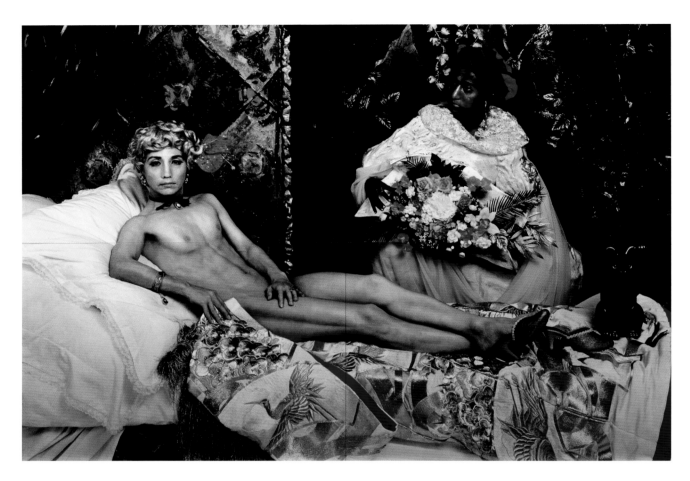

issues. 'Cindy [Sherman] and I are like brother and sister,' he has said.[7] His large-scale self-portraits depict him in scenes reinterpreting or parodying Western art masterpieces, with the artist costumed, elaborately made-up and taking the place of the original figures. In other artworks he takes off famous photographs of pop icons and celebrities such as Marilyn Monroe, Madonna and Michael Jackson, as in *Self-Portrait – After Marilyn Monroe* (1996). Morimura's work is often associated by critics with a tendency of the late 1980s known as appropriation art – a visual strategy celebrating the re-use of recognizable cultural imagery – but it also seems directed at consumerism along with a desire for personal transformation. As the artist has said:

> ... people sometimes view me as a typical example of the current lust for transformation, but that's not

quite correct. It's not as easy for me as it is for today's young people, for whom morphing into something else is a continuation of everyday existence. In my day 'transforming' oneself was a far greater hurdle than it is now, and my attempts were in part intended to overcome that very hurdle.[8]

Like Morimura, New York-based Korean **Nikki S. Lee** (b. 1970) uses self-portraiture: rather than assuming the identity of popular culture icons, however, she insinuates herself into different ethnic and sub-culture communities (including drag queens, punks, Latinos, skateboarders, hip-hop musicians and fans) and documents herself in snapshots dressed up in imitation of her hosts. Satirical/subversive self-portraits are also the basis of paintings by **Chatchai Puipia** (b. 1964) which reflect on aspects of Thai society. *Siamese Smile* (1995) is a

Morimura Yasumasa *Portrait (Futago)* 1988–90
Colour photograph, transparent medium,
240.03 x 342.9 cm (94¹/₂ x 135 in.)

Morimura Yasumasa *Self-Portrait (B/W) – After Marilyn Monroe* 1996
Gelatin silver print, 45.09 x 35.56 cm (17³/₄ x 14 in.)

self-portrait with a forced, pained smile that focuses on the veneer of happiness and superficiality of Thailand's popular self-image as the 'land of smiles'. This is a personal expression of anguish at the direction of Thai society, where the reality is far from happy – AIDS, corruption, pollution and periodic military dictatorship. As Puipia explains: 'Communicating and participating in today's world can lead to despair. Often, the only thing I can do in response is smile. The smile, for me, means "surrender", and shows that we as human beings either surrender or lose.'[9]

In China, in 1994, new dissenting voices were beginning to emerge in areas of performance and documentary photography. Some of this artwork was radical and extreme, even by Western standards, involving endurance and pain, and is often associated with Beijing's East Village, the artist community located on the eastern edge of the city. **Zhang Huan**'s *12 m²*, a 1994 performance at the East Village, was motivated by the dismal living conditions there, in particular the communal latrines. In the performance, Zhang covered his body in fish oil and honey, then sat motionless in a putrid, faeces-covered public toilet, about 12 metres (39 ft) square in size, for an hour, allowing flies and insects to cover his body. Later, in a commentary on this performance, Zhang elaborated on the socio-cultural contexts and underlying symbolism:

> What I am actually most interested in is people at their most ordinary, during typical daily moments when they are most prone to being overlooked, and this is also what constitutes the original material for when I create. In these daily activities we find the nearest thing to what humanity is, the most essential human thing – the question of the human spirit, the quest to discover how we relate to the environment we exist in.[10]

Nikki S. Lee *The Hip Hop Project (1)* 2001
Fujiflex print, 54 x 72 cm (21¼ x 28⅜ in.)

Chatchai Puipia *Siamese Smile* 1995
Oil on canvas, 240 x 220 cm (94$\frac{1}{2}$ x 86$\frac{5}{8}$ in.)

Zhang and his peers in the East Village, including performance artists Zhu Ming (b. 1972), Ma Liuming (b. 1969) and Cang Xin (b. 1967), were arrested or harassed by police for their activities. Not surprisingly some of them left China, including Zhang, who moved to New York in 1998 where he became part of the American and international art worlds. For the 2002 Whitney Biennial, he conceived the performance *My New York*, in which he bulked up like a body-builder in a suit made from slabs of red meat, and then walked the city streets setting a flock of white doves loose from cages, a Buddhist gesture of compassion.

Other Chinese artists who went abroad achieved similar success in their new homes. In France, **Huang Yong Ping** (b. 1954) explored the patterns of Chinese migration to Western nations in works such as *Chinese Hand Laundry* (1994), *Kearny Street* (1995) and *Human Snake Plan* (1993). Sculptor

Wang Du (b. 1956), also in France, recreated glossy, graphic, mass-media imagery on a giant scale in three dimensions.

In Australia, the painter **Guan Wei** (b. 1957) produced serial paintings reflecting the bureaucratic processes he had

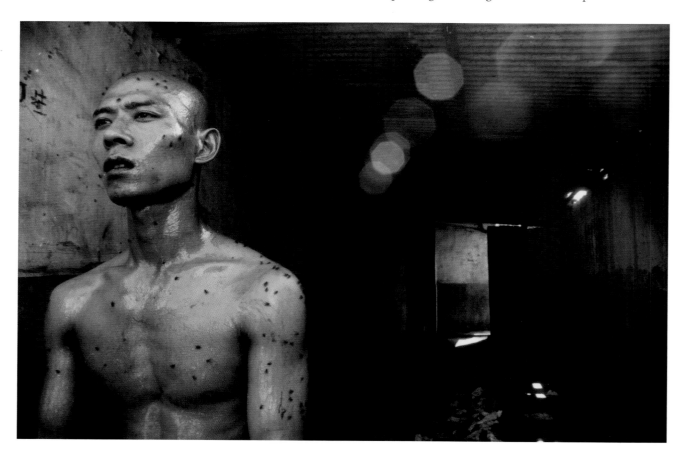

ABOVE Zhang Huan *12m²* 1994
Performance, Beijing

TOP Huang Yong Ping *Chinese Hand Laundry* 1994
Installation view: New Museum of Contemporary Art, New York
Car wash components, canvas, rubber, wood, 12 x 6 x 4 m
(39 ft 3 in. x 19 ft 6 in. x 13 ft 1 in.)

Wang Du *Défilé* 2000
Installation view: Palais de Tokyo, Paris
Acrylic, wood, paint, sound, paper, 200 x 1,200 x 50 cm
(78 3/4 x 472 3/8 x 19 5/8 in.)

to undergo before receiving permanent residency in 1993. The *Certificate Series* (1990) comprised simple, hybrid collages incorporating painted elements and passport and formal family photographs overlaid with printed impressions of invented seals, documents and stamps. These works are intensely autobiographical.

Patterns of migration – movements of people from place to place in search of a better life, and the challenges they face along the way – are popular themes in contemporary Asian art. Malaysian artist **Wong Hoy Cheong** (b. 1960) is the son of Chinese immigrants, and perhaps the most prominent of a new generation of artists of non-indigenous (Malay-Islamic) backgrounds, particularly of Chinese ethnicity, who emerged in the 1990s. Questions of identity are a key concern for these artists. Based on his family history, Wong's *Migrants Series* (1994–96) explores themes of migration and adaptation to a

new culture in Malaysia in large-scale charcoal and collage drawings on paper scrolls that in their subject matter and style recall old, faded, family-album portrait photographs:

> I grew up listening to stories. Stories told by my father and mother, grandmothers, aunties and uncles. They were stories of remembrance layered with wonder and pain, conflict and reconciliation, mystery and miracle. My drawings [*Migrants Series*] take these stories as a starting point. I am interested in how the histories of people are made; how the individual 'I' becomes the collective 'I' and how the easily forgotten dreams of one person become the dreams of a people.[11]

The drawing *Aspirations of the Working Class* (1994), from Wong's *Migrants Series*, shows a Chinese family in a staged studio interior surrounded by symbols of Malay and European identity and history – a Christian church and a windmill,

Guan Wei *Certificate Series* 1990
Mixed media on paper, 20 x 30 cm (7⁷/₈ x 11⁷/₈ in.)

Wong Hoy Cheong *Migrants Series:*
Aspirations of the Working Class 1994
Charcoal and photocopy collage on paper,
190 x 150 cm (74⁷/₈ x 59 in.)

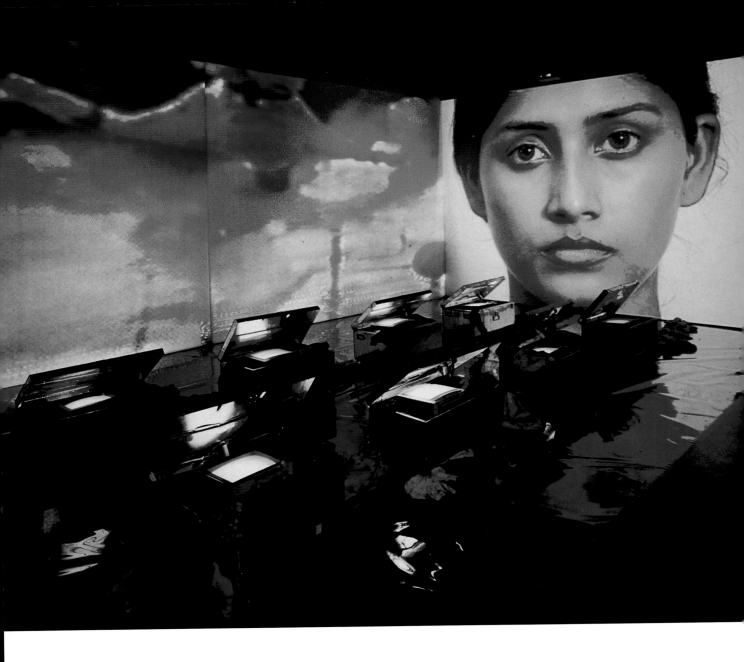

Nalini Malani *Remembering Toba Tek Singh* 1998–99
20-minute videotape installation, comprising 17 VCDs
and one CD, ed. 1/3, approx. 900 x 650 x 400 cm
(approx. 354 1/2 x 256 x 157 1/2 in.)

a Malay tribeswoman and a special knife used to shear off a thin layer of tree bark to tap rubber. The family is identifying with a new land, both its native culture and past political status as a European colony.

POLITICAL HISTORIES

National political histories, as well as contemporary political events within those nations, have widely informed contemporary Asian art. This is especially so where historical conflicts persist into the present, often as a legacy of colonialism. **Nalini Malani** (b. 1946) bases her art on the stories of people who have been hurt, forgotten or sidelined in history. *Remembering Toba Tek Singh* (1998–99) is an installation of tin storage trunks (commonly used by travellers, refugees and migrants all over the sub-continent) containing quilts and video monitors relaying scenes of violence, mass migration and the explosion of bombs, surrounded by video projections depicting overlapping scenes of suffering and violence. The work takes its inspiration and title from a short story by writer Saadat Hasan Manto set during the partition of the sub-continent into India and Pakistan in 1947. The story recalls the death of a mental patient, Bishan Singh, who, being forcibly removed from a Lahore asylum, cannot decide whether he wants to live in India or Pakistan. He ends up in the no-man's-land between the heavily fortified borders of the two countries. For Malani, Singh's story becomes emblematic of the horrors of Partition, during which an estimated 12.5 million people were displaced and several hundred thousand killed in sectarian violence.[12] It also resonates personally for the artist:

> My parents were born and brought up in what is today Pakistan – prior to the division of India.... Coming to India for my parents and my grandparents was a big cultural shock. They felt this was an alien place as they were not Hindus nor spoke Hindi or Marathi.... The whole contrast was too much for them to cope with. In one stroke they lost all their homes, their culture and their possessions.[13]

As with much contemporary art dealing with Partition, and the contested border between the two nations (they have

gone to war over the disputed territory of Kashmir), the Malani installation reflects feelings of insecurity and loss. But Partition has also inspired art that is gratifying to our senses, even pleasurable: tensions do not always prompt angst-filled images. *Line of Control* (2004), a holographic lenticular photograph by Pakistani artist **Farida Batool** (b. 1970), reveals a writhing pair of bodies pressed tight against one another, the shifting line where they come together a metaphor for the contested geographic border between India

Farida Batool *Line of Control* 2004
Lenticular print, 157.5 x 86.4 cm (62 x 34 in.)

Vivan Sundaram *Memorial* 1993
Mixed media, 18 x 10 m (59 ft x 32 ft 8 in.)

and Pakistan. The sensory fluctuations of the bodies mirror competing claims and counter-claims for territory: they are simultaneously individual people and carriers of narrative, a living, breathing embodiment of history. But we also perceive intimacy in the union of the bodies and the possibility that one day the two nations may achieve reconciliation.

In India religious violence is a recurrent topic for artists, often anchored in a critique of extremist Hindu nationalism. The centrepiece of *Memorial* (1993), **Vivan Sundaram**'s (b. 1943) installation of photographs and sculpture, is a crumpled plaster figure encased in a glass prism based on a news image from the *Times of India*. The piece honours and mourns victims of one of the worst bouts of the sectarian violence that periodically threatens India's secular identity and stability. In 1992 militant Hindus demolished the sixteenth-century Babri mosque in Ayodhya in the northern Indian state of Uttar Pradesh, vowing to replace it with a Hindu temple dedicated to Rama, a Hindu deity. The destruction prompted nationwide rioting between Hindus and India's Muslim minority, which left an estimated two thousand people dead.

Jitish Kallat *Collidonthus* 2007
Resin, paint, steel, brass, 403 x 172 x 152 cm
(158 5/8 x 67 3/4 x 59 7/8 in.)

For Rummana Hussain (1952–1999) and N. N. Rimzon (b. 1957), the violence was also a starting point for installation works, revealing something of the range here. In *Space for Healing* (1999), Hussain's last work, the artist constructed a red room for contemplation and catharsis, both for a nation divided and for herself; she had been diagnosed with breast cancer.

Religious rioting erupted again in the state of Gujarat in 2002, leaving around one thousand people, mostly Muslims, dead. Once again news images were the basis of efforts to recast and reassess events. The responses include Manish Swarup's (b. 1968) journalistic photographs of the actual violence and its aftermath, and paintings by **Jitish Kallat** (b. 1974) of the rioting mobs and bloody survivors, the blurry style of Kallat's artwork imitating the static-filled images of the riots he watched on television: his sculpture of a skeletal car body, *Collidonthus* (2007), also evokes abandoned and burnt-out vehicles destroyed by rioters. For **Navjot Altaf**'s (b. 1949) video

installation *Lacuna in Testimony* (2003), tranquil beach scenery on a three-channel video projection is gradually overlaid with fragmentary news imagery of the rioting, accompanied by eyewitness accounts of the violence; the sounds and imagery reach fever pitch and then the screens return to the original calm scenery and the cycle begins anew.

This by no means completes the list of Indian artists who have dealt with the Gujarat riots. Dating to that year, *Mirage* (2002), a painting by **Atul Dodiya** (b. 1959) made on a generic rolling metal storefront security shutter, is a black-and-white photorealist mural based on a historical photograph of Mahatma Gandhi walking the streets under the surveillance of British security officers. The role of allegory is crucial to an understanding of the work, which includes a second painting visible behind the shutter – a landscape with a weeping sun and vermin crawling over a reproduction of Constantin Brancusi's 1938 sculpture *Endless Column*, made as a tribute to Romanians who died fighting Germany during World War I.

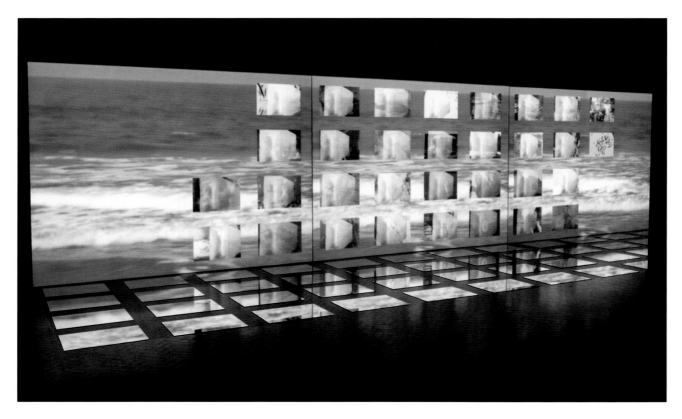

Navjot Altaf *Lacuna in Testimony* 2003
Video installation: 7 mins, 26 secs

Atul Dodiya *Mirage* 2002
Exterior: enamel paint on metal roller shutter
Interior: acrylic and marble dust on canvas with iron hooks,
274.3 × 182.9 cm (108 × 72 in.)

The combination of images alludes to the failure of Gandhian policies of non-violence, for while Gandhi's image is ubiquitous across India the hidden reality is that his message of religious tolerance has been forgotten.

Shortly before the Gujarat riots, the United States invaded Afghanistan, leading to a long and drawn-out military campaign. In confronting these events, Afghan artists such as Rahraw Omarzad (b. 1964) and **Lida Abdul** (b. 1973) have used their work as a forum to address issues less likely to be discussed in the mass media. Abdul retains a humanistic concern for the lives of ordinary people in Afghanistan, especially those displaced by war: 'I have tried to comprehend the disaster that has ravaged my country.... Language, notions of domesticity and perceptions of the other are all transformed so radically that survivors/refugees often refuse to talk.'[14] Abdul's videos give voice to these survivors, as in *Brick Sellers of Kabul* (2006). Here a line of Afghan boys stack bricks under the eye of an older man during a sandstorm in a remote and arid area of the country. The background image of a decaying

building suggests that these bricks have been pillaged from the ruins of homes abandoned or destroyed in the fighting. Allusions to poverty and trauma insert a human dimension into the war and its aftermath.

Related to work of this kind is an attempt by Vietnamese-American **An-My Lê** (b. 1960) to establish an alternative viewpoint on the war, representing it from an American perspective. In her *29 Palms* series (2003–4), she uses a large-format camera to create highly detailed black-and-white photographs of young American marines training for wars in Afghanistan and Iraq at a military base in the city of 29 Palms located in the Mojave Desert in Southern California. Lê's accurate and engaging rendering of these simulated battlefields alternates between close-ups of soldiers and sweeping landscapes to evoke the harsh reality of soldiering in desert conditions, but it also – in a profound way – brings the war back home. As the artist has said:

I had very moving conversations with some of the marines and sailors, and they were very young and

Lida Abdul *Brick Sellers of Kabul* 2006
16 mm film transferred to DVD: 6 mins

An-My Lê *29 Palms: Infantry Officers' Brief* 2003–4
Gelatin silver print, 67.3 x 96.5 cm (26¹⁄₂ x 38 in.)

Zhang Peili *Water – The Standard Version
Read from the 'Ci Hai' Dictionary* 1989
Video

idealistic, very motivated and patriotic. Knowing that
... war will affect their lives and families was at times
heartbreaking.[15]

The spirit of protest and the desire to change things take
many forms in contemporary Asian art. Some work is allegori-
cally double-edged, pretending to be about one thing but in
reality addressing another, more controversial topic. In **Zhang
Peili**'s (b. 1957) video, *Water – The Standard Version Read from
the 'Ci Hai' Dictionary* (1989), a prominent newscaster from
state-controlled Chinese Central Television (CCTV) recites
the definition of water from the dictionary as if reading the
nightly news. Though the newscaster is essentially saying
nothing, the subversiveness of the gesture cannot be over-
stated in a nation where – despite the heralded rise of a more
free-market economic model – art, culture, the internet and all

the media are still closely policed. The video, made shortly
after the killing of student and pro-democracy demonstrators
at Tiananmen Square in June 1989, pointedly satirizes the
credibility of CCTV as a source of accurate, unbiased news. Not
surprisingly, Chinese writer Pi Li identifies Zhang's choice of
medium as significant, too, since in 1989 the use of Western-
style video art was 'not simply the product of a search for artistic
language, but a phenomenon tinged with ideology'.[16]

The post-Tiananmen period witnessed a flowering of
politically based art in China, with artists often communicat-
ing in a veiled or indirect way (through sarcasm, misprision
and irony) so as to convey a trenchant message that might slip
through the cracks of the censors. Political Pop and Cynical
Realism were two of the more prominent 'unofficial' painting
styles to emerge. The artists associated with these styles

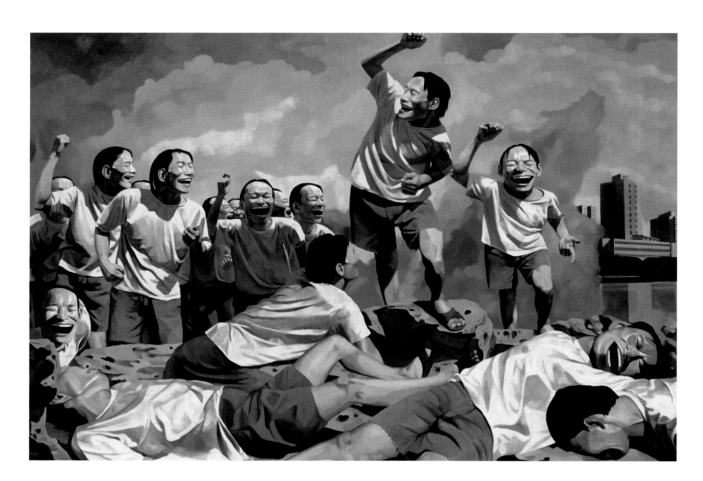

Yue Minjun *La Liberté guidant le peuple* 1995
Oil on canvas (2 panels): 249 x 360 cm (98 x 141 3/4 in.)

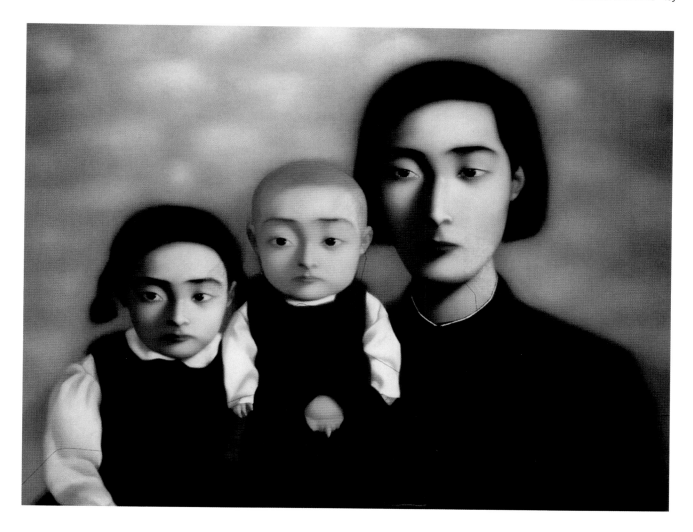

frequently employed distinctly Chinese iconography, including propaganda images of Mao and the Red Guards from the era of the Cultural Revolution (1966–76); for example, Yu Youhan's (b. 1943) *The Waving Mao* (1990), an ironic painting that re-uses imagery from an official photograph of Mao circulated during the Cultural Revolution. Art critics have compared these paintings with both Soviet Pop Art, also known as Sots Art, originating in the early 1970s as a critique of official Soviet Socialist Realist painting, and, superficially, Andy Warhol's images of Mao, which date from 1972 to 1974 and were inspired by the media coverage of US President Nixon's historic visit to China.

The paintings of **Yue Minjun** (b. 1962), Fang Lijun (b. 1963) and **Zhang Xiaogang** (b. 1958), all of whom are associated with Cynical Realism, offer a veiled criticism of Chinese society. Curator and critic Li Xianting, who coined the phrase Cynical Realism, describes these artists' attitude: 'In the place of reverence and seriousness they adopted a kind of rogue cynicism in their treatment of the reality that confronted them.'[17] Zhang's sombre-toned portraits of people – alone, in pairs, in family groups, dressed in Mao jackets and military uniforms – are reminiscent of the small black-and-white family and identity photographs made during the Cultural Revolution decade. His signature *Bloodline* series, begun in the early 1990s and

Zhang Xiaogang *Bloodline Series* 1997
Oil on canvas, 148 x 188 cm (58 1/4 x 74 in.)

TOP Hai Bo *Three Sisters* 2000
Black-and-white photograph; diptych,
each 89 x 61 cm (35 x 24 in.)

ABOVE Wang GongXin *My Sun* 2000
Video: 7 mins, 18 secs

ongoing, shows figures in the portraits connected to one another by a painted thin red line – the bloodline, suggesting the invisible yet unbreakable bonds of family. It reflects on the Cultural Revolution, an era in which party took precedence over family, people were instructed that they had no other loyalty than to the state, and families were broken up and dispersed.

Today, the influence of imagery from the Cultural Revolution in the work of contemporary Chinese artists has become more – rather than less – apparent. **Hai Bo** (b. 1962) updates group photos from the Cultural Revolution era, bringing the living subjects together and re-photographing them in the same poses, as in *Three Sisters* (2000). For **Wang GongXin** (b. 1960), the Maoist legacy is central to understanding the social and political situation in China. In *My Sun* (2000), a three-screen video installation, a peasant woman

stands in a field stretching out her arms to a white sun. The image of the woman multiplies on the screens until the individual becomes a group, all supplicating to the sun while trying to grab the sunbeams. The installation reflects, in part, on the loss of subjectivity and independence in a culture of enforced communalism, but also on the mindless cult of Mao during the Cultural Revolution: like Chinese emperors before him, Mao often chose the sun as the symbol to represent him.

The ongoing interest in Cultural Revolution-era photographs, portraits of Mao, cheery peasants, model workers and other imagery once employed by the Chinese government to serve political ends has led to tongue-in-cheek take-offs on official iconography by many artists, among them Li Luming (b. 1956), Cao Xiaodong (b. 1961), **Shen Jing Dong** (b. 1965) and Jing Kewen (b. 1965). While their works – frequently

Shen Jing Dong *Soldier Family* 2008
Oil on canvas, 200 x 300 cm (78³/₄ x 118¹/₈ in.)

glossy, idealized and made to seem mass-manufactured – no longer possess the power of political critique, and have been widely criticized as opportunistic and facile by Chinese critics, they nonetheless point to another revolution now underway: China's obsession with consumerism and materialism in the wake of seismic economic growth.

We will conclude this section with the work of **Huang Yong Ping** (b. 1954), who engages with the broader history of political and trading relations between China and the West. *Da Xian – The Doomsday* (1997) references the 1997 handover to China of the island of Hong Kong, which had been ceded to Britain by the Treaty of Nanjing in 1842, following China's defeat in the First Opium War. The piece presents enormous bowls, their painted designs derived from nineteenth-century Chinese export porcelain. Specifically, the designs depict the warehouses used by colonial powers in China to store goods, symbolizing the height of European colonial power in China. Packages of foodstuffs, placed inside the bowls by the artist, bear the stamp 'Best before 1 July 1997', the date on which Hong Kong and other ceded islands along with mainland territories were handed back to China. The inference is clear: colonialism has an expiry date.

GENDERED AGENDAS

Some of the most provocative art being produced within Asia today is gender-oriented, the artists typically seeking a platform from which to speak about sexual politics and oppression, or to signify and recreate the self. Though much of this art is concerned with ideas and practices associated with Western feminism, questions have been raised about the appropriateness of a comparison for fear it will obscure the local context of the artist's project, or lead to a misreading or appropriation of cultural signs. In her essay for *Text & Subtext*, a landmark 2000 exhibition in Singapore of Asian women's art, artist and curator Binghui Huangfu put it thus: 'Any attempt to place Asian women within a totally Western feminist context would be an act of postcolonial piracy.'[18] Moreover, few Asian women artists have made explicit comments about feminism or see themselves as feminists, even if their artworks address the lives and needs of women, such as Indian Anju Dodiya's (b. 1964) gentle paintings of private hopes, fears and desires.

The 'feminist' impulses evident in this work often have their origin in the broader social, political and cultural situation in which women are producing art in Asian nations. In Pakistan, Islamic conservatism has meant that the figurative arts are widely frowned upon and depictions of nudity and sex taboo. **Mahreen Zuberi**'s (b. 1981) paintings often use symbols to explore social stigmas attached to sexuality and gender. Her series *Doing Krishna* (2006–7), in a traditional miniature painting style, reflects frustration at the narrow attitudes towards sex in Pakistani society. In these small, delicate paintings, the artist's use of ambiguous but erotic sexual metaphors, involving arrangements of power tools personifying Krishna, Hindu god of love, articulates, by indirect means,

Huang Yong Ping *Da Xian – The Doomsday* 1997
Fibreglass, oil paint, packaged food, photographs,
3 parts, each 78 x 141 x 141 cm (30³/₄ x 55¹/₂ x 55¹/₂ in.)

Mahreen Zuberi *Doing Krishna (4)* 2006
Opaque watercolour on *wasli* paper, 25.4 x 27.9 cm (10 x 11 in.)

Zuberi's inability to express herself openly on issues of gender and sexuality. As she explains:

> *Doing Krishna* is my 21st-century representation of love. The drill machine as an object is bulky, solid and functional; violent and invasive in character. By contrast the process of painting it is gradual and tender, the image develops in layers ... there is sensitivity and sensuousness in the process.[19]

In the films of the Iranian-born, New York-based **Shirin Neshat** (b. 1957), art is a forum for the contestation of social arrangements based on gender in Islamic countries. *Turbulent* (1998) is a double black-and-white video installation, the films projected on opposite sides of a gallery: on one side a man, front on and wearing a white shirt, sings a poem by the thirteenth-century Persian poet-philosopher Rumi in a theatre that is filled with other men. On the opposite screen is a woman clad in a black chador, her back to us, who waits for the man to finish singing before beginning her song, a wordless chant. She is alone in a dark empty theatre. Neshat's inspiration came from seeing a blind girl performing on an Istanbul street, which was transmuted into a reflection upon freedom of female expression in Iran: under the regime of the Ayatollah Khomeini, from 1979 to 1989, women were banned from public performance.

Several Asian women artists reprise the interest in storytelling that was a focus of Western feminists, investigating and documenting women's labour, histories, life experiences and emotions. Amanda Heng (b. 1951) was a founding member of the Artists Village – the first art collective in Singapore, started by the performance and installation artist Tang Da Wu (b. 1943) on a farm in 1988 – and a pioneer in making artwork about women with an explicitly feminist perspective. 'Most [Asian] women artists both old and young are still afraid to be associated with terms like "women artists" and "feminist artists". I have often found myself working in isolation.'[20] Her performances and installation art have focused on gender roles and a division of labour in Singapore's rapidly changing society. Using performance, video, sound and text, *Added Value* (2000) documented stories of Singaporean

Shirin Neshat *Turbulent* 1998
Video: 10 mins

women and the labour that they perform in and out of their homes. The message of this work was that in a competitive and globalized economy women's labour provides a vital national competitive edge.

Among Asian women artists, household items are often employed as metaphors for confinement to the domestic sphere, women's labour and limited freedoms in comparison to men. These themes underlie the work of the Pakistani artist **Adeela Suleman** (b. 1970), who makes helmets and skeletal-like assemblages from generic household objects (steel drain covers, tongs, hardware, measuring spoons and utensils). Here, through multiplication and assembly, everyday items become the bearers of new, pointed messages. These themes also resonate in the work of **Lin Tianmiao** (b. 1961), one of the few

Adeela Suleman *Untitled* 2009
C-print, 50.8 x 40.6 cm (20 x 16 in.)

Lin Tianmiao *Bound and Unbound* 1995–97
White cotton thread, video projection, household objects;
dimensions variable

Chinese women who gained prominence in the Asian art world of the 1990s. Speaking about her art in an interview, Lin said: 'I have always been interested in women and the feminine; all of my work is closely linked to my own life.'[21] Her installation *Bound and Unbound* (1995–97) contained household objects wrapped in cotton thread with the assistance of female friends and family as symbols of women's domestic labour. The artwork, which took more than two years to complete, featured a video image of a pair of scissors projected onto a screen made from cotton thread, suggesting impending liberation.

Performance has been an extremely popular medium for artists to question the status and perception of women in society. Indian Sonia Khurana's (b. 1968) mock-tragic performance video *Bird* (2000) shows the artist, naked and overweight, trying to fly, as a Sisyphean allegory for the aspirations in India for women's rights, which are constantly defeated. Indonesian artist **Arahmaiani** (b. 1961) has used performance to agitate for the rights of women in her own culture as well as elsewhere. Nudity is a common element, as in

Dayang Sumbi Refuses Status Quo (1999), in which the artist partially undressed and then asked the audience to come forward and write or draw on her exposed arms and chest. It was intended as a feminist statement: 'I grew up in a community/society where exposed flesh (especially nudity) was taboo.... In other words, there is strict control over the body and its activities, particularly the body of a woman and her sexuality.'[22] In her performance *Offerings from A–Z* (1996) – a work she had to perform in Thailand because she feared the repercussions of performing it in Indonesia – the artist lay on a gravestone in a Buddhist crematorium next to a bloody cloth lying in a bowl. The performance protested the banning of women from temples and cemeteries during their menstrual cycle because of the belief that they are unclean.

The art historian Caroline Turner has pointed to the 'immense contribution' of women artists in Asia; indeed, in some countries the art world is overwhelmingly female.[23] Thai women artists have been especially active, focusing on social oppression and the status of women. Thai performance artist **Araya Rasdjarmrearnsook** (b. 1957) deals with death and dying to examine the respect – or lack of it – accorded to women in Thai culture. As she has said: 'Most women fall into the trap set up for them by society. Thai women are closed, blocked and oppressed by moralizing social norms.'[24] For a series of contemplative video performances, the artist sat and read aloud or chanted to shrouded female corpses in a morgue, and for *I'm living* (2002) she arranged clothing on the dead body of a girl, also in the morgue. Trauma and play converge in these strange but beautiful and tender videos which trigger thoughts of loss and vulnerability. The artist is fully aware of and manipulating our emotions through subject, form, mood and colour.

Stereotypical female social roles are the subject of photographic series by numerous Asian artists, both men and women, including Japanese Mariko Mori, Yanagi Miwa (b. 1967) and **Tomoko Sawada** (b. 1977), Indian **Pushpamala N.** (b. 1956) and Thai Michael Shaowanasai (b. 1964). Sawada's series of small black-and-white photographs *ID 400* (1998–2001) show the artist dressed as stereotypes of women in Japanese society; she took the shots in a photo booth in a parking lot

Arahmaiani *Offerings from A–Z* 1996
Installation view: Pha Daeng Cemetery, Chiang Mai, Thailand
Performance

at a Kobe subway stop, where she used the public restroom to change her disguises. For another series, *OMIAI♡* (2001), she dressed up as different women and had her photograph taken in the style of *omiai* portraits – pictures of marriageable women or men, which in Japan are commonly sent to prospective spouses and their families for review. Similarly, *Native Women of South India: Manners and Customs* (2002–4), shows Pushpamala posed against a studio backdrop as various women in Indian history and mythology, ranging from goddesses to beauties to criminals, all regarded as 'native types' in the national imagination. The artist's guises were inspired by sources as diverse as sixteenth-century miniature paintings, calendar art and modern newspaper photographs, and the series was made in collaboration with the photographer Clare Arni (b. 1962). The artists have said: 'The project ironically comments on the colonial obsession with classification as well as the Indian nationalist ideal of "Unity in Diversity".'[25]

Araya Rasdjarmrearnsook *Reading for female corpse* 1997
Photograph, 7 x 10 cm (2³/₄ x 3⁷/₈ in.)

Araya Rasdjarmrearnsook *I'm living* 2002
DVD

Tomoko Sawada *OMIAI♡* 2001 (detail)
C-print, 18 x 13 cm (7 x 5¹/₈ in.)

In general, the work of male artists is concerned with the personal and psychological, rather than overtly political aspects of gender. In the early 1990s in Beijing's East Village, **Ma Liuming** (b. 1969) staged performances both naked and dressed as a woman (an androgynous performance persona called Fen Ma Liuming), for which in 1994 he was arrested and detained for two months. The Filipino **Jose Legaspi** (b. 1959) paints and draws dark, strange, homoerotic scenes in empty, confined spaces over which he scribbles childhood recollections, as in *Drawings* (2000–2), an installation of a thousand small charcoal and chalk drawings on sheets of notepaper assembled in a grid. The drawings depict figures in cell-like spaces, seemingly trapped, waiting, sometimes eating and

sleeping, having sex, or engaged in cruel and strange acts. Each drawing is a distinct and complex picture, and violence and sex are ways of revealing that complexity, in addition to satisfying the artist's own homoerotic bent, which is barely disguised.

Bhupen Khakhar (1934–2003) has singularly recast male sexuality in Indian art. He started out as an accountant, though by the time of his death he was one of India's most esteemed artists, his life and work celebrated in Salman Rushdie's 1995 novel *The Moor's Last Sigh* (Rushdie's great-uncle Aires was for a time one of Khakhar's regular models, and possibly also his lover as well).[26] Humour, colour and atmospheric sensuality characterize his watercolours depicting nudity or sexual intimacy between men, such as *An Old Man from Vasad Who Had Five Penises Suffered from Runny Nose* (1995), in which a seated naked male figure sits spread-legged proudly showing off his genital peculiarity. As art historian

Pushpamala N. and Clare Arni *Lakshmi (after oleograph from Ravi Varma Press early 20th century)*, from the photo-performance project *'Native Women of South India: Manners and Customs'*, Bangalore 2000–4
C-print on metallic paper, 50.8 x 61 cm (20 x 24 in.)

Ma Liuming *Fen Ma Liuming* 1993
Photograph, 120 x 80 cm (47¼ x 31½ in.)

Jose Legaspi *Drawings* 2000–2 (detail)
Chalk and charcoal on paper; 1,000 parts,
each 30.5 x 22.8 cm (12 x 9 in.)

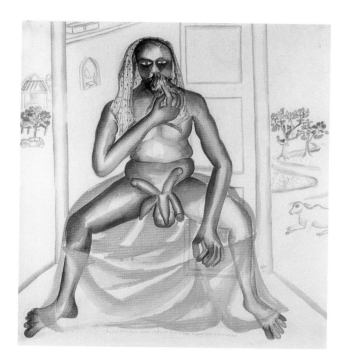

Geeta Kapur explains: 'Here is a sexuality that is neither innocent nor provocative, but a form of *jouissance* that comes through to the spectator first and foremost as color, then as an iridescent play of figuration, then as gay iconography.'[27] *White Angel* (1995) depicts several colourful male silhouettes embracing, performing fellatio or touching casually against a bright orange backdrop, suggesting a humid tropical landscape. A central tree serves to anchor the image, creating a sense of scale and perspective, while the ghostly, licentious figures flow and fuse into one another.

Lee Mingwei's *Male Pregnancy Project* (2000–present) – a collaboration with Virgil Wong – goes further in unsettling our conventional concepts of gender and sexuality. Posted on the web at malepregnancy.com, the documentary-style project contained live interviews with the artist, as well as videos and pictures portraying him with all the attributes of a pregnant woman (he has a noticeable swollen belly and walks as if carrying the weight of a real baby). Lending an air of authenticity, interviews with real physicians explain the medical process by which the artist was able to become pregnant; bogus magazine cover stories on the artist, in *Time* and elsewhere, add to the verisimili-

tude. Many people were fooled. The sense of transgression in this work is not, however, in the biological changeup per se, but in the willingness of an Asian male to assume the signal marker of femaleness – particularly in light of the many examples in this chapter of work by women exploring the challenges and disadvantages of female roles in traditional societies.

Of all the works discussed in this chapter, Lee and Wong's *Male Pregnancy Project* retains an eerie relevance. Not only is it posted free online for a global audience, and constantly updated by the artists with new information, including viewer responses, but the issues it raises continue to connect with themes in the prevailing media culture, from fertility drugs and genetic engineering to recent medically induced pregnancies among transgender people. In this regard it serves as an appropriate marker for the end of this chapter and the beginning of the next, with its focus on the power of the mass media and popular culture in contemporary Asian art.

Bhupen Khakhar *An Old Man from Vasad Who Had Five Penises Suffered From Runny Nose* 1995
Watercolour on paper, 110 x 110 cm (43³/₈ x 43³/₈ in.)

Lee Mingwei and Virgil Wong *POP! The First Human Male Pregnancy* 2000–present
Web-based work

chapter 3

ASIAN POP, CONSUMERISM AND STEREOTYPES

During the 1990s, the status of artists from Asia began to shift from obscurity to varying degrees of prominence. Whatever the cultural dynamic at work – call it pluralism, post-modernism or globalization – more and more Asian artists began to bridge what had once seemed an insurmountable gap between their own domestic art scenes and the international art world, including the global art market. Among the most successful were those making complex narrative and symbolic works of contemporary art, and often interpolating between international art styles and local popular culture to piece together a new kind of pop art in which their own heritages and appropriated fashion, art and cultural forms conflate, fuse and meld into one another.

In calling this creative impulse 'Asian Pop', we are referring broadly to its embrace of imagery that derives from mass culture or reveals a fascination with mass-produced entertainment and the myriad manifestations of consumerism, and that also frequently works with readymade art forms. But it is

Okumura Masanobu *Large Perspective Picture of a Second-Storey Parlour in the New Yoshiwara, Looking Toward the Embankment* c. 1745
Woodcut, handcoloured, 42 x 65.7 cm (16¹/₂ x 25⁷/₈ in.)

important to state that contemporary Asian Pop is more than a mere derivative of its earlier counterparts in the United States, Europe and elsewhere, drawing on distinctly local sources and referents while being frequently imbued with social, cultural and political significance. A further complicating factor is the increasing intra-regional influence of popular culture – for example, the popularity in Vietnam of Korean films and Japanese television dramas; the fad for Korean soap operas among Japanese housewives; or a widespread obsession with Japanese manga and anime, not to mention interactive video games.

There is a smoothness between art, fashion, gamesters and animators in Japan (anime is much integrated into art, and digital graphics play a large part in fashion design) that looks back uncannily to the cross-relations of cultural forms during the Edo period (1615–1868) and that reminds us that Asian Pop has its own antecedents – in particular, popular eighteenth- and nineteenth-century **ukiyo-e scroll paintings and prints** that sought to chronicle 'low' imagery of the 'floating world' of Tokyo entertainment and nightlife. Some of the world's very first comic books also emerged around this time, when ukiyo-e prints were bound together in books: the Japanese name for comics, *manga*, was coined by ukiyo-e artist Hokusai Katsushika (1760–1849).[1]

Local antecedents for contemporary pop art can be found elsewhere in Asia. In India, a hybrid-style vernacular art emerged in commercial prints based on religious and mythological themes mass-produced from the mid-nineteenth century onwards and known as 'calendar' or 'bazaar' art. Many of the artists employed in the calendar art industry were trained at the best Indian art schools, and the careers of a number of important painters have spanned the commercial and fine art worlds: M. F. Husain (b. 1915), one of the most respected Indian modernists, started out his career as a cinema billboard painter in Mumbai. Matching 'signboard' and 'bazaar' art in importance are the mass-produced propaganda **woodblock prints and posters** in China made during the Cultural Revolution, which in turn owed much to Soviet Socialist Realism.

VULGAR COMMODITIES

No one has plumbed the limits and possibilities of consumerism for art more than the Japanese artist **Takashi Murakami** (b. 1962). First trained in traditional Japanese *nihonga* painting, he has since earned an international cult following by making art featuring a cast of cute, erotic and grotesque creatures inspired by Japan's popular anime and manga subcultures. The artist's signature – and most ubiquitous – character is Mr. DOB, an all-purpose Mickey Mouse spin-off, with a happy face, big eyes, mouse ears and button nose, who is also considered to be something of a self-portrait. Mr. DOB began life in the early 1990s in paintings and sculpture, but has since morphed into a consumer product, appearing as a toy and on T-shirts, mouse pads, key chains, decals, vinyl floor covering, and even wallpaper. Critic Mika

Wang Huaiqing *Long Live Gutian Spirit* 1967
Woodblock print, 78 x 54 cm (30³/₄ x 21¹/₄ in.)

Takashi Murakami *And Then, And Then And Then*
And Then And Then (Blue) 1994
Acrylic on canvas mounted on board (2 panels):
280.5 x 300 x 7.5 cm (110³/₈ x 118¹/₈ x 2⁷/₈ in.)

Yoshitake describes Mr. DOB as not a character so much as 'an erratic manifestation of one's desire to consume and the ceaseless regeneration of this impulse'.[2]

Murakami sees his product designs and merchandising as an extension of his art. He oversees a production company, Kaikai Kiki Co., which produces both his art and its commercial spin-offs. It employs hundreds of artists, animators and artisans, and has studios and offices in Tokyo and New York. This arrangement further blurs the already fuzzy line in Murakami's work between commerce and art, high and low, public brand and private expression, none of which bothers the artist: 'I think the market of contemporary art should be more visible. I don't understand why artists pretend as if the market did not exist.'[3] Not for nothing is he frequently compared to Andy Warhol, though there are also parallels with historical artist-designers such as Louis Comfort Tiffany or William Morris. Recently Murakami teamed up with the luxury label Louis Vuitton to make coloured versions of the classic LV monogram handbags covered with the artist's signature jellyfish, bunches of red cherries and pink cherry blossoms.

Murakami's commercializing of art through branding and merchandising points up the fact that strategies of commercial mass marketing are an effective way to present art to a broader public. It is worth recalling here that Pop Art in the US and elsewhere was based not simply on a mixing up of the practices and materials of art, but on a wilful collision of art and commerce, high and low culture, mass production and exquisite hand-craftsmanship. And much like Warhol and other Pop artists, Murakami reinvests in popular culture, as well as drawing his inspiration and profiting from it. His 'art factory' Kaikai Kiki Co. organizes shows and art fairs, and even represents artists – often ex-assistants – who have forged their own careers, among them **Mr.** (b. 1969), **Chiho Aoshima** (b. 1974) and Chinatsu Ban (b. 1973). His art fair, Geisai, has launched the careers of many young Japanese artists, including the painter **Erina Matsui** (b. 1984).

Mr. *New Tokyo Ferry Terminal (Ariake 4-chome)* 2004–5
Fibreglass-reinforced plastic, 100 x 147 x 177 cm
(39³/₈ x 57⁷/₈ x 69⁵/₈ in.)

Chiho Aoshima Installation view of 'The Giant and
the Courtesans' at Galerie Emmanuel Perrotin,
Paris, 8 September–11 October 2007

Erina Matsui *Uchu☆Universe* 2004
Oil on canvas, 1,450 × 1,450 cm (570⁷/₈ × 570⁷/₈ in.)

Murakami and his protégés are frequently lumped together as adherents of what is called 'J-Pop', or 'Tokyo Pop', terms characterizing a formal weaving together of elements of Pop Art – primarily saturated colour and a catchy graphic sensibility – and iconic, distinctly Japanese cultural sources and references such as anime, manga, *kawaii* (cuteness), *otaku* (geek subculture) and ukiyo-e scroll paintings and prints, not to mention what art historian Gennifer Weisenfeld has called a 'brazen libidinousness', evident in the copious Japanese production of erotica.[4] This is, however, not to be confused with 'micropop', a term coined by the Japanese critic Midori Matsui to characterize the work of the Japanese painter and sculptor **Yoshitomo Nara** (b. 1959) and several others like him who draw from popular culture but, in contrast to Murakami, say, make art in a more critical, detached and even alienated spirit, transforming, as Matsui has written, 'the various "limitations" of their life – their invisible position in society, a lack of economic resources, and a childlike imagination – into their strength'.[5]

ABOVE Yoshitomo Nara *Untitled* 2009
Coloured pencil and crayon on paper,
22.9 x 15.9 cm (9 x 6¼ in.)

TOP Yoshitomo Nara *Pyromaniac Day and Pyromaniac Dead of Night (diptych)* 1999
Acrylic on canvas, 120 x 110 cm (47¼ x 43⅜ in.)

Like Murakami, Nara has invented his own cast of recognizable characters that would look at home in any manga or cartoon series, from which they are in part derived. As the artist has said:

> I received my visual stimuli more from television, from Japanese and American comic books, and from European children's books. That's why comic books have a greater reality for me than European painting.[6]

Manga differ from European and American comics in significant ways: they tend to contain little text, no colour, and lots of sex and violence. Some of these traits are reflected in Nara's paintings, especially youthful alienation and an overall sense of disenchantment with life: his signature character, and the subject of a majority of his images, is a squat, mean-looking girl with boyish hair and big eyes. A lonely, awkward figure, an ugly duckling, she stares down the viewer with smouldering looks, sometimes wearing boxing gloves, wielding knives or handling explosives. A troubling anger, barely contained, simmers below the surface. Through the consistent portrayal of such disaffected characters, Nara creates a different picture of children and childhood from the one portrayed in standard cartoons. His children have a molten core.

In Indonesia, some of the art that has made the biggest impact employs anime, cyber-gaming and comic-book imagery. **Nyoman Masriadi** (b. 1973) paints superheroes in ordinary, private moments. *Sorry Hero, I Forgot* (2008) depicts two of the world's most famous superheroes, Batman and Superman, sitting in adjacent bathroom cubicles, their suits down, the floor littered with cigarette butts and toilet paper. Dialogue bubbles reveal their intimate exchange: Batman grumbles to Superman about someone who forgot to thank him for saving their life; Superman, smoking, counsels

Nyoman Masriadi *Sorry Hero, Saya Lupa*
(Sorry Hero, I Forgot) 2008
Acrylic on canvas, 200 x 300 cm (78³/₄ x 118¹/₈ in.)

Wedhar Riyadi *Old Version #2* 2009
Coloured pencil on black paper, 41.9 x 29.8 cm (16¹/₂ x 11³/₄ in.)

patience. Cartoon imagery inspires the work of other Indonesian artists, including **Wedhar Riyadi** (b. 1980), whose series of small works in coloured pencil on black paper, *Old Version* (2009), consists of portraits of cartoon characters – Astro Boy, Bart Simpson and Mickey Mouse – showing the signs of ageing: their faces are wrinkled. Still other artists have banded together to form loose collectives, including Apotik Komik (Comic Chemist) and Taring Padi (Teeth of Rice), to publish and distribute posters and magazines of cartoons addressing topical social, economic and political issues. Both Riyadi and **Eko Nugroho** (b. 1977) have published their work in *Daging Tumbuh* (Diseased Tumour), a photocopied underground magazine distributed free on the streets, which collects together piquant, frequently anarchic comic strips, drawings and collages. The idea is that if readers like the magazine they photocopy it and pass it along to someone else.[7] Both artists belong to a new generation in the Indonesian art world sometimes called the '2000 Generation' because they emerged following the violence of the democratic reform period (1997–2000). Nugroho also learned embroidery techniques to make mixed-media paintings, the imagery inspired by comics, popular culture and fashion.

Mass-produced toys figure prominently in the work of Asian artists. At a glance, some of these works can resemble those of neo-pop artists Jeff Koons, Haim Steinbach or Katharina Fritsch. But there is no irony here. For the Korean

Eko Nugroho *Human Religion #1* 2008
Acrylic and embroidery on canvas, 150 x 200 cm (59 x 78³/₄ in.)

artist **Do Ho Suh** (b. 1962), coloured plastic action figures are used to assemble beautiful illusions: *Cause & Effect* (2007) is a whirling arrangement of hundreds of interlocking acrylic figures suspended from the ceiling in the shape of a tornado, each figure placed according to its colour so that alternating tones of red, orange, yellow and pink create a sense of vertical spiral movement. Some of the artworks of **Sui Jianguo** (b. 1956) have a similar feel, the Chinese sculptor enlarging cheap colourful plastic dinosaur toys to huge sizes and placing them in galleries, parks or streets to excite wonder. Stamped with the logo 'Made in China', they also point to the role of

Do Ho Suh *Cause & Effect* 2007 (and detail)
Installation view: Lehmann Maupin Gallery, New York
Acrylic, stainless-steel and aluminium frame,
362.9 x 1,016 x 1,168.4 cm (142⁷/₈ x 400 x 460 in.)

Sui Jianguo *Jurassic Time* 2001
Painted bronze and steel, 480 x 250 x 230 cm
(189 x 98³/₈ x 90¹/₂ in.)

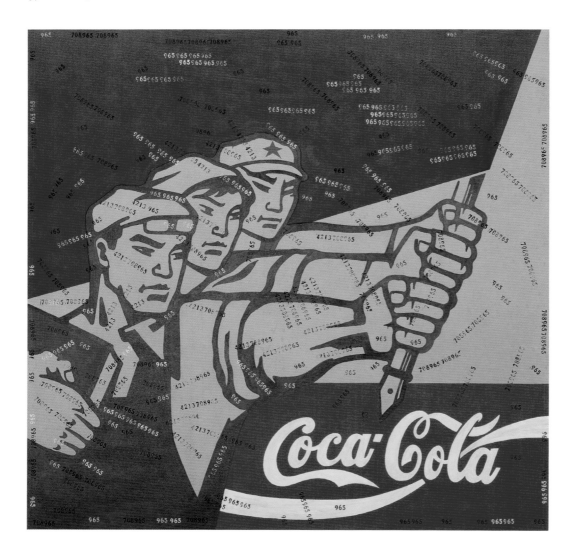

international trade in the toy business. Sui explains: 'Dinosaur toys are designed by some company from a Western country, and produced in China, then commercially distributed to the whole globe. It is the result of transnational capitalist production.'[8] In both cases, toys become an emblem of globalism.

Post-modern appropriation of multinational products, corporate logos and brand names has had particular appeal in China, a country that was economically isolated and largely cut off from developments in contemporary art. For Political Pop painter **Wang Guangyi** (b. 1957), China's transition during the 1990s from a Communist to a consumer-oriented society

inspired the *Great Criticism Series: Coca Cola* (1993), in which he juxtaposes Communist iconography – specifically imagery from the Cultural Revolution period (1966–1976) – with signs and symbols of consumerism. The painting shows the heroic triumvirate of revolutionary China – the worker, peasant and soldier – gripping in one hand Mao's Little Red Book and in the other a red Communist Party flag on a pole shaped like a pen, in reference to a popular Chinese revolutionary slogan, 'rebel with words not weapons'. But ideology gives way to contemporary reality, for running along the bottom of the painting is a Coca-Cola advertising sign.

Wang Guangyi *Great Criticism Series: Coca Cola* 1993
Oil on canvas, 200.7 x 200.7 cm (79 x 79 in.)

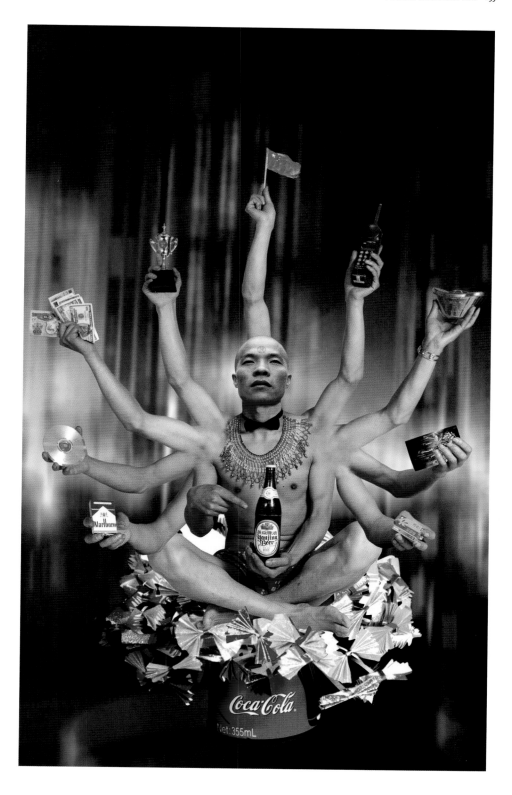

Wang Qingsong *Requesting Buddha No. 1* 1999
Photograph, 180 x 110 cm (70⅞ x 43⅜ in.)

In the mid-1990s, Political Pop gave way to other movements, such as Gaudy Art, which frequently combined propaganda imagery, advertising and popular symbols from traditional folk art. Gaudy Art includes ceramic and resin sculptures by the Luo Brothers (Luo Weidong b. 1963; Luo Weiguo b. 1964; Luo Weibing b. 1972), Qi Zhilong (b. 1962) and Xu Yihui (b. 1964), as well as sculpture and photographs by **Wang Qingsong** (b. 1966). Wang's digital photographic self-portrait *Requesting Buddha No. 1* (1999) depicts him seated on a Coca-Cola advertising sign as a many-armed representation of Guanyin, the *bodhisattva* of compassion, though instead of reaching out to aid the sick and the poor he

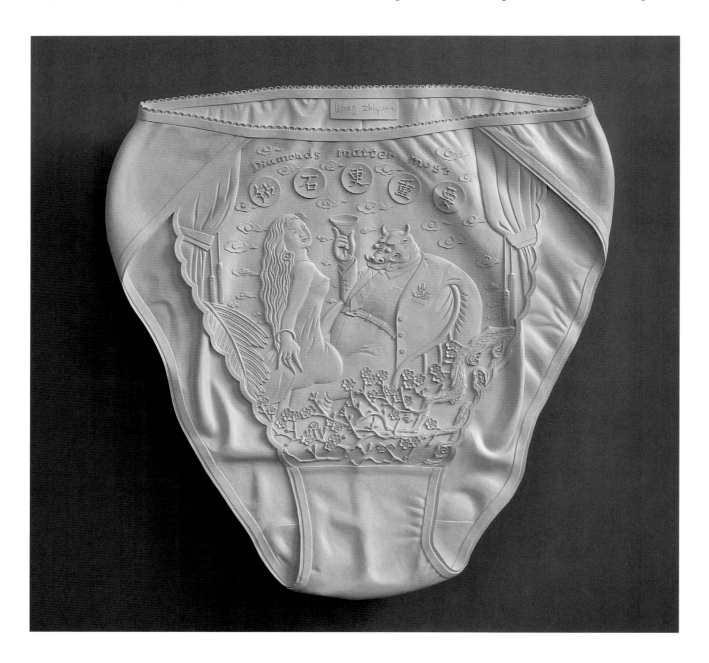

Wang Zhiyuan *Underpants Series* 2003–5
Wood, acrylic and mixed media,
82 x 73 x 10 cm (32¼ x 28¾ x 3⅞ in.)

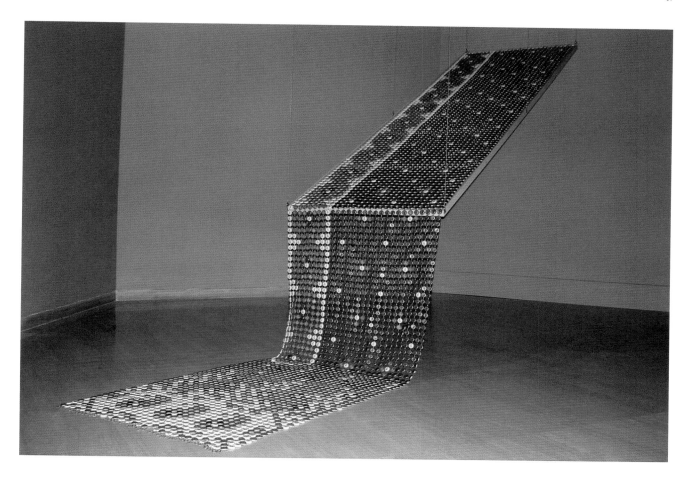

holds in his hands symbols of the new consumerism which took hold of China during that time – foreign currency, Marlboro cigarettes, compact discs, cordless phones. For Wang and others – like **Wang Zhiyuan** (b. 1958), another Chinese artist, who makes huge wood and resin sculptures of women's panties overlaid with socially suggestive imagery – consumerism in China has become a kind of religion, with money not Mao as the new god. As critic Li Xianting noted, both Gaudy Art and Political Pop were 'intuitively responding to the "get-rich-quick" attitude of the dreams and realities of peasants, brought about [by] or emerging [from] the consequences of Western consumer culture in China'.⁹

Use of multinational corporate logos and advertising as a symbol of social transformation is not restricted to China; in fact, Korean 'Minjung art' – literally, 'the people's art' – from the early 1980s onward was rooted in everyday imagery, including advertising and commercial signage. But in the Asian art world of the 1990s a preoccupation with logos became ubiquitous, even though it touches on something essentially empty – corporate branding. Two works are worth mentioning here. For Masato Nakamura (b. 1963), the opening of the first Asian McDonald's restaurant in Japan in 1971 provided inspiration for *QSC+mV [Quality, Service, Clean + m Value]* (1998–99), a tongue-in-cheek reflection on both the corporate ethos and the growing branding of cityscapes, with signage consisting of a glowing shrine made of yellow neon replicas of the international fast-food chain's recognizable 'M' logo. Such signs, Nakamura seems to suggest, are among the new icons of daily urban life. Indian artist **Sharmila Samant** (b. 1967) turned her attention to Coca-Cola. For

Sharmila Samant *A Handmade Saree* 1999 (detail)
Coke crowns, metal shackles, three ebony frames with text,
wood and perspex cradle for display, 5.5 x 1.05 m (18 x 3 ft 4 in.)

A *Handmade Saree* (1999), she collected and strung together hundreds of Coca-Cola bottle caps in imitation of a length of cloth. The caps were arranged in such a way as to replicate a traditional mango textile pattern, thereby posing several provocative, if hypothetical, comparisons – between utility and beautiful uselessness (who would wear a bottle-cap saree?), between handcraft and mass production, between small-scale ingenuity and thrift versus the wastefulness of global conglomerates and the consumption they promote.

More recently, artists have continued to co-opt the power and symbolism of corporate logos and packaging for their work. Japanese artist **Yuken Teruya** (b. 1973) has used disposable shopping bags – everything from luxury brand carriers

to McDonald's take-away paper bags – as the raw material for sculptures. He cuts the outline of a tree into one side of the paper bag and then folds it inwards to form a miniature forest visible through the open top of the bag, facing out from the wall. These objects present a case for recycling in today's disposable consumer culture, but they also reference the artist's own experiences, as the shapes he creates are based on trees near his home in New York, where he now lives, or on others encountered in his travels. For Korean Kim Joon (b. 1966), the way in which consumption can create a sense of identity and community underpins his digital photographs transposing multinational logos – from companies including Starbucks, Adidas and Heineken – onto naked figures as if they were tattoos.

Yuken Teruya *Happy Meal Crossing (Japan) (US) (Japan) (Korea)*
2006 (detail)
Paper and glue: four parts, each 8.9 x 15.2 x 25.4 cm (3¹/₂ x 6 x 10 in.)

product packaging, rather than art pieces created by the artist, like, say, Andy Warhol, who mimicked mass-produced domestic objects in artist-made originals. Xu's empty packets evoke the way in which the contemporary art market serves as a crucible of symbolic exchange, in which money is swapped for signs and symbols of art.

EVERYDAY ICONS

As developed in Europe and America, Pop Art was a style that revelled in poeticizing the ordinary and stereotypical. Think of Jasper Johns's paintings of the American flag, or Ed Ruscha's photographs of gas stations, or the flashy neo-pop works of the 1980s by artists like Jeff Koons. Similarly, in Asia, artists have turned to those stereotypical signs that characterize Asian cultures in the global marketplace, sometimes as a post-modern, self-reflexive critique, and at other times more in active celebration. **Subodh Gupta** (b. 1964) cast a replica in aluminium of the most popular car in India, the locally made Ambassador. Originally based on the 1948 British Morris Oxford model, today it is something of a national symbol. The title of Gupta's work, *Doot* (2003), which in Hindi means 'messenger', is a vernacular name for the car, which happens to be the preferred vehicle for taxis.

Elsewhere, stereotypical popular cultural forms are similarly appropriated and made the vehicle for a discussion of

Other artists take contemporary art itself as their focus, delving into its status as a commodity. In a reaction to the explosion of the Chinese art market during the world financial boom of the early years of the twenty-first century, **Xu Zhen** (b. 1977) reconstructed in galleries and art-fair booths meticulous replicas of typical 24-hour Chinese convenience stores, complete with shelving, a counter, cash register and attendant to take money, just like in a real convenience store. Viewers of his *ShanghART Supermarket* (2007–8) in a gallery booth at the Art Basel Miami Beach Art Fair were not sure whether they were looking at an art show or a misplaced shop. But nothing was as it seemed, for while all of the products in the store were for sale, they were empty of content: the objects were actual

Xu Zhen *ShanghART Supermarket* 2007–8
Mixed media; dimensions variable

Subodh Gupta *Doot* 2003
Cast-aluminium Ambassador car with toy cars and mirrors

themes and issues specific to the region. *Arabian Delight* (2008) by the Pakistani artist **Huma Mulji** (b. 1970) is a taxidermy camel stuffed into an enormous suitcase as a metaphor for the growing social, political and economic alignment of Pakistan with the Middle East and Islamic world. At any one time, for example, more than one million Pakistanis are living and working in the United Arab Emirates. The building of mosques in Pakistan has also been funded by Saudi Arabia. The irony here is that when Mulji's work was displayed at

the second Art Dubai fair, it was immediately banned from exhibition by local authorities for being 'offensive to Middle Eastern culture'.

Another interesting fusion of Asian and Western cultural signs is **Bharti Kher**'s (b. 1969) installation *Rudolf and Bambi* (2002), in which the artist decorated cast-resin sculptures of the two most famous deer in popular culture – Rudolph, one of Santa Claus's reindeer, and Bambi, the animated Disney character who debuted in 1942 – with swirls of contrasting

Huma Mulji *Arabian Delight* 2008
Installation view: 'Desperately Seeking Paradise', Art Dubai 2008
Taxidermic camel, Rexine suitcase, fabric, metal rods and cotton wool,
104.8 x 144.8 x 154.9 cm (41^1/$_2$ x 57 x 61 in.)

Bharti Kher *Rudolf and Bambi* 2002
Bindis on painted fibreglass

colourful self-adhesive *bindis*, the small circular forehead dot decorations worn by Hindu women in South Asia. The animals are visually dazzling. The cross-cultural playfulness and the craftsmanship of execution are the draw.

When art engages with decoration, it is frequently dealing with visual refinement, something whose virtue is also its limitation and is therefore liable to be easily dismissed. This quality is associated with artists who draw on traditional textiles and cloth as emblems of their culture and identity, though the very best of them have found a way of making visual refinement work within a conceptual context. Taiwanese **Michael Lin** (b. 1964) makes colourful painted wall and floor installa-

tions that reproduce on a massive, mural-like scale the floral motifs of textiles once ubiquitous in Taiwanese homes, including sheets, bedcovers and pillowcases traditionally made by women. Adapted to the architecture of each exhibition location, Lin's installations work to transform and shape the environment, graphically and memorably brightening the space, as in his 2002 hand-painted floor mural for the cafe at the Palais de Tokyo in Paris. The installation was a statement of visual pleasure, even splendour, delighting the eye with exuberant flowers in pungent colours. But it was also a statement of cultural identification and survival, celebrating a vernacular Taiwanese design tradition that is increasingly being forgotten.

Michael Lin *Atrium, Stadhuis 12.07–12.09.2002* 2002
Installation view: Stroom-City Hall of The Hague, Netherlands
Emulsion on wood, 5,000 x 2,000 cm (1,968 x 787 in.)

The ever-increasing importance of appropriated imagery has led numerous artists in Asia, as elsewhere, to recreate famous artworks using ephemeral materials. For *Museum of Soy Sauce Art* (1999), an exhibition within an exhibition, Japanese artist **Ozawa Tsuyoshi** (b. 1965) replicated Japanese paintings in that unorthodox medium: subjects of his reinvention ranged from ancient artwork, screens and scrolls from the Kamakura, Momoyama and other periods to conceptual art by On Kawara (b. 1933) and Tanaka Atsuko (1932–2005), all of which were displayed in a temporary environment resembling a provincial Japanese museum. The soy reproductions are impressive, both for their scale and majesty and also for the brazenness with which Ozawa pumps up the too-subtle nuances of the originals, as in his soy re-paintings of portraits by Kishida Ryusei (1891–1929), an important early twentieth-century Japanese modernist, or the decorative

Other artists who draw on the emblematic power of traditional Asian textiles are more difficult to characterize. Central to the performances, photographs, video and installation art of Korean **Kimsooja** (b. 1957) are *bottari*, the cloth wrapping bundles that have been used in Korea for centuries. For Kim, the bottari serve as a marker of her identity as a Korean woman, but also as a symbol for the human body. As she has stated: 'Bottari ... has significance as a container, or vessel, for carrying and transporting all sorts of goods. It can be unwrapped just as it can be bundled up and in this regard I see our body as being, in the most subtle way, a kind of bottari.'[10] *Cities on the Move – 2727 Km Bottari Truck* (1997), a video of an eleven-day performance, documents the artist's journey around Korea in a small truck filled with bottari as a signifier of travel, migration and mobility.

Kimsooja *Cities on the Move – 2727 Km Bottari Truck* 1997
Video: single-channel video projection: 7 mins, 33 secs

Ozawa Tsuyoshi *Sanuki Museum of Soy Sauce Art* 1999
Mixed media

TOP **Cai Guo-Qiang** *The Horizon from the Pan-Pacific:*
Project for Extraterrestrials No. 14 1994
Realized at the Pacific Ocean, offshore from Numanouchi to
Yotsukura Beach, Iwaki, 7 March 1994, 6.38 pm: 1 min, 40 secs
Six gunpowder fuses, rope, vinyl sheets, three boats and base ship

ABOVE **Cai Guo-Qiang** *Project to Extend the Great Wall of China*
by 10,000 Meters: Project for Extraterrestrials No. 10 1993
Realized at the Gobi Desert, west of the Great Wall, Jiayuguan,
Gansu Province, 27 February 1993, 7.35 pm: 15 mins
Gunpowder and two fuse lines

abstracts of Yayoi Kusama (b. 1929). Then there is the skill with which Ozawa executed these works, and the strangeness of seeing familiar art rendered in an equally familiar but incongruous (and ephemeral) material.

Gunpowder has been associated with China ever since it was discovered in the ninth century by Taoist monks experimenting with alchemy while searching for the mythical elixir of immortality. Chinese New York-based artist **Cai Guo-Qiang** (b. 1957) is fascinated with this combustible material, using it to create drawings, paintings and increasingly elaborate pyrotechnic installations and public performances, which he refers to as 'explosion works'. For Cai, the choice of gunpowder as an art material is both symbolic and pragmatic:

For one, the material is readily available in China. Gunpowder or firecracker production was everywhere

when I was growing up.... Another reason for my use of gunpowder is my background, where I'm from. Quanzhou is the closest port town to the Kinmen Islands in the Taiwan Strait. Because of the political situation [between Taiwan and mainland China], there was always a battle going back and forth ... the sound of the bombing in the background, is the soundtrack of my childhood.[11]

Cai first began to experiment with making art with gunpowder in the mid-1980s, when he was an active participant in the '85 New Wave Movement, one of the first experimental art movements in China. He sprinkled gunpowder across canvases in the rough shape of figures and other simplistic forms that were then lit to burn the design into the support. In 1986 Cai left China and settled in Japan, where he started to create

Jun Nguyen-Hatsushiba *Memorial Project Nha Trang, Vietnam: Towards the Complex – For the Courageous, the Curious, and the Cowards* 2001
Single-channel video projection

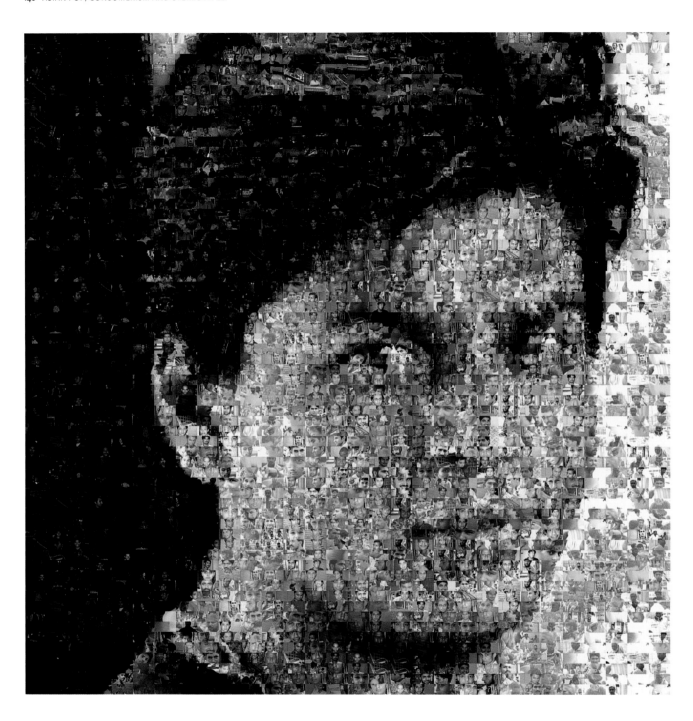

Rashid Rana *Ommatidia III (Shah Rukh Khan)* 2004
Type C photograph, 83.82 x 76.2 cm (33 x 30 in.)

larger, experimental, ephemeral gunpowder explosions as outdoor performance events, which were captured on film and video. Staged in different sites around the world, several of Cai's explosions from this time are grouped under the title *Projects for Extraterrestrials*. One work in the series, *The Horizon from the Pan-Pacific: Project for Extraterrestrials No. 14* (1994), took place at Iwaki, a remote seaside town where he installed a three-mile (5 km) line of waterproof gunpowder fuse out in the ocean. Standing on land, viewers saw a burning line of fire on the horizon in imitation of a regional atmospheric phenomenon in which the illusion of fire – streams of light, but also sometimes fireballs – appear on the horizon over the sea. *Project to Extend the Great Wall of China by 10,000 Meters: Project for Extraterrestrials No. 10* (1993) consisted of a 6-mile (10 km) length of gunpowder fuse added to one end of the Great Wall, at Jiayuguan, in an effort to symbolically lengthen the structure. In this, part of Cai's inspiration was Chinese leader Deng Xiaoping's 1984 campaign to rebuild and restore the Great Wall as a symbol of national strength, unity and identity.

References to cultural signs and symbols can reflect nostalgia for the past. In the video *Memorial Project Nha Trang, Vietnam: Towards the Complex – For the Courageous, the Curious, and the Cowards* (2001), by the Vietnamese-Japanese artist **Jun Nguyen-Hatsushiba** (b. 1968), cyclos (traditional Vietnamese bicycle-rickshaws) driven by a squadron of fishermen slowly race each other along the ocean floor. Everything moves weightlessly, as if happening in a dream, with the cyclo riders periodically forced to return to the surface for air before diving back down again to resume pedalling, an arduous job underwater. Luminous fish flash by. The work has its inspiration in Vietnam's ongoing social and economic transformation: as symbols of the past, the cyclos are increasingly being replaced on the streets with cars, buses and motorcycles.

Karaoke is a Japanese invention which swept throughout Asia – and later the world – in the 1990s. A popular form of interactive entertainment, it consists of a video monitor linked to a microphone which allows people to sing along to pop songs in the company of their friends and colleagues. Though the format varies, one constant is the intense fear and sense of vulnerability that frequently accompanies these amateur performances. Korean Lee Bul's (b. 1964) series of karaoke pods, begun in the early 2000s, are customized, soundproof capsules with leather and foam interiors equipped with karaoke machines. Viewers enter, one at a time, to sing pop songs without fear of embarrassment: inside the pods no one else can hear you singing. The isolation of the capsule encourages users to explore fantasies and memories that are evoked by popular music. Instead of making a private act public – a familiar strategy among Western artists – Lee's karaoke pods reverse the process, taking what is usually a public activity and making it private.

THE FAME GAME

Celebrity is the number one obsession of the moment in popular culture. By no means immune to this phenomenon,

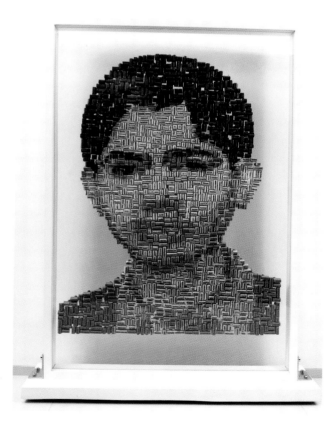

Reena Saini Kallat *Synonym* 2007
Acrylic paint, rubber stamps, Plexiglas,
198 x 146 x 30.5 cm (78 x 57¹/₂ x 12 in.)

the art world in Asia is knee-deep in playful, occasionally sardonic images of film stars, pop musicians, and historical and political figures. Journalistic photographs from magazines and the internet are a usual source material. Two examples by Pakistani artist **Rashid Rana** (b. 1968): *Ommatidia II (Salman Khan)* (2004) and *Ommatidia III (Shah Rukh Khan)* (2004), composite images of Bollywood stars created from hundreds of smaller snapshots of everyday Pakistani men. Superficially similar to Rana's composite digital prints are Indian artist **Reena Saini Kallat**'s (b. 1973) collage portraits made of hundreds of painted rubber stamps, but these are wildly different in intent. Each stamp bears the name of one of thousands of registered missing persons in India. Here the artist monumentalizes marginalized figures. Meanwhile, Pakistani artist **Faiza Butt**'s (b. 1973) *Fans and Idols* (2005) is a series of colourful, psychedelic, delicately dotted drawings in felt-tip pen of celebrities, either alone or carousing with Muslim teenagers. Somewhat unconventionally, the works seek to deal with complex cultural and social issues, and to do so in ways that make sense to the Western audience they

confront and address: the pictures counter popular perceptions of Muslims as repressed, anti-Western and unworldly.

Butt's dot paintings, which owe less to European Pointillism than to the highly detailed techniques of paint application used in Indian and Persian miniature painting, point up how, as Asian artists are absorbed into an international art world system, the kind of art they produce is affected not only by their own cultures, but by issues and events in the world around them. In Butt's words: 'I create work by chancing upon potent journalistic images, text, encounters, and experiences, as I conduct my affairs as an artist, a mother and a woman.'[12] This has led her to paint not just celebrities but random acts of violence relayed by the electronic mass media, as well as prominent political figures. *Moderate Fantasy Violence* (2007) is a painting of the smiling mouth of the former New York City mayor Rudy Giuliani, who is also the subject of Chinese **Zhou Tiehai**'s (b. 1966) *Libertas, Dei Te Servent! (Giuliani)* (2002), a 3.5-metre-tall (over 11 ft) heroic, hyperrealist portrait set against a cityscape at sunset – based on the *Time* magazine cover image of the mayor when he was featured

Faiza Butt *Fans and Idols I* 2005
Ink and polyester film mounted on acrylic sheet,
20.3 x 40.6 cm (8 x 16 in.)

Zhou Tiehai *Libertas, Dei Te Servent! (Giuliani)* 2002
Acrylic (airbrush) on synthetic canvas, 350.5 x 249 cm
(138 x 98 in.)

as Person of the Year in 2001. Zhou's painting balances on elephant dung-balls, a reference to Giuliani's notorious failed efforts in 1999 to close down an exhibition at the Brooklyn Museum of Art which included British artist Chris Ofili's painting of the Virgin Mary propped up on nuggets of elephant dung.

Elsewhere in Asia, contemporary artists share a fascination for the problematic significance of political icons, especially those involved with independence movements. Some artists produce unorthodox portraits, while others depict events, places and scenes from their lives. **Dayanita Singh**'s (b. 1961) *Anand Bhavan, Allahabad* series of black-and-white photographs (2000) document the interior of Anand Bhavan, home of the celebrated Nehru-Gandhi family and now a museum. **Nataraj Sharma**'s (b. 1958) *Freedom Bus (Or a View from the 6th Standard)* (2001–4) is a small bus made of rusted metal, the windows filled with cut-out portraits of Indian independence leaders – at least the ones identified in the sixth edition of a standard Indian school textbook. Sharma recounts his inspiration:

My daughter was six years old and she was learning about the Indian Independence Movement in her civics class. I found the chapter on the movement had been compressed into two pages and it was fascinating that this huge, complex phenomenon with many aspirations, contradictions and failures was simplified so drastically, this mythology that's created and put into the minds of young children – in this case my own daughter.... Then I thought maybe I could exorcise this negative feeling through creative expression ... a freedom bus that would take India from a colonial situation to a brave new world, an independent, just world.[13]

Gandhi and Muhammad Ali Jinnah (Pakistan's founder) are seated at the front of the bus, which has flashing headlights and a megaphone installed on the roof, in the manner of buses used for political rallies in South Asia. The viewer is asked to contemplate the spirit of optimism and camaraderie associated with the original independence movement, later sullied by prejudices and ideological battles.

Dayanita Singh *Gandhi, Anand Bhavan, Allahabad* 2000
Silver gelatin print, 60 x 60 cm (23⅝ x 23⅝ in.)

Dayanita Singh *Nehru, Anand Bhavan, Allahabad* 2000
Silver gelatin print, 60 x 60 cm (23⅝ x 23⅝ in.)

Nataraj Sharma *Freedom Bus (Or a View from the 6th Standard)* 2001–4
Cast and fabricated iron, painted wood, 1.8 x 4.9 x 4.9 m (6 x 16 x 16 ft)

Positive changes have taken place in Pakistani society since the military dictator General Muhammad Zia-ul-Haq's demise in a 1988 airplane accident, after which the economy opened up. More recently, during the rule of General Pervez Musharraf (1999–2008), Pakistan became a destination for foreign multinationals and fast-food chains. Naturally, as the critic Quddus Mirza has documented, a new generation of Pakistani artists has been attracted to the possibilities of popular culture for art.[14] Kentucky Fried Chicken is the subject of *Jinnah to Sanders* (1999), a five-panel painting by artist **Asma Ahmed Shikoh** (b. 1978), in which a portrait of Pakistan's founder Muhammad Ali Jinnah, appropriated from a postage stamp, gradually morphs into an image of Colonel Sanders, the founder of the Kentucky Fried Chicken franchise. The transformation captures the wider social change from a hard-line isolated Islamic republic to a global consumer society.

Few political figures in the twentieth century were the subject of more portraits than Mao Zedong, China's leader from 1949 until his death in 1976. Estimates of the number of his portraits are as high as two billion, including political posters produced during the Cultural Revolution.[15] Today, his image continues to exert great fascination for artists. **Zhang Hongtu** (b. 1943) has painted Mao's portrait on Quaker Oats tins and cut his silhouette into a ping-pong table. He has said:

> I asked myself, 'Why do I use Chairman Mao's image to make jokes about him, even when I feel sinful and afraid?' Later, I realized that even though I had left China more than five years before, psychologically I couldn't eliminate Mao's image from my mind.[16]

Like Zhang, Li Shan (b. 1942) works with portraits of Mao. *Rouge Series No. 8* (1990) is a rendering of a photograph taken by American journalist Edgar Snow of Mao in Shaanxi Province in 1936. The same source image forms part of a series of conceptual works by **Zhang Dali** (b. 1963), which pair doctored archival photographs published as posters and in magazines and newspapers during the Maoist era with new prints made from the original negatives unearthed in archives. *Premier Zhou Returns from Moscow, 1961* (2005) reveals background scenery changed and individuals erased to enhance the official public image of Mao. This was art for the masses used to suit the views and aims of the few.

Memorializing infamous people despite those individuals' failings, or even crimes, seems morally questionable. But that is what lies behind Malaysian **Wong Hoy Cheong**'s (b. 1960) *Chronicles of Crime* (2006), a series of loose recreations of legendary Malaysian crime scenes and events from the lives of the criminals, often using ordinary people as actors, which Wong then photographed. Enigmatic lighting, stylized scenery and an attention to symbolic details of dress and props make these black-and-white images look like stills from 1950s *film noir* movies. *Last Supper* (2006) takes us into the prison cell of Botak Chin, a notorious and much-admired criminal executed in the mid-1970s, who, like Robin Hood, stole from the rich and gave to the poor. Here Wong shows him sitting at a table alone before a plate of food, his last meal, with arms outstretched and one hand upturned in supplication, in imitation of Leonardo da Vinci's depiction of Jesus in *The Last Supper*. Wong suggests that Chin, too, is a martyr to his cause.

Asma Ahmed Shikoh *Jinnah to Sanders* 1999
Acrylic and oil paint on board, 53 x 198 cm (21 x 78 in.)

Zhang Hongtu *Quaker Oats Mao, Long Live Chairman Mao
series* 1987
Acrylic on Quaker Oats container, 24.8 x 13.3 cm (9³/₄ x 5¹/₄ in.)

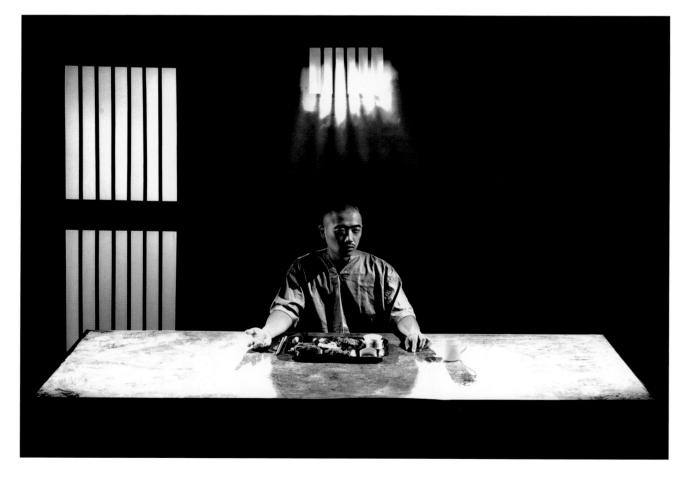

TOP Zhang Dali *Premier Zhou Returns from Moscow, 1961* 2005
Historical documents, 112 x 60 cm (44 x 23⅜ in.)

ABOVE Wong Hoy Cheong *Chronicles of Crime: Last Supper* 2006
Digital print on Kodak Professional paper, 84 x 120 cm (33 x 47¼ in.)

Yan Pei-Ming *Bruce Lee* 1999
Oil on canvas, 400 x 300 cm (157^1/$_2$ x 118^1/$_8$ in.)

FROM BOLLYWOOD TO HOLLYWOOD

Asia has always had its own buoyant film industry, with culturally specific narratives and a whole galaxy of stars. Hong Kong action cinema and Bollywood musicals are reputedly the world's biggest movie industries, after Hollywood. The success and visibility of film has attracted the attention of artists in Asia, some of them using cinematic imagery and conventions for visual gratification, others for social agitation or even a post-colonial assertion of cultural identity. Film icon Bruce Lee, popular star of 1960s and early '70s action movies in Hollywood and Hong Kong, is the subject of devotional portraits by Chinese artist **Yan Pei-Ming** (b. 1960) based on famous film stills and publicity photographs. Usually oversized, with the body or head of the actor filling the canvas, the works are painted in broad fluid brushstrokes that are

reminiscent of traditional Chinese ink painting and calligraphy. Lee, the most influential martial artist of the twentieth century, was a widely admired figure among the Chinese because of his promotion of Chinese martial arts (Kung Fu) and the overt nationalism of his films. He was also one of the first Chinese film stars to achieve mainstream success in Hollywood.

Bollywood – and Lollywood, the film industry in Lahore, Pakistan – also provide endless stimulation for artists. Examples include collaborators Iftikhar Dadi (b. 1961), a Pakistani, and American Elizabeth Dadi (b. 1957), and, in India, **Pushpamala N.** (b. 1956) and Tejal Shah (b. 1979), all of whom mock the tropes of South Asian cinema. Pushpamala N., a performance artist whose work mostly appears as photographs, made *Phantom Lady or Kismet* (1996–98), a series of

Pushpamala N. Still from *Phantom Lady or Kismet:*
A Photoromance 1996–98
Black-and-white photograph, 40.6 x 50.8 cm (16 x 20 in.)

self-portraits portraying the artist as the Zorro-esque super-heroine in a fictitious Bollywood movie of the same title. Glamour, artifice and fantasy merge in this riff on Indian popular films about the exploits of a superheroine named Nadia (a reference to 'fearless Nadia', a 1930s stunt queen of Mumbai films), presented with a mocking irony directed in part at South Asian cinematic conventions, but largely, too, against the tendency to pump up women on screen in spite of the fact that they are still not equal members of society: according to the United Nations, women in India are discriminated against in everything from jobs to land and property rights, and face the constant threat of violence both in and out of the family throughout their lives. As the artist has said about her motives: 'I like to use entertainment and the forms of entertainment to say something serious!'[17]

The Vietnamese-American **Dinh Q. Lê** (b. 1968) appropriates the power and symbolism of Hollywood movies for his intricate photo-based works, which use film shots and other popular cultural imagery cut into strips then woven together, the form referencing local Vietnamese mat weaving. *From Vietnam to Hollywood* (2003–5) blends together stills appropriated from American Vietnam War films such as *Apocalypse Now* (1979) with anonymous family portraits the artist bought in shops in Vietnam. For the artist, these multi-layered, multi-perspective works reflect the experience of living through but also later remembering the war from afar, after he escaped from Vietnam to Los Angeles with his parents at the age of eleven: 'My memory of the American-Vietnam War is quite questionable. It merges fact, fiction, and personal recollections to create a tapestry of memories that is relatively unstable.'[18]

The infiltration of American popular culture into Asia also finds voice in the work of other artists, especially of the younger generation. Several have been drawn to hip-hop music, which is increasingly popular among the region's youth. In China, Cao Fei (b. 1978) launched an international hip-hop project in 2003 for which she video-taped people dancing to American hip-hop music. In Ho Chi Minh City, **Tuan Andrew Nguyen** (b. 1976) has documented in photographs the emergence of a home-grown hip-hop scene (see p. 208).

Inasmuch as it takes its cues from the entertainment industry, a good deal of this sort of art is itself entertaining.

Dinh Q. Lê *Untitled*, from the series *From Vietnam to Hollywood* 2003
C-print and linen tape, 96.5 x 182.9 cm (38 x 72 in.)

TOP Hyungkoo Lee *Felis Catus Animatus* 2006–7
Resin, aluminium sticks, stainless-steel wires, springs, oil paint,
88 x 55 x 92 cm (34⁵/₈ x 21⁵/₈ x 36¹/₄ in.)

ABOVE Hyungkoo Lee *Mus Animatus* 2006–7
Resin, aluminium sticks, stainless-steel wires, springs, oil paint,
15 x 8 x 15 cm (5⁷/₈ x 3¹/₈ x 5⁷/₈ in.)

For example, Korean **Hyungkoo Lee** (b. 1969) has created the imaginary anatomical structures of famous cartoon characters such as Bugs Bunny, Donald Duck, Wile E. Coyote and Road Runner, and Tom and Jerry. Constructed from a mix of animal bones and resin, the skeletons are dramatically posed and spotlit in dark rooms, seemingly frozen in time and space like the stagey displays of skeletal remains of animals found at natural history museums. In one familiar grouping, the skeletons of Tom and Jerry are arranged mid-chase.

The lines of inquiry pursued by Asian-American artists are often noticeably different, even if their source material is similar. Born in Hawaii, **Paul Pfeiffer** (b. 1966) spent his childhood in the Philippines and then attended college in New York, where he now lives and works. *The Pure Products Go Crazy* (1998) is a digital video loop (the title alluding to poet

William Carlos Williams's line that 'the pure products of America/go crazy') of a young Tom Cruise gyrating on the couch in underpants in the 1983 film *Risky Business*. Our understanding of the formal possibilities of new-media technology is a fundamental factor in the appreciation of Pfeiffer's art, which is all about its potential as an increasingly versatile means of expression. As the artist explains: 'Why should we limit ourselves to "entertainment" when we can create spaces for new or alternative kinds of communication?'[19]

The idea that art holds up a mirror to the times is of central importance in appreciating Asian artists. Some of their work is symbolic of globalization and the inescapable influence of Western culture and consumer commodities, but some also poses valuable questions about the changing nature of Asian cities and daily life. This latter theme is the subject of the next chapter.

Paul Pfeiffer *The Pure Products Go Crazy* 1998
Digital video loop, projector, metal armature, DVD player: 5 secs
50.8 x 12.7 x 38.1 cm (20 x 5 x 15 in.)

chapter 4

URBAN NATURE

Today Asia is home to some of the largest metropolises on earth, with four of the world's ten most populous cities – Tokyo, Mumbai, Shanghai and Calcutta – along with other major urban centres such as Karachi, Delhi, Seoul and Beijing. According to United Nations estimates, there are over 1.6 billion people living in Asia's urban areas. Consequently, innumerable works by Asian artists are invigorated by the energy of high-density – and, more specifically, high-rise – city living. These works are also liable to convey some of the many paradoxes that continue to characterize life throughout the region, with gleaming post-modern and progressive urban developments and shopping malls often coexisting with farmland, shanty towns, traffic chaos and toxic pollution.

'Cities on the Move' was the title given to one of the earliest and largest pan-Asian contemporary art exhibitions – and with good reason. Presented in Vienna, Bordeaux, Copenhagen, London, New York and Bangkok from 1997 to 1999, it included works by over one hundred artists, architects, designers, urban planners and film-makers, examining the explosive urbanization, high-speed reconstruction and ongoing mutation of Asian cities during the 1990s. It mapped the contours of social change, the legacy of colonialism, new economic imperatives and population explosion. Looking back, the show's curators Hans Ulrich Obrist and Hou Hanru seem prescient, capturing a theme that is not only regionally but globally significant, as the work discussed in this chapter reveals.

By and large, this art reflects conflicted rather than wholeheartedly positive responses to these changing urban landscapes, attesting to different stages of social and economic development across the region as well as differing views on the changes. Some artists, moulded by the events of the recent past, focus their attention on the phenomenal urban growth and transformation in their immediate environment, while others juxtapose the signs and symbols of contemporary Asian cities in the attempt to make sense of the changes in their societies; still others lament the loss of nature and local architectural heritage. In any case, much of this work is unsettling, posing questions about the environment and the impact of industrialization and new technology on everyday life. One example: Pakistani artist **Huma Mulji**'s (b. 1970) object sculpture *Heavenly Heights* (2009), consisting of a taxidermy buffalo entangled in the scaffolding of an electricity tower as an emblem for uneven development.

Although many Asian artists are reacting to changes wrought by rapidly evolving societies, the art in this chapter need not be read only from a viewpoint informed by the events of the last few decades. One can also take a historical reading of the works as indicative of the way in which modern and contemporary art in Asia is largely synonymous with the urban experience. Jim Supangkat has identified modernism in Indonesia (and by extension, we would argue, the rest of Asia) as being almost exclusively a 'metropolitan phenomenon', since it occurred only in major metropolitan centres.[1] In India, contemporary art is often referred to as 'urban/modern' to distinguish it from tribal or folk art (*adivasi*), which still thrives in rural areas. Each artist, whether directly or indirectly, is a product of these circumstances rather than simply delving into autonomous concerns.

Huma Mulji *Heavenly Heights* 2009
Installation view: Zahoor Ul Akhlaq Gallery, National College of Arts, Lahore. Taxidermic buffalo, powder-coated pylon, cotton, wool, ceramic part and steel cable, 434.3 x 188 x 300 cm (171 x 74 x 118 in.)

TOP Weng Peijun *On the Wall – Shenzen (I)* 2002
C-print, 126 x 171 cm (49⁵/₈ x 67³/₈ in.)

ABOVE Weng Peijun *On the Wall – Haikou (2)* 2001
C-print, 80 x 100 cm (31¹/₂ x 39³/₈ in.)

URBAN TRANSITION

The photograph is unassuming, showing a wan Chinese schoolgirl seated on a brick wall, observing the feverish emergence of a new urban landscape: cranes fill the horizon as new skyscrapers emerge as far as the eye can see. *On the Wall* is a series by **Weng Peijun** (b. 1961), a photographer from Hainan Island who is troubled by the transformation of modern China. In the photographs, the schoolgirl appears to be looking out on the world in which she is growing up with a sort of bitter nostalgia. She doesn't know what the future holds for her country, but neither does anyone else. Weng's image reflects the unease felt by many contemporary artists in Asia about the pace of urban transformation and social change in the region.

This is a theme that has special relevance in China, a nation in profound transition, where the past few decades have witnessed the privatization of industry, the formation of a consumer society and a nationwide building frenzy. In the 1990s Shanghai, in particular, experienced new infrastructure initiatives, urban restructuring and social transformation on an unprecedented scale. Among the projects undertaken during those years were an enormous new international airport, an opera house, a purpose-built building for the Shanghai Museum, the relocation and expansion of the Shanghai Art Museum – home and organizer of an art biennale – and a giddy high-rise financial hub known as Pudong, built on a sliver of land by the Huangpu River that not long ago was covered in paddies. An 'oriental Manhattan' is how the late Chinese artist Chen Zhen described Shanghai in 1998, returning to his hometown and observing the transformation that had taken place since his departure for Paris in 1986.[2]

Shi Guorui's (b. 1964) *Shanghai 22–23 Oct 2004* (2004) takes stock of these changes, presenting a dim, ghostly, panoramic, black-and-white portrait of the city made using a pin-hole camera with a lengthy exposure time – for some images, as much as two days. The date used as the title impresses on us that this is a record of a place and time, and that the Shanghai skyline is changing fast, day by day. Themes of time and transformation also underlie *Mirage* (2004), a colour photograph by Miao Xiaochun (b. 1964). It shows the artist alone in a cable car observing a view of Wuxi, a city popularly referred to in China as 'little Shanghai' on account of its rapid urban growth and industry. In a second cable car opposite his own, the artist placed a lifelike mannequin dressed as a traditional Chinese scholar: the impassive figure rises towards heaven – a metaphor for the receding importance of history and tradition in daily life – while Miao descends towards the distant spread-out city, an expanse of skyscrapers and industrial development stretching in all directions.

Development has brought new energy and vitality into urban life, but it has also provoked opposition and challenges. Because of the scale and pace of urban development, many Chinese are concerned about their diminishing cultural and

Shi Guorui *Shanghai 22–23 Oct 2004* 22–23 October 2004
Unique camera obscura gelatin silver print, 129 x 400 cm
(50³/₄ x 157¹/₂ in.)

architectural heritage. Curator and critic Chang Tsong-zung sums up the problem:

> The loss of physical artefacts and ways of life is universal in an age as prodigiously productive as ours, but what is alarming in China's case is the rate and extent of change, and also the general belief that eradication of a legacy so carefully preserved by our ancestors is now inevitable if not the right thing to do.[3]

Artists have been especially sensitive to these changes, among them artist and architect **Ai Weiwei** (b. 1957), who was exhibiting internationally within a short time after leaving China in 1981 for New York, providing a model and inspiration for many of those who followed. But much of his best work was created after he returned to China to live in 1993, when he became increasingly critical of a widespread disregard for the nation's material culture. For *Dropping a Han Dynasty Urn* (1995), a series of three black-and-white photographs, Ai documented himself letting an antique pot drop on the ground and smash. The artist's finely calibrated ambivalence towards the urn underscores the disposability in contemporary China of signs and symbols of the past, displaced by a new mass-market aesthetic of cheap abundance.

Beginning in the mid-1990s, historical residential courtyards (*siheyuan*) and lanes (*hutong*) were increasingly razed in large Chinese cities to make way for high-rise buildings as part of planned re-urbanization. The inhabitants were quietly displaced to the edge of the city. Many artists witnessed first-hand this destruction and displacement, and created artwork in response. **Yin Xiuzhen**'s (b. 1963) installation *Ruined City* (1996) consisted of bits and pieces of domestic furniture, such as a wardrobe, table and chairs, salvaged from houses and rearranged, partially buried under mounds of powdered cement, and surrounded by roof tiles collected from the traditional courtyard houses that had been demolished in the Beijing neighbourhood where Yin lived. The title brands the re-urbanization plan as more an act of ruin than revival.

Where Yin used materials from building sites, other artists have seized upon urban sites as settings for performances and interventions. Japan's **Tadashi Kawamata** (b. 1953) has grafted fragile, often jury-rigged structures made of scrap

TOP Ai Weiwei *Dropping a Han Dynasty Urn* 1995
Black-and-white photographs, each 127 x 100 cm (50 x 39³/₈ in.)

ABOVE Yin Xiuzhen *Ruined City* 1996
Installation: furniture, roof tiles, cement powder

Tadashi Kawamata *Untitled (Tree Hut)* 2008
Installation view: Madison Square Park, New York
Untreated pine, rubber

in large letters on lamp posts, buildings and pavements. He claimed to have found evidence that much of Kowloon belonged to his ancestors, and his graffiti would often list his forebears along with a claim that the land rightfully belonged to him. Sometimes the graffiti would denounce new real-estate developments, or the Queen of England (until 1997 Hong Kong was a British protectorate), or demand the back-payment of land taxes. Disowned by his family and regarded by the Hong Kong government as a public nuisance, Tsang received art world recognition as an outsider artist only late in his life. Pakistani artist **Naiza H. Khan** (b. 1968), similarly, has made guerrilla wall drawings. For *Henna Hands* (2003), silhouettes of female figures were stencilled in henna paste – used by South Asian women to ornament their hands and feet for festivities – on the walls of buildings in Karachi. The figures are made up of hand prints, both revealing and hiding the female body. As Khan notes: 'The figure is turned into a sign rather than an object, and stripped of its eroticism.'[4]

From 1995, inspired by urban graffiti artists in the United States, Zhang Dali (b. 1963) illegally spraypainted the silhouetted profile of his head on old Beijing buildings slated for demolition, which he then photographed. He also sometimes took a sledgehammer to a wall he had spraypainted, creating a hole in the shape of his profile, which often framed new construction rising behind the ruins.

At the same time, **Zhan Wang** (b. 1962) occupied an abandoned building mid-way through the process of its demolition and proceeded to clean the walls and preserve the architectural remains, positioning himself as a defender of China's urban architectural heritage. Zhan documented his intervention with a series of colour photographs, titled *Ruin Cleaning Project* (1994). Not long afterwards, the 'ruin' was razed to the ground and all trace of the art action disappeared.

This by no means exhausts the list of artists who are preoccupied with urban transformation in China. Shao Yinong (b. 1961) and Mu Chen (b. 1970), a husband-and-wife artist team document elements of China's architectural history as a metaphor for a nation in transition. The ongoing *Assembly Hall* series depicts public assembly halls across China. The

lumber onto, around or over the façades of buildings in cities all over the world, in complicated and temporary installations. For *Toronto Project* (1989) at Colonial Tavern Park, Toronto, he installed a makeshift, scaffolding-like structure in the space between two buildings, in the process closing off a street. More recently, he filled the tree-tops in Madison Square Park in New York with improvised cabins, like tree-houses built for children. He is interested in ideas of alternative shelter.

Another strategy is the use of graffiti as social protest. Among its earliest practitioners was **Tsang Tsou Choi** (1921–2007), who called himself 'The King of Kowloon'. From the mid-1950s until his death, Tsang's calligraphy could be found on public sites everywhere in Hong Kong, painted

Tsang Tsou Choi (King of Kowloon) *Writing Calligraphy on Utility Box* 2002
Paint on utility box, 160 x 76 x 41 cm (63 x 29⁷/₈ x 16¹/₈ in.)

Naiza H. Khan *Henna Hands* 2003
Site-specific installation with henna pigment on the wall
at Adam Road, Cant Station, Karachi, Pakistan

TOP Zhan Wang *Ruin Cleaning Project* 1994
Paint and plaster on half-demolished sites in Wangfujing,
Beijing

ABOVE LEFT Sze Tsung Leong *No. 15 Xiangluying Fourth Lane,*
Chun Shu, Xuanwu District, Beijing 2004
C-print, 182.9 x 222.3 cm (72 x 87¹/₂ in.)

centre of daily activities during the Cultural Revolution, these buildings – sometimes decorated with Communist flags or portraits of Mao, Marx and Lenin – now stand empty and in disrepair, or have been transformed for other purposes. Equally sombre are New York-based Chinese photographer **Sze Tsung Leong**'s (b. 1970) photographs documenting the destruction and reconstruction of Beijing's urban landscape. *No. 15 Xiangluying Fourth Lane, Chun Shu, Xuanwu District, Beijing* (2004) captures a transitional moment. In the foreground we see rubble from a destroyed traditional housing complex, beyond which another, partially destroyed building

awaits demolition; further on, new apartment blocks rise skyward, flanked by cranes and covered over with protective green mesh and scaffolding. It is the landscape of tomorrow.

As urban landscapes change, the vectors of our interactions with the world alter. **Chen Qiulin**'s (b. 1975) photograph *Garden No. 4* (2007) shows a group of men standing in a levelled, vacant plot of land on the fringe of a new high-rise apartment tower development. The men hold pots of cheap plastic peony flowers, in China a symbol of prosperity. Here the construction site serves as the locus for dreams of the future, social mobility, wealth and happiness. Photographer

Chen Qiulin *Garden No. 4* 2007
Photograph, 121 x 152.7 cm (47³/₄ x 60¹/₈ in.)

Xing Danwen (b. 1967) is more sanguine about these new developments. *Urban Fiction*, a series of digitally manipulated photographs begun in 2004, dwells on the implied lifestyle promises of the flurry of luxury residential developments in China that are named for streets, suburbs and regions in Europe and America, like SOHO, Park Avenue and Tuscany – an ironic testament to our present global culture with its appetite for brand names. Xing takes digital photographs of the architectural models produced to promote these new real-estate developments, superimposing miniature characters playing roles in keeping with the lifestyles associated with them. But this is no picture-perfect world. In some of the images, crimes are being committed, people are depressed, and even car accidents occur. Xing's works question the

marketing and promotion of the new developments, and by extension the rampant consumerism that is fuelling them.

India, too, is undergoing an urban building boom. One need only visit places such as the satellite city of Gurgaon near Delhi to see the multiple construction sites and apartment high-rises speedily going up. For **Nataraj Sharma** (b. 1958), the evolving landscape of Mumbai is the subject of *Mumbai Structures* (2003), a series of monochromatic gouaches depicting cranes, scaffolding and high-rise towers and apartment buildings under construction, accompanied by a single portrait in profile of the artist's cook, a young man from a small coastal village, observing the city's quickening urban progress. Here the artist contemplates the unchecked vertical growth of the city, crystallizing the moment before a building's

Xing Danwen *Urban Fiction, image o* 2004
C-print, 170 x 241.1 cm (66⁷/₈ x 94⁷/₈ in.)

Nataraj Sharma *Mumbai Structures (no. 11)* 2003
Gouache and 'texture white' on canvas, 30.5 x 25.4 cm (12 x 10 in.)

completion. He explains: 'I find a particular poignancy in half-built buildings. I see them as works in progress – frozen in time.'⁵ His incomplete, vacant structures are purged of all trace of human life. Only time will tell what impact these changes will have on the city and the people who live there.

Sudhir Patwardhan's (b. 1949) paintings of Mumbai make it clear that certain parallels can be drawn: architecture is often used as a signifier for social change. *Lower Parel* (2001) mixes together imagery of abandoned Mumbai textile mills, forced out of business by cheaper Chinese manufacturing, with new offices and apartments under construction. He has said: 'The closing down of many of these mills since the eighties, leaving thousands of workers jobless, has cast a gloom over the area. The high-rise apartment blocks sprouting on mill lands in recent years symbolize emergent forces displacing the old order.'⁶ Another case in point is Sheela Gowda's (b. 1957) *Private Gallery* (1999), a sculptural installation in which the walls of a makeshift structure are smeared with cow dung overlaid with drawings that convey nostalgia for Gowda's home town of Bangalore, once a village and now a world centre for information technology.

CORPORATE CULTURE

Japan was one of the first countries in Asia to experience industrialization and widespread corporatization of the workplace in the post-World War II period and, consequently, artists there have focused on its effects in their work. **Tetsuya Ishida** (1973–2005) produced a very small œuvre of approximately 180 paintings – haunting, surrealistic images of himself as a lonely, isolated individual in a mechanized, soulless world. Cars and their manufacturing feature prominently in his paintings in reference to the car industry as one of the most successful Japanese corporate models. Several paintings show Ishida as part human, part object or motorized machine, as in a 2003 painting of himself with the body of a radiator. He paints himself in other works as a somewhat desperate-looking figure who is physically restricted, bound or caged, as in a 1998 painting of him trapped inside a makeshift cardboard home filling a small room. In these paintings the artist casts a melancholy eye over a world that has given up on individual happiness: at the age of thirty-one the artist was hit by a train.

Sudhir Patwardhan *Lower Parel* 2001
Acrylic on canvas, 122 x 244 cm (48 x 96 in.)

Other Japanese artists portray both men and women playing a role in a standardized, restrictive, corporate culture. In 1993, Yanagi Miwa (b. 1967) began her *Elevator Girls* series of photographs on the doll-like women in uniform who greet customers and operate elevators in Japanese department stores and offices. These women are trained to speak and behave in a particular way, and epitomize the anonymous conformity of Japanese corporate culture. Instead of fresh faces and welcoming smiles, however, Yanagi's photographs present us with impersonal figures frozen in space, posed in groups in urban settings. Suddenly we are in a consumer paradise gone badly wrong. Cold, expressionless and immobile, the elevator girls resemble robots that have been switched off by their employers at closing time. The artist has commented:

'I have a sadistic bent that leads me to make an ordeal of my own femininity. If girlishness is what gives femininity a more universal feel, I objectify it by denouncing it.'[7]

Momoyo Torimitsu (b. 1967) and Bak Ikeda (b. 1964) are also fascinated by the robotic, conformist bent of Japanese corporate culture. But both of them deal with men's roles. In photographs and video installations, Torimitsu documents the performances of her life-sized robot of a stereotypical businessman named Miyata Jiro. He is a salaryman, a term used in Japan to refer to a legion of acquiescent, unthinking, corporate drones who put in long hours for limited pay and prestige. Wearing a dark suit and glasses, this bald-headed, battery-operated corporate warrior drags himself over the pavements of cities around the world, worn out from work. He is a

Tetsuya Ishida *Untitled* 1998
Acrylic on paper with panels, 145.6 x 206 cm (57³/₈ x 81¹/₈ in.)

debased figure, equivalent to an android, and expendable, much like the race of bumbling, identical creatures that inhabit *PiNMeN* (1999–2001), Ikeda's comic, animated commentary on hyper-conformism in Japanese society. In one episode these are depicted as bowling pins waiting for a ball to strike them down.

In 1994, a dilapidated Orthodox church in central Shanghai was unexpectedly renovated. People were confused: was Christianity on the rise in China? The building was, however, to become the Shanghai stock market – 'an ironic example', curator and writer Hou Hanru has written, 'of the replacement of traditional religious spirituality with the new religion of monetary fetishism which became pervasive in China in the 1990s'.[8] Chinese artists have sought to explore the shifts in mentality and morality consequent upon growing commercialization, consumerism and corporatization,

among them Zhu Fadong (b. 1960), who in 1994 moved from his home in Yunan Province to Beijing, where he wandered the city streets dressed in a Mao-style suit with a sign on his back saying, 'This man is for sale, please discuss the price in person'. It was about the transformation of people into commodities in the new capitalist economy.

The arrival of capitalism in China has brought opportunities but, as the works of some younger artists indicate, it is also fraught with danger. **Cao Fei**'s (b. 1978) video and photographic series *Rabid Dogs* (2002) pokes fun at the prosperous urban yuppies who greeted corporate culture, in her estimation, with the enthusiasm of puppy dogs. For this series, she dressed young people in Burberry designer clothes, had their faces painted to resemble dogs, and then instructed them to crawl around an office mimicking the playful exuberance of puppies. In a similar vein, Shi Jinsong's (b. 1969) sculptural

Momoyo Torimitsu *Miyata Jiro* 1995
Performance: Wall Street, New York, 1997
Battery-operated polyester resin figure with acrylic paint

Cao Fei *Dog Days (Rabid Dogs Series)* 2002
Digital C-print, 90 x 60 cm (35³/₈ x 23⁵/₈ in.)

installation *Office Equipment – Prototype No. 1* (2004) serves as something of a cautionary tale against dreams of a salaried corporate desk job. It consists of a basic office furniture ensemble – a desk with a monitor, lamp, writing utensils and swivel chair – but with each piece transformed into an object of pain, torture and suffering: the monitor doubles as a guillotine, knife blades stick up from the chair, and the desk includes its own leg clamp.

STREET LIFE

Depictions of life on the street pervade modern and contemporary Asian art, but they are especially prevalent in India, where artists have been drawn to what the art historian Kajri Jain characterizes colourfully as:

> ... the shared spaces (mostly, though not exclusively, urban) where vernacular and cosmopolitan worlds commingle and slip past each other: the intense colors of clothing, commodities, posters, billboards, and roadside shrines; loudspeakers blaring *filmi* (movies) and devotional songs or political slogans ... the sweaty crush of buses and trains; the frenetic chaos of traffic ... dubious electrical connections; ambient smells of pollution and decay interrupted by incense, jasmine, hair oil, cow dung, and cooking.[9]

Raghubir Singh (1942–1999) is one of India's most celebrated street photographers. A keen observer of the urban landscape, he also had an eye for complex formal compositions. *Pavement Mirror Shop, Howrah, West Bengal* (1991) captures the juxtapositions of a typical Indian street. In the assortment of mirrors hanging from a pavement stall, daily

Raghubir Singh *Pavement Mirror Shop, Howrah, West Bengal* 1991
C-print

life is multiplied and reflected back at the viewer. We see a bicycle, cracked and peeling posters, objects hanging at a nearby shop, and even the roofs of the houses opposite. Singh's own blurred self-portrait can be seen reflected in a rectangular mirror at the top centre of the composition. His face is, however, obscured by the camera.

Photojournalism, or at least a style of photography that has its roots in photojournalistic traditions, predominates in Indian art. Raghu Rai (b. 1942), who became a member of the internationally renowned Magnum Photos cooperative in

1977, takes informal pictures of people and events, providing insight into the social and the political, such as his 1984 series on Indira Gandhi's death and funeral. Rai's contemporary, **Ram Rahman** (b. 1955), captures simple occasions and humorous street scenes that charm him but that also evoke broader aspects of Indian life, such as *Capital Studios* (1986). The extensive use of black-and-white photography by both artists, and others, is one of the characteristics that distinguish South Asian photography from the work of artists in East Asia. Rahman has speculated that the popularity of black-and-white

Ram Rahman *Capital Studios, Connaught Place, New Delhi, 1986*
Gelatin silver print

Ram Rahman *Gandhi March, Delhi, 1995*
Gelatin silver print

film is partly because of cost: until recently colour film was rel-atively expensive to develop commercially in India, while black-and-white film could be processed and printed easily at home.[10] Moreover, because many Indian photographers were originally photojournalists, they were comfortable shooting in black and white. Scale is another common characteristic: in an art world where everything is huge, much of the work of Indian street photographers is small and intimate.

Gulammohammed Sheikh (b. 1937) also engages with Indian street life, as well as signs and rituals that create a sense of place and belonging. He has said:

> Living in India means living simultaneously in several cultures and times.... The past exists as a living entity alongside the present, each illuminating and sustain-ing the other.... Traditional and modern, private and

public, the inside and the outside continually tele-scope and reunite.[11]

His painting *City For Sale* (1981–84) depicts an overflow-ing, colourful, kaleidoscopic crush of people: some are rioting, while others are pushing carts, riding bicycles, driving cars, begging, praying or huddled up together smoking and talking. To take this as an apocalyptic vision is to miss the artist's point: in this work we are abruptly brought face-to-face with the diversity of city life in India and the complexity of our perceptions of it.

Sheikh's description might easily apply to life in any major city in Asia, where it is not uncommon to encounter all kinds of remnants of the past in the present. Admittedly this is now a cultural cliché, but it is one that continues to resonate with the region's artists. The Vietnamese painter **Nguyen Manh**

Gulammohammed Sheikh *City For Sale* 1981–84
Oil on canvas, 223.5 x 305.2 cm (88 x 120 in.)

Hung (b. 1976) makes surrealistic paintings combining imagery of village scenes, urban apartment blocks and advanced military hardware, especially fighter jet planes. In *Rice Harvest* (2004), fighter jets and cargo planes pull carts laden with rice across the sky – a commentary on the way in which rural village life continues to dominate Vietnamese society. Nguyen has said: 'Vietnam is one of the weirdest countries in the world.... We live, fight, build, and eat just like farmers. The culture of village [life] still exists and has a hidden power on [the] Vietnamese. Even though we are in the rush toward capitalism, we are still keeping this lifestyle.'[12]

Social concerns underlie the work of several artists redeeming 'poor' or humble street materials and junked objects, often in the manner of 1960s Arte Povera. Examples include Japanese artist **Ujino Muneteru**'s (b. 1964) sculpture *OZONE-SO* (2004), a dwelling in the shape of a military tank made from waste materials, electrical appliances, books and objects collected from Tokyo streets in reference to the seeming military-like fervour of the new environmentalism in Japan, especially surrounding recycling, and Chinese artist Song Dong's (b. 1966) installation *Waste Not* (2005), made of the household objects his mother had

Nguyen Manh Hung *Rice Harvest* 2004
Oil on canvas, 100 x 100 cm (39³/₈ x 39³/₈ in.)

Ujino Muneteru *OZONE-SO* 2004
Wood and mixed media, 300 x 580 x 260 cm
(118¹/8 x 228³/8 x 102³/8 in.)

collected over decades for their potential usefulness. Then there is Indian artist Vivan Sundaram's (b. 1943) *living. it.out.in.delhi* (2005), a sprawling miniature metropolis constituted from recycled garbage collected for the artist by trash-pickers. These individuals make their living by scouring dumpsites in New Delhi to collect and sell recyclables – bricks, transistors, wire, bottles, cans, tape, cardboard, glass, tins, bags, and other odds and ends. India's poverty rate is 27.5 per cent, one of the highest in the world.[13] Sundaram's piece is a commentary on the hopeless social and economic marginalization of these trash-pickers, engaged in an industry of survival by recycling and selling the things others throw away.

Two further examples of socially concerned art using recycled or everyday materials fashioned into architectural structures reveal something of the range of work here. Burmese artist **Chaw Ei Thein**'s (b. 1969) architectural mixed-media installation, *September Sweetness* (2008), made for the Singapore Biennale in collaboration with Vietnamese artist Richard Streitmatter-Tran (b. 1972), is a 2.6-metre-high (8 ft 6 in.) pagoda created using 5.5 tons of raw sugar, the basis of a locally made mortar often used in the repair of eroding temples throughout Burma. The structure eroded over the duration of the exhibition as a metaphor for the breakdown of Burmese society under the military junta. Meanwhile, Chinese artist **Yin Xiuzhen** has made *Portable Cities*, an ongoing series (begun in 2001) of models of world cities inside suitcases, fabricated using local textiles and the old clothes of each city's residents. As Yin explains:

Chaw Ei Thein and Richard Streitmatter-Tran *September Sweetness* 2008
Installation view: Singapore Biennale, 2008
Sugar, 2.6 x 2.2 x 2.2 m (8 ft 6 in. x 7 ft 2 in. x 7 ft 2 in.)

like replica of the Taj Mahal in Agra. Her plastic-wrap palace is a fantasy object for our gaze.

Other artists treat the city itself as a kind of readymade, in a manner not dissimilar to taking found or fabricated objects, combining them or giving them another meaning or purpose. Photographic collages by Burmese artist **Aye Ko** (b. 1963) blend together views of street life in his home city of Yangon. The images are spliced into thin vertical strips and recombined to create composites. In a similar vein, **Chen Shaoxiong** (b. 1962) makes sculptural friezes of street scenes using cut-out photographic imagery of advertising signs, people, cars, bus stops, trees and buildings – some of which he takes back out into the streets and re-photographs in situ. Then there is the 'double vision' juxtaposition of **Rashid Rana**'s (b. 1968) installation *Desperately Seeking Paradise* (2008), an enormous, facetted, stainless-steel cube decorated with photographs of the buildings and street life in Lahore, the artist's home town. But the cube's varied surface also captures and combines reflections of the urban environments around the world in which the piece has been sited.

My work is concerned with examining the different social, cultural and geographical environments within which people live. Each of these different combinations of [material] elements produces a different architectural and urban texture.[14]

Beyond social commentary, the urge to recycle objects into art springs in part from the potential to create beauty from the mundane, visible in sculptures and installations by Indian-born, New York-based **Rina Banerjee** (b. 1963). Her work blends a medley of found materials that have variously included light bulbs, feathers, sari cloth, spices, tubing, Styrofoam, imitation plants, trash and flags. *In this wishing well, where pigment takes flight* (2005) is a kind of freestyle floral arrangement, pulling together with an aspiring acquisitiveness all and any materials that catch her eye. For Banerjee, cultural clichés can also be recycled. In *Taj Mahal* (2003), the artist used PVC piping and pink plastic wrap to create a tent-

Yin Xiuzhen *Portable City: New York* 2003
Suitcase, cloth, light, sound, 82 x 72 x 30 cm
(32¼ x 28⅜ x 11⅞ in.)

Rina Banerjee *Taj Mahal* 2003
PVC tube, plastic, 6 x 6 x 6 m (20 x 20 x 20 ft)

TOP Aye Ko *City Life* 2007
Digital print, 91.4 x 121.9 cm (36 x 48 in.)

ABOVE Chen Shaoxiong *The Third Street* 2001
Photo cut-collage, 30 x 30 x 1,000 cm (11⁷/₈ x 11⁷/₈ x 393⁵/₈ in.)

Rashid Rana *Desperately Seeking Paradise* 2008 (and detail)
C-print, stainless steel, 3 x 3 x 3 m (9 ft 8 in. x 9 ft 8 in. x 9 ft 8 in.)

ABOVE Junebum Park *1 Parking* 2001–2
Digital video: 5 mins, 25 secs

TOP Kuo I-Chen *Lost Contact* 2005
Video: 7 mins, 30 secs

The particular stimulation we gain from a bird's-eye view of a city is not only the pleasure in seeing something so big condensed into a more contained unity; it sometimes also engages us in a way that poses questions about urban existence. In Korean **Junebum Park**'s (b. 1976) videos of street environments, the artist pretends to manipulate the scenes by hand, like some omniscient creator. In *1 Parking* (2001–2), for which everything is shot from high above and played in fast forward, human hands perform a simulated choreography of the movement of all the vehicles and pedestrians in a bustling parking lot, as if to suggest unseen forces directing and dictating our lives. As the artist has said: 'I am interested in the structure of all life within what people call [their] environment.'[15] Taiwan's **Kuo I-Chen** (b. 1979) takes a similar bird's-eye perspective, though to an entirely different end. For the video *Lost Contact* (2005), he attached a wireless camera to a helium-filled balloon that was then released into the atmosphere. During its ascent, the camera continued to transmit images of the city streets below, but the higher it went the weaker the signal became: the transmission ended in static and eventually blackout. In this work, production values were subordinated to the gratification of the idea, the art serving as a point of entry into an alternative experience of the city: here, as if departing by plane, viewers experience the city melting away before their eyes, so that they lose contact with it just as the camera loses contact with the recording device on the ground.

In China, where in spite of economic liberalization official control over culture was never relinquished and contemporary art was largely barred from museums in the 1990s, experimental artists favoured performance art, which was temporary, could be staged anywhere and could harness a

Lin Yilin *Safely Maneuvering Across Lin He Road* 1995
Performance: 90 mins

range of meanings and purposes. **Lin Yilin** (b. 1964) belonged to an artist collective formed in 1990 in the southern Chinese city of Guangzhou, one of the Special Economic Zones where China's earliest urban renewal and economic reform started. As the artist stated: 'We were doing arts in a social laboratory.'[16] The Big Tail Elephant Group, which also included artists Xu Tan (b. 1957), Chen Shaoxiong and Liang Juhui (1959–2006), often took the city as both subject and material for artworks. For his 90-minute performance *Safely Maneuvering Across Lin He Road* (1995), Lin built a brick wall at the curb of a busy city street. Once the wall had been built, he started to move bricks, a few at a time, from one end of the wall to the other, gradually shifting the structure across the street. The traffic flow was disrupted as cyclists and motorists were forced to manoeuvre around the barrier. The critical nature of the artist's temporary wall lies in the way in which it intervenes in the fabric of the city, disturbing social equilibrium and encouraging public interaction.

Travelling back and forth between Asia and the West, many Asian artists have begun to adapt their ideas and concepts to the cities to which they travel. In New York, Sydney, Tokyo and other world cities, Thai artist **Navin Rawanchaikul** (b. 1971) interviewed local taxi drivers about their daily lives, a project that evolved out of the Navin Gallery Bangkok (1995–2000), for which he used a working Bangkok taxicab as a space in which to exhibit artworks by himself and others. He said: 'Taxi drivers see many things on their way, they know the city very well and they meet a large variety of passengers. The function of a taxi is a public function, but once you enter a taxi the relationship between yourself and the driver becomes a private one ... what interests me is the connecting point between the public and the private, and this is where I want to situate my art.'[17] From his conversations with taxi drivers in world cities, Rawanchaikul produced sound, text and image installations designed to stimulate a range of political and social discussions. He also created comic books featuring as characters people he met during the research process: these books were distributed to the public, free, in the back of the host city's taxis.

Several other Asian artists create unorthodox artworks beyond museum or gallery walls. The video *The Shortcut to the Systematic Life: City Spirits* (2005), made in London and Taipei, documents Taiwanese artist **Tsui Kuang-Yu** (b. 1974) pretending to perform various sporting activities in public.

Navin Rawanchaikul, in collaboration with Suttisak Phutararak
A Blossom in the Middle of the Heart (City) 1997
Installation view: Navin Gallery Bangkok, Bangkok

Navin Rawanchaikul, in collaboration with Yutaka Sone
At the End of All the Journeys 1998
Installation view: Navin Gallery Bangkok, Bangkok

Tsui Kuang-Yu *The Shortcut to the Systematic Life: City Spirits* 2005
Video: 4 mins, 50 secs

TOP Do Ho Suh *The Perfect Home II* 2003
Translucent nylon, 279.4 x 609.6 x 1,310.6 cm
(110 x 240 x 516 in.)

ABOVE Hiraki Sawa *Dwelling* 2002
Digital single-channel video on DVD: 9 mins, 20 secs

One segment shows him underarm bowling a ball into a plaza, treating a group of pigeons as if they were bowling pins. Another segment shows him waving a checkered flag in front of cars stopped at a city traffic light, as if to usher them across the finish line at the end of a race. In yet another segment, Tsui stands on a traffic island swinging a club as if he were on a golf course. This work uses humour to rupture the status quo and suggest new strategies of urban living through the reordering of public spaces.

For contemporary Asian artists who are resident abroad, the nature of home and ideas of shelter are recurrent themes. Dividing his time between New York and Seoul, Korean **Do Ho Suh** (b. 1962) collapses together ideas of public and private space in his replicas of the interiors in which he has lived, including his childhood home in Seoul and his apartment in New York. *The Perfect Home II* (2003) is a life-sized replica of Suh's tiny New York studio apartment. Hand-sewn from weightless, translucent fabric in light pastel colours, Suh's home appears as an atmospheric environment, as much a memory as an architectural reality. Immaterial, diaphanous, floating in the air like a ghost, this dream-like space is a metaphor for feelings of dislocation, displacement and alienation that are typical of the immigrant experience.

Living in London but moving back and forth to his native Japan, **Hiraki Sawa** (b. 1977) has made videos about the experience of cultural displacement. He has said: 'Through my work I try to capture this sense of being nowhere, living nowhere, living now right here.'[18] *Dwelling* (2002) is a short black-and-white video consisting of static shots of interior areas of the artist's tiny nondescript London apartment. Over this he superimposed animated imagery of toy airplanes taking off, cruising about and landing on tables, the floor, the kitchen countertop, bathtub, refrigerator and bed, complete with accurate shadows and a realistic airplane soundtrack. By reducing his apartment to an airport, Sawa gives a tangible form to his reality of living between cultures, as neither here nor there but hanging in mid-air somewhere in the migratory world of airline travel.

IMAGINARY CITIES

Recent predictions project that 70 per cent of the world's population will be city dwellers by the year 2050, with cities in Asia registering the biggest growth of any world region.[19] The reasons for this expansion in Asian cities are both practical and symbolic. In part, urban growth is a consequence of huge demographic shifts, as people across the region migrate from the countryside to cities for work. But it also has a symbolic dimension, for building skyscrapers has become a reflection of what has been popularly dubbed 'skyscraper competition', with an increasing competitiveness among Asian nations for the tallest building or the densest urban metropolis. As the urban geographer Larry R. Ford has observed: 'Just as Kuala Lumpur has sought to emulate (and surpass) Singapore, so too have some of the cities of China sought to be new and improved versions of Hong Kong.'[20]

What will the mega city of the future look like? It is a question that quite a few Asian artists have sought to provide answers to. Korean sculptor Bahc Yiso's (1957–2004) *World's Top Ten Tallest Structures in 2010* (2003) consists of ten models of what he believes will be the world's tallest buildings in the year 2010, some of them real, most of them fictitious, with little difference between them, suggesting the futility of the competition. For his *Urban Landscape* series, **Zhan Wang** (b. 1962) produced a miniature vision of his home city, Beijing, out of hundreds of stainless-steel kitchen implements, such as saucepans, teapots, woks, strainers, lunchboxes, cups, bowls, bain-maries, plates, cutlery, chopsticks, tongs, serving dishes and all kinds of trays. These are stacked and combined to resemble skyscrapers, apartment buildings and other structures. The net effect is a sparkling new futuristic city as a metaphor for the mercurial promises of re-urbanization in China. But, the artist implies, there is something hollow and soulless about these metropolises. The city is presented as being essentially the container for a social and cultural void.

One of the prices Asian countries are paying for their rapid urbanization and modernization is pollution. There is serious air contamination in many large cities, and the local tap water is unfit to drink. Some artists are making efforts to raise the

TOP **Zhan Wang** *Urban Landscape – Beijing Impression* 2002
Stainless-steel tableware, 700 x 700 cm (275¹/₂ x 275¹/₂ in.)

ABOVE **Oscar Oiwa** *Greenhouse Effect* 2001
Oil on canvas, 227 x 444 cm (89³/₈ x 174⁷/₈ in.)

level of social consciousness in this area, among them the Japanese-Brazilian artist **Oscar Oiwa** (b. 1965), whose painting *Greenhouse Effect* (2001) shows a city landscape filled with rubbish while the blazing sunset casts a red tint over everything. Here the city is a baking hot oven denuded of people. It is a terrifying vision of modern industrialization. People are also missing from Japanese artist **Ikeda Manabu**'s (b. 1973) *Ark* (2005), a painting showing a conglomerate of high-rise buildings packed together to form a closed island nation (perhaps as a metaphor for Japan) in a choppy sea – an ominous, dystopian vision of high-density living rendered in a quasi-traditional miniature painting style (*saimitsuga*). Modern urbanization is presented as isolating, dark and grim – with impassable streams and waterfalls running in and

between buildings stacked on top of one another, as if carved out of rock – but also as a form of dominance, power and control. For Ikeda, Japanese city life hovers between refuge and incarceration.

Playful and largely fictitious views of the metropolis that blur reality and fantasy characterize the photographic series *Location*, begun in 2005 by Korean **Yeondoo Jung** (b. 1969). He uses actors, prop-making techniques and scenery construction to create customized urban landscapes that combine both natural and artificial elements. *Location #4* (2005) shows a woman at night, observing a frozen waterfall emanating from the balcony of an apartment building. In *Location #8* (2006), a couple dance on the roof of a building that has been transformed into a stage, the city lights of Seoul gleaming in

Ikeda Manabu *Ark* 2005
Pen, acrylic ink on paper, mounted on board,
89.5 x 130.5 cm (35¹/₄ x 51³/₈ in.)

Yeondoo Jung *Location #4* 2005
C-print, 122 x 153 cm (48 x 60¹/₄ in.)

the background. Neither referential nor evidential, these photographs embody a kind of spatial fantasy in which imaging and imagining are tightly entwined. The spectator is asked to deconstruct the visual logic associated with an increasingly artificial urban environment.

Distinctions between the real and artificial are similarly obscured – and to some extent more palpably realized – in *Real World I #01* (2004), by **Back Seung-Woo** (b. 1973), one of a series of colour photographs made in a popular South Korean 'global' theme park, Aiinsworld, featuring miniatures of world-famous architectural structures such as St Basil's Cathedral, Brooklyn Bridge and the Arc de Triomphe, all visible against the skyline of Seoul. The photographs are

composed in such a way as to imitate traditional landscape paintings, with objects arranged sequentially to fill the fore, middle and background. This makes for disorienting juxtapositions, such as the sight of New York's Empire State Building looming over Osaka Castle. For the artist, the images are about urban spectacle, distraction and consumption, serving as a metaphor for South Korea's desire to play a part in global cosmopolitanism.

National ideals and aspirations underlie the work of **Alexander Ugay** (b. 1978), a photographer from Kazakhstan who reflects on the way in which this vast oil-rich Central Asian country is getting a twenty-first-century makeover following its political independence from the Soviet Union

Back Seung-Woo *Real World I #01* 2004
Digital print, 127 x 169 cm (50 x 66½ in.)

in 1991. Ugay's panoramic digital print, *Paradise Landscape* (2004), made in collaboration with fellow Kazakh Roman Maskalev (b. 1977), combines the conventions of Soviet-era Social Realist propaganda painting with the format of Chinese hand scrolls to offer a tongue-in-cheek view of Kazakhstan as a cheerful, untouched, rural landscape of fields filled with smiling peasants and exotic animals grazing. It is pure fiction – a stark contrast to the local treatment of the landscape in reality as an exploitable natural resource and the massive development projects that are taking place nationwide, such as the rebuilding of Astana, now the country's capital.

Decorative depictions of nature have a long history in traditional Japanese art. For today's Japanese artists, however, the depiction of nature is elliptical, and often takes the form of objects and installations that emphasize the physical and visual properties of materials and are anchored in an ecological consciousness. **Yoshihiro Suda** (b. 1969) and **Yutaka Sone** (b. 1965) problematize ideas of nature and landscape in an increasingly urban and post-modern society. Suda's diminutive, naturalistic sculptures of flowers and plants are hand-carved from pieces of soft magnolia wood, painted to resemble the real thing, then placed in unexpected areas around a gallery or museum. What is communicated here is both the theme of nature as poeticized but deliberately constructed, as well as the passing of time, expressed through the relationship between a durable material (wood) and a

ABOVE Alexander Ugay, in collaboration with Roman Maskalev
Paradise Landscape 2004
Digital print on canvas, 75 x 480 cm (29¹/₂ x 189 in.)

TOP Yoshihiro Suda *Rose* 2008
Installation view: PKM Gallery, Seoul
Paint on wood

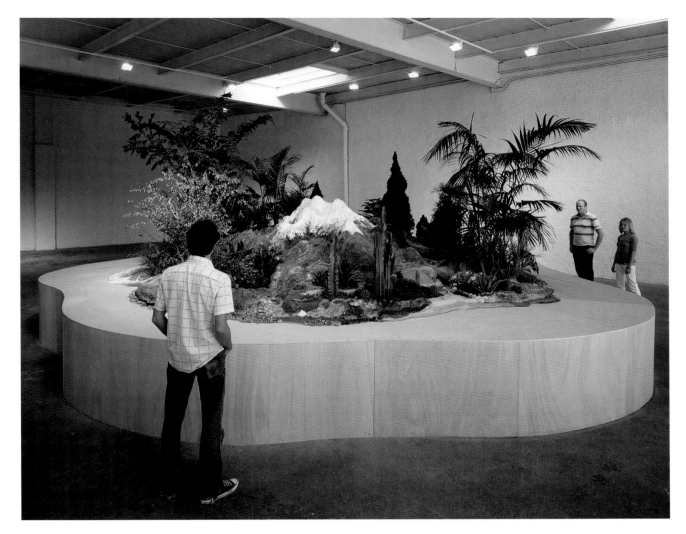

TOP **Yutaka Sone** *It Seems Like Snow Leopard Island* 2002–6
Installation view: David Zwirner, New York, 2006
Island: paper, wood, sponge, seaweed, papier-mâché,
polyurethane, paint, pump, tube, live plants, soil.
Pedestal: wood. 944.9 x 868.7 x 370.8 cm (372 x 342 x 146 in.)

transient subject (such as flowers). Suda's theme of nature as imperiled and increasingly artificial is echoed in Sone's conceptually inclined installation, *It Seems Like Snow Leopard Island* (2002–6), a self-contained environment in the form of a more than 9-metre-wide (31 ft) fake 'island' with trees and plants as a miniature imaginary habitat for the endangered snow leopard. The work is designed to inspire a sense of quietude and introspection.

Working with new media, younger Japanese and Korean artists challenge the natural order of things. The Japanese artist **Odani Motohiko**'s (b. 1972) video *Rompers* (2003) envisions a futuristic Garden of Eden, gone awry, inhabited by a genetically altered girl with yellow reptilian eyes and pointed ears, sitting on a tree branch communing with birds. This new world is premised on genetic mutation. As Odani explains: 'It is outwardly saccharine but inwardly extremely dark.'[21] The girl is singing happily, detached, yet every now and then swatting a passing insect with a long lizard-like tongue. In a similar vein, the Korean **Choe U-Ram** (b. 1970) makes hybrid robotic creatures that light up and move. *Echo Navigo* (2004) is a fish-like organism with mechanical fins that, according to the artist, inhabits the bowels of cities. We are witness here to the unfolding of another stage in evolution, and, in our wonder, are made conscious of our own redundancy. For the artist, it is the lot of mankind to be brought to the lonely conclusion that we are now obsolete.

Odani Motohiko *Rompers* 2003
Video: 2 mins, 52 secs

Choe U-Ram *Echo Navigo, Scientific Name: Anmorome Istiophorus platypterus Uram* 2004
Etched stainless steel, aluminium, painted fibreglass, circuits; motors, CPU board, cable, custom software, 56 x 232 x 53 cm (22 x 91³/₈ x 20⁷/₈ in.)

epilogue

A GLIMPSE INTO THE FUTURE

We began this book with an examination of the sources and precursors of contemporary Asian art, from Yoko Ono, Nam June Paik, Yayoi Kusama and the artists associated with Gutai to the post-independence movements in South and Southeast Asia. The chapters that followed explored the ways in which artists have collectively addressed a range of issues – the refiguring of long-held traditions, the embrace of popular culture, reconstruction of the urban environment and, perhaps most revealingly, the interrogation of society and the state. As we have seen, one of the most compelling characteristics of recent Asian art is that it reflects anxieties, tensions and issues that are socially, politically and geographically specific. But there is a paradox here: though contemporary Asian art is rooted in the basics of daily life in the region, a wider international discourse on art is essential to it, for an engagement with the larger world has helped it to grow and deepen. Art that began as a celebration of the deepest local specificities has taken its place at the centre of a new global art world.

Throughout this book, we have limited our discussion to conventional art objects. But in light of advances in technology, the expansion of the internet, plus the widespread familiarity of computers and video games to a new generation of artists, art and the art experience are undergoing rapid transformation. It can be argued that Asian artists have been at the forefront of extending this development internationally, if only for the reason that the region has long been a centre for technological innovation and manufacturing of advanced electronic devices. Moreover, during the past decades, Asian artists – primarily Japanese, Taiwanese and Korean, but increasingly also Chinese – have produced a powerful body of work embracing all forms of new technology, from the installations with LED digital counters by Tatsuo Miyajima in the 1980s to the digital video-based techno-spiritual shamanism of Mariko Mori in the 1990s, as well as the work by artists from several countries today who exploit the access provided by the internet to present their work to audiences around the world. What follows is a discussion of some recent online art projects as a glimpse into the future of contemporary art – further into the twenty-first century, if you will – and a look at the role that contemporary Asian artists might play.

Some of the first exclusively internet-based art was produced in Japan, where artists were quick to see the potential of technological changes resulting from computerization. Candy Factory, for example, was a Japanese alternative gallery that also orchestrated collaborative web-based art projects. It was established in 1998 by Takuji Kogo (b. 1965) and based

in an old Yokohama candy factory. Kogo closed the gallery in 2001, but 'Candy Factory Projects', his latest initiative, has continued to produce collaborative online art using repeated, looped or mirrored segments of imagery, often found on the internet and overlaid with text and music. For *A CANDY FACTORY PROJECT/ Cute or Creepy?* (2006), a commentary on dating, a computerized voice sings the text of anecdotes and questions scrolling over the screen against a suburban backdrop. Questions include: 'How do you get rid of a stalker?' or 'How would you react if you found your girlfriend had a weblog?' It is a cross between Karaoke TV and an online chat room. Other works poke fun at advertising and corporate culture. *A CANDY FACTORY PROJECT/ FWD: Your Future Is Just One Call Away* (2006) is a short video of people waiting in a line, overlaid with text and sound. Texts like 'Make a change in your life!' and 'Are you going through life without a degree?' flash across the screen in a parody of email advertising for promises of a new life through higher education.

The possibilities for social commentary through online art are also of importance to Shilpa Gupta (b. 1976), an Indian artist who makes work using interactive websites while drawing on the codes and conventions of what she likes to refer to as 'the global language' of advertising.[1] In 2003, she launched an online site called blessed-bandwidth.net. Linked to the website of London's Tate, Gupta's site offered viewers 'blessings' gathered from Hindu and Buddhist temples or

Christian churches around her hometown of Mumbai as a satire of the Indian obsession with religion in everyday life. Imagery on the site showed the artist travelling to shrines to have her network cable blessed. Other interactive projects have dealt with the trade in human organs. Gupta's multimedia installation at Oxford Bookstore in Mumbai, *Your Kidney Supermarket* (2002–3), consisted of displays of imitation kidneys installed in cases and a sales video, instruction manual and website that provided prospective buyers with shopping options for new kidneys. Following on from this was the internet-based *Xeno-Bio-Lab.com* (2003), where viewers could read advertisements for self-guided organ-buying tours to India and China, and even select and order an organ online.

Elsewhere in India, the Raqs Media Collective, formed in New Delhi in 1992 by Jeebesh Bagchi (b. 1965), Monica Narula (b. 1969) and Shuddhabrata Sengupta (b. 1968), have collaborated on films, video, computer, sound and web-based art projects, much of which is posted free on their website. *The Network of No_des* (2004) is an artwork created in html with sound and images, designed to be viewed online. The work begins with a newspaper clipping describing the raid and seizure in a New Delhi residential suburb of a stash of pirated films, music and software. As our cursor scrolls across the article, some words become portals to other html pages, and these are in turn linked to other texts, photographs, films and videos. Fragments of existing, often random, information are

Takuji Kogo *A CANDY FACTORY PROJECT/ Cute or Creepy?* 2006
Digital projection

Takuji Kogo *A CANDY FACTORY PROJECT/ FWD: Your Future Is Just One Call Away* 2006
Digital projection / Web-based work

woven together to create a new online entity and interface, which the artists call an 'info-face'.[2] On one level the work is about the thriving, clandestine trade in information goods, but on another level it speaks to the ways in which information-sharing and remixing are necessary for the production of knowledge and culture.

Chinese artists are also interested in the possibilities of new web tools. Cao Fei (b. 1978) has posted video art on YouTube in an effort to reach a wider audience. As she explains: 'On places like YouTube there is the potential for people just browsing videos at random to come across my work. Interacting with the audience holds a lot of interest for me.'[3] She also makes art in the online world Second Life, an alternative reality for internet users since 2003, which allows them to travel about and live virtual lives as avatars – owning land, building homes, buying and selling goods, and other activities, all done in cyberspace. The software's creator, Linden Lab, states that it has more than 20 million registered user accounts. It has proven so popular that companies are using it to hold virtual employment interviews, training sessions and sales meetings. Cao's video *i.Mirror by China Tracy (AKA: Cao Fei) Second Life Documentary Film* (2007) is an impressionistic work centering on the activities of her Second Life avatar, China Tracy, a woman with glistening white-and-red body armour who travels Second Life observing people and places. The video documents her wanderings in virtual

reality. For her latest, highly ambitious work, Cao has continued to focus on Second Life, where she has built a virtual city as an ironic look at the pace of construction and change in China. Called *RMB City* (2007) – the title being an abbreviation of *renminbi*, China's currency – it features a fictional Chinese city of colourful buildings massed together to form a small, densely developed island. In an arrangement similar to a 'real-world' lease, investors in her project gain two years' 'access' to a virtual space.

The free, ubiquitous access and the relative instantaneity of the internet – as opposed to the time it takes to visit a museum – are two of its primary strengths. The same

Lightning Raid in Basement

By Staff reporter
New Delhi

A raid on a basement in New Delhi's quiet middle class residential colony of Old Rajendra Nagar led to the seizure of pirated films, music, software and other materials worth hundreds of thousands of dollars in Indian Rupees on CDs, DVDs, MP3s and books. Latest Bollywood and Hollywood hits and other material, with pirated master editions from Malaysia, China, Pakistan and Dubai, were found in the possession of the youths running the operation. A large quantity of pornographic materials and CDs was also found on the premises, as were MP3s of latest hit songs and portions of reputed medical, law and computer science textbooks, along with CDs containing downloaded files of unreleased editions of the Harry Potter series by world famous author J K Rowling.

The Economic Offences Wing of the Crime Branch, Delhi Police had in a sting operation penetrated the basement of the house and caught a group, including the operator of a nearby Cybercafe, red handed in the act of illegal downloads and burns. This operation had been filmed using hidden cameras.

Pirated CDs confiscated in the basement, and a vicious network is unearthed

Subsequent interrogations and questioning have led to raids, seizures and arrests on similar hideouts in Karol Bagh, Seemapuri, Madipur, the notorious piracy markets in Palika Bazaar and Nehru Place, and as far as Meerut. Two Motorcycle riding couriers with caches of DVDs were also nabbed after hot pursuit in the act of transporting pirated material from the location.

The Anti Piracy Cell of the Intellectual Property Regulation Organization For India's Tomorrow (IPROFIT) has congratulated the law enforcement agencies involved in the operation. In a message, a spokesperson of IPROFIT thanked the brave anti piracy officers and said that "pirates are social vermin who must be smoked out of their lairs and crushed. Let no basement in Delhi go unsearched in the drive to protect the nation's wealth".

Links to contraband telephony, revenue stamp forgery, the illicit smuggling of mobil oil and automobile parts, as well as terrorism and cybercrime are not being ruled out. A large quantity of computer equipment, CD burners and writers, discs and scanners have been seized and the premises have been sealed. The investigative authorities are following all leads.

TOP Shilpa Gupta *Your Kidney Supermarket* 2002–3
Video and interactive installation

ABOVE Raqs Media Collective, with Iram Ghufran and Joy Chatterjee (Sarai Media Lab) *The Network of No_des* 2004
HTML + video + images + text

qualities attracted Seoul-based web-art duo YOUNG-HAE CHANG HEAVY INDUSTRIES, made up of American Marc Voge and Korean Young-Hae Chang. Through their website – www. yhchang.com – and other venues, they distribute text-based animation composed with Adobe Flash. Synchronized to music, usually jazz, motion-text graphics on black-and-white backgrounds sequentially flash over the screen in a language of the viewer's choosing. Sometimes the texts are witty, complex and evocative, even narrative-based, so that we do not need to decipher the meaning or purpose of the stories; other pieces are deliberately elliptical, ensuring that the viewer must participate in constructing the narrative. Little of the work can be defined on uniform formal lines, for it is part poetry, part graphic design and part musical improvisation.

What does the work of Candy Factory Projects, Shilpa Gupta, the Raqs Media Collective, Cao Fei and YOUNG-HAE CHANG HEAVY INDUSTRIES have to tell us about what contemporary Asian art is going to look like over the next ten, twenty, fifty years? And as the world becomes increasingly connected online, will it still be possible to speak of art from Asia as a separate and discreet category? As we begin the twenty-first century, there is no reason to think that the dynamic processes of transnational interconnection will not continue. With greater exchange of ideas and information through new technologies, art will carry on evolving, which is not to say that traditional forms such as painting will be swept away, but that there will be an even greater diversity of creative practices, visions and forms. The web is but one addition, providing an ephemeral if fundamentally democratic platform for artists to create and exhibit work. Still, there will always be cultural specificity to the work of artists in Asia, just as for artists elsewhere.

It is important, also, not to overstate the impact of new technologies and the internet on art and artists in the region. Despite a widespread proliferation of digital media, not everyone shares an enthusiasm for – or, more importantly, access to – the networked world. Salima Hashmi has described the context of the art scene in Pakistan (and by extension, we

HEY, SO I'VE ALWAYS ASSUMED IT MEANS *KISS ME A LOT.* WHAT ARE YOU PLANNING TO DO, SHOOT ME? GUYS?

would argue, other Asian nations), which helps to distinguish the art that is produced there:

> As the edges of visual practice blur, crafts and 'low-tech' options are the preference in Pakistani art. While artists such as Rashid Rana and Aisha Khalid have ventured into video, such explorations are, on the whole, sparse. The erratic power supply may be a practical reason, but the lure of addressing the community through familiar forms might be a more probable one.[4]

Perhaps what this suggests is that Asian art will remain sensitive to the effects, on the one hand, of globalization, and, on the other, of local issues and concerns.

The aim of this book has not been to exhaustively survey new art in Asia, but rather to establish a discursive framework for a dynamic, burgeoning field. We have examined the work of artists whose interests have led them to experimental and hybrid forms, and whose efforts have brought international attention to the contemporary art of this vast region. This art makes visible the transformations – as well as the misapprehensions – of life in Asia today, not only for Asian audiences but increasingly for the rest of the world as well.

YOUNG-HAE CHANG HEAVY INDUSTRIES
BLACK ON WHITE, GRAY ASCENDING 2007
Seven-channel synchronized HD QuickTime movies, each display 165 cm (65 in.). Original texts and music soundtrack, 11 mins, 32 secs

Tuan Andrew Nguyen *Hip Hop History Sampling Hip Hop History:*
The Red Remix 2008
Bicycle, speaker, music player, electric components, digital print,
40 x 50 cm (15 3/4 x 19 5/8 in.)

ARTIST BIOGRAPHIES

Biographies of selected artists written by
Melissa Chiu, Jacqueline Ganem, Benjamin
Genocchio, Maria Carmelina Howell, Sohl Lee,
Valentina Riccardi, Miwako Tezuka, Taliesin
Thomas, Daisy Yiyou Wang and Hyewon Yi.

Artists are listed by family name.

Lida ABDUL
b. 1973, Kabul, Afghanistan; lives in Los Angeles,
USA, and Kabul

Abdul studied at California State University,
Fullerton, graduating with a BA in political
science in 1997 and a BA in philosophy in 1998.
She received her MFA from the University of
California, Irvine, in 2000. Her videos, films,
photographs, installations and performances are
informed by her forced emigration from Soviet-
occupied Afghanistan in 1987. Recent videos,
such as *In Transit* (2008), explore the greater
human and material dimensions of this war-
torn area. Abdul has had a number of solo
exhibitions and film screenings, including
presentations at the Kunsthalle Wien, Austria
(2005); Museum voor Moderne Kunst Arnhem,
Netherlands (2006); Museum of Modern Art,
New York (2007); and Isabella Stewart Gardner
Museum, Boston (2008). She has also shown
her work in many group exhibitions in Central
Asia, Europe and the United States, including
'Contemporaneity' at the Academy of Fine
Arts, Tashkent, Uzbekistan, and Museum of
Fine Arts, Bishkek, Kyrgyzstan (2004); 'Now,
Here, Over There', Fonds Régional d'Art
Contemporain Lorraine, Metz, France (2006);
'Global Feminisms', Brooklyn Museum, New
York (2007); and 'Moving Perspectives: Lida
Abdul and Dinh Q. Lê', Arthur M. Sackler
Gallery, Smithsonian Institution, Washington,
DC (2008). She has participated widely in
biennials, including the 2nd Central Asian
Biennale, Bishkek, Kyrgyzstan (2004); 28th São
Paulo Biennial, Brazil (2006); and 6th Gwangju
Biennale, Korea (2006). She also took part in
the 3rd Auckland Triennial, New Zealand
(2007). She received the Taiwan Award at the
Venice Biennale of 2005, and the Pino Pascali
Award and Prince Claus Award in 2006. [JG]

Ai Weiwei
b. 1957, Beijing, China; lives in Beijing

Ai studied at the Beijing Film Academy, and
in the late 1970s became a founding member
of The Stars (*xing xing*), one of the first
experimental art movements in China. He
moved to New York in 1981, studying at Parsons
School of Design, then returned to Beijing in
1993. In addition to creating artwork, he has
curated exhibitions, including – with Feng Boyi
– the controversial 'Fuck Off' at the Eastlink
Gallery, Shanghai, China (2000). He has also
designed architecture, working with architects
Herzog & de Meuron on the National Stadium
for Beijing's 2008 Olympics, though he
withdrew from the project shortly before the
opening. His best-known works feature Chinese
antiquities, and he has shown extensively in the
United States, Belgium, Italy, Germany, France,
Australia, China, Korea and Japan. His work
was featured at the 48th Venice Biennale, Italy
(1999); 15th Biennale of Sydney, Australia
(2006); and Documenta 12, Kassel, Germany
(2007). [MC]

AIDA Makoto
b. 1965, Niigata, Japan; lives in Chiba, Japan

Aida received his MA in painting from Tokyo
National University of Fine Arts and Music in
1991, but works with a variety of media. He
often deals with sensational themes, such as
obsession with young girls, sex, war and graphic
violence, cynically exposing widespread social
ills in contemporary society. He was one of the
founding members of The Group 1965, which
played a crucial role in the development of the
1990s Japanese art scene. His work has been
shown in many exhibitions, including 'The
Group 1965: The Voices from Tokyo', Galeria
Metropolitana de Barcelona, Spain (1997);
1st Yokohama Triennale, Japan (2001); 'The
American Effect: Global Perspectives on the
United States, 1990–2003', Whitney Museum
of American Art, New York (2003); 'GUNDUM
Generation Futures', Suntory Museum,
Osaka, Japan (2005); 'Art de Sauro: Aida
Makoto/Yamaguchi Akira', Ueno Royal

Museum, Tokyo, Japan (2007); 'Thermocline
of Art: New Asian Waves', ZKM, Karlsruhe,
Germany (2007); and 'Heavy Light: Recent
Photography and Video from Japan',
International Center of Photography, New
York (2008). [MT]

Zahoor ul AKHLAQ
b. 1941, New Delhi, India; d. 1999

Akhlaq studied at the National College of Arts,
Lahore, from 1958 to 1962. After graduation,
he became an influential teacher of painting
at the school, mentoring numerous young
Pakistani artists. In the 1960s he also received
a number of scholarships which led him to
study abroad. From 1984 to 1992 he was head
of the department of fine arts at NCA. He
participated in numerous exhibitions, including
'Out of Pakistan', Northeastern University,
Boston (1995); 47th Venice Biennale, Italy
(1997); and 'Zahoor ul Akhlaq: A Retrospective
1961–1998', Gallery NCA, Lahore (1998). [MT]

Vyacheslav AKHUNOV
b. 1948, Osh, Kyrgyzstan; lives in Tashkent,
Uzbekistan

Akhunov studied art at the W. I. Surikow State
Art Institute in Moscow, Russia. Considered by
his fellow artists during the Soviet era to be an
'official anti-official artist', he has continuously
explored the question of power relations. He
works in various media, including performance,
installation and painting. His *Cage for Leaders*
(2000) is an installation of 250 polystyrene
busts of Lenin, all enclosed in a cage. In his
single-channel video *Cleaner* (2007), he
painstakingly uses a toothbrush to clean the
surfaces of national monuments in London,
England. In collaboration with artist Sergey
Tychina, he has also worked in video art since
2000, exhibiting works in the Central Asian
Pavilion at the 51st Venice Biennale, Italy (2005);
3rd Auckland Triennial, New Zealand (2007);
and 'I Dream of the Stans: New Central Asian
Video', Winkleman Gallery, New York (2008).
[SL]

Navjot ALTAF

b. 1949, Meerut, India; lives in Mumbai, India

Altaf received a diploma from the Sir J. J. School of Art, Mumbai, in 1972. She has worked in painting, lithography, film and installation, addressing social, political and ecological issues. Her work has been shown in numerous solo exhibitions, including at the Sakshi Gallery and Guild Gallery, Mumbai, and the Talwar Gallery, New York. She has also participated extensively in biennales and group exhibitions in India and internationally, including the 1st International Biennale of Prints, São Paulo, Brazil (1985); Intergrafik 87, Berlin, Germany (1986); '50 Years of Mumbai Artists', National Gallery of Modern Art, Mumbai (1998); 1st Fukuoka Asian Art Triennale, Japan (1999); 'A-ORTA-Projekt: Contemporary Indian Art', BBK Kunst Forum, Düsseldorf, Germany (2001); 'Century City: Art and Culture in the Modern Metropolis', Tate Modern, London, England (2001); 'Zoom: Art in Contemporary India', Edificia Sede da Caixo, Garal de Depositos, Lisbon, Portugal (2004); 'Bombay: Maximum City', Lille, France (2006); 15th Biennale of Sydney, Australia (2006); 'India: Public Places, Private Spaces', Newark Museum, New Jersey (2007); and 'India Art Now: Between Continuity and Transformation', Milan, Italy (2007). Recently, she has organized site-specific educational projects in rural communities of Chhattisgarh (Central India). Her various honours include the All India Fine Arts and Crafts Society Award (1983). [JG]

Chumpon APISUK

b. 1948, Nan Province, Thailand; lives in Bangkok, Thailand

Performance artist Apisuk received art training at Changsilpa School of Art and Silpakorn University in Bangkok in the 1960s. From 1973 to 1976 he studied at the School of the Museum of Fine Arts, Boston. Since the 1980s, he has played a leading role in promoting performance art in Thailand. His performances, characterized by community involvement and strong socio-political content, correspond to his activism in AIDS, human rights and advocacy for the rights of sex workers in Thailand. Since 1996, he has performed in Asia, North America, Europe and Australia. He is also a founder and director of 'Asiatopia' – an international performance art festival launched in Thailand in 1998. [DYW]

ARAHMAIANI

b. 1961, Bandung, Indonesia; lives in Jakarta and Bandung, Indonesia

Arahmaiani studied art at Bandung Institute of Technology; College of Fine Arts, Sydney, Australia; and Akademie voor Beeldende Kunst en Vormgeving, Enschede, Netherlands. Her installations and performances are often politically charged, especially around gender issues. Her works have been included in the 2nd Asia-Pacific Triennial of Contemporary Art, Queensland Art Gallery, Brisbane, Australia (1996); 6th Havana Biennial, Cuba (1997); 5th Lyon Biennale, France (2000); 26th São Paulo Biennial, Brazil (2002); 4th Gwangju Biennale, Korea (2002); and in the Indonesian Pavilion, 50th Venice Biennale, Italy (2003). [MC]

BACK Seung-Woo

b. 1973, Daejon, Korea; lives in Seoul, Korea, and London, England

Back studied photography at Chung-Ang University, Korea, before furthering his education in fine art and theory at Middlesex University, London, England. He is best known for two projects: *Real World* (2004–6), a series of photographs taken at a South Korean theme park, and *Blow Up* (2005–7), a series of large-scale photographs shot during his visit to Pyongyang, North Korea, in 2001. He has had solo shows in Tokyo, Seoul, Paris and Frankfurt. He won the Grand Prize for the Photography Critics' Award, iphos Photospace/Sports Chosun, Korea (2001), and was cited for Best Portfolio at the Bratislava Photography Festival, Slovakia (2005). His work has been shown at Fotografie Forum International, Frankfurt, Germany (2005); Wimbledon School of Art, London, England (2006); Seoul Museum of Art, Korea (2007); Cité Internationale Arts, Paris, France (2008); Artsonje Center, Seoul (2008); 3rd Moscow Biennale of Contemporary Art, Russia (2009); and Mexico Biennial of Photography, Mexico City (2009). [HY]

Chinatsu BAN

b. 1973, Tokoname, Japan; lives in Tokyo, Japan

Ban graduated from Tama Art University, Tokyo, with a degree in oil painting. She is one of the artists in Takashi Murakami's company Kaikai

Kiki. Frequent motifs in her work are young girls, animals and underwear, rendered in a childlike style in pastel colours. Ban has had solo exhibitions at Modern Art Museum of Fort Worth, Texas (2006), and Parco Factory, Tokyo, Japan (2009). She has also been included in several group exhibitions, including 'Hiropon Show 2: Yokai Festival', Museum of Contemporary Art, Tokyo (2001); 'Little Boy: The Arts of Japan's Exploding Pop Culture', Japan Society, New York (2005); and 'Red Hot: Contemporary Asian Art Rising', Museum of Fine Arts, Houston, Texas (2007). [MT]

Rina BANERJEE

b. 1963, Kolkata, India; lives in New York, USA

Banerjee received a BS in polymer engineering from Case Western Reserve University in 1993, and an MFA in painting and printmaking from Yale University in 1995. She is known for transforming a range of culturally specific imagery into drawings, sculptures, installations and videos. Her work has been widely exhibited in the US, as well as Europe and Asia, including solo exhibitions at VOLTA, Basel, Switzerland (2006); Galerie Nathalie Obadia, Paris, France (2006); Galerie Volker Diehl, Berlin, Germany (2007); and Tokyo Wonder Site, Shibuya-Tokyo, Japan (2007). She has participated in numerous biennials and group exhibitions, including the 70th Whitney Biennial, New York (2000); 'Open House: Working in Brooklyn', Brooklyn Museum of Art, New York (2004); 'The Greater New York Show', PS1/Museum of Modern Art, Queens, New York (2005); 'Agra', Peabody Essex Museum, Salem, Massachusetts (2005); 'Fatal Love: Exhibition of South Asian Contemporary Art Now', Queens Museum of Art, New York (2005); Tsumari-Echigo 3rd Triennial, Japan (2006); and 'Distant Nearness', Nerman Museum of Contemporary Art, Kansas City (2008). [JG]

Farida BATOOL

b. 1970, Lahore, Pakistan; lives in Lahore

Batool received a BFA from the National College of Arts, Lahore, in 1993, and an MA from the College of Fine Arts, University of New South Wales, Australia, in 2003. She has taught at the National College of Arts, Lahore, and the Beaconhouse National University, Lahore. She is also an activist, author, curator and

producer of short films, and has conducted several community-based projects with a focus on empowering women in Bangladesh, India, Pakistan and Portugal. Recently she has worked in lenticular prints, such as *Line of Control* (2004), with its references to the 1947 Partition and subsequent Indo-Pakistan wars. She has participated in a number of group exhibitions, including the 9th Cairo Biennale, Egypt (2003); 'Artists Beyond Boundaries', Kudos Gallery, Sydney, Australia (2004); 'Beyond Borders: Art of Pakistan', National Gallery of Modern Art, Mumbai, India (2005); and 'Desperately Seeking Paradise', Art Dubai (2008). In addition to competitive educational scholarships, she has received the Jang Talent Award (1994). [JG]

Montien BOONMA
b. 1953, Bangkok, Thailand; d. 2000

Boonma studied painting at Silpakorn University, Bangkok (1974–78), before moving to Europe, where he studied sculpture at the École Nationale Supérieure des Beaux-Arts, Paris (1986–88) and Maîtrise Nationale en Arts Plastiques, Université de Paris VIII, Faculté d'Arts Plastiques, Saint Denis (1986–89). On returning to Thailand, he began to show his work internationally, including at the 45th Venice Biennale, Italy (1993); 1st Asia-Pacific Triennial of Contemporary Art, Queensland Art Gallery, Brisbane, Australia (1993); 4th Istanbul Biennial, Turkey (1995); 'Contemporary Art in Asia: Traditions/Tensions', organized by the Asia Society, New York (1996); 1st Fukuoka Asian Art Triennale, Japan (1999); and 3rd Shanghai Biennale, China (2000–1). Posthumously his work was featured in the 4th Asia-Pacific Triennial of Contemporary Art, Australia (2002); 'Montien Boonma: Temple of the Mind', Asia Society Museum, New York, travelling to Asian Art Museum, San Francisco, and National Gallery of Art, Canberra, Australia (2003–4); 'Montien Boonma: Death Before Dying', National Gallery of Art, Bangkok, Thailand (2004); and in the Thai Pavilion, 51st Venice Biennale, Italy (2005). [MC]

Faiza BUTT
b. 1973, Lahore, Pakistan; lives in London, England

Butt received a BFA from the National College of Arts, Lahore, in 1993 and an MFA from the

Slade School of Fine Art, London, England, in 1999. In 2001 she also earned a teaching certificate from the Institute of Education, University of London. Her work is informed by cross-cultural, media-generated images that are rendered in highly variable painting techniques that reference both Indo-Persian miniatures and Western abstraction. She has primarily shown her work at galleries in Pakistan, South Africa and the UK. Her participation in group exhibitions includes 'Beyond Borders: Art of Pakistan', National Gallery of Modern Art, Mumbai, India (2005); 'it's still hard being British-I, but where are you really from?' (with Naeem Rana), Cartwright Hall Art Gallery, Bradford, England (2005); 'Desi Pop', Maison Folie, Lille, France (2006); inaugural exhibition, National Art Gallery, Islamabad (2007); Hong Kong International Art Fair, presented by Green Cardamom, London (2008); and 'Desperately Seeking Paradise', Art Dubai (2008). [JG]

CAI Guo-Qiang
b. 1957, Quanzhou, China; lives in New York, USA

Cai was trained in stage design at the Shanghai Drama Institute. Drawing on a wide variety of symbols, narratives, traditions and materials, he is best known for his ambitious explosion events entitled *Projects for Extraterrestrials*. He quickly achieved international prominence after a move to Japan (he went to the US in 1995). His work has been shown widely around the world, including at the Shanghai Art Museum, China (2002); Tate Modern, London, England, and Bunker Museum of Contemporary Art, Taiwan (2004); Metropolitan Museum of Art, New York (2006); and Guggenheim Museum, New York (2008). He was Director of Visual and Special Effects for the opening and closing ceremonies of the Beijing Olympics in 2008. His numerous awards include the Golden Lion at the 48th Venice Biennale, Italy (1999); Best Monographic Museum Show and Best Installation or Single Work in a Museum from the International Association of Art Critics, New England (2005); and 7th Hiroshima Art Prize (2008). [TT]

CAO Fei
b. 1978, Guangzhou, China; lives in Beijing, China

Cao studied at the Guangzhou Academy of Fine Arts and is best known for her photographs and

video work. Her recent project in 'Second Life' has made her one of the first artists to work in the new virtual world. Her solo exhibitions include a show at Para/Site Art Space, Hong Kong (2006), and her group exhibitions include 'Reinterpretation: A Decade of Experimental Chinese Art', 1st Guangzhou Triennale, China (2002); 'Alors, La Chine?', Centre Pompidou, Paris, France (2003); 'Z.O.U (Zone of Urgency)', 50th Venice Biennale, Italy (2003); 'Between Past and Future: New Photography and Video from China', International Center of Photography and Asia Society, New York (2004); 1st Moscow Biennale of Contemporary Art, Russia (2005); and 15th Biennale of Sydney, Australia (2006). [MC]

CAO Xiaodong
b. 1961, Lian Yungang, Jiangsu Province, China; lives in Beijing, China

Cao graduated from the Industry Design College at Jiangnan University in 1982, and was a member of Red Trip, an art group located in Jiangsu Province. His early works concentrated primarily on oil painting. In 1991 he launched a magazine, *Art Currents*, followed a year later by a series of books entitled *Culture and Art Forum*. He has presented his work extensively in China, including: 'First Stop Exhibition', Nanjing (1987); 'China Modern Art Exhibition', Beijing (1989); 'Images Telling Stories: Chinese New Concept Photography Exhibition', Shanghai (1998); 'Abstract 798', Beijing (2006); 'Sunshine', Beijing (2007); and 'Predicament', Shanghai (2007). Outside of China, his paintings have been presented in several exhibitions, including 'Revolution', ChinaSquare, New York (2007) and 'SAVE AS: Contemporary Chinese Art featuring Cao Xiaodong and Li Xiaofeng', ArtSpace/Virginia Miller Galleries, Miami (2008). [MCH]

CHEN Chieh-Jen
b. 1960, Taoyuan County, Taiwan; lives in Taipei, Taiwan

Although Chen began his career in performance art in the 1980s, his work is now almost exclusively in video art and film. His works have been shown in various international exhibitions, including 'Routes', 24th São Paulo Biennial, Brazil (1998); 5th Shanghai Biennale, China

(2004); 'The Experience of Art', Italian Pavilion, 48th Venice Biennale, Italy (2005); 6th Gwangju Biennale, Korea (2006); 4th Liverpool Biennial, England (2006); and 3rd Guangzhou Triennial, China (2008). Solo exhibitions include shows at the Asia Society Museum, New York (2007), and Reina Sofia, Madrid, Spain (2008). He was awarded the Special Prize at the 3rd Gwangju Biennale (2000). [MC]

CHEN Shaoxiong
b. 1962, Shantou, China; lives in Guangzhou, China

Chen graduated from the print department of the Guangzhou Academy of Fine Arts in 1984. In 1990, together with fellow installation artists Lin Yilin, Xu Tan and Liang Ju Hui, he founded the Big Tail Elephant Group with the goal of questioning the modernization of China. Using painting, photography, video and other media, Chen creates works that blur the border between fiction and everyday life. He has had solo exhibitions in China and Europe. He has also participated in numerous group exhibitions, including the touring exhibition 'Cities on the Move' at the Wiener Secession, Vienna, Austria, and other sites (1997–2000); 'Inside Out: New Chinese Art', Asia Society Galleries and PS1, New York, and other venues (1998–2000); 1st and 2nd Guangzhou Triennials, China (2002, 2005); 50th Venice Biennale, Italy (2003); 'Between Past and Future: New Photography and Video from China', International Center of Photography and Asia Society, New York (2004); and 'Refabricating City', Hong Kong & Shenzhen Bi-City Biennale of Urbanism/Architecture, China (2008). [DYW]

CHEN Zhen
b. 1955, Shanghai, China; d. 2000

Chen received his training at the Shanghai Fine Arts and Crafts School, and later from the Shanghai Drama Institute, where he specialized in stage design. He moved to Paris, France, in 1986, and during the 1990s gained an international reputation for large-scale installations. One of his first exhibitions outside China was in 1991 at the École Nationale Supérieure des Beaux-Arts in Paris. His US debut was in 1994 at the New Museum of Contemporary Art, New York, followed by a solo

exhibition at Deitch Projects in 1996. His work was also featured in the touring exhibition 'Cities on the Move' at the Wiener Secession, Vienna, Austria, and other sites (1997–2000) and in the 48th Venice Biennale, Italy (1999). Following his death, retrospective exhibitions of his work have been held at PS1, New York (2003), and at Palais de Tokyo in Paris (2003–4). [MC]

CHOE U-Ram
b. 1970, Seoul, Korea; lives in Seoul

Choe is one of Korea's leading young artists, best known for his mechanical sculptures which move gracefully like living creatures. He inherited an interest in kinetics from his engineer father, but decided to pursue art and obtained a BFA and MFA from Chung-Ang University in Seoul. He has participated in a number of exhibitions, including the 4th Busan Biennale, Korea (2004); 6th Shanghai Biennale, China (2006); 'City Energy-MAM Project004', Mori Art Museum, Tokyo, Japan (2006); 'U-Ram Choe', Crow Collection of Asian Art, Dallas, Texas (2007); 1st Asian Art Triennial, Manchester Art Gallery, England (2008); and 5th Liverpool Biennial, England (2008). [MT]

Dadang CHRISTANTO
b. 1957, Tegal, Indonesia; lives in Brisbane, Australia

Christanto studied at the Indonesian Institute of the Arts in Yogyakarta from 1975 to 1979, and in 1986 completed a BFA in painting. Today he is a leading Indonesian artist, working in a variety of media, including painting, drawing, performance, sculpture and installation. Many of his performances and sculptural installations reflect on political oppression and social injustice in Indonesia. He has participated in many international art biennales and triennales, and has work in the collections of the Fukuoka Art Museum, Japan; Queensland Art Gallery, Brisbane, Australia; and the Widayat Museum, Magelang, Indonesia. [BG]

CHUN Kwang-Young
b. 1944, Hongchun, Korea; lives in Korea

Chun received his BFA from Hongik University in Seoul, and his MFA from the Philadelphia

College of Art in Pennsylvania. For thirty years he was known primarily as a painter, but in 1994 he began to make the *Aggregation* series, which combines myriad units made of handmade paper wrapped around Styrofoam shapes. His work references traditional Korean culture, especially its tradition of wrapping medicinal herbs with mulberry paper, and has been widely shown in Asia, North America, Australia and Europe. He has also received a number of awards, including 'Artist of the Year' at the National Museum of Contemporary Art in Korea (2001). [DYW]

Atul DODIYA
b. 1959, Mumbai, India; lives in Mumbai

Dodiya studied at the Sir J. J. School of Art in Mumbai, and later at the École Nationale Supérieure des Beaux-Arts in Paris (1991–92). His paintings have been shown at the 1st Yokohama Triennale, Japan (2001); 'Edge of Desire: Recent Art in India', co-organized by the Asia Society Museum, New York, and the Art Gallery of Western Australia, Perth (2005); Indian Pavilion, 51st Venice Biennale, Italy (2005); Documenta 12, Kassel, Germany (2007); and 7th Gwangju Biennale, Korea (2008). He was given the Sanskriti Award in New Delhi in 1995. [MC]

Heri DONO
b. 1960, Jakarta, Indonesia; lives in Yogyakarta, Indonesia

From 1980 to 1987 Dono studied at the Indonesian Institute of the Arts in Yogyakarta. From 1988 he studied with a *wayang* puppet master, Sukasman, and this had a great impact on his installations and sculptures. His major exhibitions include the 3rd and 4th Asia-Pacific Triennials of Contemporary Art, Queensland Art Gallery, Brisbane, Australia (1999, 2002); 1st Yokohama Triennale, Japan (2001); 50th Venice Biennale, Italy (2003); 'Happiness: A Survival Guide for Art and Life', Mori Art Museum, Tokyo, Japan (2003); 6th Gwangju Biennale, Korea (2006); and 2nd Singapore Biennale (2008). [MC]

Victorio C. EDADES
b. 1895, Dagupan City, Philippines; d. 1985

Edades is considered one of the progenitors of modern art in the Philippines. He studied architecture and fine arts at the University of Washington, Seattle, graduating with an MFA, and later gained a degree in architecture from the École Nationale Supérieure des Beaux-Arts in Paris, France. On his return to the Philippines, he held a solo exhibition at the Philippine Columbian Club (1928). A decade later, he founded and led the Thirteen Moderns, a revolutionary group of artists whose interests lay in modern art. [MC]

FANG Lijun
b. 1963, Handan, Hebei Province, China; lives in Beijing, China

In 1989 Fang graduated from the Central Academy of Fine Arts, one of China's most prestigious art schools, and soon became an exponent of the Cynical Realism movement, a loose group of painters living in Yuan Ming Yuan artist village in the early 1990s, whose works reflected the feelings of a disaffected younger generation in post-Tiananmen China. These artists were the first in China to experience international success. Fang is one of the best-known painters in China today, and his works were included in the first wave of international survey exhibitions of Chinese contemporary art, including 'China's New Art, Post-1989', Hong Kong Arts Centre (1993); 'Mao Goes Pop: China Post-1989', Museum of Contemporary Art, Sydney, Australia (1993); and 'Inside Out: New Chinese Art', Asia Society Galleries and PS1, New York, and other venues (1998–2000). Fang also participated in the 45th and 46th Venice Biennales, Italy (1993, 1995), and at the 22nd São Paulo Biennial, Brazil (1994) and the 1st Gwangju Biennale, Korea (1995). [MC]

Wenda GU
b. 1955, Shanghai, China; lives in New York, USA

Gu graduated from the Shanghai School of Arts in 1976. In 1981 he completed his MFA at the Zhejiang Academy of Fine Arts, Hangzhou (now China Academy of Art), where he studied under ink master Lu Yanshao. He participated in the experimental movement by showing his false or mis-written characters in Hangzhou. In 1987 he moved to the US, where he currently

resides. He has participated in a number of international exhibitions, including 'China Avant-Garde', National Art Gallery, Beijing, China (1989); 'Mao Goes Pop: China Post-1989', Museum of Contemporary Art, Sydney, Australia (1993); 1st Shanghai Biennale, China (1996); 'Inside Out: New Chinese Art', Asia Society Galleries and PS1, New York, and other venues (1998–2000); 'Re: Duchamp', 49th Venice Biennale, Italy (2001); 'New Way of Tea', Asia Society Museum, New York (2002); and 1st Guangzhou Triennial, China (2002). [MC]

GUAN Wei
b. 1957, Beijing, China; lives in Sydney, Australia, and Beijing, China

Guan graduated from the department of fine arts at Beijing Capital University before becoming a high-school art teacher. In 1989 he moved to Australia, and since then has produced works that combine Chinese traditions, Aboriginal culture and the colonial history of Australia. His solo exhibitions have included 'Nesting, or Art of Idleness 1989–1999', Museum of Contemporary Art, Sydney (1999); 'Other Histories: Guan Wei's Fable for a Contemporary World', Powerhouse Museum, Sydney (2006); and 'A Distant Land', Contemporary Art Centre of South Australia, Adelaide (2006). He has also participated in a number of international group exhibitions, including 'China's New Art, Post-1989', Hong Kong Arts Centre (1993); 3rd Asia-Pacific Triennial of Contemporary Art, Queensland Art Gallery, Brisbane, Australia (1999); 3rd Gwangju Biennale, Korea (2000); and 'Cycle Tracks Will Abound in Utopia', Australian Centre for Contemporary Art, Melbourne (2004). He has received numerous awards and fellowships. [DYW]

Hendra GUNAWAN
b. 1918, Bandung, Indonesia; d. 1983

At the age of nineteen Gunawan joined a theatre troupe as a scenery painter and performer. After the breakout of the Indonesian National Revolution against Dutch colonial rule in 1945, he fought with the Indonesian armed forces and made anti-Dutch posters. In the 1950s he joined the Institute of People's Culture, an organization affiliated with the Indonesian

Communist Party. In the aftermath of the 1 October 1965 coup, he was imprisoned for thirteen years for his political involvement. A socially engaged artist, he advocated the idea that art should be dedicated to and inspired and understood by the people. Often working on large canvases, he used bright colours and bold brushstrokes to depict ordinary Indonesian citizens and everyday scenes. He was one of the founders of the Indonesian Fine Art Academy in Yogyakarta (present-day Indonesian Arts Institute of Yogyakarta). His works are held in the collections of the Galeri Nasional Indonesia, Jakarta; Singapore Art Museum; and Fukuoka Asian Art Museum, Japan. [DYW]

Shilpa GUPTA
b. 1976, Mumbai, India; lives in Mumbai

Gupta studied at the Sir J. J. School of Fine Art, Mumbai. In 2004 she received the Transmediale Award, Berlin, and Sanskriti Award, New Delhi. As part of a young generation of artists, she uses the internet extensively in her works. While engaging with technology, she simultaneously confronts issues relating to commodification and globalization. Most of her works are online art projects and videos, with elements of sculpture and photography that encourage viewer-participation. Her works have been exhibited at the 15th Biennale of Sydney, Australia (2006); 9th Lyon Biennale, France (2007); 7th Gwangju Biennale, Korea (2008); Tate Modern, London, England (2003); 'Edge of Desire: Recent Art in India', co-organized by the Asia Society Museum, New York, and the Art Gallery of Western Australia, Perth (2005); and Daimler Chrysler Contemporary, Berlin, Germany (2006). Her work was also included in 'Indian Highway', Serpentine Gallery, London, England (2008–9). [VR]

Subodh GUPTA
b. 1964, Khagaul, India; lives in New Delhi, India

Gupta received his BFA in painting from the College of Art, Patna, in 1988, then in 1991 won a research grant scholarship from the Lalit Kala Akademi in New Delhi. The French government offered him a visiting professorship at the École Nationale Supérieure des Beaux-Arts in Paris, with a residency in 2004. In recent years

Gupta's art has reflected his increased international exposure: large-scaled works communicate a wide range of complex issues related to his roots and the place India has in today's globalized world. He often uses icons of everyday Indian life, such as stainless-steel kitchenware, bicycles and three-wheeled taxis, but also cows and cow dung. He has exhibited extensively in Europe, Asia and the US. Among his major exhibitions are 'Edge of Desire: Recent Art in India', co-organized by the Asia Society Museum, New York, and the Art Gallery of Western Australia, Perth (2005); 'Indian Summer', Palais des Beaux-Arts, Paris (2005); and 'Altered, Stitched and Gathered', PS1 Contemporary Art Center, New York (2007). He also participated in the 51st Venice Biennale, Italy (2005); 'Indian Highway', Serpentine Gallery, London, England (2008–9); and 'Chalo! India: New Era of Indian Art', Mori Art Museum, Tokyo, Japan (2009). [VR]

HA Chong-hyun
b. 1935, Sanchung, Kyung-Nam, Korea; lives in Kyunggi-do, Korea

Ha received a BFA in painting from Hongik University, Seoul, in 1959. Since then, he has been one of the leading painters and art educators in Korea. His early installations and paintings used materials such as wire, string and nails. Since 1975, he has worked on a series of paintings, *Conjunction*, dealing with the physicality of the medium. He presses oil paints into the back of unprimed canvas, causing the pigments to permeate the weave and yield a rough textural surface, then he uses a knife or his hands to add scratches and broad strokes of colour in a restricted palette. Since the early 1990s, he has made semi-calligraphic works with layered lines and traces of brushstrokes on a monochromatic background. Solo exhibitions have been held in Korea, Japan, Germany, France, Belgium and Italy, including at the Mudima Foundation for Contemporary Art, Milan, Italy (2003); 'Ha Chong-Hyun: A Half-Century of Abstract Art', Gana Art Gallery, Seoul, Korea (2008); and Galerie Winter, Wiesbaden, Germany (2008). His works have been included in the 4th and 7th Paris Biennales, France (1965, 1971); 9th and 14th São Paulo Biennales, Brazil (1967, 1977); A.G. Group Show 'Réaliser la Réalité', National Museum of Modern Art, Seoul, Korea (1971);

Hiroshima City Museum of Contemporary Art, Japan (1989); and 45th Venice Biennale, Italy (1993), among many others. He has also worked as an art administrator, serving as President of the Korea A.G. (Avant-Garde) Organization (1969–74); Commissioner of the 1st Gwangju Biennale, Korea (1995); General Commissioner of the Cagnes International Painting Festival, France (1980, 1992), and the 43rd Venice Biennale, Italy (1988); and Director of the Seoul Museum of Art (2001–6). He has also received many awards. [HY]

HAI Bo
b. 1962, Changchun, China; lives in Beijing, China

Conceptual photographer Hai graduated from the Fine Art Institute of Jilin in 1984, and later studied at the Central Academy of Fine Arts in Beijing. His work explores themes of history, memory and impermanence, inspired by formally posed portrait photographs. He pairs group photos, taken in the 1970s during the Cultural Revolution, with contemporary re-creations that depict the subjects in the same relative positions. These juxtapositions evoke time's passage and hint at the social upheavals of the cataclysmic Revolutionary era. In recent years, Hai has photographed landscapes, often depicting the same view through the seasons. Many sites he has chosen to photograph are closely related to his memory and personal life. His work has been shown widely in solo and group exhibitions, including the 3rd Shanghai Biennale, China (2000–1); 49th Venice Biennale, Italy (2001); 1st Guangzhou Triennial, China (2002); 'Hai Bo: Photography Exhibition', China Art Archives & Warehouse, Beijing (2002); 'A Strange Heaven: Contemporary Chinese Photography', Galerie Rudolfinum, Prague, Czech Republic (2003); and 'Between Past and Future: New Photography and Video from China', International Center of Photography and Asia Society, New York (2004). [TT]

FX HARSONO
b. 1948, Blitar, Indonesia; lives in Jakarta, Indonesia

Like many other prominent Indonesian artists, Harsono studied at the Indonesian Institute of the Arts in Yogyakarta (1969–1974). He later (1987–91) studied at the Jakarta Art Institute,

where he had his first solo exhibition in 1988. He works in painting and printmaking, along with photography, installation and performance, frequently addressing social, urban and environmental issues in Indonesia. He participated in the 1st Asia-Pacific Triennial of Contemporary Art, Queensland Art Gallery, Brisbane, Australia (1993), and 'Contemporary Art in Asia: Traditions/Tensions', organized by the Asia Society, New York (1996). Queensland Art Gallery has collected his work, as have museums of contemporary art in Asia and Australia. [BG]

Amanda HENG
b. 1951, Singapore; lives in Singapore

Heng received a BFA from Curtin University of Technology in Western Australia, and a diploma in printmaking from Lasalle School of Art, Singapore. A performance, installation and mixed-media artist, she is a founding member of the Artists Village (the first artist-run collective in Singapore) and the Women in the Arts (the first women artists' collective in Singapore). Heng is interested in cultural identity and communication within the particular socio-political situation of Singapore. She has exhibited her works at the 1st Fukuoka Asian Art Triennale, Japan (1999); 3rd Asia-Pacific Triennial of Contemporary Art, Queensland Art Gallery, Brisbane, Australia (1999); and 1st Singapore Biennale (2006). [SL]

HONG Hao
b. 1965, Beijing, China; lives in Beijing

Hong graduated from the printmaking department at the Central Academy of Fine Arts, Beijing, in 1989. His œuvre is characterized by a zest for cataloguing and reassembling reality. His *Selected Scriptures* silkscreen prints (from the early 1990s) at first glance look like pages from an old-fashioned atlas, except that Hong has rearranged the geography to reflect the comparative strength of global corporations or military power. The large-format digital photographs in his *My Things* series (begun 2001) are made of individually photographed items in the artist's possession, dynamically arranged by shape and colour. While many of his works implicitly critique consumer culture, some – such as *My Things No. 6 (The Hangover*

of Revolution in My Home) (2002) – hint at the shadows still cast by the Cultural Revolution. Hong's work has been shown in numerous exhibitions around the world, including 'China's New Art, Post-1989', Hong Kong Arts Centre (1993); 'Inside Out: New Chinese Art' at Asia Society Galleries and PS1, New York, and other venues (1998–2000); 1st Guangzhou Triennial, China (2002); 'A Strange Heaven: Contemporary Chinese Photography', Galerie Rudolfinum, Prague, Czech Republic (2003); and 'Between Past and Future: New Photography and Video from China', International Center of Photography and Asia Society, New York (2004). [TT]

HUANG Rui
b. 1952, Beijing, China; lives in Beijing

Huang is a self-taught artist, and an original founder of China's first avant-garde artist group, The Stars (xing xing). The group faced hostility, then censorship, and in 1984 Huang moved to Japan. He later returned to Beijing, where he established – and continues to be an active supporter of – the 798 Art District. His work is a powerful combination of pieces that are both visually compelling and historically and politically charged. At the start of his career he focused primarily on painting, before later experimenting with other media including performance and installation art. Since the first Stars exhibition outside the China National Art Gallery in 1979, Huang has had numerous solo exhibitions worldwide, including 'Huang Rui Exhibition' at the Gallery Bellefroid, Paris, France (1995), and Tokyo Gallery, Japan (1997); 'Chairman Mao 10,000 RMB', Chinese Contemporary, Beijing, China (2006); 'One Country Two Systems – 50 Years Unchanged!', 10 Chancery Lane Gallery, Hong Kong (2006); and 'A work by Huang Rui: Peking 2008: time, animals and history', Museo delle Mura, Rome, Italy (2008). [MCH]

HUANG Yan
b. 1966, Jilin, China; lives in Beijing, China

Huang graduated from the Changchun Normal Academy in China in 1987, and is currently a lecturer at Changchun University. In 1999 he produced Chinese Landscapes, a series of traditional paintings implemented on the

human body. The use of classical scenery is employed to affirm Chinese identity as a concept firmly embedded within the individual, but the traditional format is revived and redefined through the centralization of the body – an image seldom portrayed in classical Chinese art. The work was highly regarded by leading Chinese artists Feng Boyi and Ai Weiwei, who included it in the notorious 'Fuck Off' exhibition at the Eastlink Gallery, Shanghai (2000). Since then, Huang's work has been widely displayed, including at 'Red Hot', Red Gate Gallery, Beijing (2001); 1st Guangzhou Triennial, China (2002); 'Mahjong: Chinese Contemporary Art from the Sigg Collection', Hamburger Kunsthalle, Germany (2006); and 'MADE in CHINA: The Estella Collection', Israel Museum, Jerusalem (2007). Huang has also had solo exhibitions at Red Gate Gallery, Beijing (2004); Chinese Contemporary, London, England (2005); and Priska C. Juschka Fine Art, New York (2007), and his work is in the collection of the Asia Society Museum, New York. [MCH]

HUANG Yong Ping
b. 1954, Xiamen, China; lives in Paris, France

In 1982 Huang graduated from the Zhejiang Academy of Fine Arts, Hangzhou (now China Academy of Art). He was an active participant in China's avant-garde movement during the 1980s and best known as one of the founders of the Xiamen Dada group. In 1989 he travelled to Paris to participate in the 'Magiciens de la Terre' exhibition at the Centre Pompidou and decided to settle there. His work has been included in exhibitions such as the 'Carnegie International', Carnegie Museum of Art, Pittsburgh (1991); 'Inside Out: New Chinese Art', Asia Society Galleries and PS1, New York, and other venues (1998–2000); 48th Venice Biennale, Italy (1999); 3rd Shanghai Biennale, China (2000–1); and 26th and 27th São Paulo Biennials, Brazil (2002, 2004). A major retrospective of his work, 'House of Oracles: A Huang Yong Ping Retrospective', was staged at the Walker Art Center, Minneapolis (2005–6), and toured to MASS MoCA, Massachusetts (2006–7), Vancouver Art Gallery, Canada (2007) and Ullens Centre for Contemporary Art, Beijing, China (2008). [MC]

M. F. HUSAIN
b. 1915, Pandharpur, India; lives in Dubai, UAE

Maqbool Fida Husain is primarily a self-taught artist who, upon gaining recognition in 1948, was invited to join the Progressive Artists' Group, a Mumbai-based avant-garde collective founded by Francis Newton Souza. Husain's paintings have been shown extensively in India, with retrospectives in Mumbai (1969), Kolkata (1973) and Delhi (1978). He has also participated widely in international exhibitions, including the 11th São Paulo Biennial, Brazil (1971); Hirshhorn Museum and Sculpture Garden, Washington, DC (1982); Royal Academy of Arts and Tate Gallery, London, England (1982); 'Coups de Cœur', Halles de L'Île, Geneva, Switzerland (1987); and Peabody Essex Museum, Salem, Massachusetts (2007). In addition to painting and other media, he has produced and directed several films, including Through the Eyes of a Painter, for which he received the Golden Bear at the International Film Festival in Berlin, Germany (1967). Recently, his work has been criticized by both Indian Hindu and Muslim groups due to so-called blasphemous portrayals of sacred images and text. Among numerous awards and honorary degrees, Husain has received the prestigious Padma Shri (1955), Padma Bhushan (1973) and Padma Bibhushan (1989). In 1986 he was nominated to the Rajya Sabha (upper house of Parliament), and in 1997 he won the Aditya Vikram Birla 'Kalashikhar' Award for Lifetime Achievement. [JG]

Bak IKEDA
b. 1964, Kagoshima, Japan; lives in Tokyo, Japan

Ikeda is a multi-talented artist, whose activities range from scriptwriting and graphic design to music and filmmaking; he also produces video work in labour-intensive, computer-graphic animation. His works have been shown at numerous film festivals and graphic art exhibitions in Japan and Europe, including, among others, the Yubari International Fantastic Film Festival, Hokkaido, Japan (2000); Tokyo International Fantastic Film Festival, Japan (2003); and 'Location of the Spirit', Ludwig Museum Budapest – Museum of Contemporary Art, Budapest, Hungary, and Moscow Museum of Modern Art, Russia (2004). [MT]

IKEDA Manabu
b. 1973, Saga, Japan; lives in Tokyo, Japan

Ikeda received his MA in design from Tokyo University of the Arts in 2000. His painstakingly detailed drawings, created with a pen and coloured ink, present fantastical scenes in which nature and culture are merged into organic structures. His work has appeared in numerous exhibitions in Japan and Europe, including 'Expression to the Next Generation' vols 6 and 7, Obuse Museum, Nagano, Japan (1998, 1999); 'Kotatsu-ha (Kotatsu School) 2', Mizuma Art Gallery, Tokyo, Japan (2004); 'Alllooksame.ArtChinaKoreaJapannest', Fondazione Sandretto Re Rebaudengo, Turin, Italy (2006); 'Thermocline of Art: New Asian Waves', ZKM, Karlsruhe, Germany (2007); 10th Exhibition of the Taro Okamoto Award for Contemporary Art, Taro Okamoto Museum of Art, Kawasaki, Japan (2007); and 'Re-Imagining Asia', Haus der Kulturen der Welt, Berlin, Germany (2008). [MT]

Tetsuya ISHIDA
b. 1973, Yaizu City, Japan; d. 2005

Ishida graduated from the department of visual communication design at the Musashino Art University in 1996. His surrealistic paintings poignantly depicting oppressive aspects of life in contemporary Japan won him a number of prizes, including the Mainichi Design Award (1996); Kirin Contemporary Award (1998); and VOCA Exhibition Encouragement Prize (2001). In 2005 he was killed in a train accident. His work has been shown in several solo and group exhibitions, including at the University Art Museum of Tokyo University of the Arts (2001); Gallery Iseyoshi, Ginza, Tokyo (2003); and posthumously at Gallery Q, Ginza, Tokyo (2006), and Shizuoka Prefectural Museum of Art (2007). [MT]

Yun-Fei JI
b. 1963, Beijing, China; lives in New York, USA

Ji earned his BFA from the Central Academy of Fine Arts, Beijing, in 1982. In 1986 he received a fellowship to study at the University of Arkansas in the US. There he began to move away from the influence of Soviet Socialist Realism, creating works inspired by China's

Song-period landscape painting. He is well known for a group of densely composed paintings referencing the Three Gorges Dam, a massive and controversial hydroelectric project along China's Yangtze River. Since 2001, Ji has had solo exhibitions in the US and Europe, including 'The Empty City' (2004), which toured St Louis, Brooklyn, Washington, DC, and other venues. He has also participated in a number of group exhibitions, such as 'Displacement: The Three Gorges Dam and Contemporary Chinese Art', Smart Museum of Art, Chicago, and Nasher Museum of Art at Duke University, North Carolina (2008). He has received numerous awards, including the New York Foundation for the Arts Grant, New York (1999); Rome Prize, American Academy in Rome (2005–6); and Parasol Unit Artists-In-Residence, London, England (2006–7). [DYW]

Michael JOO
b. 1966, Ithaca, New York, USA; lives in New York, USA

Joo grew up in the Midwest, studying science prior to receiving an education in art. He received a BFA from Washington University, St Louis, Missouri, in 1989, and an MFA from Yale School of Art, Yale University, New Haven, Connecticut, in 1991. His works have been shown widely in the US, Europe and Asia, including at the 2nd Johannesburg Biennale, South Africa (1997); 'Media_City Seoul 2000', National Historical Museum, Seoul, Korea (2000); 70th Whitney Biennial, New York (2000); and 49th Venice Biennale, Italy (2001). Major solo exhibitions have been held at the MIT List Visual Arts Center, Cambridge, Massachusetts (2003); Asia Society, New York (2005); and Samsung Museum, Seoul (2006). His works are also held in the collections of major museums such as the Museum of Modern Art, New York, and Walker Art Center, Minneapolis. [MT]

Yeondoo JUNG
b. 1969, Jinju, Korea; lives in Seoul, Korea

Jung received a BFA in sculpture from the Fine Art College at Seoul National University in 1994. He then attended Advanced Study in Fine Art at Central Saint Martins College of Art and Design in London, England, and in 1997

received a Master's degree in fine art from Goldsmiths College, London University. Jung's work often focuses on everyday environments and surroundings. His major exhibitions include the 2nd Fukuoka Triennale, Japan (2002); 4th Gwangju Biennale, Korea (2002); 3rd Busan Biennale, Korea (2002); 'Under Construction: New Dimension of Asian Art', Japan Foundation and Tokyo Opera City Gallery, Tokyo (2002); 4th Shanghai Biennale, China (2002–3); 8th Istanbul Biennial, Turkey (2003); 'Seoul Until Now', Charlottenborg Museum, Copenhagen, Denmark (2005); 51st Venice Biennale, Italy (2005); 'Thermocline of Art: New Asian Waves', ZKM, Karlsruhe, Germany (2007); 'Elastic Taboos', Kunsthalle Wien, Vienna, Austria (2007); and 'Wonderland', Galerie Espacio Minimo, Madrid, Spain (2007), among many others. His video work was screened at the Museum of Modern Art, New York, in 2008. Jung was also a winner of the 2007 Artist of the Year Award from the National Museum of Contemporary Art, Seoul. [MT]

Ranbir KALEKA
b. 1953, Patiala, India; lives in New Delhi, India

In 1975 Kaleka received a diploma in painting from the College of Art, Punjab University, Chandigarh, and in 1987 an MA from the Royal College of Art, London, England. From 1976 to 1977 he taught at Punjabi University, Patiala, and from 1980 to 1985 at the College of Art, New Delhi. His recent multimedia work, which comprises painting, video, photography and installation, has been shown in solo exhibitions at Bose Pacia, New York, and at galleries in New Delhi. He has participated in numerous biennales and group exhibitions in Asia, the US and Europe, including the 10th Biennial of Moving Images, Geneva, Switzerland (2003); 'Edge of Desire: Recent Art in India', co-organized by the Asia Society Museum, New York, and the Art Gallery of Western Australia, Perth (2005); 51st Venice Biennale, Italy (2005); 'Hungry God: Indian Contemporary Art', Arario Gallery, Beijing, and Busan Museum of Modern Art, Korea (2006); 'Horn Please: The Narrative in Contemporary Indian Art', Kunstmuseum Bern, Switzerland (2007); 'India: Public Places, Private Spaces', Newark Museum, New Jersey (2007); and 16th Biennale of Sydney, Australia (2008). His installation work *Consider* (commissioned 2007) is in the collection of the

Spertus Institute of Jewish Studies, Chicago. Kaleka has received the National Award, Lalit Kala Akademi (New Delhi, 1979), and the Sanskriti Award (New Delhi, 1986). [JG]

Jitish KALLAT
b. 1974, Mumbai, India; lives in Mumbai

Kallat studied painting at the Sir J. J. School of Art, Mumbai, where he received his BFA in 1996. The following year he was awarded a fellowship at the school, as well as the Indian Government First Prize and the K. K. Hebbar Art Foundation Award. Kallat works in a variety of media, often putting together painting, collage, photography, sculpture and multimedia installations. His works reflect issues relating to his native city of Mumbai – the environment, urban life – as well as wider themes relating to the role of India in the global economy. His work has been shown in major exhibitions, including 'Pictorial Transformations', National Art Gallery of Malaysia (2003); 'subTerrain: artists dig the contemporary', Haus der Kulturen der Welt, Berlin, Germany, curated by Geeta Kapur (2003); and 'Masala', William Benton Museum, University of Connecticut (2005). [VR]

Gulnara KASMALIEVA and Muratbek DJUMALIEV
b. 1960 and 1965 respectively in Bishkek, Kyrgyzstan; live in Bishkek

This husband-and-wife artist team has been working together since 1998, producing documentary-style video installations and photography exploring the impact of political upheaval and rapid modernization on everyday life in Central Asia. Their artwork has been exhibited at the Art Institute of Chicago (2007); Museum of Modern Art, New York (2009); Central Asian pavilion at the 51st Venice Biennale, Italy (2005); and at the 1st Singapore Biennale (2006). [BG]

Tadashi KAWAMATA
b. 1953, Mikasa, Japan; lives in Tokyo, Japan

Kawamata studied painting at Tokyo National University of Fine Arts, but moved into installation art. He is known for site-specific projects, usually makeshift architectural structures made of wood, cardboard or other materials that are grafted onto buildings or placed in trees. His works blend art, architecture and social critique. In 1982 he was invited to exhibit in the Japanese Pavilion at the Venice Biennale, and since then has exhibited all over the world in locations as varied as Madison Square Park in New York and a church in Kassel, Germany. Documenta 8 and 11, Kassel (1987, 1992), the 19th São Paulo Biennial, Brazil (1987) and 11th Biennale of Sydney, Australia (1998) are just some of the more prominent international survey exhibitions in which Kawamata has participated over the course of his career. [BG]

On KAWARA
b. 1933, Aichi, Japan; lives in New York, USA

Kawara is one of the most important conceptual artists active since the 1950s. Much of his biographical information is ambiguous, but he most likely never attended any formal art school. He left Japan in 1959 and briefly lived in Mexico, but since 1965 has been based in New York, where in 1966 he began his most famous ongoing work, the *Today* date-painting series. His work has been shown in numerous exhibitions, including 'One Thousand Days, One Million Years', Dia Center for the Arts, New York (1993); 'On Kawara: Whole and Parts 1964–1995', Museum of Contemporary Art, Tokyo, Japan (1998); Documenta 11, Kassel, Germany (2002); 'Tokyo – Berlin/Berlin – Tokyo', Mori Art Museum, Tokyo (2006); and 'Made in Munich', Haus der Kunst, Munich, Germany (2008–9). [MT]

Aisha KHALID
b. 1972, Faisalabad, Pakistan; lives in Lahore, Pakistan

Khalid originally intended to pursue a career in medicine, but in 1997, after her family experienced financial difficulties, she enrolled at the National College of Arts, Lahore, where she studied fine art. She majored in miniature painting, which she later taught at the college and at the Al-Khair University, Lahore, before receiving a two-year fellowship in 2001 at the Rijksakademie in Amsterdam. Khalid's work revives the traditions of Mughal court painting to explore contemporary issues. Retaining women as her focal point, she investigates gender limitations through her signature motif, the curtain. Her work has been shown at, among others, the Lahore Museum, Pakistan (1997); Off Set Gallery, Islamabad, Pakistan (1999); Ivan Dougherty Gallery, Sydney, Australia (2001); and Royal Academy of Arts, London, England (2002). Her solo exhibitions include shows at Sim Sim Gallery, Lahore (2000); Admit One Gallery, New York (2001); and Corvi-Mora, London (2004). In 2008 a complete review of her career, including her recent sculptural pieces and video work, *Conversation*, was held at the Pump House Gallery in London. Khalid attended the Open Circle Workshop in Mumbai, India, in 2000, and in 2001 was part of the International Artists Workshop, Skoki, Poland. [MCH]

Bharti KHER
b. 1969, London, England; lives in New Delhi, India

Kher was raised in England and studied painting at Newcastle Polytechnic, where she received her BA in fine art in 1991. After moving to Delhi in 1993, she participated in the Khoj Collective Independent art space for a residency in 2002, and another in Paris, France, in 2004, granted by the French government. Her works have been exhibited in Europe, Asia and the US. She uses the *bindi* as a stylistic tool to convey issues relating to social roles and tradition in India and globally. Her works embrace sculpture, photography and painting, and have been included in 'Indian Summer', Palais des Beaux-Arts, Paris (2005); 'Passage to India' for Initial Access, the space opened in Wolverhampton, England, by James Cohen (2008); and 'Indian Highway', Serpentine Gallery, London, England (2008–9). [VR]

Atta KIM
b. 1956, Geojedo, Korea; lives in Seoul, Korea

Kim studied mechanical engineering at Changwon University in Korea. His work has been exhibited at numerous international exhibitions, including the 26th São Paulo Biennial, Brazil (2002); 5th Gwangju Biennale, Korea (2004); 'Fast Forward: Photographic Message from Korea', Fotografie Forum International, Frankfurt, Germany (2005);

and 'Contemporary Art of Korea', Busan Museum of Modern Art, Korea (2005), among others. In 2006 the International Center for Photography, New York, held his first major solo exhibition, 'On-Air', which was also the first solo show of an Asian photographer at ICP. In 2003 Kim received the 4th Lee Myoungdong Photo Prize in Seoul. His works are in major museum collections worldwide, including Los Angeles County Museum of Art, California; Museum of Fine Arts, Houston, Texas; Museet for Fotokunst, Odense, Denmark; and Daelim Contemporary Art Museum, Seoul, Korea. [MT]

KIM Ho-Suk

b. 1957, Chongup, Korea; lives in Seoul, Korea

Kim graduated in fine art from Hongik University, Seoul, in 1977. His ink-on-paper paintings employ traditional techniques to explore contemporary issues, focusing particularly on the effect of Japanese colonialism in Korea and the way this has affected the country's national identity. Kim has participated in numerous group exhibitions, including 'Korean Contemporary Ink Paintings: The Crossing of Eastern and Western Consciousness', Korean Cultural Centre, Paris, France (1986); 'Across the Pacific', Queens Museum of Art, Flushing, New York (1993); 'The Future of Korean Art', Nara Gallery, Seoul, Korea (1995); and 'Contemporary Art in Asia: Traditions/Tensions', organized by the Asia Society, New York (1996). Solo exhibitions include 'Traditional Ink Painting', Kwanhoon Gallery, Seoul, Korea (1986) and 'Traditional Ink Portraiture', Seoul Arts Centre, Korea (1995). In 1979, Kim received an award at the 2nd Joong-Ahng Grand Art Exhibition at the National Museum of Contemporary Art in Seoul, and in 1980 he was the recipient of an award at the 7th Hankook Fine Art Exhibition. His works are held in the collections of the National Museum of Contemporary Art, Seoul, and the Ho-Am Art Museum, Yongin, Korea. [MCH]

KIM Joon

b. 1966, Seoul, Korea; lives in Seoul

Kim studied painting at Hongik University, Seoul. Best known for his sensuous 'social tattoo' photographs, he has used the human form as his primary canvas. His early works (1995–2004) are small sculptural objects that are stuffed, sewn and coated with latex (resembling human skin), then stencilled with tattoos or scars. Since 2005, Kim has made photographs depicting multi-limbed bodies covered with patterns often drawn from advertisements and commercial signage. Many of his recent works are manipulated digitally. He has had solo shows in Seoul, Tokyo, Amsterdam, Berlin, Los Angeles and Chicago. His works have also been included in the 2nd Asia-Pacific Triennial of Contemporary Art, Queensland Art Gallery, Brisbane, Australia (1996); 3rd and 5th Gwangju Biennales, Korea (2000, 2004); and 1st Asian Art Biennial, National Taiwan Museum of Fine Arts (2007). [HY]

KIMSOOJA

b. 1957, Taegu, Korea; lives in New York, USA

Kimsooja graduated from the painting department of Hongik University, Seoul. On receiving a French government scholarship, she attended the École Nationale Supérieure des Beaux-Arts in Paris, where she studied lithography. Since 1998 she has lived in New York. In her photography, installation, performance and video work she focuses on conceptual issues of dislocation and displacement. She has had several solo exhibitions, including 'Conditions of Humanity', which travelled to the Museum Kunst Palast, Düsseldorf, Germany; Padiglione d'Arte Contemporanea, Milan, Italy; and Museum of Contemporary Art, Lyon, France (2003–4). Her work has also been included in major group exhibitions, biennials and triennials, such as the 1st and 3rd Gwangju Biennales, Korea (1995, 2000); 24th São Paulo Biennial, Brazil (1998); 3rd Asia-Pacific Triennial of Contemporary Art, Queensland Art Gallery, Brisbane, Australia (1999); 48th, 49th and 51st Venice Biennales, Italy (1999, 2001, 2005); the touring exhibition 'Cities on the Move' at the Wiener Secession, Vienna, Austria, and other sites (1997–2000); 71st Whitney Biennial, New York (2002); and 'It's Your Bright Future: 12 Korean Artists', Los Angeles County Museum of Art, California, travelling to the Museum of Fine Arts, Houston, Texas (2009). [MT]

Aye KO

b. 1963, Pathein, Burma; lives in Yangon, Burma

Although trained in classical painting, Ko departs from this tradition with his photography, video and performance work. In his video art, he explores interiority and spirituality by capturing the multiplicity of perception with his camera. He has exhibited in Burma, Vietnam, Thailand and Japan. His photographs were also included in 'Thermocline of Art: New Asian Waves' at ZKM, Karlsruhe, Germany (2007). [SL]

Mami KOSEMURA

b. 1975, Kanagawa, Japan; lives in Tokyo, Japan

Kosemura studied painting at Tokyo National University of Fine Arts and Music. Her video work often presents slowly moving collages of images, composed from photographs and digital animation. Her work has been shown and screened at the 3rd Bangkok Experimental Film Festival: Digit O, Project 304, Thailand (2001); '25 Hrs', El Raval Sports Pavilion, Spain (2004); 'MOT Annual 2004: Where do I come from? Where am I going?', Museum of Contemporary Art, Tokyo, Japan (2004); 'Projected Realities: Video Art from East Asia', Asia Society, New York (2006); and 'East of Eden: Gardens in Asian Art', Freer & Sackler Galleries, Smithsonian Institution, Washington, DC (2007). She is a recipient of the Filip Morris K.K. Art Award 2002: The First Move, administered by Tokyo International Forum. [MT]

Yayoi KUSAMA

b. 1929, Matsumoto, Japan; lives in Tokyo, Japan

Kusama graduated from the Kyoto Arts and Crafts School in 1951. In 1957 she moved to the US, where she went on to study at the Art Students League of New York. During this period she exhibited her objects and installations at Brata Gallery and Castellane Gallery. Since her return to Japan in 1973, her work has been exhibited in numerous survey retrospectives around the world, including 'Yayoi Kusama: A Retrospective', Center for International Contemporary Arts, New York (1989); 'Love Forever: YAYOI KUSAMA 1958–1968', Los Angeles County Museum of

Art, California, and Museum of Modern Art, New York (1998); 'Kusamatrix', Mori Art Museum, Tokyo (2004); and 'Yayoi Kusama: Eternity-Modernity', National Museum of Modern Art, Tokyo (2004–5). In 1993 she represented Japan in its national pavilion at the 45th Venice Biennale in Italy. Her works have also been included in historical survey exhibitions such as 'The 1960s: A Decade of Change in Contemporary Art', National Museum of Modern Art, Tokyo (1981); 'Reconstructions: Avant-Garde Art in Japan, 1945–1965', Museum of Modern Art, Oxford (1985); 'The Object Transformed', Museum of Modern Art, New York (1996); 'Japon des Avant-Garde, 1910–70', Centre Pompidou, Paris, France (1986); and 'Japanese Art After 1945: Scream Against the Sky', Guggenheim Museum SoHo, New York (1994). [MC]

Surasi KUSOLWONG
b. 1965, Ayutthaya, Thailand; lives in Bangkok, Thailand

Kusolwong received his BFA from Silpakorn University, Bangkok, in 1987, and his MFA from the Hochschule für Bildende Künste, Braunschweig, Germany, in 1993. His installation- and performance-based work often comments on the relationship between people, art and commodity. He has had a number of solo exhibitions, including 'Smells Like Art', About Studio/About Café, Bangkok, Thailand (1999), and 'Surasi Kusolwong: Woman, Machine and Motion (Mini-Monsterbike Tiger)' at BALTIC Centre for Contemporary Art, Gateshead, England (2006). He has also participated in many international group shows, including the touring exhibition 'Cities on the Move' at the Wiener Secession, Vienna, Austria, and other sites (1997–2000); 3rd Asia-Pacific Triennial of Contemporary Art, Queensland Art Gallery, Brisbane, Australia (1999); 50th Venice Biennale, Italy (2003); 2nd Guangzhou Triennial, China (2005); and 6th Busan Biennale, Korea (2008). [DYW]

KWON Young-woo
b. 1926, E-won, Hamgyeongnam-do, Korea; lives in Yong-In, Korea

Kwon is a member of the first generation of artists to come up in Korea following

independence. Although originally trained in traditional Korean painting (BFA and MFA from Seoul National University), he has since abandoned these strictures to explore more unconventional subjects found in daily life. Some of his early paintings manifest a surrealistic style that is rarely seen in traditional Eastern painting. During the Korean War, Kwon served as a military service painter, producing images of the devastation of war. By 1962, pursuing the expressive potential of ink on *hanji* (traditional Korean mulberry paper), he had started to create abstract calligraphic images. In his next phase, instead of painting, Kwon constructed images using paper that was cut, torn, glued, perforated and pulled. In 1978 he moved to Paris, relinquishing a professorship in Korea. Until his return to the country in 1989, he made collage works using abandoned car number plates, *hanji* and wrapping paper. Among other honours, he has been awarded the Minister of Education Prize at the National Exhibition (1958) and the Artist of the Year Prize from the Korean Art Association (2008). His solo exhibition 'Young-Woo Kwon: Life Contained on Paper', which included seventy donated works, was held at the Seoul Museum of Art in 2007. [HY]

An-My LÊ
b. 1960, Saigon, Vietnam; lives in New York, USA

As a refugee from Vietnam, Lê moved to the US in 1975. She graduated from Stanford University with a degree in biology, and later received her MFA from Yale University. In her photography she focuses on Vietnam and the representation of war rampant in today's world through media and entertainment. Her group exhibitions include 'New Photography 13', Museum of Modern Art, New York (1997); 'Only Skin Deep: Changing Visions of the American Self', International Center of Photography, New York, Seattle Art Museum and San Diego Museum of Art (2004–5); 'Dirty Yoga', 5th Taipei Biennial, Taiwan (2006); and 'That Was Then ...This Is Now', PS1 Contemporary Art Center, New York (2008). [MT]

Dinh Q. LÊ
b. 1968, Ha Tien, Vietnam; lives in Ho Chi Minh City, Vietnam

Lê's family left Vietnam in 1978 and settled in Los Angeles. He studied at the University of California, Santa Barbara, and then the School of Visual Arts, New York. He works mainly in photography, having perfected a technique of weaving together multiple photographs to present multiple views on subjects such as the Vietnam War. More recently he has explored the media of sculpture, installation and video art, all of which were presented at the artist's solo exhibition 'Vietnam: Destination for the New Millennium', Asia Society, New York (2006). Other exhibitions include 'Fever Variations', 6th Gwangju Biennale, Korea (2006), and 2nd Singapore Biennale (2008). [MC]

LEE Bul
b. 1964, Yongwol, Korea; lives in Seoul, Korea

Lee studied at Hongik University, Seoul. Her work has developed from early street performances to gleaming cyborg sculptures and installations. She has shown her work at the 1st Gwangju Biennale, Korea (1995); Museum of Modern Art, New York, (1997); Korean Pavilion, 48th Venice Biennale, Italy (1999); and Kunsthalle Bern Projektraum, Switzerland (1999). She was also a finalist for the Hugo Boss Prize at the Guggenheim Museum in 1998, and was awarded the Menzione d'Onore at the 48th Venice Biennale (1999). [MC]

Hyungkoo LEE
b. 1969, Pohang, Korea; lives in Seoul, Korea

Lee studied art at Hongik University, Seoul, then received an MFA from Yale University in 2002 before going to Brooklyn, New York, on an award from the Joan Mitchell Foundation. On his return to Korea, he became a resident at Ssamzie Art Studio. Since 2001, his works have included devices such as optical helmets with convex lenses that distort facial features, as well as distorted skeletal representations of Disney cartoon characters, presented as 'fossil sculptures'. His solo shows include 'The Objectuals' at the Sungkok Art Museum, Seoul (2004), and 'Animatus' at Arario Gallery, Cheonan, Korea (2006) and New York (2008). A selection of works entitled *Homo Species* was presented at the Korean Pavilion in the 52nd Venice Biennale, Italy (2007). [HY]

LEE Mingwei
b. 1964, Taipei, Taiwan; lives in New York, USA

Lee studied at California College of Arts and Crafts and Yale University. His conceptual art practice brings together elements of performance art and public art, and he has staged projects at the Museum of Modern Art, New York (2003); Gallery of Modern Art, Brisbane, Australia (2008); and Isabella Stewart Gardner Museum, Boston (2000). Group exhibitions include 'Way Stations', Whitney Museum of American Art, New York (1998); 'Sleeping Project', 50th Venice Biennale, Italy (2003); 72nd Whitney Biennial, New York, (2004); and 4th Liverpool Biennial, England (2006). [MC]

Nikki S. LEE
b. 1970, Kye-Chang, Korea; lives in New York, USA

Lee is an artist and filmmaker who studied at Chung-Ang University in Korea before moving to New York in 1994, where she attended the Fashion Institute of Technology, later earning her MA in photography at New York University. Her signature work consists of colourful portrait photographs in which she takes on the trappings of and poses with people from different ethnic and social groups. She has had solo exhibitions at major international institutions, including the Institute of Contemporary Art, Boston (2001), and the Cleveland Museum of Art, Ohio (2003). Her works are in the collections of many museums, including the San Francisco Museum of Modern Art, California; Los Angeles County Museum of Art, California; Solomon R. Guggenheim Museum, New York; and Fukuoka Asian Art Museum, Japan. [BG]

LEE Ufan
b. 1936, Haman, Kyungsang Namdo, Korea; lives in Kamakura, Japan, and Paris, France

Although Lee was born in Korea, most of his professional life has been spent in Japan. He studied philosophy at Nihon University in Tokyo, graduating in 1961. He was a founding member of Japan's post-war Mono-ha movement, and his writings are central to an understanding of the movement's objectives. His work has been included in many significant international group exhibitions, such as Documenta 6, Kassel,

Germany (1977), and the 52nd Venice Biennale, Italy (2007). Solo exhibitions include shows at Galerie Nationale du Jeu de Paume, Paris (1997), and National Museum of Contemporary Art, Seoul (1994). [MC]

Jose LEGASPI
b. 1959, Manila, Philippines; lives in Camarines Norte, Philippines

Legaspi studied zoology and biological science at the University of Santo Tomas, Manila, before switching in the mid-1980s to making art, specifically small, surrealistic drawings of pain, violence and horror that combine social commentary with an investigation of personal psychological states. Legaspi draws on childhood memories, along with religious imagery and newspaper photographs, as source material for his work. He has exhibited in the Philippines, as well as Hong Kong, Europe, Australia and the US, and in 2001 was artist-in-residence at Art in General in New York. [BG]

LI Shan
b. 1942, Lanxi County, China; lives in Shanghai, China

Li graduated from the art department of the Shanghai Drama Institute in 1968. As a leading figure of the Political Pop movement that emerged in the 1990s, he is well known for his *Rouge* series – portraits of a stylized young Mao Zedong with feminine facial features. These portraits were influenced by propaganda posters produced during the Cultural Revolution and by folk art in China. Li's other works explore issues of gender and biology, such as his 2005 *Reading* series depicting fantastic insects collaged from human body parts. His work has been exhibited internationally, including at the 45th Venice Biennale, Italy (1993); 'China's New Art, Post-1989', Hong Kong Arts Centre (1993); 1st Guangzhou Triennial, China (2002); and "85 New Wave: The Birth of Contemporary Chinese Art', Ullens Center for Contemporary Art, Beijing, China (2007). [DYW]

Michael LIN
b. 1964, Tokyo, Japan; lives in Shanghai, China, and Taipei, Taiwan

In 1990 Lin graduated in fine art from the Parsons School of Design, Los Angeles, then in 1993 received his MFA from the College of Design, Pasadena. His inspiration emerges from traditional Taiwanese floral textiles, which he has utilized in a variety of fashions, from cushions to armchairs. Renowned for his site-specific wall and floor installations, Lin explores the notion of space and breaks down the boundaries between high art and art found in everyday domestic life. His works have been included in the 2nd Taipei Biennial, Taiwan (2000); 49th Venice Biennale, Italy (2001); 4th Asia-Pacific Triennial of Contemporary Art, Queensland Art Gallery, Brisbane, Australia (2002); and Asian Art Museum, San Francisco, California (2004). He has also had solo exhibitions at Galerie Tanit, Munich, Germany (2002); PS1 Contemporary Art Center, Long Island, New York (2004); Kunsthalle Wien, Vienna, Austria (2005); and Nogueras Blanchard, Barcelona, Spain (2007). In 1999 he was selected to attend the Khōj International Artists Workshop in New Delhi, India. His works are held at the Fundación NMAC – Montenmedio Arte Contemporáneo, Spain, and the Elgiz Museum of Contemporary Art, Istanbul, Turkey. [MCH]

LIN Tianmiao
b. 1961, Taiyuan, Shanxi Province, China; lives in Beijing, China

Lin graduated in fine art from Beijing Normal University in 1984. In 1989 she attended the Art Student League in New York. She also worked there as a textile designer before returning to Beijing in 1995 to focus on mixed-media installations. The recurring use of white cotton thread throughout Lin's work is a personal reflection of her childhood experiences in thread-winding, and a way to transform her subject matter through the paradoxical nature of the material, which is both delicate and strong, real and notional. Lin's work has been included in the 5th Istanbul Biennial, Turkey (1997); 'Inside Out: New Chinese Art', Asia Society Galleries and PS1, New York, and other venues (1998–2000); 'Bound-Unbound 1995–1997', Gallery of the Central Academy of Fine Arts, Beijing, China (2002); 'New Zone Chinese Art', Zacheta National Art Gallery, Warsaw, Poland (2003); 'Global Feminism', Brooklyn Museum, New York (2007); 'Focus: Works on Paper',

Singapore Tyler Print Institute, Singapore (2007); and 'Mother's!!!', Long March Space, Beijing, China (2008). Her work is in the collections of the Long March Project, Beijing; Seattle Art Museum, Washington; and Museum of Modern Art, New York. [MCH]

LIN Yilin
b. 1964, Guangzhou, China; lives in New York, USA, and Guangzhou, China

Lin graduated from the Guangzhou Academy of Arts and soon after, in 1990, co-founded one of the most important southern Chinese artist groups of the 1990s, the Big Tail Elephant Group (the three other artist co-founders were Xu Tan, Chen Shaoxiong and Liang Juhui). Lin's performances, videos and installation works have been exhibited in 'China Avant-Garde: Countercurrents in Art and Culture', Haus der Kulturen der Welt, Berlin, Germany (1993); 'Big Tail Elephant Group', Kunsthalle Bern, Switzerland (1998); 1st and 2nd Guangzhou Triennials, China (2002, 2005); 50th Venice Biennale, Italy (2003); Asia Society Museum, New York (2003); and 'The Monk and the Demon', Lyon Museum of Contemporary Art, France (2004). He was awarded the Contemporary Chinese Art Award in 2000. [MC]

LU Shengzhong
b. 1952, Dayuji, Shandong, China; lives in Beijing, China

A product of the Cultural Revolution, Lu served in the army before graduating in art from Shandong Normal University in 1978. In 1987 he returned to university and graduated with an MFA from the prestigious Central Academy of Fine Arts in Beijing, where he is currently a professor in the folk art department. As the Cultural Revolution came to an end, Lu, unlike many of his contemporaries, did not turn to Western styles for inspiration but instead referred back to his rural upbringing and the traditional Chinese art of paper-cutting. Best known for his signature 'little red figures', he engages in a philosophical process by which he explores Taoist binaries and the fragility of human life through elaborate large-scale installations. Since his first major solo exhibition in 1988 at the National Art Gallery of China in Beijing, he has exhibited

internationally, and his work has been included in, among others, the 1st Gwangju Biennale, Korea (1995); 'Notes Across Asia', Berlin, Germany (1998); 'Square Earth, Round Heaven', Chambers Fine Art, New York (2007); and 'Out of the Ordinary: Spectacular Craft', Victoria and Albert Museum, London, England (2007). His art is also in the collection of the Fukuoka Asian Art Museum, Japan. [MCH]

MA Desheng
b. 1952, Beijing, China; lives in Paris, France

A self-taught painter, Ma was a founding member of The Stars (*xing xing*), one of the first avant-garde art groups formed in China in the late 1970s. In the mid-1980s, he relocated first to Switzerland and then to France in pursuit of artistic freedom. His work has been shown in major survey exhibitions, including 'Mahjong: Chinese Contemporary Art from the Sigg Collection', Kunstmuseum Bern, Switzerland (2005). His works are also held in many collections, including the Musée d'Histoire Contemporaine, Paris, France. [SL]

MA Liuming
b. 1969, Huangshi, China; lives in Beijing, China

Ma graduated from the Hubei Academy of Arts in 1991 with a degree in painting. In the early 1990s he helped establish Beijing's East Village, an avant-garde artists' community. He is well known for *Fen Ma Liuming*, a series of nude performances in which he uses his feminine looks and make-up to create a persona with a female face and male body. His explorations of gender and sexuality, coupled with his nudity, made these early works particularly controversial. In 1994 he was arrested during a performance, held for two months and charged with pornography. In addition to performance pieces, Ma works in painting and photography. He has participated in numerous international exhibitions and performance art events, such as 'Inside Out: New Chinese Art', Asia Society Galleries and PS1, New York, and other venues (1998–2000); 48th Venice Biennale, Italy (1999); 3rd Asiatopia International Performance Art Festival, Bangkok, Thailand (2001); and 'Between Past and Future: New Photography and Video from China', International Center of Photography and Asia Society, New York (2004). [TT]

Nalini MALANI
b. 1946, Karachi, Pakistan; lives in Mumbai, India

In 1969 Malani graduated with a diploma in fine arts from the Sir J. J. School of Art, Mumbai. In 1972 the French government awarded her a scholarship to study in Paris. She has participated in many residency programmes, including at the Lasalle-SIA in Singapore (1999); Fukuoka Asian Art Museum, Japan (2000); and Civitella Rainieri, Italy (2003). Her practice focuses on people, histories and cultures, challenging social and political issues relating to race, gender and class. She has also collaborated with other artists. Her works include drawing, performance, installation and video, and have been extensively exhibited in major international museums and biennales, such as 'Edge of Desire: Recent Art in India', co-organized by the Asia Society Museum, New York, and the Art Gallery of Western Australia, Perth (2005); 51st Venice Biennale, Italy (2005); and 'The Pantagruel Syndrome', Castello di Rivoli Museo d'Arte Contemporanea, Turin, Italy (2005–6). Solo exhibitions have taken place at the Peabody Essex Museum, Salem, Massachussetts (2006), and Irish Museum of Modern Art, Dublin (2007). [VR]

Nyoman MASRIADI
b. 1973, Gianyar, Bali, Indonesia; lives in Yogyakarta, Indonesia

Masriadi received his training at the Indonesian Art Institute. His monumental figure paintings have made him one of the most prominent contemporary Indonesian artists. He translates everyday life onto his canvases, depicting volumetric forms of dark-skinned men and women. The activities of his figures reflect his interests in sport, mass media and celebrity culture. He has shown widely in Indonesia, Australia and the Netherlands, and his solo show 'Masriadi: Black is My Last Weapon' was staged at Singapore Art Museum in 2008. [SL]

Tyeb MEHTA
b. 1925, Kapadvanj, India; d. 2009

Mehta graduated from the Sir J. J. School of Art, Mumbai, in 1952. In 1959 he moved to London, where he stayed until 1964. He has been loosely associated with the Bombay Progressive Artists'

Group, established shortly after the 1947 partition of India and Pakistan, and identifying with international art styles. Mehta's first solo exhibition was at the Jehangir Art Gallery in Mumbai in 1959, and he continued to stage exhibitions inside and outside India, including at Nandan, Kala Bhavan, Vishwa-Bharati and Santiniketan (1986) and Bharat Bhavan, Bhopal and Madhya Pradesh (1988). Other notable exhibitions include 'Pictorial Space', Lalit Kala Akademi, New Delhi, India (1977); 'Modern Indian Paintings from the Collection of the National Gallery of Modern Art, New Delhi', Hirshhorn Museum and Sculpture Garden, Washington, DC (1982); 'Contemporary Indian Painters', Grey Art Gallery, New York (1985); '17 Indian Painters', Jehangir Art Gallery, Mumbai (1988); 'Tryst with Destiny: Art From Modern India', Singapore Art Museum (1997); '50 Years of Art in Bombay 1947–1997', National Gallery of Modern Art, Mumbai (1997); 'Century City: Art and Culture in the Modern Metropolis', Tate Modern, London, England (2001); and 'Multiple Modernities: India, 1905–2005', Philadelphia Museum of Art, Pennsylvania (2008). In 1970 he wrote and directed the film *Koodal*, which earned him a Filmfare Critics Award. He was also given a Padma Bhushan Award by the government of India in 2007. [MC]

Almagul MENLIBAYEVA
b. 1969, Almaty, Kazakhstan; lives in Amsterdam, Netherlands, and Berlin, Germany

Menlibayeva is one of the few female artists from post-Soviet Central Asia, and a leading figure in the field of performance and video art. She re-situates the region's native nature-worship and related rituals within a contemporary context. Her work has been exhibited at various exhibitions, including the 51st and 52nd Venice Biennales, Italy (2005, 2007); 'Thermocline of Art: New Asian Waves', ZKM, Karlsruhe, Germany (2007); 10th Istanbul Biennial, Turkey (2007), and many others. [MT]

Mariko MORI
b. 1967, Tokyo, Japan; lives in New York, USA

Mori is a leading Japanese artist, known for her futuristic photography, video and installation art. She began studying design in Japan, and

also worked as a fashion model. From 1989 to 1992 she studied at the Chelsea College of Art and Design, London, England. From 1992 to 1993 she participated in the Independent Study Program at the Whitney Museum of American Art, New York. Since then she has been based in New York, and has exhibited her work widely in the US, Europe and Asia, including at the 47th and 51st Venice Biennales, Italy (1997, 2005); 'Regarding Beauty: A View of the Late Twentieth Century', Hirshhorn Museum and Sculpture Garden, Washington, DC (1999–2000); 3rd Shanghai Biennale, China (2000–1); and 'Moving Pictures', Guggenheim Museum Bilbao, Spain (2003–4). Her major solo exhibitions include 'Mariko Mori', Andy Warhol Museum, Pittsburgh (1998); 'Empty Dream', Brooklyn Museum of Art, New York (1999); 'Dream Temple', Prada Foundation, Milan, Italy (1999); 'Pure Land', Museum of Contemporary Art, Tokyo, Japan (2002); 'Wave UFO', Kunsthaus Bregenz, Austria, and New York (2003); and 'Oneness', ARoS Aarhus Kunstmuseum, Denmark (2007). [MT]

MORIMURA Yasumasa
b. 1951, Osaka, Japan; lives in Osaka

Morimura received his BA from Kyoto City University of Art in 1978. His photographic self-portraits picture him in famous historical paintings or dressed as celebrities. More recently he has produced video works. His art has been shown at the 43rd, 45th and 52nd Venice Biennales, Italy (1988, 1993, 2007); 'Japanese Art After 1945: Scream Against the Sky', Guggenheim Museum SoHo, New York (1994); 'Rrose is a Rrose is a Rrose', Guggenheim Museum, New York (1997); 'Fame: After Photography', Museum of Modern Art, New York (1999); and 'Beauty Now', Haus der Kunst, Munich, Germany (2000). He was winner of the Hugo Boss Prize at the Guggenheim Museum in 1996. [MC]

Farhad MOSHIRI
b. 1963, Shiraz, Iran; lives in Tehran, Iran

Moshiri received an MFA from the California Institute of the Arts, Valencia, in 1984. His work comprises paintings, photography, sculptures and installations, including a highly acclaimed series of monumental jars rendered in oil on

canvas and inscribed with calligraphic verses from popular culture. He has shown his work in several solo exhibitions in Tehran and Dubai, including at The Third Line, Dubai (2006, 2007), and in galleries in London, Geneva, New York, Rome and Copenhagen. He has also participated in numerous group exhibitions, including 'Welcome', Kashya Hildebrand Gallery, New York (curator, 2005); 'Word into Art: Artists of the Modern Middle East', British Museum, London, England (2006); 'Iran.com', Museum of New Art, Freiburg, Germany (2006); and 'East West Dialogues, Mysticism, Satire, and the Legendary Past', Leila Taghinia-Milani Heller Gallery, New York (2008). His work is held in several collections, including the Virginia Museum of Fine Art, Richmond, and British Museum, London. [JG]

MR.
b. 1969, Cupa [Mr.'s imaginary city]; lives in Saitama, Japan

Mr. graduated from Sokei Art School, Tokyo, in 1996. His *nom de plume* is taken from the nickname of the baseball player Shigeo Nagashima, whom the Japanese affectionately called *misutā* ['Mr.']. His work is populated by anime-inspired characters in the form of paintings, sculptures and video, revealing the influence of Otaku subculture. Mr. came to Takashi Murakami's attention in 1995, and he has since been closely involved with Murakami's company Kaikai Kiki. His work has been shown in 'Superflat', Museum of Contemporary Art, Los Angeles, and Walker Art Center, Minneapolis (2001); 'Little Boy: The Arts of Japan's Exploding Pop Culture', Japan Society, New York (2005); 'Red Hot: Contemporary Asian Art Rising', Museum of Fine Arts, Houston, Texas (2007), and 'Krazy! The Delirious World of Anime + Comics + Video Games + Art', Vancouver Art Gallery, Canada (2008). [MT]

Huma MULJI
b. 1970, Karachi, Pakistan; lives in Lahore, Pakistan

Mulji received a BFA in sculpture and printmaking from the Indus Valley School of Art and Architecture, Karachi. Since 2002, she has taught at the School of Visual Arts, Beaconhouse

National University, Lahore. Her work also incorporates photography, video and installation. Through irony and humour she approaches issues of feminism and cultural identity that have involved, for instance, a taxidermy camel and C-prints of Ken and Barbie. She has exhibited her work extensively in Pakistan, as well as India, China, the UK and US. Recently, her work was featured in a solo exhibition, 'Arabian Delight', at the Rohtas Gallery, Lahore (2008). Her participation in group exhibitions includes 'Beyond Borders: Art of Pakistan', National Gallery of Modern Art, Mumbai, India (2005); 'Something Purple: Media Art from Pakistan', Hong Kong (2005); 'Sub-Contingent', Fondazione Sandretto Re Rebaudengo, Turin, Italy (2006); 'Contemporary Art from Pakistan', Thomas Erben Gallery, New York (2007); and 'Desperately Seeking Paradise', Art Dubai (2008). [JG]

Takashi MURAKAMI
b. 1962, Tokyo, Japan; lives in Tokyo

First trained in traditional Japanese-style painting (*nihonga*), Murakami is today one of the world's leading neo-pop artists. His globally influential work incorporates elements of anime and manga subculture. Major exhibitions include 'Superflat', Museum of Contemporary Art, Los Angeles, and Walker Art Center, Minneapolis (2001); 'Little Boy: The Arts of Japan's Exploding Pop Culture', Japan Society, New York (2005); and 'Murakami ©', Museum of Contemporary Art, Los Angeles (2007), Brooklyn Museum, New York (2008), and Guggenheim Museum, Bilbao, Spain (2009). [MT]

Masato NAKAMURA
b. 1963, Odate, Japan; lives in London, England

Nakamura received his BFA and MFA from Tokyo University of the Arts, where he is currently Associate Professor in the department of painting. In 1998, together with seven other artists, he established a non-profit organization, Artist Initiative Command N, which has created many international artist-exchange programmes and artistic projects that directly interact with local communities. Nakamura has participated in a number of group exhibitions, including 'Threshold', Power Plant, Toronto, Canada (1998); 3rd Asia-Pacific Triennial of

Contemporary Art, Queensland Art Gallery, Brisbane, Australia (1999); 'MOT Annual', Museum of Contemporary Art, Tokyo, Japan (2000); 49th Venice Biennale, Italy (2001); 'Neo Tokyo', Museum of Contemporary Art, Sydney, Australia (2001); and 'Art & Economy', Deichtorhallen, Hamburg, Germany (2002). [MT]

Yoshitomo NARA
b. 1959, Hirosaki, Japan; lives in Tokyo, Japan

Nara received a BFA (1985) and MFA (1987) from the Aichi Prefectural University of Fine Arts and Music. From 1988 to 1993 he attended the Kunstakademie Düsseldorf in Germany. His paintings and sculptures are identified with Japanese pop, but music – especially punk and rock – are equal influences. His exhibitions include 'Tokyo Pop', Hiratsuka Museum of Art, Kanagawa, Japan (1997); 'Superflat', Museum of Contemporary Art, Los Angeles, and Walker Art Center, Minneapolis (2001); 'Little Boy: Pop Culture in Japan', Japan Society, New York (2005); 2nd Yokohama Triennale, Japan (2005); 'Moonlight Serenade', 21st Century Museum of Contemporary Art, Kanazawa, Ishikawa, Japan (2006); and 6th Shanghai Biennale, China (2006). Solo exhibitions include 'Yoshitomo Nara: Nothing Ever Happens', Institute of Contemporary Art, Philadelphia (2004), and 'Yoshitomo Nara + graf', BALTIC Centre for Contemporary Art, Gateshead, England (2008). [MC]

Shirin NESHAT
b. 1957, Qazvin, Iran; lives in New York, USA

Neshat is a photographer and video artist who was educated at University of California, Berkeley (1979–82). She arrived in the US when she was seventeen and it was not until 1990 that she returned to Iran to visit. Her work first came to prominence with a series of photographs, *Women of Allah* (1993–97). In 1996 she turned to video, developing a dual-screen projection technique that often spoke of gender differences in societies such as her homeland, Iran. Her work has featured in 'Transculture', 46th Venice Biennale, Italy (1995); Whitney Museum of American Art at Philip Morris, New York (1998); Tate Gallery, London, England (1998); Art Institute of Chicago (1999); 'Moving Pictures', Solomon R.

Guggenheim Museum of Art, New York (2002); and 'Tooba', Asia Society Museum, New York (2003). Neshat was awarded the First International Prize at the 48th Venice Biennale, Italy (1999), and the Grand Prix at the 3rd Gwangju Biennale, Korea (2000). [MC]

NGUYEN Manh Hung
b. 1976, Hanoi, Vietnam; lives in Hanoi

Nguyen received a BFA from the Hanoi University of Fine Arts in 2002. He is a self-taught composer and sound performance artist. A prominent military theme is common in many of his paintings, sculptures, installations and digital photographs, appearing in the form of tanks, airplanes, monuments of generals and soldiers' uniforms. His experiences in – and observations of – Vietnamese society are brought to life in his interdisciplinary approach to art. In addition to participating in performance-art festivals in Vietnam, Japan and Taiwan, he has exhibited at the Goethe Institute in Hanoi (2002); Ryllega Gallery, Hanoi (2005); and Location One, New York (2008). [SL]

NGUYEN Minh Thanh
b. 1971, Kim Lan, Vietnam; lives in Dalat, Vietnam

Nguyen graduated from the Vietnam College of Fine Arts, Hanoi, in 1996. He is best known for his portrayals of rural Vietnamese life and Vietnamese women. Executed in Chinese ink and watercolour on hand-made *do* paper, these portraits are often related to his childhood experience of living in rural Vietnam. Since 1996, he has had solo exhibitions in Vietnam, Germany and the Netherlands. He has also participated in a number of group exhibitions, including the 3rd Asia-Pacific Triennial of Contemporary Art, Queensland Art Gallery, Brisbane, Australia (1999); 1st Fukuoka Asian Art Triennale, Japan (1999); 'Lines of Descent: The Family in Contemporary Asian Art', Queensland Art Gallery/Gallery of Modern Art, Brisbane, Australia (2000); and 5th Gwangju Biennale, Korea (2004). [DYW]

Jun NGUYEN-HATSUSHIBA
b. 1968, Tokyo, Japan; lives in Ho Chi Minh City, Vietnam

Nguyen-Hatsushiba's education was exclusively in the United States. He studied at the School of the Art Institute of Chicago and at Maryland Institute. His video installations picture various activities conducted in the ocean. His first work to gain international attention was *Memorial Project, Nha Trang, Vietnam, Towards the Complex?, For the Courageous, the Curious, and the Cowards* (2001). Solo exhibitions include shows at the Mori Art Museum, Tokyo, Japan; Museo d'Arte Contemporanea, Rome, Italy; Kunsthalle Wien, Vienna, Austria; and Asia Society Museum, New York. [MC]

Eko NUGROHO
b. 1977, Yogyakarta, Indonesia; lives in Yogyakarta

Nugroho studied painting at the Indonesian Art Institute in Yogyakarta. Before graduating, he had already been named Best Artist 2005 by Indonesian magazine *TEMPO*. His comic-inspired works have been shown at the 5th Asia-Pacific Triennial of Contemporary Art, Queensland Art Gallery, Brisbane, Australia (2006); 'Geopolitical of Animation', Andalusian Centre of Contemporary Art, Seville, Spain (2007); 'Manifesto', National Gallery, Jakarta, Indonesia (2008); and 6th Busan Biennale, Korea (2008). [MT]

Manuel OCAMPO
b. 1965, Quezón City, Philippines; lives in Berkeley, USA, and Manila, Philippines

Ocampo studied at the University of the Philippines in Quezón City and at California State University in Bakersfield. Much of his work criticizes Spanish colonialism in the Philippines, and serves more broadly as a postcolonial critique of global capitalism. Political content is evident in references to the Ku Klux Klan and to symbols such as the swastika, as well as in visual imagery from the Baroque period, recalling the time in his youth when he reproduced religious Baroque paintings for tourists. He has exhibited his work in numerous solo shows in the Philippines, Canada, France, Germany, Spain, the US and elsewhere. He has also participated in a number of group shows, including Documenta 9, Kassel, Germany (1992); 'Asia/America: Identities in Contemporary Asian American

Art', Asia Society, New York (1994); 5th Lyon Biennale, France (2000); and 'Bastards of Misrepresentation', Casa Asia, Barcelona, Spain (2005). [SL]

ODANI Motohiko
b. 1972, Kyoto, Japan; lives in Tokyo, Japan

Odani studied sculpture and received a BA and MA from Tokyo University of the Arts, where he now teaches as Associate Professor in the department of intermedia art. His work has been shown internationally at, among others, the 5th Lyon Biennale, France (2000); 7th Istanbul Biennial, Turkey (2001); 4th Gwangju Biennale, Korea (2002); 50th Venice Biennale, Italy (2003); 'Tokyo Style: Motohiko Odani', Moderna Museet, Stockholm, Sweden (2004); 'ARS 06', Museum of Contemporary Art Kiasma, Helsinki, Finland (2006); and 'Becoming Animal', MASS MoCA, Massachusetts (2006). [MT]

Oscar OIWA
b. 1965, São Paulo, Brazil; lives in New York, USA

Oiwa is a Brazilian artist of Japanese descent, known for his nightmarish realistic painting. He graduated from São Paulo University in 1989. In 1991 he moved to Tokyo, but since 2002 has been based in New York. His work has been shown at many exhibitions, including the 21st São Paulo Biennial, Brazil (1991); 'VOCA 95: Vision of Contemporary Art', Ueno Royal Museum, Tokyo, Japan (1995); 4th Yokohama Biennale, Japan (1996); 'In Search of Form', Pusan Municipal Art Museum, Korea (2001); and 'Traveling: Towards the Border', National Museum of Modern Art, Tokyo (2003). In 2008 the Museum of Contemporary Art, Tokyo, presented his solo exhibition, 'The Dreams of a Sleeping World'. Oiwa has received grants from the Pollock-Krasner Foundation, New York (1997), and from the Simon Guggenheim Foundation, New York, and Asian Cultural Council, Tokyo and New York (2002). [MT]

Yoko ONO
b. 1933, Tokyo, Japan; lives in New York, USA

Ono is a conceptual artist who began to stage performances and Happenings in New York in

the 1960s, sometimes with Fluxus artists. Her films and music have also gained international prominence; in 1982 she was awarded the 'Album of the Year' Grammy for *Double Fantasy* with John Lennon and Jack Douglas. Her artwork has been recognized in the retrospective touring exhibition 'Yes Yoko Ono', organized by Japan Society, New York (2000), which toured to the Walker Art Center, Minneapolis (2001), MIT List Visual Arts Center, Cambridge, Massachusetts (2002), San Francisco Museum of Modern Art, California (2002), Rodin Gallery, Seoul, Korea (2003), and Hiroshima City Museum of Contemporary Art, Art Tower Mito, Japan (2003). [MC]

OZAWA Tsuyoshi
b. 1965, Tokyo, Japan; lives in Saitama, Japan

In 1989 Ozawa graduated from Tokyo University of the Arts with a degree in oil painting. He continued to study at the graduate school there, finishing the programme in 1991. While distinctly comical in his approach, Ozawa often examines art history or contemporary socio-political conditions through performance, installation, photography and video. In 2007 he established a group, Xijing Men, with artists Chen Shaoxiong of China and Gimhongsok of Korea. Ozawa's work has been shown in exhibitions such as the 50th Venice Biennale, Italy (2003); 8th Istanbul Biennial, Turkey (2003); 'Adaptive Behavior', New Museum of Contemporary Art, New York (2004); 2nd Guangzhou Triennial, China (2006); 5th Asia-Pacific Triennial of Contemporary Art, Queensland Art Gallery, Brisbane, Australia (2006); and 'Heavy Light: Recent Photography and Video from Japan', International Center of Photography, New York (2008), among many others. [MT]

Nam June PAIK
b. 1932, Seoul, South Korea; d. 2006

The performance and conceptual artist Nam June Paik has been recognized as one of the most influential pioneers of media-based art. He was born into a family that fled the Korean War, first to Hong Kong and later to Japan. In the 1950s he studied aesthetics, art history and music at the University of Tokyo in Japan and then at Munich University and Freiburg

Conservatory in Germany. He became a central figure in the Fluxus movement in the late 1950s and 1960s. His work often incorporates various art forms and espouses radical social positions. He became the first artist to use video in 1965, and continued to explore the expressive possibilities of this new medium. With a belief in the communicative potential between contemporary art and its audiences, he had the TV project *Good Morning, Mr. Orwell* broadcast throughout the world via satellite in 1984. One of his representative works, *Fin de Siècle II* (1989–90), consists of hundreds of television monitors, confronting the viewer with multiple images and sounds. In 2000 Paik began his exploration of laser technology. His work has been exhibited around the globe, with major retrospectives at the Whitney Museum of American Art, New York (1982), and at the Solomon R. Guggenheim Museum, New York (2000), which then travelled to Seoul, Korea. Paik received grants and awards from the Guggenheim Museum, Rockefeller Foundation, American Film Institute and UNESCO. [DYW]

Junebum PARK
b. 1976, Seoul, Korea; lives in Seoul

Park graduated from Sungkyunkwan University in Seoul and has shown his video works in a range of local and international venues, including the 5th Shanghai Biennale, China (2004); Insa Art Space of Korean Culture and Arts Foundation, Seoul (2005); and 'Projected Realities: Video Art from East Asia', Asia Society, New York (2006). [MC]

PARK Seo-bo
b. 1931, Ye-cheon, Gyeong-Buk, Korea; lives in Seoul, Korea

Park studied painting at Hongik University, Seoul, and was a leader of École de Seoul, a school of Korean Modernism. His earliest influences came from the West, especially following a visit to Paris in 1961. His post-Korean War pathos was expressed in an Art Informel manner, involving a muddy palette and splashes of paint on canvas. After a brief period of surrealistic figuration, he abandoned colour, and, in the 1970s, found his signature style of 'white' paintings, featuring repetitious, wave-like lines on a monochromatic

background. He titled these works *Écriture* (the French term for 'writing'). This ongoing project has gone through structural transformations in the last three decades. The most recent all-over *Écriture* paintings, which have re-introduced colour from a variety of sources, consist of vertical impasto stripes on layers of *hanji* (traditional Korean mulberry paper). Park has shown extensively in Korea, China, Japan, Taiwan, Australia, France, Germany, Austria, Brazil, Vietnam, Canada, the UK and US. Major solo shows include 'Park Seo-Bo's Paintings: It's Forty Years' at the National Museum of Contemporary Art, Seoul (1991); Musée d'art moderne, Saint-Étienne, France (2006–7); Arario Beijing, China (2007); Gyeonggido Museum of Art, Ansan, Korea (2007); Arario New York (2008). He was awarded First Prize at the Jeunes Peintres du Monde à Paris, National Committee of the IAA France (1961); Culture and Art Prize for the Republic of Korea, Ministry of Public Information (1979); National Medal of Korea (Medal of Seokryu) (1984); and Order of Cultural Merit, Korea (1994). [HY]

Sudhir PATWARDHAN
b. 1949, Pune, India; lives in Thane, India

Patwardhan is a self-taught artist, having studied medicine at the Armed Forces Medical College, Pune, from 1967 to 1972. Until 2005 he worked as a radiologist in Thane, near Mumbai. He is known for his paintings and works on paper invoking urban realities. Since his first solo exhibition at Art Heritage, New Delhi (1979), his work has been presented in over twenty solo exhibitions at galleries in India and internationally, including several shows at the Jehangir Art Gallery and Sakshi Gallery, Mumbai. He has participated extensively in group exhibitions in India, the UK, France, Germany, Switzerland and the US, including 'Edge of Desire: Recent Art in India', co-organized by the Asia Society Museum, New York, and the Art Gallery of Western Australia, Perth (2005); 'Indian Art: Inventing/Inverting Traditions', Grosvenor Vadehra, London, England (2006); 'Gateway Bombay', Peabody Essex Museum, Salem, Massachusetts (2007); 'Horn Please: Narratives in Contemporary Indian Art', Kunstmuseum Bern, Switzerland (2007); and 'Multiple Modernities: India, 1905–2005', Philadelphia Museum of Art, Pennsylvania (2008). His work is also held in

numerous collections. The film *Saacha* ('The Loom', 2001) explores his and the poet Narayan Surve's involvement in the Left movement in Mumbai. [JG]

Paul PFEIFFER
b. 1966, Honolulu, Hawaii; lives in New York, USA

Pfeiffer received a BFA from San Francisco Art Institute and an MFA from Hunter College in New York, after which he participated in the Whitney Independent Study Program, also in New York. His primary media are sculpture and video. In his video artworks, Pfeiffer uses digital editing techniques to manipulate found images and footage from mass media and popular culture. In addition to having solo shows internationally, including in the US, Spain, Germany, Italy and Greece, he has exhibited his art in group shows, such as the 70th Whitney Biennial, New York (2000); 49th Venice Biennale, Italy (2000); and 16th Biennale of Sydney, Australia (2008). His works are held in the collections of the Solomon R. Guggenheim Museum, New York; Hirshhorn Museum and Sculpture Garden, Washington, DC; and Museo d'Arte Contemporanea Castello di Rivoli, Turin, Italy. He has been awarded numerous grants and awards, including the Bucksbaum Award from the Whitney Museum of American Art (2000); a residency at the MIT List Visual Arts Center, Cambridge, Massachusetts (2001); and a residency at Art Space in San Antonio, Texas (2003). [SL]

Chatchai PUIPIA
b. 1964, Mahasarakham, Thailand; lives in Bangkok, Thailand

Puipia received his BFA in painting from the faculty of painting, sculpture and graphic arts at Silpakorn University, Bangkok. His signature works are large self-portraits done in oil on canvas, evocative of the anxiety and social malaises in rapidly industrializing Thailand. Since 1985, Puipia has participated in numerous exhibitions in Asia, Europe and North America, including 'Les peintres thailandais traditionnels et contemporains', Espace Pierre Cardin, Paris, France (1989); 'Siamese Smile', Japan Cultural Center, Bangkok (1995); 'Contemporary Art in Asia: Traditions/Tensions', organized by the

Asia Society, New York (1996); 3rd Shanghai Biennale, China (2000–1); and 1st Singapore Biennale (2006). [DYW]

PUSHPAMALA N.
b. 1956, Bangalore, India; lives in Bangalore

Pushpamala N. received an MA in sculpture from the faculty of fine arts, Maharaja Sayajirao University, Baroda, in 1985. She is renowned for her performance photography, in which she assumes various personas in an exploration of gender and popular culture. Her work has been widely exhibited in India, as well as Canada, France, Italy, Austria, Thailand, the UK and US. She has participated in numerous solo exhibitions, including 'Phantom Lady and Sunhere Sapne', Walsh Gallery, Chicago (2003); 'Native Women of South India', Nature Morte, Delhi (2005); and 'Paris Autumn', Bose Pacia Gallery, New York (2008). Her work has also been included in group exhibitions, including the 1st Johannesburg Biennale, South Africa (1995); '100 Years of NGMA', National Gallery of Modern Art, New Delhi (1995); 'Edge of Desire: Recent Art in India', co-organized by the Asia Society Museum, New York, and the Art Gallery of Western Australia, Perth (2005); 'Indian Video Art: Between Myth and History', Tate Modern, London, England (2006); and 'Ultra New Vision of Contemporary Art', Singapore Art Museum (2006). Among numerous honours, she has received the National Award (1984); Gold Medal, VI Triennale, India, and Karnataka Rajyothsava Award (1986); and the Karnataka Shilpa Kala Akademi Award (1998). [JG]

QIU Zhijie
b. 1969, Zhangzhou, China; lives in Hangzhou and Beijing, China

In 1992 Qiu graduated from the printmaking department of the Zhejiang Academy of Fine Arts, Hangzhou (now China Academy of Art, where Qiu is Associate Professor). Since then, he has curated exhibitions, published writings and created conceptual artworks in calligraphy, photography, painting, stone carving and video. His exhibitions include 'Inside Out: New Chinese Art', Asia Society Galleries and PS1, New York, and other venues (1998–2000); 4th Gwangju Biennale, Korea (2002); 1st

Guangzhou Triennial, China (2002); 50th Venice Biennale, Italy (2003); 'Alors La Chine', Centre Pompidou, Paris, France (2003); 'Between Past and Future: New Photography and Video from China', International Center of Photography and Asia Society, New York (2004); 5th Shanghai Biennale, China (2004); and 3rd Guangzhou Triennial, China (2008). [MC]

Imran QURESHI
b. 1972, Hyderabad, Pakistan; lives in Lahore, Pakistan

In 1993 Qureshi received a BA in fine art from the National College of Arts, Lahore, where he is now a professor of miniature painting and drawing. He is a member of Darmiyaan, an arts collective established by the artist Aisha Khalid. In 2003 he initiated a project involving a series of collaborative paintings that were inspired by the working methods of the Mughal ateliers. These paintings were featured in 'Karkhana: A Contemporary Collaboration', organized by the Aldrich Contemporary Art Museum, Ridgefield, Connecticut (2005). His work has been widely exhibited in Pakistan and internationally, including solo exhibitions in Lahore (1995), Islamabad (1996), New York (2001), Karachi (2002), London (2004), New Delhi (2006) and Oxford (2007). His work has also been included in group exhibitions, such as the 3rd Asia-Pacific Triennial of Contemporary Art, Queensland Art Gallery, Brisbane, Australia (1999); 'The American Effect: Global Perspectives on the United States, 1990–2003', Whitney Museum of American Art, New York (2003); 'Playing with a Loaded Gun', Kunsthalle Fridericianum, Kassel, Germany (2003); 'Contemporary Miniature Paintings from Pakistan', Fukuoka Asian Art Museum, Japan (2004); 'Beyond Borders: Art of Pakistan', National Gallery of Modern Art, Mumbai, India (2005); 'Beyond the Page', Manchester Art Gallery and Asia House, London, England (2006); 1st Singapore Biennale (2006); and 'Desperately Seeking Paradise', Art Dubai (2008). [JG]

Nusra Latif QURESHI
b. 1973, Lahore, Pakistan; lives in Melbourne, Australia

Qureshi received a BFA in 1995 from the National College of Arts, Lahore, where she

specialized in miniature painting. In 2002 she received an MFA from the Victorian College of the Arts, University of Melbourne, Australia. Her work reflects a reconfiguration of imagery drawn from Mughal-period miniature painting and British-period photography in an exploration of feminism, political authority and collective memory. Her work has been widely exhibited in Pakistan, India, Australia, the UK and US, including solo gallery exhibitions in Islamabad, Melbourne, London and New Delhi. Her first solo exhibition in the US was '"The Way I Remember Them": Paintings by Nusra Latif Qureshi', Smith College Museum of Art, Northampton, Massachusetts (2004). Her work has also been shown in numerous group exhibitions, including 'Contemporary Miniature Paintings from Pakistan', Fukuoka Asian Art Museum, Japan (2004); 'Beyond Borders: Art of Pakistan', National Gallery of Modern Art, Mumbai, India (2005); 'Karkhana: A Contemporary Collaboration', Aldrich Contemporary Art Museum, Ridgefield, Connecticut (2005); 'Beyond the Page', Manchester Art Gallery and Asia House, London, England (2006); and 5th Asia-Pacific Triennial of Contemporary Art, Queensland Art Gallery, Brisbane, Australia (2006). She has been the recipient of numerous awards, including the Julian Burnside Prize (2002), the UNESCO residency in the US (2003) and Darebin La Trobe Acquisitive Art Prize (2005). [JG]

Ram RAHMAN
b. 1955, New Delhi, India; lives in New Delhi, India

Rahman studied physics at the Massachusetts Institute of Technology in the mid-1970s, and completed a degree in graphic design at Yale University in 1979. He is a founding member of the Safdar Hashmi Memorial Trust (SAHMAT), a New Delhi-based organization that advocates against communalism through art exhibitions and other events. He has gained wide recognition for his photographic work, particularly that covering the political and urban landscapes of Delhi. His work has been exhibited in India and internationally, including solo exhibitions at Admit One Gallery, New York (2000); Cleveland Museum of Art, Ohio (2002); India International Center, New Delhi (2003); and Rabindra Bhavan, Lalit Kala Akademi, New Delhi (2008). His participation in group exhibitions includes 'Heat:

Moving Picture Visions, Phantasms and Nightmares', Bose Pacia Modern, New York (artist and curator, 2003); 'Faces', Sepia International, New York (2003); 'Middle Age Spread', National Museum, New Delhi (2004); 'Click!: Contemporary Photography from India', Vadehra Art Gallery, New Delhi, and Grosvenor Vadehra, London (2007); and 'India: Public Places, Private Spaces', Newark Museum, New Jersey (2007). [JG]

Raghu RAI
b. 1942, Jhhang, Pakistan; lives in New Delhi, India

Rai's formative years as a photographer began in 1966 at *The Statesman*, a New Delhi news publication, followed by various positions at leading Indian news magazines, including *Sunday* and *India Today*. Since 1977, he has been a member of Magnum Photos, the international photographic cooperative. His work, specializing in Indian-related topics, has resulted in extensive book publications and in photo essays in leading journals, including *Time*, *Life* and *The New Yorker*. Among his critically acclaimed projects, he collaborated with Greenpeace in documenting the 1984 chemical disaster at Bhopal, India. In addition to a book publication, exhibitions of this work toured internationally. Retrospectives include exhibitions at the National Gallery of Modern Art, New Delhi (1997), and Photofusion, London, England (2002). His work is held in the collection of the Bibliothèque Nationale, Paris, France. Rai has served multiple times as a jurist for the World Press Photo and UNESCO's International Photo Contest. Among numerous awards, he has received the Padma Shri (Government of India, 1971) and the Photograph of the Year Award (US, 1992) for his *National Geographic* piece on human management of wildlife in India. [JG]

Rashid RANA
b. 1968, Lahore, Pakistan; lives in Lahore

In 1992 Rana received a BFA from the National College of Arts, Lahore, and in 1994 an MFA from the Massachusetts College of Art, Boston. In 2003 he won the International Artist of the Year Award from the South Asian Visual Arts Collective in Toronto, Canada, as well as the

Hathor Prize at the 9th Cairo Biennale, Egypt. His works have been included in many international exhibitions, including the travelling 'Vision: 50 Years of Art from Pakistan', first presented at the Brunei Gallery, School of Oriental and African Studies, London, England (2000). He also participated in the 1st Singapore Biennale (2006) and the 5th Asia-Pacific Triennial of Contemporary Art, Queensland Art Gallery, Brisbane, Australia (2006). In 2007 he inaugurated the new venue of the National Art Gallery of Islamabad, Pakistan. His works appear in a wide range of media and sizes, and deal with social and political issues relating to faith and popular culture. [VR]

RAQS MEDIA COLLECTIVE (founded 1992)

Delhi-based Jeebesh Bagchi (b. 1965, India), Monica Narula (b. 1969, India) and Shuddhabrata Sengupta (b. 1968, India) founded the Raqs Media Collective after graduating from the Jama Millia Islamia School with MAs in mass communication. Although they started with a common interest in documentary filmmaking, in time their works varied from new media and digital art to photography, graphic design and use of the internet. In 2001 they co-founded Sarai: The New Media Initiative with Ravi Vasudevan and Ravi Sundaram as part of the Centre for the Study of Developing Societies at the University of New Delhi. Their works have been shown extensively throughout Europe, the US and India, including at Documenta 11, Kassel, Germany (2002); 50th Venice Biennale, Italy (2003), with *The Structure of Survival*; 'Edge of Desire: Recent Art in India', co-organized by the Asia Society Museum, New York, and the Art Gallery of Western Australia, Perth (2005); and 'Indian Highway', Serpentine Gallery, London, England (2008). In addition to creating artworks, the collective has collaborated in projects that explore the link between social commentary and new media. They co-curated 'Scenarios' at Manifesta 7 (2008). [VR]

Araya RASDJARMREARNSOOK
b. 1957, Trad, Thailand; lives in Chiang Mai, Thailand

Rasdjarmrearnsook acquired a BA and MFA in graphic art from Silpakorn University, Bangkok.

In 1994 she was awarded a further diploma from the Hochschule für Bildende Künste, Braunschweig, Germany. Currently lecturing in art at the faculty of fine art at Chiang Mai University, she is well known for her reflective and provocative art, which works across many media and often focuses on the relationship between life and death. She has had solo exhibitions at the National Gallery Bangkok (1987, 1992, 1994, 1995) and at the Atelier Forsthaus, Gifhorn, Germany (1990, 1991). Group exhibitions include 'Bangkok Bicentennial Art Exhibition', Memorial Art Gallery, University of Rochester, New York (1982); 'Thai Women Artists', Amarin Art Gallery, Bangkok (1987); 1st Asia-Pacific Triennial of Contemporary Art, Queensland Art Gallery, Brisbane, Australia (1993); 'Visions of Happiness', Japan Foundation ASEAN Cultural Center, Tokyo, Japan (1995); and 'Contemporary Art in Asia: Traditions/Tensions', organized by the Asia Society, New York (1996). She received awards in graphic art at the National Exhibition of Art at the Contemporary Art Exhibition, Bangkok, in 1980, 1987 and 1990, and her work is held at the Kiasma Museum of Contemporary Art, Helsinki, Finland. [MCH]

Navin RAWANCHAIKUL
b. 1971, Chiang Mai, Thailand; lives in Chiang Mai, Thailand, and Fukuoka, Japan

In 1994 Rawanchaikul graduated in painting from Chiang Mai University. In 1992, before graduation, he had already served as co-organizer of the 'Chiang Mai Social Installation', a three-month alternative art and culture forum in the north of Thailand. His installations almost always involve collaborations with others. He has shown his work in 'Contemporary Art in Asia: Traditions/ Tensions', organized by the Asia Society, New York (1996); 2nd Gwangju Biennale, Korea (1998); 'Fly With Me to Another World', Le Consortium, Dijon, France (2000); 'I ♥ Taxi', PS1 Contemporary Art Center, New York (2001); 'SUPER(M)ART', Palais de Tokyo, Paris, France (2002); and 4th Shanghai Biennale, China (2002–3). [MC]

Syed Haider RAZA
b. 1922, Barbaria, Madhya Pradesh, India; lives in Paris and Gorbio, France

Educated at the Nagpur School of Art (1939–43) and the Sir J. J. School of Art, Mumbai (1943–47), Raza received a scholarship in 1950 to train at the École Nationale Supérieure des Beaux-Arts, Paris. He later became a founding member of the Progressive Arts Movement and a visiting lecturer at the University of California, Berkeley. He is best known for abstract geometric work, his vibrant and colourful paintings drawing inspiration from nature and Indian metaphysical philosophy. His art has been exhibited internationally, including at the 28th Venice Biennale, Italy (1956); 'India, Myth and Reality: Aspects of Modern Indian Art', Museum of Modern Art, Oxford, England (1982); and 'Modern and Contemporary Indian Art', Vadehara Art Gallery, New Delhi, India (2008). He has also received numerous awards, including the Prix de la Critique, Paris, in 1956; in 1981 the Indian government awarded him the Padma Shri. He was elected a Fellow at the Lalit Kala Akademi, New Delhi, in 1983. His work is held in numerous collections, including the Fukuoka Asian Art Museum, Japan, and the Musée National d'Art Moderne, Paris, France. [MCH]

Ravinder REDDY

b. 1956, Suryapet, Andhra Pradesh, India; lives in Visakhapatnam, India

Reddy received his BA and MA in sculpture from Maharaja Sayajirao University, Baroda. In 1983 he went to Goldsmiths College, London, England, to study sculpture. His best-known works feature large female heads made of terracotta or polyester resin, coated in bright colours and representative of contemporary Indian women. In 1998 Reddy was awarded a working grant from the Pollock-Krasner Foundation, New York. He has had many solo exhibitions, including shows at the Art Heritage, New Delhi and Bombay (1981); Contemporary Art Gallery, Ahmedabad (1982); Max Muller Bhavan Hydrabad (1989); and 'Contemporary Art in Asia: Traditions/Tensions', organized by the Asia Society, New York (1996). In 2004 he participated in 'Margi & Desi Exhibition' at the Lalit Kala Galleries, New Delhi, curated by Alka Pande. Some of his works are held in major collections such as the Queensland Art Gallery, Brisbane, Australia; Fukuoka Asian Art Museum, Japan; Chester Herwitz Trust, Peabody Essex Museum, Salem, Massachusetts;

National Gallery of Modern Art, New Delhi; and Victoria and Albert Museum, London, England. [VR]

N. N. RIMZON

b. 1957, Kakkoor, India; lives in Kerala, India

In 1982 Rimzon received his BFA in sculpture from the College of Fine Arts, Trivandrum; in 1984 an MA from the faculty of fine arts, Maharaja Sayajirao University, Baroda; and in 1989 an MA from the Royal College of Art, London, England. His paintings, drawings and sculptures have been presented in several solo exhibitions in India, New York and Amsterdam. He has also participated in numerous biennales and group exhibitions in India and internationally, including the 4th Havana Biennial, Cuba (1991); 45th Venice Biennale, Italy (1993); 'One Hundred Years: From the National Gallery of Modern Art Collection', National Gallery of Modern Art, New Delhi (1994); 'The Other Self', National Gallery of Modern Art, New Delhi, and Stedelijk Museum, Amsterdam, Netherlands (1996); 2nd Asia-Pacific Triennial of Contemporary Art, Queensland Art Gallery, Brisbane, Australia (1996); 'Contemporary Art in Asia: Traditions/Tensions', organized by the Asia Society, New York (1996); and 'Edge of Desire: Recent Art in India', co-organized by the Asia Society Museum, New York, and the Art Gallery of Western Australia, Perth (2005). Among various honours, he has received the Navdeep Award (Ahmedabad, 1985) and the Sanskriti Award (New Delhi, 1992). [JG]

Sharmila SAMANT

b. 1967, Mumbai, India; lives in Mumbai

Samant received a BFA from the Sir J. J. School of Art, Mumbai, in 1989. She is the founder of Open Circle, a Mumbai-based organization practising various art-related initiatives. During her residency at the Rijksakademie van Beeldende Kunsten, Amsterdam, Netherlands (1998–2000), she produced pieces including her widely exhibited Coca-Cola bottle-cap sari and *Shifts*, an installation piece involving a mapping of land routes from Mumbai to Amsterdam with traditional footwear from nineteen countries. She has shown her work extensively in India, as well as other countries

including the Netherlands and the UK. She has had solo exhibitions at galleries in Ahmedabad (1993), Chennai (1994), Mumbai (1996) and Amsterdam (1999). Her participation in group exhibitions includes 'Century City: Art and Culture in the Modern Metropolis', Tate Modern, London, England (2001); 'Indian Video Art', Fukuoka Asian Art Museum, Japan (2004); 'Rites/Rights/Rewrites: Women's Video Art from India', Cornell University, Ithaca, New York (2004), and other venues in the US; 'Edge of Desire: Recent Art in India', co-organized by the Asia Society Museum, New York, and the Art Gallery of Western Australia, Perth (2005); 'Mirror Worlds: Contemporary Video from Asia', Australian Centre for Photography, Sydney (2005), and other venues; and the 16th Biennale of Sydney, Australia (2008). Among various honours, Samant has received the Maharashtra State Award at the annual art exhibition, Pune, India (1989). [JG]

Hiraki SAWA

b. 1977, Ishikawa, Japan; lives in London, England

Sawa, now based in London, is one of the world's leading video artists. He received his BA in sculpture from the University of East London in 2000. Developing an interest in video and studying the technique on his own, he also completed an MFA in sculpture at the Slade School of Fine Art, London, in 2003. His digital-animation video works collage images from reality and the imagination, and transport the spectator to a dream-like state in which time progresses slowly. His solo exhibitions include 'Hiraki Sawa', Hirshhorn Museum and Sculpture Garden, Washington, DC (2005); 'Hammer Projects: Hiraki Sawa', UCLA Hammer Museum, Los Angeles (2005); and 'Six Good Reasons to Stay at Home', National Gallery of Victoria, Melbourne, Australia (2006). He has also participated in 'Media_City Seoul 2000', National Historical Museum, Seoul, Korea (2000); 7th Lyon Biennale, France (2003); 2nd Yokohama Triennale, Japan (2005); 51st Venice Biennale, Italy (2005); 'Thermocline of Art: New Asian Waves', ZKM, Karlsruhe, Germany (2007); and 'Beautiful New World: Contemporary Visual Culture from Japan', Beijing and Guangzhou, China (2007). [MT]

Tomoko SAWADA
b. 1977, Kobe, Japan; lives in New York, USA, and Kobe, Japan

Sawada graduated from the Seian University of Art and Design, Kyoto, in 2000. Her photography examines social customs in Japan and the way in which individualism and originality relate to them. Sawada has had a number of solo exhibitions in Japan, the US and Europe, and her works have also been included in many group exhibitions, such as 'The Year of New Work: Contemporary Asian Photography', Japan Society, New York (2002); 'How Human: Life in the Post-Genome Era', International Center of Photography, New York (2003); 'Geometry of the Face', National Museum of Photography, Copenhagen, Denmark (2003); 'Out of the Ordinary/Extraordinary: Japanese Contemporary Photography', Japanischen Kulturinstituts, Cologne, Germany (2004); and 'Heavy Light: Photography and Video from Japan', International Center of Photography, New York (2008). In 2004 she received the Kimura Ihei Memorial Photography Award. [MT]

SEKINE Nobuo
b. 1942, Saitama, Japan; lives in Tokyo, Japan

In 1968 Sekine graduated with a master's degree in oil painting from Tama Fine Art College in Tokyo. The first public presentation of his work was that same year in an exhibition in Kobe, where he showed his *Phase* series, begun in 1967. This series, much of which consists of a hole in the ground in the shape of a column, alongside a similar column shape composed of the excavated soil, is recognized as a forerunner to the Mono-ha movement, which aims to bring things together, drawing attention to the interdependent relationships between objects and the space surrounding them. Sekine's *Phase* works also include paintings, in which the artist's gesture and Japanese materials play a key role. In 1973 Sekine established Environment Art Studio. He has had solo shows in Europe and Asia, and his work has been included in the 35th Venice Biennale, Italy (1970); 'Avant-Garde Japanese Art', Centre Pompidou, Paris, France (1986); 'Scream Against the Sky: Japanese Art after 1945', Yokohama Museum of Art, Japan, and Guggenheim Museum, New York (1994); 3rd Gwangju Biennale, Korea (2000); 'Century City: Art and Culture in the Modern Metropolis',

Tate Modern, London (2001); 'Mono-Ha Reconsidered', National Museum of Art, Osaka, Japan (2005); and 'What is Mono-ha?', Beijing Tokyo Art Projects, Beijing, China (2007). He has been the recipient of several prizes, including awards at the 8th Contemporary Art Exhibition of Japan, Tokyo (1968) and the 6th Paris Biennale, France (1969). [DYW]

Nataraj SHARMA
b. 1958, Mysore, India; lives in Baroda, India

Sharma studied applied art and painting at the faculty of fine arts, Maharaja Sayajirao University, Baroda, graduating in 1982. His early years were spent in England, and also Ethiopia and Zambia. He is renowned for his work depicting the human costs of industrialization. He works in a variety of media, including painting, digital photography, prints, sculpture and installation. His first solo exhibition was in New Delhi in 2000, followed by solo exhibitions in major Indian cities and internationally. Recently, his work has been inspired by aerial acrobatics, culminating in the solo exhibitions 'Air Show' at Bodhi Art, Singapore (2006), and 'Flight' at Art & Public, Geneva, Switzerland, and Bodhi Art, Mumbai, India (2007). His work has also been shown in group exhibitions, including at the House of World Cultures, Berlin, Germany (2005); Bose Pacia, New York (2005); École Nationale Supérieure des Beaux-Arts, Paris, France (2006); and Studio La Città, Verona, Italy (2008), and he participated in 'Edge of Desire: Recent Art in India', co-organized by the Asia Society Museum, New York, and the Art Gallery of Western Australia, Perth (2005), and the 51st Venice Biennale, Italy (2005). He received the Sotheby Award for Best Emerging Asian Artist (1993) and a residency at Singapore Tyler Print Institute (2006). [JG]

Gulammohammed SHEIKH
b. 1937, Surendranagar, India; lives in Baroda, India

In 1961 Sheikh received an MA from the faculty of fine arts, Maharaja Sayajirao University, Baroda, where he taught until 1993. He received his MA in 1966 from the Royal College of Art, London, England. He is renowned for his painting, as well as his poetry and art-historical

writing. His first solo exhibition was in Bombay in 1960, followed by numerous exhibitions in India and internationally, including 'Group 1890', Rabindra Bhavan, New Delhi (1963); 5th Paris Biennale, France (1967); 'Returning Home', a retrospective at the Centre Pompidou, Paris, France (1985); 'IV Asian Art Show', Fukuoka Asian Art Museum, Japan (1995); 'Edge of Desire: Recent Art in India', co-organized by the Asia Society Museum, New York, and the Art Gallery of Western Australia, Perth (2005); and 'From Everyday to the Imagined: Modern Indian Art', Singapore Art Museum and Museum of Art, Seoul National University, Korea (2007–8). His publications include *Athwa: Poems in Gujarati* (1974), *Laxma Goud: Monograph on the Artist* (1981) and *Contemporary Art in Baroda* (ed., 1996). His numerous awards include the National Award (Lalit Kala Akademi, New Delhi, 1962) and Padma Shri (Government of India, 1983). [JG]

Nilima SHEIKH
b. 1945, New Delhi, India; lives in Baroda, India

Sheikh studied at Delhi University from 1962 to 1965. In 1971 she received her MA from the faculty of fine arts, Maharaja Sayajirao University, Baroda, where she taught painting from 1977 to 1981. While trained in Western-style oil painting, her work primarily reflects the scale and format of the miniature tradition, with its emphasis on the narrative. Her first solo exhibition was in New Delhi in 1983, followed by participation in numerous exhibitions, including 'Through the Looking Glass' (1987–89) and 'Expanding Horizons: Contemporary Indian Art' (2008–9), both of which toured nationally. Her work has been widely exhibited internationally, including 'Conversations with Traditions: Nilima Sheikh and Shahzia Sikander', Asia Society Museum, New York (2001), and 'Horn Please: Narratives in Contemporary Indian Art', Kunstmuseum Bern, Switzerland (2008). Her work was shown in 'Edge of Desire: Recent Art in India', co-organized by the Asia Society Museum, New York, and the Art Gallery of Western Australia, Perth (2005). She also participated in the 3rd Asian Biennale, Dhaka, Bangladesh (1986); 1st Johannesburg Biennale, South Africa (1995); and 2nd Asia-Pacific Triennial of Contemporary Art, Queensland Art Gallery, Brisbane, Australia (1996). [JG]

SHI Guorui
b. 1964, Shanxi, China; lives in Beijing, China

Shi studied photography at the Nanjing Normal University. In 2000 he began to experiment with the *camera obscura* technique, which allows natural light to come through a small aperture and be burned onto light-sensitive paper. Sui's large-scale, black-and-white, photographic panoramas, containing minute details and rich grey tonalities, feature monuments such as the Great Wall, Mount Everest and Hollywood. Often in reverse or negative, they offer compelling new views of familiar icons. The several hours' exposure time that is often required results in the exclusion of fast-moving objects, leaving traces of more permanent structures. Shi has had a number of solo shows in China, the UK and US, and has also participated widely in group exhibitions, including 'Re-viewing the City', Guangzhou Photo Biennial, China (2005); 'Mahjong: Chinese Contemporary Art from the Sigg Collection', Kunstmuseum Bern, Switzerland (2005); 'Transformations: New Chinese Photography', Fremantle Arts Centre, Australia (2006); and 'FotoGrafia', Palazzo delle Esposizioni, Rome, Italy (2008). [DYW]

Wilson SHIEH
b. 1970, Hong Kong; lives in Hong Kong

Shieh received a BA (1994) and an MFA (2001) from the Chinese University of Hong Kong. His fine ink paintings on silk and paper are often in the traditional *gongbi* (fine-brush painting) style. He has exhibited his work at Hong Kong Arts Centre (1998) and at the 3rd Asia-Pacific Triennial of Contemporary Art, Queensland Art Gallery, Brisbane, Australia (1999). He was also the winner of the Painting Category of the Philippe Charriol Foundation Art Competition in 1997 and the Prize of Excellence at the Hong Kong Art Biennial in 2003. [MC]

Shozo SHIMAMOTO
b. 1928, Osaka, Japan; lives Nishinomiya, Japan

Shimamoto graduated from the School of Humanities, Kwansei Gakuin University, Hyogo, in 1950. In 1954, along with other avant-garde artists in western Japan, he founded Gutai Art Association and is credited with giving the group its name ['Gutai' meaning 'concreteness']. Today he is Professor Emeritus at Kyoto University of Education and Chairman of Takarazuka University of Art and Design. He has participated in numerous exhibitions, including the 45th, 48th and 50th Venice Biennales, Italy (1993, 1999, 2003), and 'Out of Actions: Between Performance and the Object 1949–1979', Museum of Contemporary Art, Los Angeles (1998). [MT]

Kazuo SHIRAGA
b. 1924, Hyogo, Japan; d. 2008

Shiraga was a leading abstract painter, who joined Gutai Art Association in 1955. He initially studied Japanese-style painting (*nihonga*) at Kyoto Municipal School of Painting (present-day Kyoto City University of Arts), but later began to explore oil painting, continuing his studies at Osaka Municipal Institute of Art. In 1971, while practising as an artist, Shiraga took Buddhist tonsure. His work has been shown at numerous exhibitions, including the 'International Art Exhibition of Japan/Tokyo Biennale', Japan (1965); 'Kazuo Shiraga', Musée d'Art Moderne Réfectoire des Jacobins, Ville de Toulouse, Centre Régional d'Art Contemporain Mid-Pyrénées, Labége, France (1993); 'Kazuo Shiraga', Hyogo Prefectural Museum of Art, Japan (2001); and 'What's GUTAI?', also at Hyogo Prefectural Museum of Art (2004). [MT]

Shahzia SIKANDER
b. 1969, Lahore, Pakistan; lives in New York, USA

Sikander received a BFA from the National College of Arts, Lahore, in 1992, and an MFA from the Rhode Island School of Design, Providence, in 1995. She is known for transforming the Indian and Persian miniature tradition into a contemporary art form, and in recent years has also staged performances. Her work has been widely exhibited in Asia, North America and Europe, including solo exhibitions at the Hirshhorn Museum and Sculpture Garden, Washington, DC (1999); Whitney Museum of American Art at Philip Morris, New York (2000); San Diego Museum of Art, California (2004); Museum of Contemporary Art, Sydney, Australia (2007); and IKON Gallery, Birmingham, England (2008). She has participated in numerous biennials and group exhibitions, including at the Museum of Modern Art, New York (2000, 2006); Asia Society Museum, New York (2001); and 51st Venice Biennale, Italy (2005). She was featured in the PBS documentary series *Art:21* (2001), and has received numerous awards, including a Commendation Award from the Mayor's Office, City of New York (2003), the Tamgha-e-imtiaz, National Medal of Honour, Government of Pakistan (2005), and a MacArthur Foundation fellowship (2006). [JG]

Dayanita SINGH
b. 1961, New Delhi, India; lives in Goa and New Delhi

Singh studied visual communication at the National Institute of Design, Ahmedabad, from 1980 to 1986. From 1987 to 1988 she studied at the International Center of Photography, New York, where she concentrated on photojournalism and documentary photography. She is renowned for her black-and-white portraits and for her work showing the interiors of the urban elite. Her work has been widely exhibited in India and internationally. Solo exhibitions with related publications include 'Myself Mona Ahmed', Museum für Indische Kunst, Berlin, Germany (2003); 'Privacy', Nationalgalerie im Hamburger Bahnhof, Berlin (2003); 'Chairs', Isabella Stewart Gardner Museum, Boston (2005); and 'Go Away Closer and Sent a Letter', Hermes Space, Berlin (2008). Her work has been shown in numerous biennales and group exhibitions, including 'India: A Celebration of Independence', Philadelphia Museum of Art, Pennsylvania (1997); Venice Photo Biennale, Italy (1999); 'Century City: Art and Culture in the Modern Metropolis', Tate Modern, London, England (2001); 'Banaras: The Luminous City', Asia Society Museum, New York (2002); 'Edge of Desire: Recent Art in India', co-organized by the Asia Society Museum, New York, and the Art Gallery of Western Australia, Perth (2005); and 'Wedded Bliss', Peabody Essex Museum, Salem, Massachusetts (2008). Among various awards, she has received the Prince Claus Award (Amsterdam, 2008). [JG]

Raghubir SINGH
b. 1942, Jaipur, India; d. 1999

Singh was primarily a self-taught artist. He gained acclaim in the 1970s for his pioneering use of colour photography. His work, which focused on contemporary India, its cities and people, has been widely published and featured in exhibitions in India, Europe and the US. A major retrospective entitled 'River of Colour: The India of Raghubir Singh' was organized by the Art Institute of Chicago (1999). His work has also been exhibited in numerous solo and group shows, including 'Auto Focus: Raghubir Singh's Way into India', Arthur M. Sackler Gallery, Smithsonian Institution, Washington, DC (2003); 'In the Realm of Gods and Kings: Arts of India', Asia Society Museum, New York (2004); a retrospective at Sepia International, New York (2004); and 'Raghubir Singh and Dayanita Singh: The Home and the World', Hermès, Paris, France (2008). His work is in the collections of the Museum of Modern Art and the Metropolitan Museum of Art, New York; Tate Modern, London, England; National Museum of Photography, Bradford, England; and Musée Guimet, Paris, France, among others. In addition to practising photography, Singh taught at the School of Visual Arts, Columbia University, and Cooper Union, New York. He was awarded the Padma Shri (Government of India, 1983), and the Maharaja Sawai Ram Singh Award posthumously in 2001. [JG]

Vasan SITTHIKET
b. 1957, Nakhorn Sawan Province, Thailand; lives in Bangkok, Thailand

Sitthiket is a graduate of the College of Fine Arts in Bangkok. He works in a wide range of media, from installation and painting to performance and video, and is also a prolific writer, having published political statements as well as volumes of poetry. A self-proclaimed activist artist, he targets government corruption and comments on socio-political issues both in Thailand and abroad. He has exhibited his work in Thailand, Indonesia, Italy, Japan, Korea, Singapore and the US. He was one of seven artists to represent Thailand in the 50th Venice Biennale, Italy (2003). In 2007 he received the Silpathorn Award, given to contemporary Thai artists by the Office of Contemporary Art and Culture in the Ministry of Culture of Thailand. His work is held in the collection of the Museum of Modern Art, New York. [SL]

Yutaka SONE
b. 1965, Shizuoka, Japan; lives in Los Angeles, USA

Sone received his MA in architecture from Tokyo University of the Arts in 1992. He is known for his sculpture, painting, video work and performances, which often address conceptual issues related to space. He has participated in a number of international biennales, triennales and other group exhibitions, including the 1st Yokohama Triennale, Japan (2001); 'Loop', PS1 Contemporary Art Center, Long Island City, New York (2001); 50th Venice Biennale, Italy (2003); 72nd Whitney Biennial, New York (2004); 'Tokyo Blossoms', Hara Museum of Contemporary Art, Tokyo, Japan (2006); and 'Hugues Reip: Parallel Worlds', Museum of Contemporary Art, Tokyo (2008). He has had solo exhibitions at the Geffen Contemporary at Museum of Contemporary Art, Los Angeles (2003); Renaissance Society, University of Chicago (2006); and Kunsthalle Bern, Switzerland (2006). [MT]

SONG Dong
b. 1966, Beijing, China; lives in Beijing

In 1989 Song graduated in visual arts from the Capital Normal University in Beijing. He is now eminent among the new generation of Chinese avant-garde artists. He employs video, photography and performance art to convey his private memories, at the same time highlighting China's changing social, political and cultural traditions. His work is a highly personal and often meditative exploration into the evanescent nature of life, evident through his ongoing work *Writing Diary with Water*, in which he inscribes calligraphy daily onto stone using water and a brush. His work has been exhibited in China and internationally, with group exhibitions such as 'Fuck Off', Eastlink Gallery, Shanghai, China (1997); 'Inside Out: New Chinese Art', Asia Society Galleries and PS1, New York, and other venues (1998–2000); 'Transience: Chinese Experimental Art in China', Smart Museum of Art, Chicago (2000); and 4th Asia-Pacific Triennial of Contemporary Art, Queensland Art Gallery, Brisbane, Australia (2002). Solo exhibitions include: 'Song Dong in London', Tablet Gallery, London, England (2000); 'Broken Mirror', Times Square Astrovision,

New York (2005); and 'Waste Not', Beijing Tokyo Art Project, Beijing 798 Factory, China (2005). His work is held in the collection of the Queensland Art Gallery. In 2000 he was awarded a UNESCO-Aschberg bursary in Beijing. [MCH]

Francis Newton SOUZA
b. 1924, Saligao, Goa, India; d. 2002

Souza was expelled from the Sir J. J. School of Art, Mumbai, in 1945 for participating in the 'Quit India' movement. In 1947 he co-founded the Progressive Artists' Group to encourage Indian artists to participate in the international avant-garde movement. In 1949 he moved to London, where he studied at the Central School of Art. His work gradually gained international recognition, and in 1967 he settled in New York. Drawing on a rich variety of artistic styles and cultural traditions, Souza is best known for his bold and inventive paintings of the human figure. His work has been shown in exhibitions at the Institute of Contemporary Arts, London (1954); 28th Venice Biennale, Italy (1954); 'Commonwealth Artists of Fame', London (1977); 'India: Myth and Reality – Aspects of Modern Indian Art', Museum of Modern Art, Oxford, and Festival of India, Royal Academy of Arts, London (1982); and 'Modern Indian Painting', Hirshhorn Museum, Washington, DC (1982). Major retrospective exhibitions were organized by Art Heritage Gallery, Delhi, in 1986 and 1996. He received the John Moore Prize at the Walker Art Gallery, Liverpool (1957); the Guggenheim International Award (1958); and the Italian Government Scholarship (1960). [DYW]

Manit SRIWANICHPOOM
b. 1961, Bangkok, Thailand; lives in Bangkok

Sriwanichpoom studied visual art at Srinakharinvirot University in Bangkok. Throughout his career he has used photography as a means of social critique. One of his better-known works is *The Pink Man Series* (1997–2004), highlighting the excess and obscenity of consumerist society. In *Pink Man on Tour* (1998), he portrays the Pink Man in famous tourist sites throughout Thailand, critiquing the Thai government's national campaign to promote tourism in the wake of

the Asian financial crisis – an effort that many viewed as selling national heritage in order to make a quick profit. His artwork has been included in various international exhibitions, including the touring show 'Cities on the Move' at the Wiener Secession, Vienna, Austria, and other sites (1997–2000); 24th São Paulo Biennial, Brazil (1998); 1st Fukuoka Asian Art Triennale, Japan (1999); and Thai Pavilion, 50th Venice Biennale, Italy (2003). [SL]

Yoshihiro SUDA
b. 1969, Yamanashi, Japan; lives in Tokyo, Japan

Suda graduated from Tama Art University in Tokyo in 1992. His delicate, painted-wood sculptures have been shown extensively in Japan and beyond, including solo exhibitions 'Yoshihiro Suda', Palais de Tokyo, Paris, France (2004), and 'Focus: Yoshihiro Suda', Art Institute of Chicago (2003). Group exhibitions include 'Imagine Workshop', 2nd Fukuoka Asia Triennale, Japan (2002); 'Slowness', 1st Kyoto Biennale, Japan (2003); 'Blumenmythos: Van Gogh bis Jeff Koons', Fondation Beyeler, Basel, Switzerland (2005); and 'Three Person Show', National Museum of Contemporary Art, Osaka, Japan (2006). [MC]

Hiroshi SUGIMOTO
b. 1948, Tokyo, Japan; lives in New York, USA, and Tokyo, Japan

The internationally acclaimed photographer Sugimoto initially studied politics and sociology at Saint Paul's University in Tokyo. He shifted his interest to art, and in 1972 graduated from the Art Center College of Design in Los Angeles. In 1974 he moved to New York. He is best known for his use of extreme long exposure, and has had a number of solo exhibitions at major museums, including, among others, the Metropolitan Museum of Art, New York (1995); Guggenheim Museum, Bilbao, Berlin and New York (2000–1); DIA Art Center, New York (2001); and Galerie de l'Atelier Brancusi, Centre Pompidou, Paris, France (2006). A major retrospective was jointly organized by the Mori Art Museum, Tokyo, and the Hirshhorn Museum and Sculpture Garden, Washington, DC (2005, 2006), followed by an international tour. [MT]

Do Ho SUH
b. 1962, Seoul, Korea; lives in Seoul

Suh's training began in oriental painting at Seoul National University, after which he travelled to the US to attend Rhode Island School of Design, followed by Yale University. His installations frequently reference specific living environments. His work has been recognized in his home country, where he currently has his studio. He represented Korea (with Michael Joo) in the national pavilion at the 49th Venice Biennale, Italy (2001), and a retrospective of his work was held at the Seattle Art Museum, Washington (2002). Other exhibitions have included shows at the Whitney Museum of American Art at Philip Morris, New York (2001); Museum of Modern Art, New York (2001); and Serpentine Gallery, London, England (2002). [MC]

SUH Se-ok
b. 1929, Taegu, Korea; lives in Seoul, Korea

Suh is one of the leading Korean painters active since the 1950s. He has contributed significantly to the modernization of ink painting in his native land. After studying painting at the College of Fine Arts, Seoul National University, he was Dean of the Art School from 1982 to 1985, and is now Professor Emeritus. In 1998 he received an Honorary Doctorate of Art from Road Island School of Design. His work has been presented at numerous group exhibitions and biennales, including the National Fine Art Exhibition on many occasions since 1949 at Kyung Bok Palace Museum, Seoul, and after 1972 at the National Museum of Contemporary Art, Seoul; 7th São Paulo Biennial, Brazil (1963); 'Korean Drawing Exhibition', Brooklyn Museum of Art, New York (1981); 3rd Gwangju Biennale, Korea (2000); and 'Void in Korean Art', Samsung Museum of Art, Seoul, Korea (2007). He has also had major solo exhibitions at Pacific Asia Museum, Pasadena, California (1983); FIAC, Paris, France (1996); and Museum of Fine Arts, Houston, Texas (2008). [MT]

SUI Jianguo
b. 1956, Qingdao, China; lives in Beijing, China

After studying sculpture at Shandong Art College, Sui received an MFA from the Central

Academy of Fine Arts in Beijing. His most well-known works include sculptures inspired by Mao suit jackets made from metal. Sui has participated in numerous international exhibitions, including 'Between Past and Future: New Photography and Video from China', International Center for Photography and Asia Society, New York (2004); 'Mahjong: Chinese Contemporary Art from the Sigg Collection', Kunstmuseum Bern, Switzerland (2005); and 'New World Order: Contemporary Installation Art and Photography from China', Groninger Museum, Netherlands (2008). Sui now teaches at the Central Academy of Fine Arts in Beijing. [SL]

Adeela SULEMAN
b. 1970, Karachi, Pakistan; lives in Karachi

In 1999 Suleman received her BFA in sculpture from the Indus Valley School of Art and Architecture, Karachi, and then an MA in international relations from the University of Karachi. She is known for her highly creative manipulations of everyday 'found' objects. Her work has been shown in solo exhibitions in Karachi (2007, 2009) and Lahore (2008). She has also participated in group exhibitions in Pakistan and internationally, including the 2nd Fukuoka Triennale, Japan (2002); 'Playing with a Loaded Gun', Kunsthalle Fridericianum, Kassel, Germany (2003); 'Beyond Borders: Art of Pakistan', National Gallery of Modern Art, Mumbai, India (2005); 'Love', National Art Gallery, Islamabad (2007); CP Open Biennale, Jakarta, Indonesia (2005); 'Video Loop '08', Barcelona, Spain (2008); and 'Adeela Suleman, Farida Batool, Tazeen Qayyum: Contemporary Art from Pakistan', Aicon Gallery, New York (2008). [JG]

Vivan SUNDARAM
b. 1943, Shimla, India; lives in New Delhi, India

Sundaram studied painting at the faculty of fine arts, Maharaja Sayajirao University, Baroda, and at Slade School of Fine Art, London, England, in the 1960s. In the early 1970s, he was actively involved in the student movement in India. He has had numerous solo exhibitions in New Delhi, Baroda, Mumbai, Kolkata, Bangalore, Madras, London, Montreal, Winnipeg and Vancouver. Important group

shows include: 'Pictorial Space', New Delhi (1977); 'Six Who Declined to Show in the Triennale', New Delhi (1978); 'Place for People', Mumbai (1981); Contemporary Indian Art, Festival of India, London (1982); 2nd and 4th Havana Biennials, Cuba (1987, 1991); 'A Critical Difference: Contemporary Art from India', touring exhibition, UK (1993); 2nd Asia-Pacific Triennial of Contemporary Art, Queensland Art Gallery, Brisbane, Australia (1996); and 5th Shanghai Biennale, China (2004). He has also organized international artists' workshops, exhibitions and public art projects, and is a member of SAHMAT, the cultural activist forum based in New Delhi. [DYW]

Manish SWARUP
b. 1968, Bhopal, India; lives in New Delhi, India

Swarup has worked as a photographer for various Indian news organizations, including the *Sunday Mail*, *Pioneer* and *Hindustan Times*. Since 2001, he has been a photojournalist for the New Delhi bureau of Associated Press. He has gained acclaim for his coverage of conflicts in India and internationally, including the Kargil war, communal riots in Mumbai and Gujarat, post-war Kosovo, and war-torn Iraq and Afghanistan. He has documented devastation, such as the 2004 tsunami, as well as art and culture, such as the Kumbh Mela. His photographs have been included in numerous publications, and shown in a solo exhibition at the Shridharani Art Gallery, New Delhi (2004). He has received various awards, including Best Photograph for his image of the Kargil war (Government of India, 1999); Second Prize for his photo showing human dignity during war (International Committee of Red Cross, 2000); Second Prize for his photo on fifty years of Indian independence (Government of India, 2000); several awards from the Mumbai Press Club (2005); and Best Photograph in the Daily Life category (Ramnath Goenka India Press, 2006). [JG]

TABAIMO
b. 1975, Hyogo, Japan; lives in Tokyo, Japan

Ayako Tabata, one of Japan's leading video artists, is more commonly known by her nickname 'Tabaimo' (meaning 'Tabata's little sister'). She studied at Kyoto University of Art

and Design. In 1999 she received the Kirin Contemporary Award. Her video works have been exhibited at various international shows and film festivals, including the 1st Yokohama Triennale, Japan (2001); 26th São Paulo Biennial, Brazil (2002); 'How Latitudes Become Forms', Walker Art Center, Minneapolis (2003); and 52nd Venice Biennale, Italy (2007). Major solo exhibitions have been held at such institutions as Hara Museum of Contemporary Art, Tokyo, Japan (2003); Fondation Cartier pour l'Art Contemporain, Paris, France (2006); and Yokohama Museum of Art, Japan (2009). [MT]

Truong TAN
b. 1963, Hanoi, Vietnam; lives in Hanoi

Tan graduated from Hanoi Fine Arts College in 1989, then lectured at Hanoi Fine Arts University from 1989 to 1998. Mainly using lacquer as a painting medium, he is best known for his bold depictions of homosexuality. Since 1994, he has had numerous solo shows in Vietnam, France, Germany and Australia. Group exhibitions include 'Vietnamese Art after Doi Moi', Fujita Art Museum, Tokyo, Japan (1996); 'Der Rest der Welt', Haus der Kulturen der Welt, Berlin, Germany (1997); 'New Vietnamese Painting', Siam Society, Bangkok, Thailand (1997); 'Art in Freedom', Museum Boijmans Van Beuningen, Rotterdam, Netherlands (1998); 2nd Liverpool Biennial, England (2002); and 'Come In', Viet Art Center, Hanoi, Vietnam (2007). [DYW]

TANAKA Atsuko
b. 1932, Osaka, Japan; d. 2005

Tanaka studied painting at the Osaka Municipal Institute of Art. She joined Gutai Art Association in 1955 but withdrew her membership in 1965. Her work has been included in numerous international solo and group exhibitions, such as 'Electrifying Art: Atsuko Tanaka 1954–1968', Grey Art Gallery, New York University (2004); 'What's GUTAI?', Hyogo Prefectural Museum of Art, Japan (2004); 'Resounding Spirit: Japanese Contemporary Art of the 1960s', Samek Art Gallery, Bucknell University, Lewisburg, Pennsylvania (2005); and 'Traces: Body and Idea in Contemporary Art', National Museum of Modern Art, Kyoto, Japan (2005). [MT]

TENMYOUYA Hisashi
b. 1966, Tokyo, Japan; lives in Saitama, Japan

Before becoming an artist, Tenmyouya worked as an art director of a record label and illustrated underground Japanese magazines, including *Burst*. His paintings merge references to Japanese traditional painting, especially *nihonga*, with commercial or graphic arts. They have been shown in exhibitions including 'One Planet under a Groove: Hip Hop and Contemporary Art', Bronx Museum, New York (2001); 'The American Effect: Global Perspectives on the United States, 1990–2003', Whitney Museum of American Art, New York (2003); and 'GUNDAM – Generating Futures', Suntory Museum, Osaka, Japan (2006). Tenmyouya received the Special Judge's Award at the 11th Japan Graphic Exhibition in 1990 and the Special Award at the 6th Exhibition of the Taro Okamoto Memorial Award for Contemporary Art, Kawasaki, Japan, in 2003. [MC]

Masami TERAOKA
b. 1936, Onomichi, Japan; lives in Hawaii, USA

Teraoka was born in Onomichi in Hiroshima Prefecture, Japan. He first studied aesthetics at Kwansei Gakuin University in Kobe, Japan, and later moved to the US and continued studying at Otis Art Institute, Los Angeles, from which he received a BFA and MFA. His work has been shown at a number of exhibitions, including 'Transvoices', Whitney Museum of American Art, New York, and Centre Pompidou, Paris, France (1993); 'Asia/America: Identities in Contemporary Asian American Art', Asia Society, New York (1995); 'Paintings by Masami Teraoka', Arthur M. Sackler Gallery, Smithsonian Institution, Washington, DC (1996); 'Gyroscope', Hirshhorn Museum and Sculpture Garden, Washington, DC (2003); and 5th Asia-Pacific Triennial of Contemporary Art, Queensland Art Gallery, Brisbane, Australia (2006). His works are also in the collections of major international museums such as the Metropolitan Museum of Art, New York; Los Angeles County Museum of Art, California; Tate Modern, London, England; and Queensland Art Gallery, Brisbane. [MT]

Yuken TERUYA
b. 1973, Okinawa, Japan; lives in New York, USA

Teruya received his BFA from Tama Art University in Tokyo. After moving to the US, he continued his studies at Maryland Institute College of Art, and received his MFA from the School of Visual Arts, New York, in 2001. In 2007 he received the Painters and Sculptors Grant Program Award from the Joan Mitchell Foundation, New York. His work has been included in many international exhibitions, including 'Greater New York 2005', PS1 Contemporary Art Center, Queens, New York (2005); 2nd Yokohama Triennale, Japan (2005); and 'Free Fish: The Art of Yuken Teruya', Asia Society, New York (2007), among others. [MT]

Rirkrit TIRAVANIJA
b. 1961, Buenos Aires, Argentina; lives in New York, USA; Berlin, Germany; and Bangkok, Thailand

Tiravanija was educated at the Ontario College of Art, Toronto; Banff Center School of Fine Arts, Alberta; and School of the Art Institute of Chicago. He graduated from the Whitney Independent Study Program in New York in 1986, and is currently an associate professor of professional practice in the faculty of the arts at Columbia University, New York. An early solo exhibition, 'Untitled 1992 (Free)', at the 303 Gallery – an installation event for which the artist transformed the gallery into a kitchen and offered visitors Thai food – gained him instant international recognition. Renowned for his new approaches to art, Tiravanija aims to provide a setting in which to encourage social interaction and break down the boundaries between art and life. He has exhibited at major museums, galleries and art fairs worldwide, including the Museum of Modern Art, New York (1997); 50th Venice Biennale, Italy (2003); and Serpentine Gallery, London, England (2005). In 2003 he was selected for the Benesse Prize, and in 2004 he won the Hugo Boss Prize. His work is in the collections of numerous institutions, including the Solomon R. Guggenheim Museum, New York. [MCH]

Momoyo TORIMITSU
b. 1967, Tokyo, Japan; lives in New York, USA

Torimitsu graduated from Tama Art University, Tokyo, in 1994. In 1996 she moved to New York to participate in the PS1 International Studio Program. She is known for her satirical and humorous robotic sculptures and installation works, commenting on the utterly inhuman working conditions that can be found in Japan and the wider corporate world. Her solo exhibitions include 'Never Forever', Fuchu City Art Museum, Tokyo, Japan (2004), and 'Horizons', Swiss Institute, New York (2004). Group exhibitions include 'Best of Season', Aldrich Museum of Contemporary Art, Connecticut (1999); 'Videodrome', New Museum of Contemporary Art, New York (1999); 'Abracadabra', Tate Gallery, London, England (1999); 'Neo-Tokyo', Museum of Contemporary Art, Sydney, Australia (2001); 'My Reality', Norton Museum of Art, Florida (2003); 5th Gwangju Biennale, Korea (2004); 'Making a Home', Japan Society, New York (2007); 'Thermocline of Art: New Asian Waves', ZKM, Karlsruhe, Germany (2007); 'All About Laughter', Mori Art Museum, Tokyo (2007); and 'ISEA 2008', National Museum of Singapore (2008). [MT]

TSANG Tsou Choi
b. 1921, Huaxian, China; lived in Hong Kong; d. 2007

At the age of sixteen, Tsang moved from a Chinese village to Hong Kong, where he became a farmer and labourer. In his thirties, he started to brush incoherent Chinese scripts on walls and other public spaces, which made him a household name in Hong Kong. Having dubbed himself 'The King of Kowloon', Tsang created graffiti that often claimed his family's royal background and ancestral rights to the Kowloon area in Hong Kong. His calligraphic work was presented at the touring exhibition 'Cities on the Move' at the Wiener Secession, Vienna, Austria, and other sites (1997–2000). He also participated in the 50th Venice Biennale, Italy (2003). [DYW]

Su-Mei TSE
b. 1973, Luxembourg; lives in Paris, France, and Luxembourg

First trained as a classical cellist, Tse is now a leading video artist, whose poetic work often reflects her musical sensibility. She studied at

the École Nationale Supérieure des Beaux-Arts in Paris, France. In 2003 she received the Golden Lion for the Best National Participation at the 50th Venice Biennale, Italy. Her work has been exhibited internationally in solo and group shows, including 'The First of Moderna Su-Mei Tse', Moderna Museet Stockholm, Sweden (2004); 27th São Paulo Biennial, Brazil (2004); 'The ICH-Manifestation', Renaissance Society, Chicago (2005); and 'Su-Mei Tse: The Desert Sweepers', MIT List Visual Arts Center, Cambridge, Massachusetts (2007). [MT]

TSUI Kuang-Yu
b. 1974, Taipei, Taiwan; lives in Taipei

One of Taiwan's leading artists, Tsui creates performance-based video art that is both conceptual and humorous. He attended Taipei National University of the Arts, and in 2003 received the Jury's Special Award at the annual Taishin Arts Awards. His video works have been shown widely at exhibitions, including the 4th Taipei Biennial, Taiwan (2004); 51st Venice Biennale, Italy (2005); 'Projected Realities: Video Art from East Asia', Asia Society, New York (2006); and 'Thermocline of Art: New Asian Waves', ZKM, Karlsruhe, Germany (2007). [MT]

Alexander UGAY
b. 1978, Kyzilorda, Kazakhstan; lives Almaty, Kazakhstan

Of Korean descent, Ugay studied in St Petersburg, Russia, then Bishkek, Kyrgyzstan. He works in digital painting, photography, video-performance and filmmaking. Much of his art deals with the landscape, people and identity of Central Asia, along with the utopian social ideals of former Communist regimes that dominated Central Asian republics until the fall of the Soviet Union. Ugay has exhibited in the region as well as internationally, including at the 9th Istanbul Biennale, Turkey (2005), and 52nd Venice Biennale, Italy (2007). [BG]

WANG Du
b. 1956, Wuhan, China; lives in Paris, France

Wang enrolled at the Guangzhou Institute of Fine Art in 1981. From 1985 to 1990, he taught

visual arts at the Institute of Architecture at the Polytechnic University of South China. He was also a founding member and chairman of the art movement Southern Artists Salon (1986–90). In 1989 he was imprisoned for nine months after participating in pro-democracy protests. Upon his release he moved to Paris, and from 1997 to 2000 taught visual arts at the University Paris 8 (Vincennes-Saint-Denis). Noted for his large-scale installations, Wang transforms media images into sculptural pieces in order to explore how the mass media is consumed and distorted in contemporary society. He has participated in numerous group shows, including 'Uncertain Pleasure: Chinese Artists in the 1990's', Art Beatus Gallery, Vancouver, Canada (1997); 'Inside Out: New Chinese Art', Asia Society Galleries and PS1, New York, and other venues (1998–2000); and 'The Sky is the Limit', 2nd Taipei Biennial, Taiwan (2000). Solo exhibitions include 'Wang Du', Yerba Buena Center for the Arts, San Francisco (2005); 'Wang Du: The Space-Time Tunnel', BALTIC Centre for Contemporary Art, Gateshead, England (2006); and 'Wang Du', Akbank Sanat, Istanbul, Turkey (2007). His works are in the collection at the Ullens Center for Contemporary Art, Beijing. [MCH]

WANG GongXin
b. 1960, Beijing, China; lives in Beijing

Wang completed his artistic training at Capital Normal University, Beijing, in 1982. In 1987 he studied in America at the State University of New York at Cortland and Albany. His *The Sky of Brooklyn: Digging a Hole in Beijing* (1995) was one of the first site-specific installations in China. To realize the work, Wang had a hole dug in his Beijing residence, then positioned a video monitor playing footage he had shot of the Brooklyn sky. The piece references the American childhood fantasy of 'digging a hole to China' and the Chinese saying 'to watch the world from a well'. Wang also collaborated with his wife Lin Tianmiao to produce *Here? Or There*, a multimedia commentary on China's urban transformation and people's relationship to their environment. His work has been presented widely in exhibitions, including 'Inside Out: New Chinese Art', Asia Society Galleries and PS1, New York, and other venues (1998–2000); 49th Venice Biennial, Italy (2001); 25th São Paulo Biennial, Brazil (2002); 1st Guangzhou

Triennial, China (2002); 4th Shanghai Biennale, China (2002–3); 'Between Past and Future: New Photography and Video from China', International Center of Photography and Asia Society, New York (2004); European Media Art Festival, Osnabruck, Germany (2006); 'Projected Realities: Video Art from East Asia', Asia Society, New York (2006); and 'The Real Thing: Contemporary Art from China', Tate Liverpool, England (2007). Wang has also served as guest professor at the Central Academy of Fine Arts, Beijing, since 2003. [DYW]

WANG Guangyi
b. 1957, Harbin, China; lives in Beijing, China

Wang received his training in oil painting at the Zhejiang Academy of Fine Arts, Hangzhou (now China Academy of Art), graduating in 1984. That same year, he became a founding member of the North Art Group in Harbin, one of the many experimental groups across the country known as the ''85 New Wave Movement'. In around 1992 Wang moved to Beijing, where his paintings found success and he was identified as a leading exponent of the Political Pop movement. He has regularly exhibited internationally, including in 'Mao Goes Pop: China Post-1989', Museum of Contemporary Art, Sydney, Australia (1993); 'China Avant-Garde', Haus der Kulturen der Welt, Berlin, Germany (1993–94); 45th Venice Biennale, Italy (1995); 2nd Asia-Pacific Triennial of Contemporary Art, Queensland Art Gallery, Brisbane, Australia (1996); 1st Guangzhou Triennial, China (2002); and 'Visual Polity: Another Wang Guangyi', He Xiangning Art Museum, Shenzhen (2008). [MC]

WANG Jin
b. 1962, Datong, China; lives in Beijing, China

Wang studied painting at the Zhejiang Academy of Fine Arts (present-day China Academy of Fine Arts), graduating in 1987. Among his most provocative works are *Fighting the Flood: Red Flag Canal* (1994), a performance in which the artist poured red pigment into a canal built during the Cultural Revolution; *Knocking at the Door* (1996), in which he painted US currency on bricks taken from the Forbidden City; and *The Dream of China* (1997), in which he presented an antique imperial robe meticulously replicated in embroidered

plastic. Wang works in photography, performance art and sculpture, and has been shown in several international exhibitions, including 'Inside Out: New Chinese Art' at Asia Society Galleries and PS1, New York, and other venues (1998–2000), and 'Between Past and Future: New Photography and Video from China', International Center of Photography and Asia Society, New York (2004). [TT]

WANG Keping
b. 1949, Beijing, China; lives in Paris, France

Wang is a self-taught sculptor and an original founder of China's first avant-garde artist group, The Stars (*xing xing*). During the Cultural Revolution, he was a member of the Red Guard. He later worked at the Central Broadcast and Television Company as an actor and scriptwriter. His early work is a direct reflection of his early political environment. Among his most famous works is the controversial 1979 piece *Idol*, a carved wooden sculpture of Mao imitating the image of the Buddha. In 1984, Wang moved to Paris and as a result his art began to take on a less political format. Reverting back to nature and simplicity, he produced a series of sculptures that focused upon the female form. He has participated in group exhibitions at the Chinese Modern Art Centre, Osaka, Japan (1993), and Ethan Cohen Gallery, New York (1996). He has also had numerous solo exhibitions at the Galerie Zurcher, Paris, France, and 10 Chancery Lane Gallery, Hong Kong. In 1997 he was an artist-in-residence at the Hong Kong University of Science and Technology. His work is held in the collections of the Olympic Sculpture Park, Seoul, Korea, and the Ashmolean Museum, Oxford, England. [MCH]

WANG Qingsong
b. 1966, Daqing, Heilongjiang Province, China; lives in Beijing, China

Wang was trained at the Sichuan Academy of Fine Arts, Chengdu. He is best known for elaborately staged scenes, which he captures in digitally composed, brightly coloured photographs. Combining traditional tales, fantasy and a touch of reality TV, these works explore the contradictions between China's ancient traditions and its contemporary consumer culture. Though the imagery

occasionally echoes well-known scenes from Western art history, Wang's photo-murals most closely resemble horizontal Chinese scroll paintings. He has had solo exhibitions in numerous countries, including China, Germany, Brazil, Canada and the UK. He has also participated in many international exhibitions, including the 1st Taipei Biennial, Taiwan (1998); 'Between Past and Present: New Photography and Video from China', International Center of Photography and Asia Society, New York (2004); and 10th Venice Architecture Biennale, Italy (2006). [TT]

Zhan WANG
b. 1962, Beijing, China; lives in Beijing

After training at the Beijing Industrial Arts College, Zhan studied sculpture at the Central Academy of Fine Arts in Beijing in the 1980s. He is best known for his stainless-steel rock sculptures based on ancient Chinese scholars' rocks. He creates these by moulding a flat sheet of metal to a natural rock formation; once removed, this shiny skin is re-shaped to create a hollow representation of the natural object. Zhan has participated in numerous exhibitions, including the 'First Academic Exhibition of Chinese Contemporary Artists', Hong Kong Arts Centre (1996); 'A Revelation of 20 Years of Contemporary Chinese Art', Workers' Cultural Palace, Beijing, China (1998); and 'The New Chinese Landscape', Arthur M. Sackler Museum, Harvard University, Cambridge, Massachusetts (2006). [TT]

Saira WASIM
b. 1975, Lahore, Pakistan; lives in Chicago, USA

In 1999 Wasim received a BFA in Indian and Persian miniature painting from the National College of Arts, Lahore. Through irony, wit and allegory, she has adapted this artistic tradition to explore a range of socio-political issues relating to imperialism, religious fundamentalism and war. Her identity as an Ahmadi – a member of a minority and often-persecuted Muslim group in Pakistan – partly serves to inform her work. She has participated in numerous group exhibitions held in India, Pakistan, Australia, France, Finland, the UK and US, including 'The American Effect: Global Perspectives on the United States, 1990–2003', Whitney

Museum of American Art, New York (2003); 'Transcendent Contemplations', Green Cardamom, London, England (2004); 'Karkhana: A Contemporary Collaboration', Aldrich Contemporary Art Museum, Ridgefield, Connecticut (2005); and 'One Way or Another: Asian American Art Now', Asia Society Museum, New York (2006). A solo exhibition of her work was presented at Ameringer & Yohe Fine Arts, New York (2008). [JG]

WENG Peijun
b. 1961 Hainan, China; lives in Haikou, China

Weng graduated from the Guangzhou Academy of Fine Arts in 1985. He produces simple, direct, colour photographs documenting urban transformation across China. He has exhibited internationally, in shows including 'Paris-Pekin' at the Espace Cardin, Paris, France (2002); 4th Shanghai Biennale, China (2002–3); 'Alors, la Chine?', Pompidou Centre, Paris, France (2003); and 'Between Past and Future: New Photography and Video from China', International Center of Photography and Asia Society, New York (2004). [BG]

WONG Hoy Cheong
b. 1960, Penang, Malaysia; lives in Kuala Lumpur, Malaysia

In 1982 Wong graduated with a BA from Brandeis University, Massachusetts. He received an MA in education from Harvard University in 1984, and in 1986 studied fine art at the University of Massachusetts. Working across a variety of disciplines, including installation, photography, video and performance art, Wong explores national identity and Malaysian socio-political history. He has undertaken artist residencies at the Canberra Institute of Art, Australia (1992), and Gasworks, London, England (2002). He was also a visiting tutor at Central St Martins, London (1998), Head of the Foundation Department at the Parsons/Centre for Advanced Design in Kuala Lumpur, Malaysia (1998–2001), and a visiting fellow at Goldsmith College, University of London (1999). He has participated in numerous group exhibitions, including 'Lines of Descent: The Family in Contemporary Asian Art', Queensland Art Gallery, Australia (2000); 50th Venice Biennale,

Italy (2003); and 'Coffee, Cigarettes and Pad Thai: Contemporary Asian Art in Southeast Asia', Eslite Gallery, Taipei, Taiwan (2008). Solo shows include 'Selected Works 1994–2002', John Hansard Gallery, Southampton, England (2002); 'Slight Shifts', Pitt Rivers Museum, Oxford, England (2004); and 'Wong Hoy Cheong: Bound for Glory', Valentine Willie Fine Art, Kuala Lumpur, Malaysia (2006). [MCH]

Damrong WONG-UPARAJ
b. 1936, Chiang Rai Province, Thailand; d. 2002

Wong-Uparaj received his BFA in painting from Silpakorn University, Bangkok, in 1962. From 1962 to 1963, he studied at the Slade School of Fine Arts, University College, London, England, where he obtained a certificate in drawing and painting. In 1969 he received an MFA from the University of Pennsylvania, Philadelphia, before studying art history at Columbia University, followed by further studies in Europe, Australia and Japan. His early cityscapes show the influence of Impressionism; later he began to concentrate on village scenes, using refined brushwork and distinctive perspective. As professor at Silpakorn University, Wong-Uparaj served as a critical liaison between a community of artists and museums, galleries and collectors. His work has been shown in national and international exhibitions, including the 7th and 11th National Exhibitions of Art in Thailand (1956, 1960); 1st International Art Exhibition, Bangkok (1965); 'Paintings and Prints by Damrong Wong-Uparaj', Philadelphia Civic Center Museum Gallery, Pennsylvania (1969); 'Contemporary Art of Thailand', Pacific Asia Museum, Pasadena, California (1982); and 'Integrative Art of Thailand', University of California, Berkeley (1991). He received numerous grants, fellowships and awards, including 2nd Prize, Silver Medal, Monochrome (1956) and 1st Prize, Gold Medal, Painting (1960) at the National Exhibitions of Art, Thailand. [DYW]

WU Guanzhong
b. 1919, Yixing, China; lives in Beijing, China

Wu studied both Chinese traditional painting and Western oil painting at the Hangzhou Academy of Art during the 1930s and '40s. In 1947 he received a fellowship to study in

Europe, where he developed a strong interest in French Modernist art. He returned to China in 1950 and pursued a teaching career at the Central Academy of Fine Arts and other schools in Beijing. From 1956 to 1964 he travelled extensively in China, but during the Cultural Revolution he was sent to the countryside to do hard labour. Although he had worked primarily in oil since 1950, Wu began to paint in more Chinese traditional styles upon his return to Beijing in 1972. The end of the Cultural Revolution brought artistic freedom and he subsequently received widespread recognition. His works were shown internationally, including at the British Museum, London, England (1992), and the Musée Cernuschi, Paris, France (1993–94). In 1991 he was awarded the Officier de l'Ordre des Arts et des Lettres from the French Ministry of Culture in honour of his contribution to contemporary Chinese painting. [DYW]

AH XIAN
b. 1960, Beijing, China; lives in Sydney, Australia

Ah Xian is a self-taught artist who held his first exhibition in Shanghai in 1985. He migrated to Sydney, Australia, in 1989. His work has been shown in major survey exhibitions such as 'Mao Goes Pop: China Post-1989', Museum of Contemporary Art, Sydney (1993), while his solo exhibitions include shows at Powerhouse Museum, Sydney; Asia Society Museum, New York; and Städtische Museen Heilbronn, Germany. In 1999 he received an Australia Council grant to travel to Jingdezhen to explore porcelain production, enabling him to expand his *China, China* series of porcelain portrait busts. He was awarded the National Sculpture Prize in an exhibition at the National Gallery of Australia in 2001, and his works are in collections such as Queensland Art Gallery, Brisbane, and Asia Society Museum, New York. [MC]

XING Danwen
b. 1967, Xian, China; lives in Beijing, China

After receiving a BFA in painting from the Central Academy of Fine Arts in Beijing, Xing became interested in photography and created series such as *I am a Woman* (1994–96) and *Born with Cultural Revolution* (1995). A fellowship from the Asian Cultural Council allowed her to

come to New York in 1998, where she received an MFA from the School of Visual Arts. Her principal media have expanded to video and installation. Xing interprets her interest in cultural displacement, environment and urban development through contemplation of reality, fiction, desire and fantasy. International exhibitions in which she has participated include the 1st Yokohama Triennale, Japan (2001); 'Alors, la Chine?', Centre Pompidou, Paris, France (2003); Venice Architecture Biennale, Italy (2006); and 'New World Order', Groninger Museum, Netherlands (2008). Her work has been collected by, among others, the Whitney Museum of American Art, New York; San Francisco Museum of Modern Art, California; Centre Pompidou, Paris; Victoria and Albert Museum, London, England; and Guangdong Museum of Art, Guangzhou, China. [SL]

XU Bing
b. 1955, Chongqing, China; lives in New York, USA

Xu received an MFA from the Central Academy of Fine Arts, Beijing, in 1987. A calligrapher, printmaker and installation artist, he is renowned for his invention of a new visual script. His work is informed by the cultural meaning of language, and the power and ambiguity of the written word. In 1990 he accepted an invitation from the University of Wisconsin-Madison to become an honorary fellow and he relocated to the US. He has participated in numerous group exhibitions, including the 45th Venice Biennale, Italy (1993); 'Inside Out: New Chinese Art' at Asia Society Galleries and PS1, New York, and other venues (1998–2000); and 'Accelerate: Chinese Contemporary Art', Singapore Art Museum (2008). His solo exhibitions include 'Word Play: Contemporary Art by Xu Bing', Arthur M. Sackler Gallery, Smithsonian Institute, Washington, DC (2001); 'Xu Bing', Chinese Art Centre, Manchester, England (2003); and 'Xu Bing: Tobacco Project', Shanghai Gallery of Art, China (2004). He received the MacArthur Genius Award in 1999, and in 2004 was awarded the Artes Mundi Prize. In 2008 he was appointed Vice-President of Beijing's Central Academy of Fine Arts. His work is held in international collections, including the British Museum, London, England, and the Museum of Modern Art, New York. [MCH]

XU Zhen
b. 1977, Shanghai, China; lives in Shanghai

Xu graduated from the Shanghai Arts and Crafts Institute in 1996. His conceptual and often provocative work contemplates life's realities and delusions through a diverse range of media, including sculpture, photography, installation and performance art. His work has been selected for group exhibitions worldwide, including 'Exit', Chisenhale Gallery, London, England (2000); 49th Venice Biennale, Italy (2001); 'China Now', Museum of Modern Art, New York (2004); and 'The Real Thing: Contemporary Art from China', Tate Liverpool, England (2007). His solo exhibitions include 'Careful, Don't Get Dirty', Galerie Waldburger, Berlin, Germany (2002); '8848 – 1.86', ShanghART H-Space, Shanghai, China (2006); 'Just did It', James Cohan Gallery, New York (2008); and 'Impossible is Nothing', Long March Space, Beijing, China (2008). In 2004 Xu won the China Contemporary Art award. His works are held in the collection of Tate Liverpool. [MCH]

YAN Pei-Ming
b. 1960, Shanghai, China; lives in Dijon, France

Yan was educated at the Institut des Hautes Études en Arts Plastiques in Paris, France. He is famous for his monumental portraits of iconic figures rendered in bold, sweeping brushstrokes. His subjects include the Mona Lisa, Mao Zedong, Bruce Lee and Barack Obama. In 2009 he received the French Legion of Honour, and showed *The Funeral of Mona Lisa* at the Louvre in Paris. He has exhibited his paintings extensively in Europe and around the world. International exhibitions include the 3rd Gwangju Biennale, Korea (2000); 50th Venice Biennale, Italy (2003); 2nd Seville Biennial, Spain (2006); and 10th Istanbul Biennial, Turkey (2007). [SL]

YANAGI Miwa
b. 1967, Kobe, Japan; lives in Kyoto, Japan

One of Japan's leading women photographers, Yanagi studied art at the graduate school of Kyoto City University of Arts. In her series of photographs, she addresses the role of women in contemporary society. She has had major solo

exhibitions at Deutsche Guggenheim, Berlin, Germany (2004); Hara Museum of Art, Tokyo, Japan (2005); Chelsea Art Museum, New York (2007); and Museum of Fine Arts, Houston, Texas (2008). Her work has also been shown in many international group exhibitions, including the 1st Yokohama Triennale, Japan (2001); 13th Biennale of Sydney, Australia (2002); and 'The American Effect: Global Perspectives on the United States, 1990–2003', Whitney Museum of American Art, New York (2003). [MT]

YANG Fudong
b. 1971, Beijing, China; lives in Shanghai, China

Yang Fudong graduated from the Zhejiang Academy of Fine Arts, Hangzhou (now China Academy of Art), in 1995. He then moved to Beijing, and in 1998 to Shanghai, where he began to create works in video, a medium he is best known for today. Solo exhibitions of his work include '5 Films', Renaissance Society, Chicago (2004); 'Yang Fudong', Castello di Rivoli, Torino, Italy (2005); 'Don't worry, it will be better...', Kunsthalle Wien, Vienna, Austria (2005); 'No Snow on the Broken Bridge', Parasol Unit, London, England (2006); and 'Yang Fudong: Seven Intellectuals in a Bamboo Forest', Asia Society Museum, New York (2009). He has also participated in group exhibitions such as Documenta 11, Kassel, Germany (2002); 50th Venice Biennale, Italy (2003); 4th and 5th Shanghai Biennales, China (2002–3, 2004); 'Between Past and Future: New Photography and Video from China', International Center for Photography and Asia Society, New York (2004); and 1st Moscow Biennale of Contemporary Art, Russia (2005). [MC]

William YANG
b. 1943, Dimbulah, Australia; lives in Sydney, Australia

Yang is a third-generation Chinese-Australian artist who studied architecture at the University of Queensland in Brisbane before, in 1969, moving to Sydney, where he spent several years as a playwright. In the mid-1970s he turned to photography, initially documenting the city's burgeoning gay and party scenes. Over the years his photographic themes have broadened to include the impact of AIDs on the gay and lesbian community, the landscape and the story of the Chinese in Australia. He has held over twenty solo exhibitions of his photographs across Asia, Australia, Europe and North America. [BG]

YIN Xiuzhen
b. 1963, Beijing, China; lives in Beijing

Yin studied oil painting at the Capital Normal University in Beijing, graduating in 1989. She has shown her work extensively, including at 'Inside Out: New Chinese Art', Asia Society Galleries and PS1, New York, and other venues (1998–2000); 'Transience: Chinese Art at the End of the 20th Century', Smart Museum of Art, Chicago (1999); 3rd Asia-Pacific Triennial of Contemporary Art, Queensland Art Gallery, Brisbane, Australia (1999); 4th Gwangju Biennale, Korea (2002); 2nd Fukuoka Asian Art Triennale, Japan (2002); 'How Latitudes Become Forms: Art in a Global Age', Walker Art Center, Minneapolis (2003); 14th Biennale of Sydney, Australia (2004); China Pavilion, 52nd Venice Biennale, Italy (2007); and 7th Shanghai Biennale, China (2008). [MC]

YOO Seung-Ho
b. 1973, Suhcheon, Korea; lives in Seoul, Korea

Yoo graduated in fine art from Han-Sung University, Seoul, in 1999. His work, which initially appears conservative, is inspired by traditional Korean landscape paintings but, instead of being formed by brushstrokes, the landscapes are formed by scores of miniature Korean Hangul characters. Yoo has participated in numerous group shows, including 'Beyond Landscape', Artsonje Museum, Gyeongju Bomun, Korea (1999); 'The Elegance of Silence: Contemporary Art from East Asia', Mori Art Museum, Tokyo, Japan (2005); 5th Asia-Pacific Triennial of Contemporary Art, Queensland Art Gallery, Brisbane, Australia (2006); and 'Stick and Move: Young Asian Artists in a Global Context', Frey Norris Gallery, San Francisco (2007). He has also had solo exhibitions, including at the One and J. Gallery, Seoul, Korea (2005), and the Mizuma Art Gallery, Tokyo, Japan (2007). His work is held in the collection of the Mori Art Museum, Tokyo. [MCH]

YOSHIDA Toshio
b. 1928, Kobe, Japan; d. 1997

Yoshida studied art under Jiro Yoshihara and joined him as one of the co-founders of Gutai Art Association. Yoshida's work has been included in a number of exhibitions featuring Gutai, such as 'Japon des Avant-gardes 1910–1970', Centre Pompidou, Paris, France (1986); 'Japan in the Vanguard: The Gutai Group in the 1950s', Galleria Nazionale d'Arte Moderna, Rome, Italy (1990); 'Gutai: Japanese Avant-Garde 1954–1965', Institut Mathildenhöhe, Darmstadt, Germany (1991); 45th Venice Biennale, Italy (1993); and 'Gutai', Galerie Nationale du Jeu de Paume, Paris (1999). [MT]

YOSHIHARA Jiro
b. 1905, Osaka, Japan; d. 1972

Yoshihara was a leading modern painter who, in 1954, co-founded Gutai Art Association in western Japan. He developed an interest in oil painting while still in high school, and, after graduating from Kansai Gakuin University, took part in art exhibitions and gained a reputation as a prominent avant-garde artist. He played a crucial role in promoting contemporary Japanese art abroad, establishing contact with major international art critics such as Michel Tapié from the late 1950s onwards. His work has been exhibited widely, including in 'Remaking Modernism in Japan 1900–2000', Museum of Contemporary Art, Tokyo, Japan (2004); 'Jiro Yoshihara: A Centenary Retrospective', National Museum of Modern Art, Tokyo (2006); and 'Resounding Spirit: Japanese Contemporary Art of the 1960s', Spencer Museum of Art, Lawrence, Kansas (2008). [MT]

YOUNG-HAE CHANG HEAVY INDUSTRIES
(Young-Hae Chang & Marc Voge; both live in Seoul, Korea)

YOUNG-HAE CHANG HEAVY INDUSTRIES was formed in 1999 by Korean-born Young-Hae Chang and US-born Marc Voge. They are among the most important pioneers of online art, known for their text-based works characteristically utilizing the animation and interactive facility of Adobe Flash. Beyond the presentation of work on their free-access website, they have shown their art in many

exhibitions, including 'The American Effect: Global Perspectives on the United States, 1990–2003', Whitney Museum of American Art, New York (2003); 50th Venice Biennale, Italy (2003); 'Bust Down the Door', Leeum – Samsung Museum of Modern Art, Seoul, Korea (2004); 'Elastic Taboos', Kunsthalle Wien, Vienna, Austria (2007); 10th Istanbul Biennial, Turkey (2007); 'Black on White, Gray Ascending', New Museum, New York (2007–8); and 'Playback', ARC/Musée d'Art Moderne de la Ville de Paris, France (2008). [MT]

YU Youhan
b. 1943, Shanghai, China; lives in Shanghai

Yu graduated from the Central Academy of Art and Design, Beijing, in 1973. In the 1990s he became one of the founding members of Political Pop, a style that combines Chinese political iconography and Western Pop art. His work had a major impact on a generation of younger artists in China. Earlier work shows the influence of folk art and Yu's experiences during the Cultural Revolution. In his highly acclaimed Mao portrait series, the iconic images are decorated with a profusion of brightly coloured flowers. Yu's more recent work consists of landscape paintings depicting pastoral scenes. He has participated in numerous exhibitions, including the 1st Asia-Pacific Triennial of Contemporary Art, Queensland Art Gallery, Brisbane, Australia (1993); 45th Venice Biennale, Italy (1993); 'Chine, le corps partout?', Musée d'Art Contemporain, Paris, France (2004); 'Yu Youhan: Landscape of Yi Meng Shan', ShanghART H-Space, Shanghai, China (2004); and ''85 New Wave: The Birth of Contemporary Chinese Art', Ullens Center for Contemporary Art, Beijing, China (2007). [DYW]

YUE Minjun
b. 1962, Daqing, Heilongjiang Province, China; lives in Beijing, China

Yue studied in the oil painting department at the Hebei Normal University from 1985 to 1989. Upon graduation, he moved to Yuanmingyuan artist village in Beijing and began his career as a professional artist. He is well known for his brightly coloured paintings and sculptures, showing multiple images of himself with a grinning face. He is one of the key figures of Cynical Realism, a style that employs ironic and grotesque images to respond to the period of government repression that followed the Tiananmen Square incident of June 1989. His work has been widely exhibited around the world, including at the 48th Venice Biennale, Italy (1999); 5th and 7th Shanghai Biennales, China (2004, 2008); and 7th Gwangju Biennale, Korea (2008). His first US retrospective was at the Queens Museum of Art, New York (2007). [TT]

ZHANG Dali
b. 1963, Harbin, China; lives in Beijing, China

Zhang graduated from the National Academy of Fine Arts and Design, Beijing, in 1987. In 1989 he relocated to Bologna in Italy. Inspired by Italian graffiti art, he began to develop his career as a conceptual artist, using a signature profile head that he later applied to walls marked for demolition in Beijing. His recent work *Slogans*, a series of paintings in which the faces of migrant workers are inscribed with government catchphrases, continues the theme of urbanization and its effects upon society. His work has been shown at 'Serendipity', Japan Foundation Asia Center, Tokyo (2000); 'Fuck Off', Eastlink Gallery, Shanghai, China (2000); and 'New Photography and Video from China', Victoria and Albert Museum, London, England (2005). Solo exhibitions include 'Headlines', Chinese Contemporary Gallery, London (2002); 'Zhang Dali', Base Gallery, Tokyo, Japan (2002); and 'A Second History', Walsh Gallery, Chicago (2006). Zhang's work is held in the collections of the Asia Society Museum, New York, and the Museum of Modern Art, New York. [MCH]

ZHANG Hongtu
b. 1943, Pingliang, Gansu Province, China; lives in New York, USA

Zhang graduated from the Central Academy of Applied Arts, Beijing, in 1969. In 1982 he moved to New York, where he was a member of the Art Students League until 1986. Renowned for his deconstruction of the Mao image, he has recently engaged in work involving the reproduction of traditional Chinese landscape paintings using a Western Impressionist format. He was an artist-in-residence at the Hong Kong University of Science and Technology (1996) and the South Africa Workshop, Johannesburg (2000). His work has been selected for group exhibitions, including 'Four Artists from China', American Museum of Natural History, New York (1992); 'Trading Place', Museum of Contemporary Art, Taipei, Taiwan (2005); and 'Made in China', Louisiana Museum of Modern Art, Denmark (2007). Solo exhibitions include 'Material Mao', Gallery 456, Chinese American Arts Council, New York (1993); 'Soy Sauce, Lipstick, Charcoal', Hong Kong University of Science and Technology (1996); and 'Zhang Hongtu: Recent Paintings', Lin & Keng Gallery, Taipei (2007). His work is held in the collections of institutions worldwide, including the National Museum of Art, Beijing, and the Bronx Museum of the Arts, New York. [MCH]

ZHANG Huan
b. 1965, Anyang, China; lives in Shanghai, China, and New York, USA

In 1993 Zhang graduated from the Central Academy of Fine Arts in Beijing with a degree in Chinese traditional painting. During the mid-1990s he and other avant-garde artists established the East Village, an alternative artists' collective on the outskirts of the city. In 1998 Zhang moved to the US. His performances often involve ritualized acts and physical endurance with rich socio-political references. He also works in painting, prints, photography, large-scale sculpture and installation art. His work is held in the collections of the Museum of Modern Art and the Guggenheim Museum, New York; National Gallery of Australia; and Israel Museum. His work has been shown internationally in solo and group exhibitions, including 'Inside Out: New Chinese Art' at Asia Society Galleries and PS1, New York, and other venues (1998–2000); 'Zhang Huan: Performance on Video', Artspace, Sydney, Australia (1999); 71st Whitney Biennial, New York (2002); 'Mahjong: Contemporary Chinese Art from the Sigg Collection', Kunstmuseum Bern, Switzerland (2005); 'On the Edge: Contemporary Chinese Artists Encounter the West', Cantor Center for Visual Arts, Stanford University (2005); 'Altered States', Asia Society Museum, New York (2007); and 'Zhang Huan: Memory Doors', Haunch of Venison, Zurich, Switzerland (2009). [TT]

ZHANG Peili

b. 1957, Hangzhou, China; lives in Hangzhou

Zhang graduated from the Zhejiang Academy of Fine Arts (present-day China Academy of Fine Arts) with a degree in oil painting in 1984. He was a founding member of two non-official art groups – New Space (1985) and Pool Society (1986). In the late 1980s he began to experiment with video and is now known as a pioneer Chinese video artist. His video style is considered an influence on the Cynical Realism of the early 1990s, and has been exhibited internationally, including at the 45th and 48th Venice Biennales, Italy (1993, 1999); a solo show at the Museum of Modern Art, New York (1998); 'Global Conceptualism: Points of Origin 1950s–1980s', Queens Museum of Art, New York (1999); and 'Inside Out: New Chinese Art', Asia Society Galleries and PS1, New York, and other venues (1998–2000). Zhang is Chair of the new media department at the China Academy of Art in Hangzhou. [TT]

ZHANG Xiaogang

b. 1958, Kunming, China; lives in Beijing, China

Zhang attended the Sichuan Academy of Fine Arts from 1978 to 1982. In the 1980s he emerged as a leading painter of the Sichuan School, which probed the psychological impact of China's recent political history. His *Bloodline* series of portraits, begun in the 1990s, are among the most recognized works of Chinese contemporary art today. Inspired by old family photographs, Zhang explores themes of personal identity in the context of family, history, politics and modern China's rapidly dissolving traditions of collectivism. His work has been widely exhibited in Asia, Europe and America, including the landmark 'China/Avant-Garde' show at the National Art Museum of China, Beijing (1989), and 'Inside Out: New Chinese Art' at Asia Society Galleries and PS1, New York, and other venues (1998–2000). He was awarded the Bronze Prize at the 22nd São Paulo Biennial, Brazil (1994), and the Document Prize at the first Academic Exhibition of Chinese Contemporary Art, Beijing (1996). [TT]

ZHOU Tiehai

b. 1966, Shanghai, China; lives in Shanghai

Zhou graduated from the Fine Art College, Shanghai University, in 1987. His conceptual artwork, which makes use of a variety of media, often provides witty and bold critiques of the conditions of the global art world. He is best known for his *Camel* series, in which iconic figures in Western art history and visual culture assume a camel head, reminiscent of the logo of Camel cigarettes. Zhou has had numerous solo exhibitions in Asia, Europe and North America; his first in a Chinese museum was 'Another History' at the Shanghai Art Museum (2008). His work has also been included in national and international shows such as the touring exhibition 'Cities on the Move' at the Wiener Secession, Vienna, Austria, and other sites (1997–2000); 48th Venice Biennale, Italy (1999); 1st Guangzhou Triennial, China (2002); 'The American Effect', Whitney Museum, New York (2003); 5th Shanghai Biennale, China (2004); 'Mahjong: Chinese Contemporary Art from the Sigg Collection', Kunstmuseum Bern, Switzerland (2005); 5th Asia-Pacific Triennial of Contemporary Art, Queensland Art Gallery, Brisbane, Australia (2006); 'The Real Thing: Contemporary Art from China', Tate Liverpool, UK (2007); and 3rd Chengdu Biennial, China (2007). Zhou was awarded first prize in the Contemporary Chinese Art Awards by the CCAA Association, Switzerland (1998). [DYW]

Mahreen ZUBERI

b. 1981, Karachi, Pakistan; lives in Karachi

Zuberi received her BFA in Indo-Persian miniature painting from the National College of Arts, Lahore, in 2003. Since 2005, she has taught in the department of visual studies at Karachi University. She has also illustrated books for children and participated in numerous workshops and residencies, including the VASL International Artist Workshop at Gadani, Pakistan (2006), and an international artist workshop in the village of Shatana, Jordan (2007). Zuberi's paintings (often executed in gouache on *wasli* paper), photographs and installations explore socio-political issues, particularly gender relations. She has had solo exhibitions at galleries in Pakistan, including Rohtas Gallery, Islamabad (2008). She has also participated in numerous group exhibitions in Pakistan as well as Morocco, Japan, Europe and the US, including 'Contemporary Miniature Paintings from Pakistan', Fukuoka Asian Art Museum, Japan (2004); 'Re-inventing Narratives', La Galerie Mohamed el Fassi Rabat, Morocco (2005); 'Miniatures contemporaines du Pakistan', La Halle Villefranche-de-Rouergue, France (2005); 'A Thousand and One Days: The Art of Pakistani Women Miniaturists', Honolulu Academy of Arts, Hawaii (2005); and 'Associated Metaphors', IVSAA Gallery, Karachi (2008). [JG]

notes

Introduction

1. Although the Triennale began in 1999, the Fukuoka Asian Art Museum has been organizing pan-Asian exhibitions under the title of 'Asian Art Shows' since 1979.

2. Additional pan-Asian exhibitions include: 'Past in Reverse: Contemporary Art of East Asia', San Diego Museum of Art (2004); 'Under Construction: New Dimensions of Asian Art', Japan Foundation Asia Center, Tokyo (2002); 'Translated Acts: Performance Art from East Asia' at the House of World Cultures, Berlin, and the Queens Museum of Art, New York (2001); and 'Art in Southeast Asia 1997: Glimpses into the Future', Museum of Contemporary Art, Tokyo (1997).

3. For a discussion of these issues, see T. K. Sabapathy, 'Developing Regionalist Perspectives in South-East Asian Art Historiography', in Caroline Turner and Rhana Davenport (eds) *The Second Asia-Pacific Triennial of Contemporary Art* (exh. cat.), Brisbane: Queensland Art Gallery, 1996, pp. 13–17.

4. Yusuke Nakahara, 'Session III: Plenary Session', in Yasuko Furuichi (ed.), *Symposium: 'Asian Contemporary Art Reconsidered' Report*, Tokyo: Japan Foundation Asia Center, 1998, p. 187.

5. Jong-Soong Rhee, 'PortaPaik: Nam Jun Paik Interviewed', in *ARTAsiaPacific*, Vol. 3, No. 3, 1996, p. 54.

6. Yoshida Toshio, 'What I Want To Do', in Alexandra Munroe (ed.), *Japanese Art After 1945: Scream Against the Sky* (exh. cat.), New York: Harry N. Abrams, Inc., 1994, p. 372.

7. Akira Tatehata, 'Mono-ha and Japan's Crisis of the Modern', in *Third Text*, Vol. 16, Issue 3, 2002, p. 226.

8. *Ibid.*

9. See John Clark, *Modern Asian Art*, Sydney and Honolulu: Craftsman House and University of Hawai'i Press, 1998; Yasuko Furuichi and Kazumi Nakamoto (eds), *Asian Modernism: Diverse Development in Indonesia, the Philippines, and Thailand* (exh. cat.), Tokyo: Japan Foundation Asia Center, 1995; Kenjin Miwa, Katsuo Suzuki, Tohru Matsumoto and Yasuko Furuichi (eds), *Cubism in Asia: Unbounded Dialogues* (exh. cat.), Tokyo: National Museum of Modern Art and Japan Foundation, 2005.

10. Jim Supangkat, 'Multiculturalism/ Multimodernism', in Apinan Poshyananda (ed.), *Contemporary Art in Asia: Traditions/ Tensions* (exh. cat.), New York: Asia Society Museum, 1996, pp. 70–81.

11. See Lee Hwaik, 'Painting Nothing: The Minimal Aesthetic of Korean Monochrome Painting', in *ARTAsiaPacific*, Vol. 3, No. 3, 1996, pp. 68–73; Mikyung Kim, 'So: Rereading Korean Monotone Painting Through the Concept of Soye: Thoughts on "Korea five artists five HINSEK WHITE" Exhibition (Tokyo Gallery, 1975)', in *Rereading Korean Modern Art III*, Vol. 2, ICAS, Seoul, 2003, p. 439.

12. For an account of a notorious incident of censorship in Singapore, see Lee Weng Choy, 'Chronology of a Controversy', http://www.biotechnics.org/Chronology %20of%20a%20controversy.htm (accessed January 2010). For a more general assessment, see Lucy Davis, 'State of Censorship Singapore post-CRC 3', in *Focas: Forum on Contemporary Art and Society*, No. 5, 2004, pp. 295–309.

13. Artists from the New Zero Group in Yangon recounted this to the authors, 31 December 2007, Yangon.

14. See Nora A. Taylor, 'The Body and the Self in Contemporary Vietnamese Art', in Viet Le and Yong Soon Min (eds), *transPOP: Korea Vietnam Remix* (exh. cat.), Seoul: Arko Art Center, 2008, p. 142.

15. Of course artists did stray from the party line, but often covertly. The No Name Group was a group of artists who painted bucolic rural scenes and other subjects in secret during the Cultural Revolution. See Gao Minglu (ed.), *The No Name: A History of A Self-Exiled Avant-Garde* (exh. cat.), Guilin: Guangxi Normal University Press, 2007.

16. For a discussion of Chinese artists who settled in New York, Paris and Sydney, see Melissa Chiu, *Breakout: Chinese Art Outside China*, Milan: Charta, 2007.

17. For an account of the many experimental contemporary exhibitions closed by officials in China, see Wu Hung, *Exhibiting Experimental Art in China* (exh. cat.), Chicago: David and Alfred Smart Museum of Art, University of Chicago, 2000.

18. Carol Lutfy, 'Japan's Museum Boom: What Now?', in *International Herald Tribune*, 20 December 1991: http://www.nytimes.com/ 1991/12/20/style/20iht-muse.html (accessed January 2010).

19. For an in-depth discussion of biennales and their impact on Asian contemporary art, see John Clark, 'Histories of the Asian "New": Biennales and Contemporary Asian Art', in Vishakha N. Desai (ed.), *Asian Art History in the Twenty-First Century*, Williamstown, Mass.: Sterling and Francine Clark Art Institute, 2007, pp. 229–49; and Lee Weng Choy, 'Biennale Demand', in *Broadsheet*, Vol. 37, No. 1, 2008, p. 39.

20. For an overview of alternative spaces in Asia, see Yasuko Furuichi (ed.), *Alternatives 2005: Contemporary Art Spaces in Asia*, Tokyo: Japan Foundation, 2004.

21. Apinan Poshyananda, *Thai-Tanic: Thai Art in the Age of Constraint and Coercion* (exh. cat.), New York: Ethan Cohen Fine Arts, 2003, p. 7.

22. Michelle Antoinette, 'Different Visions: Contemporary Malaysian art and Exhibition in the 1990s and Beyond', in Caroline Turner (ed.), *Art and Social Change: Contemporary Art in Asia and the Pacific*, Canberra: Pandanus Books, 2005, pp. 229–52.

Chapter 1: Rethinking Tradition

1. Edward Said, 'Preface', *Orientalism*, New York: Vintage, 2003, p. xxiii.

2. Caroline Turner and Morris Low (eds), *Beyond the Future: Papers from the Conference of the Third Asia-Pacific Triennial of Contemporary Art Brisbane, 10–12 September, 1999*, Brisbane: Queensland Art Gallery, 2000, p. 53.

3. See Fei Dawei (ed.), *'85 New Wave: The Birth of Chinese Contemporary Art* (exh. cat.),

Beijing: Ullens Center for Contemporary Art, 2007.

4. Michael Sullivan, *Art and Artists of Twentieth-Century China*, Berkeley: University of California Press, 1996, p. 265.

5. Binghui Huangfu, 'Interview with Song Dong', in *Yishu: Journal of Contemporary Chinese Art*, Vol. 1, No. 1, Spring/May, 2002, p. 85.

6. http://www.grottofineart.com/WilsonShieh 2002/AlternativeAntiquity03.html (accessed January 2010).

7. Melissa Chiu, 'Ghosts, Three Gorges, and Ink: An Interview with Yun-Fei Ji', in Shannon Fitzgerald (ed.), *Yun-Fei Ji: The Empty City* (exh. cat.), St Louis: Contemporary Art Museum St Louis, 2004, pp. 86–87.

8. Robert J. Fouser, 'Disrupture: Politics and History in the Art of Kim Ho-Suk', in *ARTAsiaPacific*, No. 14, 1997, p. 77.

9. Grazia Quaroni, 'Interview with Tabaimo', in *Tabaimo* (exh. cat.), Paris: Fondation Cartier pour l'art contemporain, 2006, p. 12.

10. Melissa Chiu, 'A Conversation with the Artist', in Melissa Chiu and Miwako Tezuka (eds), *Yang Fudong: Seven Intellectuals in a Bamboo Forest* (exh. cat.), New York: Asia Society Museum, 2009, p. 19.

11. Wang Qingsong, http://www.wangqingsong. com/html/words.htm (accessed January 2010).

12. Geeta Kapur, 'Dismantled Norms: Apropos Other Avantgardes', in Caroline Turner (ed.), *Art and Social Change: Contemporary Art in Asia and the Pacific*, Canberra: Pandanus Books, 2005, pp. 63–64.

13. Archibald McKenzie, 'Interviews with Six Survivors', in Melissa Chiu and Archibald McKenzie (eds), *Six Contemporary Chinese Artists* (exh. cat.), Sydney: University of Western Sydney, 1992, n.p.

14. Salima Hashmi, 'Tracing the Image: Contemporary Art in Pakistan', in Caroline Turner (ed.), *Art and Social Change: Contemporary Art in Asia and the Pacific*, Canberra: Pandanus Books, 2005, p. 175.

15. Vishakha N. Desai (ed.), *Conversations With Traditions: Nilima Sheikh, Shahzia Sikander* (exh. cat.), New York: Asia Society Museum, 2001, p. 42.

16. *Ibid.*, p. 18.

17. Apinan Poshyananda (ed.), *Montien Boonma: Temple of the Mind* (exh. cat.), New York: Asia Society Museum, 2003, p. 7.

18. Albert Paravi Wongchirachai, 'Montien Boonma: Grief, Buddhism and the Cosmos', in *Art and Asia Pacific*, Vol. 2, No. 3, 1995, p. 79.

19. Apinan Poshyananda (ed.), *Montien Boonma: Temple of the Mind* (exh. cat.), New York: Asia Society Museum, 2003, p. 33.

20. Jerome Sans, 'Chen Zhen: Between Therapy and Meditation: An Interview with Jerome Sans, Paris, January 1999', in *Chen Zhen: Between Therapy and Meditation* (exh. cat.), Perigueux: Espace Culturel François Mitterrand, 1999, n.p.

21. Cities with higher rates are city-states, such as Singapore and Hong Kong, where the figure is close to 100%. See Pontus Kyander and Jiyoon Lee, 'Modern Seoul', in Jiyoon Lee and Pontus Kyander (eds), *Seoul: Until Now! City and Scene* (exh. cat.), Copenhagen: Charlottenborg Udstillingsbygning, 2005, pp. 13–14.

22. David Ian Miller, 'Finding My Religion: Photographer Hiroshi Sugimoto on Subjects of a Spiritual Nature', in *San Francisco Chronicle*, September 10, 2007: http://www.sfgate.com/cgi-bin/article. cgi?f=/g/a/2007/09/10/findrelig.DTL (accessed January 2010)

23. Kamala Kapoor, 'Conjuring the World: Ravinder Reddy's Sculptural Emblems', in *ARTAsiaPacific*, Issue 21, 1999, p. 74.

Chapter 2: Politics, Society and the State

1. Caroline Turner (ed.), *Art and Social Change: Contemporary Art in Asia and the Pacific*, Canberra: Pandanus Books, 2005, p. 9.

2. Jim Supangkat, 'Multiculturalism/ Multimodernism', in Apinan Poshyananda (ed.), *Contemporary Art in Asia: Traditions/ Tensions*, New York: Asia Society Museum, 1996, p. 79.

3. Carla Bianpoen, 'Heri Dono Achieves New Milestone', in *The Jakarta Post*, 10 July 2003, p. 20.

4. Jordan Troeller, 'Interview with Rirkrit Tiravanija', in *ART India*, Vol. XIII, Issue III+IV, 2008–9, p. 30.

5. Lee Weng Choy, 'The "Real" China – Has Modernism's "Universal" Become the Contemporary "Global"? Questions for Arthur Danto', in Caroline Turner and Morris Low (eds), *Beyond the Future: Papers from the Conference of the Third Asia-Pacific Triennial of Contemporary Art Brisbane, 10–12 September, 1999*, Brisbane: Queensland Art Gallery, 2000, p. 60.

6. Ing K., 'Manit Sriwanichpoom in Pink, White and Blue', in *Neo-Nationalism* (exh. cat.), Bangkok: Art Center, Chulalongkorn University, 2005, p. 77.

7. Morimura Yasumasa and Yanagi Miwa, 'Morimura Yasumasa and Yanagi Miwa: The Suffering of Girls and Boys', in *Art iT*, No. 19, Spring/Summer 2008, p. 54.

8. *Ibid.*, p. 55.

9. Robert Preece and Gridthiya Gaweewong, 'Cracking Beneath the Surface: An Interview with Chatchai Puipia', in *ARTAsiaPacific*, Issue 22, 1999, pp. 70–71.

10. Gao Minglu, 'Private Experience and Public Happenings: The Performance Art of Zhang Huan', in *Pilgrimage to Santiago* (exh. cat.), 2000, p. 51.

11. Wong Hoy Cheong, 'Artist's Statement', in Valentine Willie (ed.), *Of Migrants & Rubber Trees: An Exhibition of Drawings and Installations* (exh. cat.), Kuala Lumpur: Fine Arts Centre and Valentine Willie Fine Art, 1996, p. 6.

12. Barbara D. Metcalf and Thomas R. Metcalf, *A Concise History of India*, Cambridge: Cambridge University Press, 2002, p. 219.

13. Johan Pijnappel, *CC: Crossing Currents– Video Art and Cultural Identity*, New Delhi: Royal Netherlands Embassy, 2006, p. 82.

14. Wonil Rhee, Peter Weibel and Gregor Jansen (eds), *Thermocline of Art: New Asian Waves* (exh. cat.), Ostfildern: Hatje Cantz , 2007, p. 280.

15. Anne Marie Cummings, 'An-My Lê's "Small Wars"', in *The Ithaca Journal*, October 2, 2008, p. 10M.

16. Pi Li, 'Synthetic Reality: A Historical Note', in Ni Haifeng and Zhu Jia (eds), *Synthetic Reality* (exh. cat.), Hong Kong: Timezone 8 Limited, 2004, p. 15.

17. Li Xianting, 'Major Trends in the Development of Contemporary Chinese Art', in Valerie C. Doran (ed.), *China's New Art, Post-1989* (exh. cat.), Hong Kong: Hanart TZ Gallery, 1993, p. xx.

18. Binghui Huangfu, 'Contemporary Art and Asian Women', in Binghui Huangfu (ed.), *Text & Subtext (Vol. 1): Contemporary Art and Asian Women* (exh. cat.), Singapore: Earl Lu Gallery, 2000, p. 160.

19. Mahreen Zuberi, unpublished artist's statement, 2009.

20. Amanda Heng, 'Working as a Woman Artist and Making Projects with a Female Focus', in Caroline Turner and Morris Low (eds), *Beyond the Future: Papers from the Conference of the Third Asia-Pacific Triennial of Contemporary Art Brisbane, 10–12 September, 1999*, Brisbane: Queensland Art Gallery, 2000, p. 47.

21. Wu Hung and Christopher Phillips (eds), *Between Past and Future: New Photography and Video from China* (exh. cat.), New York and Chicago: International Center for Photography and Smart Art Museum, 2004, p. 180.

22. Binghui Huangfu (ed.), *Text & Subtext (Vol. 2): International Contemporary Asian Women Artists Exhibition* (exh. cat.), Singapore: Earl Lu Gallery, 2000, p. 18.

23. Caroline Turner (ed.), *Art and Social Change: Contemporary Art in Asia and the Pacific*, Canberra: Pandanus Books, 2005, p. 10.

24. Apinan Poshyananda, 'Roaring Tigers, Desperate Dragons in Transition', in Apinan Poshyananda (ed.), *Contemporary Art in Asia: Traditions/Tensions* (exh. cat.), New York: Asia Society Museum, 1996, p. 44.

25. Chaitanya Sambrani (ed.), *Edge of Desire: Recent Art in India* (exh. cat.), Perth and New York: Art Gallery of Western Australia and Asia Society Museum, 2005, p. 70.

26. Apinan Poshyananda, 'Roaring Tigers, Desperate Dragons in Transition', in Apinan Poshyananda (ed.), *Contemporary Art in Asia: Traditions/Tensions* (exh. cat.), New York: Asia Society Museum, 1996, p. 53.

27. Geeta Kapur, 'Lightness of Being, Indifferent Loves: Bhupen Khakhar's Recent Watercolours', in *ARTAsiaPacific*, No. 14, 1997, p. 60.

Chapter 3: Asian Pop, Consumerism and Stereotypes

1. John A. Lent, 'A Survey of Asian Comic Art', in *ARTAsiaPacific*, Issue 21, 1999, p. 68.

2. Mika Yoshitake, 'The Meaning of the Nonsense of Excess', in Paul Schimmel (ed.), © *Murakami* (exh. cat.), Los Angeles: Museum of Contemporary Art Los Angeles, 2007, p. 126.

3. Midori Matsui, 'Murakami Matrix: Takashi Murakami's Instrumentalization of Japanese Postmodern Culture', in Paul Schimmel (ed.), © *Murakami* (exh. cat.), Los Angeles: Museum of Contemporary Art Los Angeles, 2007, p. 81.

4. Gennifer Weisenfeld, 'Reinscribing Tradition in a Transnational Art World', in Vishakha N. Desai (ed.), *Asian Art History in the Twenty-First Century*, Williamstown, Mass.: Sterling and Francine Clark Art Institute, 2007, p. 187.

5. Midori Matsui, 'The Door into Summer: The Age of Micropop', in Midori Matsui (ed.), *The Age of Micropop: The New Generation of Japanese Artists* (exh. cat.), Tokyo: Parco Co. Ltd., 2007, p. 29.

6. Stephan Trescher, 'My Superficiality is Only a Game: A Conversation between Stephan Trescher and Yoshitomo Nara', in Manfred Rothenberger (ed.), *Yoshitomo Nara: Lullaby Supermarket* (exh. cat.), Nürnberg: Institut Für Moderne Kunst Nürnberg, 2002, p. 104.

7. Enin Suprianto, 'Tales from Wounded-Land', in *Tales from Wounded-Land: Eko Nugroho and Wedhar Riyadi* (exh. cat.), New York: Tyler Rollins Fine Art, 2009.

8. Britta Erickson, 'Sui Jianguo', in Britta Erickson (ed.), *On the Edge: Contemporary Chinese Artists Encounter the West* (exh. cat.), Stanford: Iris & B. Gerald Cantor Center for Visual Arts, 2005, p. 101.

9. Charles Merewether, 'The Spectre of Being Human', in Caroline Turner (ed.), *Art and Social Change: Contemporary Art in Asia and the Pacific*, Canberra: Pandanus Books, 2005, p. 123.

10. Kim Sun-jung, 'Baubles, Bangles and Beads: Interviews with Four Korean Women Artists', in *ARTAsiaPacific*, Vol. 3, No. 3, 1996, p. 60.

11. Melissa Chiu, 'Interview', in Melissa Chiu (ed.), *Cai Guo-Qiang, Light Cycle: Explosion Project for Central Park* (exh. cat.), New York: Asia Society Museum and Creative Time, 2003, n.p.

12. Faiza Butt, unpublished artist's statement, 2009.

13. Andrew Maerkle, 'The Iron Man: Nataraj Sharma', in *ARTAsiaPacific*, No. 54, July/August 2007, pp. 96–97.

14. Quddus Mirza, 'After a Fashion: Using Popular Imagery', in *ART India*, Vol. IX, Issue II, 2004, pp. 58–60.

15. See Melissa Chiu and Zheng Shengtian (eds), *Art and China's Revolution* (exh. cat.), New Haven: Yale University Press, 2008.

16. Lydia Yee, 'An Interview with Zhang Hongtu', in Lydia Yee (ed.), *Zhang Hongtu: Material Mao* (exh. cat.), New York: Bronx Museum of the Arts, 1995, p. 2: http://www.momao.com/reading_in2.htm#ly (accessed January 2010).

17. *Pushpamala N.: Indian Lady* (exh. cat.), New York: Bose Pacia, 2004, n.p.

18. Melissa Chiu, 'Interview with Dinh Q. Lê', in *Vietnam: Destination for the New Millennium, The Art of Dinh Q. Lê* (exh. cat.), New York: Asia Society Museum, 2005, p. 21.

19. Jennifer González, 'Paul Pfeiffer', in *Bomb*, Issue 83, Spring 2003: http://www.bombsite.com/issues/83/articles/2543 (accessed January 2010).

Chapter 4: Urban Nature

1. Jim Supangkat, 'Multiculturalism/Multimodernism', in Apinan Poshyananda (ed.), *Contemporary Art in Asia: Traditions/Tensions* (exh. cat.), New York: Asia Society Museum, 1996, p. 76.

2. Hou Hanru, 'Filling the Urban Void: Urban Explosion and Art Intervention in Chinese Cities', in Yu Hsiao-Hwei (ed.), *On the Mid-Ground*, Hong Kong: Timezone 8, 2002, p. 182.

3. Wu Hung, *Making History: Wu Hung on Contemporary Art*, Hong Kong: Timezone 8, 2008, p. 246.

4. Salima Hashmi, 'Tracing the Image: Contemporary Art in Pakistan', in Caroline Turner (ed.), *Art and Social Change: Contemporary Art in Asia and the Pacific*, Canberra: Pandanus Books, 2005, p. 173.

5. Sandhya Bordewekar, 'Big Things Have Small Beginnings: Interview with Nataraj Sharma', in *ART India*, Vol. XIII, Issue III+IV, 2008–9, p. 44.

6. Sudhir Patwardhan, 'Lower Parel', in Ranjit Hoskote, *Sudhir Patwardhan: The Complicit Observer* (exh. cat.), Mumbai: Sakshi Gallery, n.d., p. 194.

7. Morimura Yasumasa and Yanagi Miwa, 'Morimura Yasumasa and Yanagi Miwa: The Suffering of Girls and Boys', in *Art iT*, No. 19, Spring/Summer 2008, p. 51.

8. Hou Hanru, 'Filling the Urban Void: Urban Explosion and Art Intervention in Chinese Cities', in Yu Hsiao-Hwei (ed.), *On the Mid-Ground*, Hong Kong: Timezone 8, 2002, p. 188.

9. Kajri Jain, 'India's Modern Vernacular – On the Edge', in Chaitanya Sambrani (ed.), *Edge*

of Desire: Recent Art in India (exh. cat.), Perth and New York: Art Gallery of Western Australia and Asia Society Museum, 2005, p. 179.

10. Benjamin Genocchio, 'Reaching Out with a Flourish of Indian Art', in *New York Times*, October 7, 2007, Section 14 NJ, p. 1.

11. Bernhard Fibicher and Suman Gopinath (eds), *Horn Please: Narratives in Contemporary Indian Art* (exh. cat.), Bern: Kunstmuseum Bern, 2007, p. 92.

12. Wonil Rhee, Peter Weibel and Gregor Jansen (eds), *Thermocline of Art: New Asian Waves* (exh. cat.), Ostfildern: Hatje Cantz, 2007, p. 254.

13. http://www.undp.org.in/index.php?option=com_content&view=article&id=14&Itemid=62 (accessed January 2010).

14. Nakao Tomomichi, Yamaki Yuko and Kondo Kazuyo (eds), *The 2nd Fukuoka Asian Art Triennale* (exh. cat.), Fukuoka: Fukuoka Asian Art Museum, 2002, p. 135.

15. Junebum Park, 'Interview with Junebum Park', in Kyungmin Lee (ed.), *Channel 1: Single Channel Video Exhibition* (exh. cat.), Seoul: Gallery Hyundai, 2007, p. 49.

16. David Garcia, 'Lin Yilin and the Rise of the Chinese Transnational Avant-Garde': http://www.linyilin.com/ (accessed January 2010).

17. Helen Michaelsen (ed.), *Comm ... Navin Rawanchaikul: Individual and Collaborative Projects* (exh. cat.), Tokyo and Vancouver: S by S Co. and Contemporary Art Gallery, 1999, p. 216.

18. Wonil Rhee, Peter Weibel and Gregor Jansen (eds), *Thermocline of Art: New Asian Waves* (exh. cat.), Ostfildern: Hatje Cantz, 2007, p. 230.

19. *World Urbanization Prospects, The 2007 Revision*, United Nations, New York, 26 February 2008, p. 2: http://www.un.org/esa/population/publications/wup2007/2007WUP_ExecSum_web.pdf (accessed January 2010).

20. Larry R. Ford, 'Skyscraper Competition in Asia: New City Images and New City Forms', in Rebecca M. Brown and Deborah S. Hutton (eds), *Asian Art*, Malden: Blackwell, 2006, p. 194.

21. Yuko Hasegawa, 'Interview with Odani Motohiko', in *Art iT*, No. 18, Winter/Spring 2008, p. 47.

Epilogue

1. Johan Pijnappel, *CC: Crossing Currents – Video Art and Cultural Identity*, New Delhi: Royal Netherlands Embassy, 2006, p. 54.

2. http://www.raqsmediacollective.net/nodes.html (accessed January 2010).

3. Tetsuya Ozaki, 'Interview with Cao Fei', in *Art iT*, No. 20, Summer/Fall 2008, p. 62.

4. Salima Hashmi, 'Tracing the Image: Contemporary Art in Pakistan', in Caroline Turner (ed.), *Art and Social Change: Contemporary Art in Asia and the Pacific*, Canberra: Pandanus Books, 2005, p. 178.

bibliography

Nancy Adajania, 'Shifting Routes, Floating Continents', in Wonil Rhee, Peter Weibel and Gregor Jansen (eds), *Thermocline of Art: New Asian Waves* (exh. cat.), Ostfildern: Hatje Cantz, 2007, pp. 74–79.

Corazón Alvina, Jeff Baysa and Dana Friis-Hansen (eds), *At Home and Abroad: 20 Contemporary Filipino Artists* (exh. cat.), San Francisco: Asian Art Museum, 1998.

Hossein Amirsadeghi (ed.), *Different Sames: New Perspectives in Contemporary Iranian Art*, London: Thames & Hudson, 2009.

Julia F. Andrews, *Painters and Politics in the People's Republic of China, 1949–1979*, Berkeley: University of California Press, 1994.

Julia F. Andrews and Kuiyi Shen (eds), *A Century in Crisis: Modernity and Tradition in the Art of Twentieth-Century China* (exh. cat.), New York: Guggenheim Museum, 1998.

Rustam Bharucha, 'Beyond the Box: Problematising the New Asian Museum', in *Third Text*, Vol. 52, Summer 2000, pp. 11–19.

Marc Bollansee and Enin Supriyanto, *Indonesian Contemporary Art Now*, Singapore: SNP International Publishing, 2007.

Melissa Chiu, *Breakout: Chinese Art Outside China*, Milan: Charta, 2007.

Melissa Chiu and Zheng Shengtian (eds), *Art and China's Revolution* (exh. cat.), New York: Asia Society Museum, 2008.

John Clark, *Modern Asian Art*, Sydney: Craftsman House, 1998.

John Clark (ed.), *Modernity in Asian Art*, University of Sydney East Asian Studies No. 7, Sydney: Wild Peony, 1993.

David Clarke, *Art and Place: Essays on Art from a* *Hong Kong Perspective*, Hong Kong: Hong Kong University Press, 1996.

——, 'Contemporary Asian Art and its Western Reception', in *Third Text*, Vol. 16, Issue 3, 2002, pp. 237–42.

Jo-Anne Birnie Danzker, Ken Lum and Zheng Shengtian (eds), *Shanghai Modern 1919–1945* (exh. cat.), Ostfildern: Hatje Cantz, 2004.

Vishakha N. Desai, 'Beyond the "Authentic-Exotic": Collecting Contemporary Asian Art in the Twenty-First Century', in Bruce Altshuler (ed.), *Collecting the New: Museums and Contemporary Art*, Princeton: Princeton University Press, 2005, pp. 103–14.

Vishakha N. Desai (ed.), *Asian Art History in the Twenty-First Century*, Williamstown, Mass.: Sterling and Francine Clark Art Institute, 2007.

Valerie C. Doran (ed.), *China's New Art, Post-1989* (exh. cat.), Hong Kong: Hanart TZ Gallery, 1993.

Dinah Dysart and Hannah Fink (eds), *Asian Women Artists*, Sydney: Craftsman House, 1996.

Bernhard Fibicher and Suman Gopinath (eds), *Horn Please: Narratives in Contemporary Indian Art* (exh. cat.), Ostfildern: Hatje Cantz, 2007.

Jean Fisher (ed.), *Lee Ufan: The Art of Encounter*, London: Lisson Gallery, 2004.

Patrick D. Flores, 'The Curatorial Turn in Southeast Asia and the Afterlife of the Modern', in Furuichi Yasuko (ed.), *Count 10 Before You Say Asia: Asian Art After Postmodernism*, Tokyo: Japan Foundation, 2009, pp. 222–31.

Furuichi Yasuko (ed.), *Symposium: Asian Art Reconsidered*, Tokyo: Japan Foundation Asia Center, 1998.

——, *International Symposium 2005: Cubism in* *Asia: Unbounded Dialogues*, Tokyo: Japan Foundation, 2006.

Furuichi Yasuko and Nakamoto Kazumi (eds), *Asian Modernism: Diverse Development in Indonesia, the Philippines, and Thailand* (exh. cat.), Tokyo: Japan Foundation Asia Center, 1995.

Gao Minglu (ed.), *Inside Out: New Chinese Art* (exh. cat.), New York: Asia Society Museum, 1998.

Gridthiya Gaweewong, 'Experimental Art in Thailand: Work in (a slow) Progress', in Binghui Huangfu (ed.), *Next Move: Contemporary Art from Thailand* (exh. cat.), Singapore: La Salle-Sia College of the Arts, 2003, pp. 25–35.

Alice Guillermo, *Protest/Revolutionary Art in the Philippines, 1970–1990*, Quezon City: University of Philippines Press, 2001.

Salima Hashmi, *Unveiling the Visible: Lives and Works of Women Artists of Pakistan*, Lahore: Sang-E-Meel Publications, 2002.

Jonathan Hay and Mimi Young (eds), *Why Asia? Contemporary Asian and Asian American Art: Alice Yang*, New York: New York University Press, 1998.

Maxwell K. Hearn and Judith G. Smith, *Chinese Art: Modern Expressions*, New York: Metropolitan Museum of Art, 2001.

Betti-Sue Hertz (ed.), *Past in Reverse: Contemporary Art of East Asia* (exh. cat.), San Diego: San Diego Museum of Art, 2004.

Ranjit Hoskote, 'Contemporary Indian Art: A Brief Survey', in Yasuko Furuichi (ed.), *Private Mythology: Contemporary Art from India* (exh. cat.), Tokyo: Japan Foundation Asia Center, 1998, pp. 92–97.

Hou Hanru and Hans-Ulrich Obrist (eds), *Cities on the Move* (exh. cat.), Ostfildern: Hatje Cantz, 1997.

Binghui Huangfu (ed.), *Text & Subtext: Contemporary Art and Asian Women* (exh. cat.), Singapore: Earl Lu Gallery, 2000.

Ishida Tetsuro, Shioda Junichi, Kumagai Isako, Fukunaga Osamu and Okamoto Yoshie (eds), *Art in Southeast Asia 1997: Glimpses into the Future* (exh. cat.), Tokyo: Museum of Contemporary Art, Hiroshima Museum of Contemporary Art and Japan Foundation Asia Center, 1997.

John Junkerman (ed.), *The History of Japanese Photography* (exh. cat.), New Haven: Yale University Press, 2003.

Geeta Kapur, *When Was Modernism: Essays on Contemporary Cultural Practice in India*, New Delhi: Tulika, 2000.

Joan Kee, 'What is Feminist about Contemporary Asian Women's Art?', in *Global Feminisms: New Directions in Contemporary Art* (exh. cat.), New York and London: Brooklyn Museum and Merrell Press, 2007, pp. 107–21.

Joan Kee (ed.), *Positions: East Asia Cultures Critique*, Vol. 12, No. 3, Winter 2004.

Kim Kyong-woon (ed.), *Performance Art of Korea 1967–2007* (exh. cat.), Seoul: Gyeol Publishers, 2007.

Kim Youngna, *Tradition, Modernity and Identity: Modern and Contemporary Art in Korea*, New Jersey: Hollym Corporation, 2005.

Martina Köppel-Yang, *Semiotic Warfare: The Chinese Avant-Garde, 1979–1989*, Hong Kong: Timezone 8, 2003.

Natalia Kraevskaia, *From Nostalgia Towards Exploration: Essays on Contemporary Art in Vietnam*, Hanoi: Kim Dong Publishing House, 2005.

Melissa Larner (ed.), *Outlet: Yogyakarta within the Contemporary Indonesian Art Scene*, Yogyakarta: Cemeti Art Foundation, 2001.

Lee Weng Choy, 'Just What Is It That Makes the Term Global-Local So Widely Cited, Yet So Annoying?', in Gerardo Mosquera and Jean Fisher (eds), *Over Here: International Perspectives on Art and Culture*, New York and Cambridge, Mass.: New Museum and MIT Press, 2004, pp. 12–25.

Moon Young Min, 'Cultural Politics of Curating Contemporary Korean Art for Audiences Abroad', in *Journal Bol 010*, 2008, pp. 128–141.

Alexandra Munroe (ed.), *Japanese Art After 1945: Scream Against the Sky* (exh. cat.), New York: Harry N. Abrams, Inc., 1994.

Apinan Poshyananda, *Modern Art in Thailand: Nineteenth and Twentieth Centuries*, Singapore: Oxford University Press, 1992.

——, 'Asian Art and the New Millennium: From Glocalism to Techno-Shamanism', in *Asian Art: Prospects for the Future Report*, Tokyo: Japan Foundation Asia Center, 1999, pp. 165–67.

Apinan Poshyananda (ed.), *Contemporary Art in Asia: Traditions/Tensions* (exh. cat.), New York: Asia Society Museum, 1996.

Jae-Ryung Roe, *Contemporary Korean Art*, Sydney: Craftsman House, 2001.

T. K. Sabapathy, 'Developing Regionalist Perspectives in South-East Asian Art Historiography', in *The Second Asia-Pacific Triennial of Contemporary Art* (exh. cat.), Brisbane: Queensland Art Gallery, 1996, pp. 13–17.

Chaitanya Sambrani (ed.), *Edge of Desire: Recent Art in India* (exh. cat.), New York and Perth: Asia Society Museum and Art Gallery of Western Australia, 2005.

Gayatri Sinha and Paul Sternberger (eds), *India: Public Places/Private Spaces: Contemporary Photography and Video Art* (exh. cat.), Newark: Newark Museum, 2007.

Michael Sullivan, *Art and Artists of Twentieth-Century China*, Berkeley: University of California Press, 1996.

Jim Supangkat, *Indonesian Modern Art and Beyond*, Jakarta: Indonesian Fine Arts Foundation, 1997.

Akira Tatehata, 'Mono-ha and Japan's Crisis of the Modern', in *Third Text*, Vol. 3, September 2002, pp. 223–36.

Elise K. Tipton and John Clark (eds), *Being Modern in Japan: Culture and Society from the 1910s to the 1930s*, Sydney: Australian Humanities Research Foundation, 2000.

Caroline Turner (ed.), *Tradition and Change: Contemporary Art of Asia and the Pacific*, St Lucia: University of Queensland Press, 1993.

—, *Art and Social Change: Contemporary Art in Asia and the Pacific*, Canberra: Pandanus Books, 2005.

Wang Hui, 'Imagining Asia: A Genealogical Analysis', in *Edges of the Earth: Migration of Contemporary Asian Art and Regional Politics*, Hangzhou: China Academy of Art, 2003, pp. 374–85.

Gennifer Weisenfeld, *Mavo: Japanese Artists and the Avant-Garde, 1905–1931*, Berkeley: University of California Press, 2002.

Wu Hung, *Making History: Wu Hung on Contemporary Art*, Hong Kong: Timezone 8, 2008.

Wu Hung, Wang Huangsheng and Feng Boyi (eds), *The First Guangzhou Triennial – Reinterpretation: A Decade of Experimental Chinese Art (1990–2000)* (exh. cat.), Guangzhou: Guangdong Museum of Art, 2002.

Yu Hsiao-Hwei (ed.), *On the Mid-Ground: Hou Hanru*, Hong Kong: Timezone 8, 2002.

list of museums and galleries

Selected museums and non-profit contemporary art spaces:

Afghanistan
Center for Contemporary Arts Afghanistan (CCAA), Kabul: www.ccaa.org.af

Australia
Queensland Art Gallery, Brisbane: qag.qld.gov.au
National Gallery of Victoria, Melbourne: ngv.vic.gov.au
Art Gallery of New South Wales, Sydney: artgallery.nsw.gov.au
Gallery 4 A, Asian Australian Artists Association, Sydney: www.4a.com.au
Sherman Contemporary Art Foundation, Sydney: sherman-scaf.org.au/exhibitions/ #/about
White Rabbit, Sydney: whiterabbitcollection. org/modules/about

China
National Art Museum of China, Beijing: namoc.org/en
Today Art Museum, Beijing: www.todayartmuseum.com
Ullens Center for Contemporary Art, Beijing: ucca.org.cn/portal/home/index.798?lang=en
Guangdong Museum of Art, Guangzhou: www.gdmoa.org
Shanghai Art Museum, Shanghai: www.sh-artmuseum.org.cn
Zendai Museum of Modern Art, Shanghai: www.zendaiart.com/zh-CN/main/Default. aspx
Shenzhen Art Museum, Shenzhen: szam.org

Hong Kong
Hong Kong Museum of Art: www.lcsd.gov.hk/ ce/Museum/Arts
Para/Site Art Space: para-site.org.hk

India
Devi Art Foundation, Delhi: deviartfoundation.org
National Gallery of Modern Art, Mumbai: ngmaindia.gov.in/ngma_mumbai.asp

National Gallery of Modern Art, New Delhi: ngmaindia.gov.in

Indonesia
Indonesian National Gallery, Jakarta: galeri-nasional.or.id/index_en.php
Cemeti Art House, Yogyakarta: cemetiarthouse.com

Iran
National Museum of Iran, Tehran: www.nationalmuseumofiran.ir
Tehran Museum of Contemporary Art, Tehran: tehranmoca.com

Japan
Fukuoka Asian Art Museum, Fukuoka: faam.city.fukuoka.lg.jp/eng/home.html
21st Century Museum of Contemporary Art, Kanazawa: kanazawa21.jp/en
Center for Contemporary Art, Kitakyushu: cca-kitakyushu.org
National Museum of Art, Osaka: www.nmao.go.jp/english/home.html
Hara Museum of Contemporary Art, Tokyo: www.haramuseum.or.jp
Mori Art Museum, Tokyo: mori.art.museum/eng/index.html
Museum of Contemporary Art, Tokyo: mot-art-museum.jp/eng
National Museum of Modern Art, Tokyo: www.momat.go.jp
Watari-Um, The Watari Museum of Contemporary Art, Tokyo: watarium.co.jp/museumcontents.html
Yokohama Museum of Art, Yokohama: yaf.or.jp/yma/index.php

Kazakhstan
Soros Center for Contemporary Art, Almaty: scca.kz

Korea
Arko Art Center, Seoul: arkoartcenter.or.kr/artcenter_kor/index.jsp
Artsonje Center, Seoul: artsonje.org/eng
Leeum – Samsung Museum of Art, Seoul: leeum.samsungfoundation.org

National Museum of Contemporary Art, Seoul: moca.go.kr/eng/index.do?_method=engMain
Seoul Museum of Art, Seoul: seoulmoa.seoul.go.kr/global/eindex.jsp
Nam June Paik Art Center, Yongin: njp.kr/ff_eng.html

Malaysia
National Art Gallery Malaysia, Kuala Lumpur: artgallery.gov.my/home

Pakistan
Alhamra Art Gallery, Lahore: www.alhamraartscouncil.com.pk
Rohtas 2 Gallery, Lahore: www.rohtasgallery.com

Philippines
Green Papaya Art Projects, Quezon City: greenpapayaartprojects.org

Singapore
Singapore Art Museum: singart.com
The Substation: substation.org

Taiwan
National Taiwan Museum of Fine Arts, Taichung: www.tmoa.gov.tw/english/index.aspx
Museum of Contemporary Art, Taipei: www.mocataipei.org.tw
Taipei Fine Arts Museum, Taipei: tfam.museum
IT Park, Taipei: itpark.com.tw

Thailand
Bangkok Art and Culture Center, Bangkok: bacc.or.th
Jim Thompson House Art Center, Bangkok: jimthompsonhouse.org
National Gallery, Bangkok: national-gallery.go.th/index.html
VER Gallery, Bangkok: ver.mono.net

Vietnam
Sàn Art, Ho Chi Minh City: san-art.org/about.html

list of illustrations

City Museums Service. Courtesy the artist; p. 60 left Vasan Sitthiket, *Lord Buddha Visits Thailand*, 2009. Collection of Surind Limmanond. Courtesy Surapon Gallery, Bangkok. Photo: Aroon Permpoonsopon; p. 60 right Michael Shaowanasai, *Study in Sculpture*, 2000. Courtesy the artist; p. 61 Montien Boonma, *House of Hope*, 1996–97. Photo Norihiro Ueno. Courtesy the artist; p. 62 Chen Zhen, *Obsession of Longevity*, 1995. Courtesy Xu Min and Galleria Continua, San Gimignano/Beijing/Le Moulin. Photo: Dimitsis Tamviskos; p. 63 Atta Kim, *The Museum Project #141*, from the *Nirvana* series, 2001. Courtesy of Atta Kim Studio; p. 64 Mariko Mori, *Nirvana*, 1997. Courtesy Shiraishi Contemporary Art, Inc., Tokyo and Deitch Projects, New York; p. 65 Hiroshi Sugimoto, *Sea of Buddha*, 1995. Private collection. Courtesy the artist and Gagosian Gallery. © Hiroshi Sugimoto; p. 66 Ravinder Reddy, *Radha*, 2007. Collection of Julie Walsh. Courtesy the artist and Walsh Gallery; p. 67 Gonkar Gyatso, *Pokémon Buddha*, 2004–5. Collection of Sharon Solomons. Courtesy the artist and Rossi & Rossi; pp. 68, 69 Michael Joo, *Headless (Mfg. Portrait)*, 2000. Commissioned by Artsonje Center, Seoul, South Korea. Collection of Denver Art Museum, Colorado. Courtesy the artist; p. 70 Almagul Menlibayeva, *Steppen Baroque II*, 2003. Production photograph from SteppenBaroque. Courtesy Priska C. Juschka Fine Art; p. 71 Almagul Menlibayeva, *Apa I*, 2003. Production photograph from Apa. Courtesy of Priska C. Juschka Fine Art; p. 72 Ranbir Kaleka, *Man with Cockerel 2*, 2004. Courtesy the artist and Bose Pacia Gallery, New York. Photo: David Flores; p. 73 Chaolun Baatar, *Burning Toono-I, The Skylight*, 2002. Courtesy the artist; pp. 74–75 Lida Abdul, *Brick Sellers of Kabul*, 2006. Courtesy of Giorgio Persano Gallery; p. 77 Shirin Neshat, *Rebellious Silence*, 1994. RC print & ink (photo taken by Cynthia Preston), 118.4 x 79.1 cm (46⅝ x 31⅛ in.). © Shirin Neshat. Courtesy Gladstone Gallery, New York; p. 78 Dadang Christanto, *Kekerasan I (Violence I)* (detail), 1995. Courtesy Asia Society Museum, New York; p. 79 above FX Harsono, *The Voices are Controlled by the Powers*, 1994. Courtesy Asia Society Museum, New York; p. 79 below Heri Dono, *Flying Angels*, 1996. Collection: National Gallery of Australia, Canberra, Australia (Gift of

Gene and Brian Sherman 2008). Courtesy the artist and Walsh Gallery. Photo: Chris Meerdo; p. 80 Rirkrit Tiravanija, *Mai Mee Chue (pad thai)*, 1990/2004. Courtesy the artist and Gavin Brown's enterprise, New York; p. 81 Surasi Kusolwong, *Night Market*, 2001. Courtesy of Art & Public, Geneva. Photo: Ilmari Kalkkinen; p. 82 above Wang Jin, *Ice: Central China*, 1996. Courtesy of Friedman Benda, New York, and Pekin Fine Arts, Beijing; p. 82 below Lin Yilin, *100 Pieces and 1,000 Pieces*, 1993. Courtesy the artist; p. 83 Lee Mingwei, *The Letter-Writing Project*, 1998–2008. Collection: The Whitney Museum of American Art, Yageo Foundation Collection, Taiwan. Courtesy the artist, Lombard Freid Projects, New York, and Albion Gallery, London. Photo: George Hirose; p. 84 Zhang Huan, *To Raise the Water Level in a Fishpond*, 1997. Courtesy the artist; p. 85 Truong Tan, *Untitled #23*, 1994–95. Courtesy of Art Vietnam Gallery. Photo: Matthew Dakin; p. 86 William Yang, *Stephen #1*, 1992. Courtesy the artist; p. 87 Manit Sriwanichpoom, *Pink Man Begins* (detail), 1997. Courtesy the artist; p. 88 Morimura Yasumasa, *Portrait (Futago)*, 1988–90. Courtesy the artist and Luhring Augustine, New York; p. 89 Morimura Yasumasa, *Self-Portrait (B/W) – After Marilyn Monroe*, 1996. Courtesy the artist and Luhring Augustine, New York; p. 90 Nikki S. Lee, *The Hip Hop Project (1)*, 2001. Courtesy Sikkema Jenkins & Co.; p. 91 Chatchai Puipia, *Siamese Smile*, 1995. Private collection. Courtesy the artist; p. 92 above Huang Yong Ping, *Chinese Hand Laundry*, 1994. Courtesy the artist and Gladstone Gallery; p. 92 below Zhang Huan, *12m²*, 1994. Courtesy the artist; p. 93 Wang Du, *Défilé*, 2000. Courtesy Galerie Laurent Godin, Paris; p. 94 Guan Wei, *Certificate Series*, 1990. Collection: Museum of Contemporary Art, Sydney. Courtesy the artist; p. 95 Wong Hoy Cheong, *Migrants Series: Aspirations of the Working Class*, 1994. Courtesy the artist. Photo: David Lok; p. 96 Nalini Malani, *Remembering Toba Tek Singh*, 1998–99. Purchased 2000. Queensland Art Gallery Foundation Grant Collection: Queensland Art Gallery; p. 97 Farida Batool, *Line of Control*, 2004. Courtesy the artist and Aicon Gallery; p. 98 Vivan Sundaram, *Memorial*, 1993. Courtesy the artist; p. 99 Jitish Kallat, *Collidonthus*, 2007. Collection: Frank Cohen Collection, UK. Courtesy of Jitish Kallat

Studio. Photo: Iris Dreams, Mumbai; p. 100 Navjot Altaf, *Lacuna in Testimony*, 2003. Courtesy the artist and Talwar Gallery New York/New Delhi. Photo: Greg Weight; p. 101 Atul Dodiya, *Mirage*, 2002. Courtesy the artist. Photo: Prakesh Rao; p. 102 Lida Abdul, *Brick Sellers of Kabul*, 2006. Courtesy of Giorgio Persano Gallery; p. 103 above An-My Lê, *29 Palms: Infantry Officers' Brief*, 2003–4. Courtesy Murray Guy, New York; p. 103 below Zhang Peili, *Water – The Standard Version Read from the 'Ci Hai' Dictionary*, 1989. Courtesy Asia Society Museum, New York; p. 104 Yue Minjun, *La Liberté guidant le peuple*, 1995. Sigg Collection. Courtesy Uli Sigg; p. 105 Zhang Xiaogang, *Bloodline Series*, 1997. Sigg Collection. Courtesy Uli Sigg; p. 106 above Hai Bo, *Three Sisters*, 2000. Courtesy the artist and AW Asia; p. 106 below Wang GongXin, *My Sun*, 2000. Collection: Asia Society Museum, New York: Guangdong Museum of Art, Guangzhou. Courtesy the artist; p. 107 Shen Jing Dong, *Soldier Family*, 2008. Courtesy the artist & ChinaSquare Gallery, NY. Photo: Shen Jing Dong; p. 108 above Huang Yong Ping, *Da Xian – The Doomsday*, 1997. Collection of Harold and Ruth Newman. Courtesy the artist and Gladstone Gallery; p. 108 below Mahreen Zuberi, *Doing Krishna (4)*, 2006. Collection: Queensland Art Gallery, Gallery of Modern Art. Courtesy the artist; p. 109 Shirin Neshat, *Turbulent*, 1998. Courtesy Gladstone Gallery; p. 110 Adeela Suleman, *Untitled*, 2009. Courtesy the artist. Photo: Sohail Zuberi; p. 111 Lin Tianmiao, *Bound and Unbound*, 1995–97. Collection of Hong Kong Art Center. Photo: Wang GongXin. p. 112 Arahmaiani, *Offerings from A–Z*, 1996. Photo: Manit Sriwanichpoom; p. 113 above Araya Rasdjarmrearnsook, *Reading for female corpse*, 1997. Courtesy the artist. Photo: Eakarach Prangchaikul; p. 113 below Araya Rasdjarmrearnsook, *I'm living*, 2002. Collection: Kiasma Museum of Contemporary Art. Courtesy the artist. Photo: Eakarach Prangchaikul; p. 114 Tomoko Sawada, *OMIAI♡* (detail), 2001. Courtesy MEM, Osaka. © Tomoko Sawada; p. 115 left Pushpamala N. and Clare Arni, *Lakshmi (after oleograph from Ravi Varma Press early 20th century)*, from the photo-performance project '*Native Women of South India: Manners and Customs*', Bangalore, 2000–4. Image courtesy Bose Pacia, New York,

acknowledgments

Nearly twenty years ago, when we both began to live, study and travel in Asia, nobody paid much attention to contemporary Asian art. Some in the blinkered European/American art worlds even questioned whether or not it existed. That has now changed, with many Asian artists exhibiting regularly all over the world. This book is a testament to their success.

Books always take longer to write than intended. This book is the product of ten years of combined research, writing, and shared or individual travelling to nearly every country in Asia and the Pacific, including Iran. During this time, it has been a tremendous pleasure to visit the studios and homes of a good portion of the artists discussed in this book. Curators, critics and collectors have also contributed to our understanding of the emergence of contemporary Asian art through countless conversations, usually over meals, and shared visits to exhibitions, biennales and performances. To those living and working in the Asia-Pacific region who have helped us in so many ways, we thank you. This book is dedicated to you.

Several people and organizations require special mention. Research for the book was undertaken with support from the Australia Council (Sydney) and the Asian Cultural Council (New York). During the writing process we also benefitted from guidance and comments by experts in the field, which greatly helped us hone and improve the manuscript. We thank, in particular, Sooran Choi, Adam Geczy, Allen Hockley, Joan Kee, Arshiya Lokhandwala, Kaja McGowan and Miwako Tezuka. We appreciate the work of our colleagues who contributed biographies to the book: Jacqueline Ganem, Maria Carmelina Howell, Sohl Lee, Valentina Riccardi, Miwako Tezuka, Taliesin Thomas, Daisy Yiyou Wang and Hyewon Yi.

We are grateful to Susan Delson for editorial advice, and to Daisy Yiyou Wang, Valentina Riccardi and Hannah Pritchard for assisting with images. We would also like to acknowledge all of the artists who granted us permission to reproduce their works in this book. Finally, thanks so much to Jamie Camplin and his team at Thames & Hudson for believing in this seemingly daunting project. We are forever in your debt.

Thanks also to those who assisted with sourcing and providing images for the book: Isabelle Chen of Galerie Laurent Godin, Euna Yoo, Hiroyuki Sasaki of Tokyo Gallery+BTAP, Tarané Ali Khan and Katrina Weber of The Third Line, Jee-Young Maeng of Gana Art Gallery, Johnson Chang and Loretta Lo, Hanart TZ Gallery, Fang Zhang, Stefano Riba of Giorgio Persano, Anuradha Ghosh-Mazumdar of Sotheby's Inc., Xiaoyan Guo of Ullens Center for Contemporary Art Beijing, Jon Hendricks and Karla Merrifield, Lea Freid and Kelsey Sundberg of Lombard-Freid Projects, Cesar Jun Villalon of Drawing Room, Kajette Bloomfield of The Project, Samuel Rauch of Madison Square Park Conservancy, Jessica Witkin of David Zwirner, New York, Uli Sigg, Yvonne Jaggi, Janice Guy of Murray Guy, Jasdeep Sandhu of Gajah Gallery, Tina Kim and Jaime Schwartz of Tina Kim Gallery, James McKee of Gagosian Gallery, Kingsley Liu, Sylvia Wong, Jamie Sterns of P.P.O.W Gallery, George Chang and Katherine Don of Red Box, Kusaka Eriko, Ishizaki Ayaka of Mizuma, Eva McGovern, Fabio Rossi of Rossi & Rossi, Julie Walsh and Tijana Jovanovic of Walsh Gallery, Eric Nylund of Gladstone Gallery, Suzanne Lecht and Eloise Sohier of Art Vietnam, Nicole J. Caruth of Arario Gallery New York, Yoriko Tsuruta of Ota Fine Arts, Tokyo, Nao Sakai of Yamamoto Gendai Gallery, Chris Mao of Chambers Fine Art, Amit Kumar Jain of Devi Art Foundation, Simone Subal of Peter Blum Chelsea, Priska C. Juschka of Priska C. Juschka Fine Art, Peter Nagy, Edward Winkleman, Tom Bigelow, Matthew Droege, Ellie Bronson of Sikkema Jenkins & Co, Amy Schmersal of Lehmann Maupin, Alex Cao and Carrie Clyne of China Square, Alice Fontanelli of GALLERIACONTINUA, Tyler Rollins, Nicholas Cohn and Colin Winkelman of Tyler Rollins Fine Art, Craig Barnes and Nozomi Oshima of Kaikai Kiki New York LLC, Marc Benda of Benda Friedman, Deepak Talwar and Alicia J. D. Cooper of Talwar Gallery, Esa Epstein, Anne de Henning of Succession Raghubir Singh, Christopher Rawson of James Cohan Gallery, Huiting Ho of Chen Chieh-jen Studio, Brandon N. Barrow of Max Protetch Gallery, I-Hua Lee of Cai Studio, Katie de Tilly and Celine Ho of 10 Chancery Lane Gallery, Caroline Burghardt of Luhring Augustine, Surapon Bunyapamai, Laura Zhou of Shanghart, Esra Joo, Ami Fukuda of MEM, Taliesin Thomas, Larry Warsh, Hsinyi Hu, Rhiannon E. MacFadyen, Priyanka Mathew and Prajit Dutta of Aicon, Aey Phanachet of 100 Tonson Gallery, Robyn Ziebell of Queensland Art Gallery, RaYoung Hong of Leeum – Samsung Museum of Art, Rebecca Davis of Bose Pacia, Marianne Boesky and Eve Wasserman of Marianne Boesky Gallery and Laëtitia Chevigny, Atelier YAN Pei-Ming, and Shoshana Wayne of Shoshana Wayne Gallery.

index

Individuals are indexed by family name.

Numbers in *italic* refer to illustrations.

Abdul, Lida 74–75, 102, *102*
Adipurnomo, Nindityo 78
Affandi 17
Afghanistan 10, 102; *see also* Lida Abdul, Rahraw Omarzad
Ai, Weiwei 22, 168, *168*
Aida, Makoto 47, *47*
AIDS/HIV 31, 78, 84–86, 90
Akhunov, Vyacheslav 70
Akira, Tatehata 15
Akhlaq, Zahoor ul 55, *55*
Altaf, Navjot 100, *100*
anime 31, 69, 123, 128–29
Aoshima, Chiho 125, *126*
Apisuk, Chumpon 84
Arahmaiani 78, 112, *112*
Arni, Clare 113, *115*
Art Dubai 140
Artis Pro Activ group (Malaysia) 80
Artists Village group (Singapore) 109
Asia Society Museum, New York 8, 60
Asian Pop 122–23
Australia 9, 10, 29, 86

Baatar, Chaolun 73, *73*
Back, Seung-Woo 199, *199*
Bagchi, Jeebesh 205
Bahc, Yiso 195
Ban, Chinatsu 125
Banerjee, Rina 187, *187*
Batool, Farida 97, *97*
'bazaar' art ('calendar' art) 113, 123
Beuys, Joseph 81
biennials (*see also* triennials):
 Brisbane 25
 Busan 25
 Gwangju 25

Jakarta 25
Paris 17
São Paulo 17
Shanghai 25, *25*
Singapore 24, 186
Sydney 81
Taipei 25
Tashkent 24
Tokyo 25
Venice 7, 25, 27, 73, 87
Whitney 92
Big Tail Elephant Group (China) 192
Binghui, Huangfu 108
Bombay Progressive Artists group (India) 15
Boonma, Montien 59–60, *61*
Bose, Santiago 37
Brancusi, Constantin 100
Buddhism 20, 59–60, 63, 65, 69, 81, 92, 112
 Buddhist scroll paintings 42
Burma 10, 20; *see also* Chaw Ei Thein, Aye Ko
Butt, Faiza 148, *148*
byobu screens 47

Cai, Guo-Qiang 7, *8*, 22, 60, *144*, *145*, 147
'calendar' art, *see* 'bazaar' art
calligraphy 17, 21, 36, 37–42, 156, 170
Candy Factory 204–205, *205*, 207
Cang, Xin 92
Cao, Fei *1*, 157, 178, *179*, 206–207
Cao, Xiaodong 107
Carnegie Recital Hall, New York 12
cartoons 69, 158–59
Castellane Gallery, New York 12
celebrity 69, 147–57
Central Academy of Fine Arts, Beijing 38
ceramics 36, 52–54, 136
Cézanne, Paul 17
Chang, Tsong-zung 168
Chang, Young-Hae, *see* YOUNG

HAE-CHANG HEAVY INDUSTRIES
Chatterjee, Joy *206*
Chaw, Ei Thein 186, *186*
Chen, Chieh-jen 29, *30*
Chen, Qiulin 173, *173*
Chen, Shaoxiong 187, *188*
Chen, Zhen 22, 60, 61, *62*, 167
Chin, Botak 152
China 7, 10, 19, 21, 22, 27, 29, 30, 36, 42, 45, 48, 51, 55, 82, 90, 92, 104–108, 123, 133–34, 137, 145, 147, 152, 167–70, 172–74, 178, 191, 195, 206; *see also* Ai Weiwei, Cai Guo-Qiang, Cao Fei, Cao Xiaodong, Chang Tsong-zung, Chen Qiulin, Chen Shaoxiong, Chen Zhen, Fang Lijun, Gao Minglu, Gu Hongzhong, Wenda Gu, Hai Bo, Hong Hao, Huang Rui, Huang Yan, Huang Yong Ping, Yun-Fei Ji, Jing Kewen, Sze Tsung Leong, Li Keran, Li Luming, Li Pi, Li Shan, Li Shuang, Li Xianting (Lao Li), Lin Tianmiao, Lin Yilin, Liu Juanhua, Lu Shengzhong, Luo Brothers, Ma Deshen, Ma Liuming, Miao Xiaochun, Mu Chen, Mu Fei, Qi Zhilong, Qiu Zhijie, Shao Yinong, Shen Jing Dong, Shi Dongshan, Shi Guorui, Shi Jinsong, Shi Lu, Song Dong, Sui Jianguo, Wang GongXin, Wang Guangyi, Wang Jin, Wang Keping, Wang Qingsong, Zhan Wang, Wang Zhiyuan, Weng Peijun, Wu Guanzhong, Ah Xian, Xing Danwen, Xu Bing, Xu Yihui, Xu Zhen, Yan Pei-Ming, Yang Fudong, William Yang, Yin Xiuzhen, Yu Youhan, Yuan Muzhi, Yue Minjun, Zhang Dali, Zhang Hongtu, Zhang Huan, Zhang Peili, Zhang Xiaogang, Zhang Zeduan,

Zhou Tiehai, Zhu Fadong
Choe, U-Ram 203, *203*
Christanto, Dadang 78, *78*
Christianity 73
Chughtai, Abdur Rahman 17
Chun, Kwang-Young 44, *45*
collages 73, 94, 131, 148, 187
colonialism 24, 45, 97, 108, 112, 150, 164
comic books 123, 129–31, 192
Confucianism 45, 63, 85
consumerism 31, 134, 137
corporate branding 134–38
corporate culture 176–80
Cruise, Tom 159
Cultural Revolution (China, 1966–1976) 21, 42, 104–105, 107, 123, 134, 152, 173
Cynical Realism 104–105

Dadi, Elizabeth 156
Dadi, Iftikhar 156
Daging Tumbuh magazine 131
dance 17, 38–39
Deng, Xiaoping 7, 21, 147
digital art 27, 65, 70, 123, 129, 136, 138, 148, 159, 174, 200, 204, 207
Djumaliev, Muratbek 30, *31*
Documenta 7
Dodiya, Anju 108
Dodiya, Atul 100, *101*
Dono, Heri 78, *79*

East Village artist community, Beijing 90, 92, 115
Edades, Victorio C. 17
Edo period 47–48, 123
'85 New Wave Movement (China) 39, 145
Europe 7, 10, 29–30, 55, 69, 73, 94, 97, 108, 123, 129, 138, 174
Experimental Workshop group (Japan) 12

Fang, Lijun 105
feminism 108–117

PROPERTY OF SENECA COLLEGE LIBRARIES MARKHAM CAMPUS

PROPERTY OF SENECA COLLEGE LIBRARIES NEWNHAM CAMPUS